MARK ROTHKO

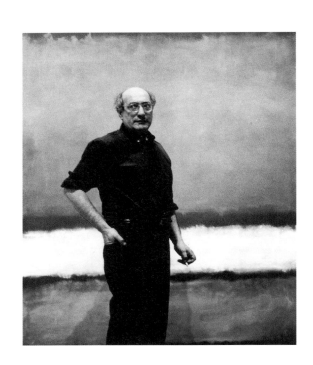

JEFFREY WEISS

WITH CONTRIBUTIONS BY

JOHN GAGE

CAROL MANCUSI-UNGARO

BARBARA NOVAK

BRIAN O'DOHERTY

MARK ROSENTHAL

JESSICA STEWART

NATIONAL GALLERY OF ART
WASHINGTON

YALE UNIVERSITY PRESS
NEW HAVEN AND LONDON

MARK ROTHKO

THE EXHIBITION IS SPONSORED BY MOBIL

The exhibition has been organized by the National Gallery of Art, Washington

Exhibition Dates

National Gallery of Art, Washington
3 May–16 August 1998

Whitney Museum of American Art, New York
10 September–29 November 1998

Musée d'Art Moderne de la Ville de Paris
8 January–18 April 1999

This book has been produced by the Editors Office, National Gallery of Art, Washington.

Editor-in-chief, Frances P. Smyth
Edited by Tam Curry Bryfogle
Designed by Margaret Bauer

Typeset in Adobe Minion and Cronos by the National Gallery of Art. Printed on Gardapat 135gsm by Arnoldo Mondadori Editore, Verona, Italy.

Clothbound books distributed by Yale University Press, New Haven and London

Library of Congress Cataloging-in-Publication Data

Weiss, Jeffrey.
Mark Rothko / by Jeffrey Weiss; with contributions by John Gage…[et. al.].

p. cm.

Catalogue of an exhibition held at the National Gallery of Art, Washington, DC, 3 May–16 Aug. 1998; Whitney Museum of American Art, New York, 10 Sept.– 29 Nov. 1998; Musée d'Art Moderne de la Ville de Paris, 8 January–18 April 1999.

ISBN 0-89468-229-6 (softcover)
ISBN 0-300-07505-7 (hardcover)

1. Rothko, Mark, 1903–1970 — Exhibitions. I. Gage, John. II. National Gallery of Art (U.S.) III. Whitney Museum of American Art. IV. Musée d'Art Moderne de la Ville de Paris. V. Title.

N6537.R63A4 1998
760'.092 — dc21 97-51532

Cover: *Untitled,* 1953, National Gallery of Art, Washington, Gift of The Mark Rothko Foundation, Inc. See also cat. 57.

Page 2: Rothko in front of *No. 7,* 1960. Photograph c. 1961. See also cat. 83.

Page 5: Rothko moving *Untitled,* 1954, seen inverted. Photograph by Henry Elkan. See also cat. 65.

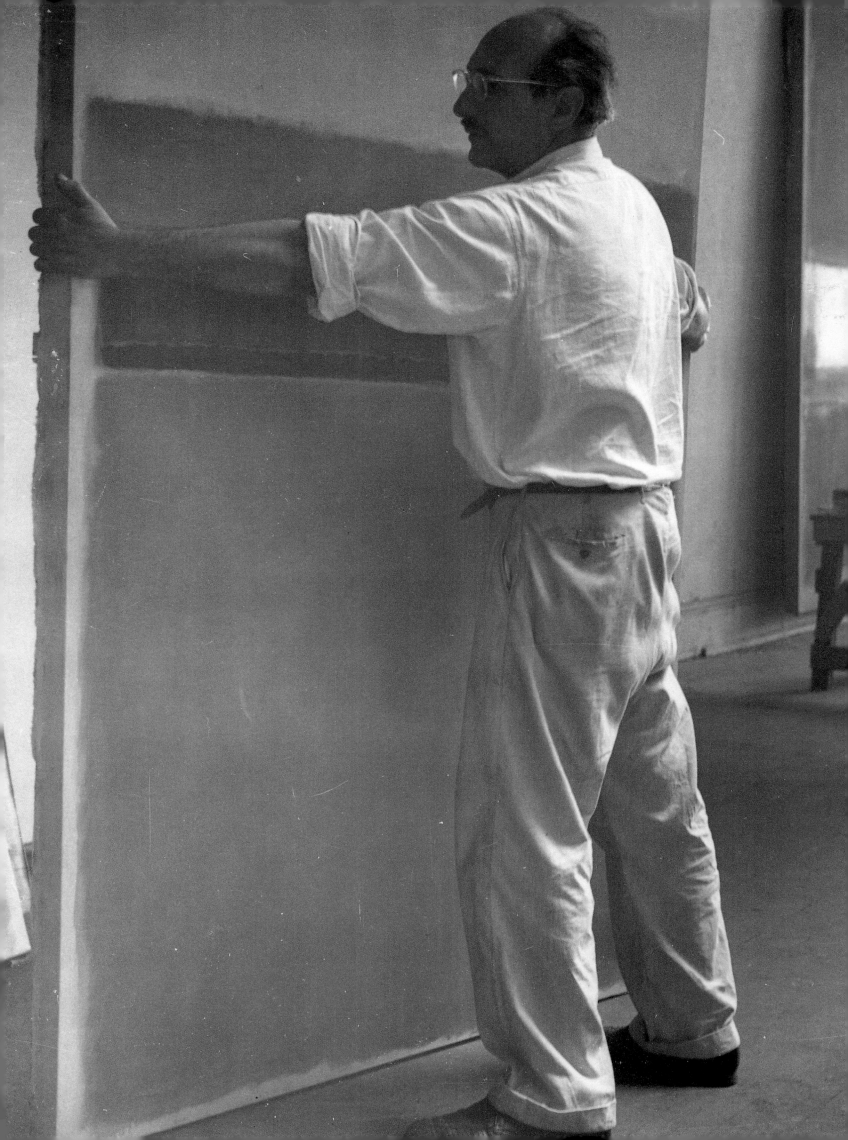

This is the first American retrospective of Mark Rothko's career in twenty years. More than ten years ago the National Gallery of Art became the beneficiary of a sweeping gift of the artist's work from The Mark Rothko Foundation, including hundreds of paintings and works on paper. This special relationship with Rothko confers on us a responsibility to bring his art to a broad public.

Starting with a significant number of works from the National Gallery's own extraordinary Rothko holdings, we have assembled major loans from collections in the United States, Europe, and Japan. The exhibition covers virtually every period of the artist's career, beginning with his early figurative paintings and tracing the emergence and complex development of his signature abstract style. We are deeply indebted to the many lenders, both private and public, who have committed important works to this exhibition. Special mention must go to Kate Rothko Prizel and Christopher Rothko for their generous support of the project. Rothko is a giant of American painting, and his monumental artistic achievement is revealed here in new depth.

The exhibition and its accompanying catalogue have been organized by Jeffrey Weiss, associate curator of twentieth-century art at the National Gallery. Curatorial consultants included Mark Rosenthal, curator of twentieth-century art at the Solomon R. Guggenheim Museum, New York, and David Anfam, author of the forthcoming catalogue raisonné of Rothko's works.

We wish to thank the Mobil Corporation, and especially its chairman and chief executive officer, Lucio Noto, for sponsorship of the Rothko exhibition. The Mobil Corporation has been a friend of the Gallery for many years. Such corporate involvement has become invaluable in mounting large exhibitions, and we are grateful to Mobil for its continued support.

Earl A. Powell III
Director, National Gallery of Art

LENDERS TO THE EXHIBITION

Gisela and Dennis Alter

Art Gallery of Ontario, Toronto

The Art Institute of Chicago

The Baltimore Museum of Art

Ambassador and Mrs. Donald Blinken

Peter Blum

The Brooklyn Museum of Art

Carnegie Museum of Art, Pittsburgh

The Chrysler Museum, Norfolk

Jane Lang Davis and Richard Lang

Barbaralee Diamonstein and
Carl Spielvogel

Aaron I. Fleischman

Fondation Beyeler, Riehen/Basel

The Frances Lehman Loeb Art Center,
Vassar College, Poughkeepsie, New York

Mr. and Mrs. Richard S. Fuld Jr.

Solomon R. Guggenheim Museum,
New York

Hirshhorn Museum and Sculpture
Garden, Smithsonian Institution,
Washington, DC

Mr. and Mrs. Gilbert H. Kinney

Kunsthaus Zürich

Museum of Contemporary Art,
Los Angeles

Linda and Harry Macklowe

Mrs. Paul Mellon

The Metropolitan Museum of Art,
New York

Robert and Jane Meyerhoff

Milwaukee Art Museum

Adriana and Robert Mnuchin

Munson-Williams-Proctor Institute
Museum of Art, Utica, New York

The Museum of Modern Art, New York

National Gallery of Art, Washington, DC

National Gallery of Canada, Ottawa

John and Mary Pappajohn

The Phillips Collection, Washington, DC

Ulla and Heiner Pietzsch

Kate Rothko Prizel

Ivan Reitman and Genevieve Robert

Christopher Rothko

San Francisco Museum of Modern Art

Sezon Museum of Modern Art,
Karuizawa, Japan

Ira Smolin

Tate Gallery, London

The Toledo Museum of Art

University of California, Berkeley
Art Museum

Walker Art Center, Minneapolis

Ealan Wingate

Bagley and Virginia Wright

Yale University Art Gallery, New Haven

And other lenders who wish
to remain anonymous

Antoine de Saint-Exupéry once asked, in a context admittedly unrelated to the present subject, "how can one tell the difference between an image and an act of the will?" In a manner of speaking, Rothko's paintings can resemble acts of the will, objects that have sprung forth fully formed. The uncomplicated appearance and instant recognition of works from the classic period, however, disguise the complex nature of the oeuvre. In addition to showing the broad scope of his career, our retrospective addresses Rothko's work overall as a sequence of overlapping researches in an increasingly distilled approach to pictorial form. As such, it portrays Rothko's development as an unfolding of various compositional formats within which the artist implemented elements such as color, structure, measure, luminosity, and the definition of shape. This principle was first observed in 1970 by Thomas Hess, who characterized it as the "serious, complicated, profoundly analytical part of his effort," and it is demonstrated in the exhibition by a number of works that were selected to represent sets or groups. While such a typological approach remains essentially chronological, the recurrence of certain formats and motifs is observed to deviate, with some frequency, from a strictly sequential timeline.

Speaking of his own work, Rothko referred much more often to content than form, reflecting a profound devotion to grand themes such as tragedy, ecstasy, and death, some of which are alluded to in his early use of figures and symbols. Further, the commanding yet vulnerable presence for which his mature paintings are best known reveals the artist's commitment to creating a physical and emotional relationship between the canvas and the observer. Nonetheless, especially after the mid-1940s, content is ultimately expressed through the nonobjective impact of the paintings. In this regard, establishing a coherent narrative of Rothko's approach to pictorial form (an account based on patterns that are internal to the works themselves and can be traced back to the 1930s) enables us to chart the role of the canvas as an abstract theater of emotions and ideas.

Our catalogue follows suit. Four essays plot the significance of formal elements in Rothko's work that were, for the artist, charged with meaning. The implication is not that these elements—color, darkness, surface, and space—can ever be said to function independently of one another, but that each bore distinct implications for Rothko. Thus each may be isolated for the purpose of fathoming the various meanings that coalesce around and within his paintings. One explanatory note: the catalogue does not include a bibliography or exhibition history, since definitive versions of each will appear in the catalogue raisonné of Rothko's work, which is being prepared by David Anfam.

In their singularity and fullness, Rothko's works tend to live uncomfortably on the wall next to paintings by other artists (something that Rothko knew); they are most at home when installed alone or in monographic groups. This quality insinuates that the work is hermetic, an impression that can be usefully dispelled. To this end, the catalogue essays are accompanied by interviews with five artists whose own work reflects on the nature and legacy of Rothko's achievement. Each first addressed Rothko's art during a time when Rothko himself had begun to feel that his ambition for painting was beginning to appear outmoded. In fact, Rothko emerges from this setting as both an innovative modernist and something like the last old master: an acutely original painter's painter, and a model of high-minded conviction in the value of a profoundly expressive art.

ACKNOWLEDGMENTS

I must begin by recognizing Christopher Rothko, Kate Rothko Prizel, and Ilya Prizel, who were partly responsible for initiating this retrospective. Approaching the artist's legacy with deep commitment, they have been a gracious source of encouragement and support. The Rothkos have also lent numerous works from their personal collections. Thanks to them, the exhibition is not just an event, it is an occasion.

In preparing the exhibition, I have benefited from two curatorial consultants. David Anfam has spent a number of years working for the National Gallery of Art on the catalogue raisonné of Rothko's works on canvas, over the course of which he has accumulated a great amount of vital information and special expertise. We have greatly profited from both. Mark Rosenthal, curator of twentieth-century art at the Guggenheim Museum, New York, has been a sage and generous supporter, contributing invaluable information and counsel at every stage.

I am grateful to the authors of the catalogue, John Gage, Carol Mancusi-Ungaro, Barbara Novak, Brian O'Doherty, and Jessica Stewart, as well as Mark Rosenthal, for approaching the subject of Rothko with originality and dedication. Their text will be an enduring one. I would also like to thank the artists who graciously agreed to be interviewed: Ellsworth Kelly, Brice Marden, Gerhard Richter, Robert Ryman, and George Segal.

Projects such as this are often produced with the help of an assistant — ultimately a collaborator — who handles the thousand details that demand daily attention, and without whom the pursuit of a final product would run aground. In preparing both the exhibition and the catalogue, I am indebted

to Jessica Stewart, exhibition specialist in the department of twentieth-century art. Jessica has coordinated the myriad particulars with energy, ingenuity, outstanding judgment, and a high sense of purpose. Her contribution has been a prominent one, and she deserves a large share of credit. Laura Rivers, staff assistant in the department, has provided untiring and uncommonly attentive logistical support at all stages, always one step ahead of the project's many needs. Important additional support was also provided by staff assistant Lisa Coldiron. Helen Burnham, an intern in the department, contributed research at an early stage.

Many colleagues have further contributed in a great number of ways to the exhibition and the catalogue, and all deserve my gratitude. It has been a pleasure working with Marion Kahan, registrar for works belonging to the Rothko family, who coordinated the viewing and transport of numerous objects and has been a vital source of information. At PaceWildenstein, Arne Glimcher, Douglas Baxter, Eileen Costello, and Noelle Soper have been exceedingly generous in sharing materials and information and in facilitating the loan process. At C&M Arts, Robert Mnuchin, Jennifer Vorbach, and Maureen Bray have graciously and enthusiastically given of their time and energy at every stage. Jay Krueger, conservator of modern paintings at the National Gallery, treated several paintings by Rothko in the museum's collection in preparation for the exhibition and was a source of essential and enlightening technical guidance. I have also received generous advice about technical aspects of Rothko's work from Carol Mancusi-Ungaro, Dana Cranmer, and Sandra Amann.

This exhibition will travel to two museums. At the Whitney Museum of American Art, I have worked with David Ross and Willard Holmes; at the Musée d'Art Moderne de la Ville de Paris, our efforts were coordinated with Suzanne Pagé, Jean-Louis Andral, and Jean-Michel Foray.

Working with many museums and private collectors, I am especially indebted to Dee Ardrey, Ida Balboul, Peter Blum, Markus Brüderlin, Christopher Burke, Beverly Carter, Robin Clark, Francesca Consagra, Kathleen Curry, Bruce Davis, Lisa Dennison, Carol Eliel, Volkmar Essers, Trevor Fairbrother, Simona Fantinelli, Andrea Farnick, Jean Feinberg, Edith Ferber, Linda Ferber, Dawn Frank, Gary Garrels, Madeleine Grynsztejn, Lisa Hodermarsky, Jeffrey Hoffeld, Robert Hollister, Connie Homburg, Joe King, Charlotta Kotik, William Lieberman, Robert Littman, Anne-Louise Marquis, Michael McGinnis, Neil Meltzer, Sara Miller, David Monkhouse, Susan Oshima, Bob Phillips, Julie Phillips, Leslie Prouty, Laura Paulson, Joann Potter, Kelly Purcell, Kenneth Rabin, Liana Radvak, Brooke Rapaport, Carter Ratcliff, Eliza Rathbone, Jane Richards, Christina Ritchie, James Rondeau, Nan Rosenthal, Cora Rose-

vear, Margit Rowell, Helene Rundell, Paul Schimmel, Paul Schweizer, Lee Seldes, Brydon Smith, Jeremy Strick, Shuji Takashima, Matthew Teitelbaum, Kirk Varnedoe, Joanna Weber, and John Wilson. In addition, I would like to thank Anne Adams, Robin Airey, Geraldine Aramanda, Linda Battis, Patricia Berube, Ann Cain, Rose Candelaria, Susan Cary, Christine Cottle, Crosby Coughlin, Bridget Evans, Ann Freedman, Laura Harden, Judith Jacobs, Beth Joffrion, Pepe Karmel, Julia Marlow, Dianne Nilsen, Mark Pascale, Betsy Peare, Lynda Roven, Jeffrey Ryan, Patricia Sheinman, Barbi Spieler, Judy Throm, Diane Vandegrift, Dee White, Patricia Whitesides, Debora Winderl, Rose Wood, and Pascale Zoller.

At the National Gallery of Art I would like to thank director Earl A. Powell III and deputy director Alan Shestack for their continued support. Working with D. Dodge Thompson, Naomi Remes expertly managed the administrative details of the exhibition, ably assisted by Jonathan Walz. In the conservation department Judy Walsh handled conservation issues concerning works on paper. Ruth Fine and Carlotta Owens provided curatorial advice on the numerous works on paper in the museum's collection. Mark Leithauser, Gordon Anson, Bill Bowser, Donna Kwederis, and Jane Rodgers produced the exceptional installation of the exhibition. In the office of the registrar, it has been a pleasure to work with Michelle Fondas, who coordinated the packing and transport of works, and with Robert Cwiok, who supervised the art handlers. Sandy Masur and Chris Myers organized corporate funding. Barbara Moore and Donna Mann developed a Web site feature related to the exhibition, and Isabelle Dervaux wrote the brochure and prepared other educational materials.

Production of the exhibition catalogue was directed at the National Gallery by Frances Smyth, editor-in-chief. Tam Curry Bryfogle edited the catalogue with her usual discernment, proficiency, and tact. Special gratitude goes to Margaret Bauer, who conceived and executed an original and superb design. Jennifer Wahlberg provided technical support, Mariah Seagle contributed editorial assistance, and Maria Tousimis coordinated the publication finances. In the department of imaging and visual services, Sara Sanders-Buell assembled many of the transparencies and photographs. In the library Ted Dalziel and Thomas McGill helped secure important references. Laili Nasr, assistant on the Rothko catalogue raisonné project, has also provided much-needed information.

Jeffrey Weiss
Associate Curator of Twentieth-Century Art
National Gallery of Art

Titles of works in this exhibition are based on research by David Anfam, author of the forthcoming catalogue raisonné of Rothko's paintings. Where multiple titles appear, they are listed in order of authenticity. Titles assigned by the artist, when known, are given first and set in simple italics. When such titles are not known, the earliest recorded title appears first. Other titles assigned during Rothko's lifetime are enclosed in parentheses; those assigned posthumously are enclosed in square brackets.

Dates are also based on the catalogue raisonné, although in some cases previously assigned dates are also given.

Dimensions appear in centimeters followed by inches in parentheses; height precedes width.

Many works were assigned estate numbers by Rothko and his assistants between 1968 and 1970; these numbers (generally four digits followed by a year) are noted when known.

CATALOGUE

1 *Self-Portrait*, 1936
 oil on canvas
 81.9 x 65.4 (32 ¼ x 25 ¾)
 Collection of Christopher Rothko
 estate no. 3266.36

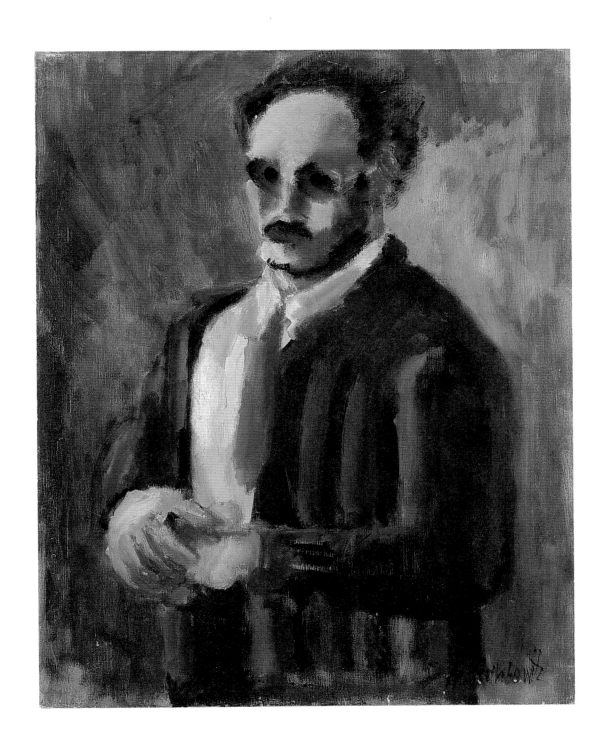

2 *Rural Scene,* c. 1936
oil on canvas
68.5 x 96.8 (27 x 38 ⅛)
National Gallery of Art, Washington,
Gift of The Mark Rothko Foundation, Inc., 1986
estate no. 3049.34

3 *Interior*, 1936
 oil on hardboard
 60.6 x 46.4 (23 ⅞ x 18 ¼)
 National Gallery of Art, Washington,
 Gift of The Mark Rothko Foundation, Inc., 1986
 estate no. 3069.32

4 *Street Scene*, c. 1937
 oil on canvas
 73.5 x 101.4 (29 x 40)
 National Gallery of Art, Washington,
 Gift of The Mark Rothko Foundation, Inc., 1986
 estate no. 3053.36

5 *Untitled*, 1937 – 1938
 oil on canvas
 60.7 x 46.1 (23 ⅞ x 18 ⅛)
 National Gallery of Art, Washington,
 Gift of The Mark Rothko Foundation, Inc., 1986
 estate no. 3235.36

6 *Untitled*, c. 1937
 oil on canvas
 101.6 x 76.2 (40 x 30)
 Ira Smolin

7 *Untitled,* 1938
 oil on canvas
 127 x 94 (50 x 37)
 Collection of Kate Rothko Prizel
 estate no. 3019.38

8 *Untitled (Portrait),* 1939
oil on canvas
101.6 x 76.5 (40 x 30 ⅛)
Collection of Christopher Rothko
estate no. 3092.36

9 *Entrance to Subway [Subway Scene],* 1938
 oil on canvas
 86.4 x 117.5 (34 x 46 ¼)
 Collection of Kate Rothko Prizel
 estate no. 3241.38

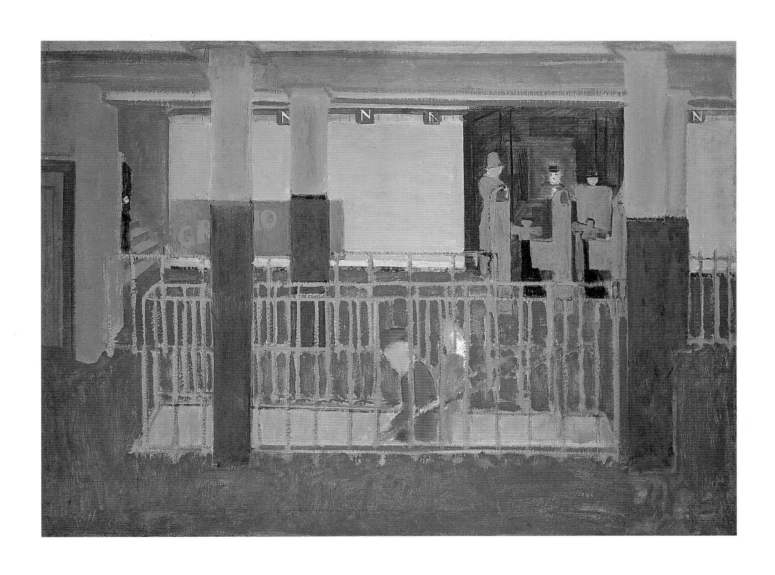

10 *Underground Fantasy [Subway]*, c. 1940
oil on canvas
87.3 x 118.2 (34 ⅜ x 46 ½)
National Gallery of Art, Washington,
Gift of The Mark Rothko Foundation, Inc., 1986
estate no. 3261.30

11 *Untitled*, 1941 – 1942
 oil and graphite on linen
 61 x 81 (24 x 31⅞)
 National Gallery of Art, Washington,
 Gift of The Mark Rothko Foundation, Inc., 1986
 estate no. 3079.40

12 *Untitled*, 1941 – 1942
 oil on canvas
 76 x 91.3 (29 ⅞ x 36)
 National Gallery of Art, Washington,
 Gift of The Mark Rothko Foundation, Inc., 1986
 estate no. 3082.39

13 *Untitled*, 1941 – 1942
 oil on canvas
 90.9 x 60.6 (35 ¾ x 23 ⅞)
 National Gallery of Art, Washington,
 Gift of The Mark Rothko Foundation, Inc., 1986
 estate no. 3083.39

14 *Untitled,* 1942 (alternatively dated to 1940 – 1941)
oil on canvas
71.3 x 92.1 (28 ⅛ x 36 ¼)
Solomon R. Guggenheim Museum, New York,
Gift of The Mark Rothko Foundation, Inc., 1986
estate no. 3133.40

15 *Sacrifice of Iphigenia,* 1942
oil and graphite on canvas
127 x 93.7 (50 x 36 ⅞)
Collection of Christopher Rothko
estate no. 3055.42

16 *Hierarchical Birds*, 1944
 oil on canvas
 100.7 x 80.5 (39 ⅝ x 31 ⅝)
 National Gallery of Art, Washington,
 Gift of The Mark Rothko Foundation, Inc., 1986
 estate no. 3052.40

17 *Primeval Landscape,* 1944
 oil on canvas
 138.1 x 88.9 (54 ⅜ x 35)
 Private Collection
 estate no. 3021.46

18 *Gethsemane,* 1944
 oil and charcoal on canvas
 138.1 x 90.2 (54 ⅜ x 35 ½)
 Collection of Kate Rothko Prizel
 estate no. 3024.45

19 *Slow Swirl at the Edge of the Sea,* 1944
 oil on canvas
 191.1 x 215.9 (75 ¼ x 85)
 The Museum of Modern Art, New York,
 Bequest of Mrs. Mark Rothko
 through The Mark Rothko Foundation, Inc., 1981
 estate no. 5042.44

20 *Untitled,* 1944 – 1945
watercolor on paper
75.9 x 55.3 (29 ⅞ x 21 ¾)
Collection of Christopher Rothko
estate no. 1124.40

21 *Untitled*, 1944 – 1945
 watercolor, tempera, graphite, and ink on paper
 53.3 x 66.8 (21 x 26 ¼)
 National Gallery of Art, Washington,
 Gift of The Mark Rothko Foundation, Inc., 1986
 estate no. 1128.40

22 *Archaic Idol* (recto), 1945
 wash, pen and ink, and gouache on paper
 55.6 x 76.2 (21⅞ x 30)
 The Museum of Modern Art, New York,
 The Joan and Lester Avnet Collection, 157.78.a – b

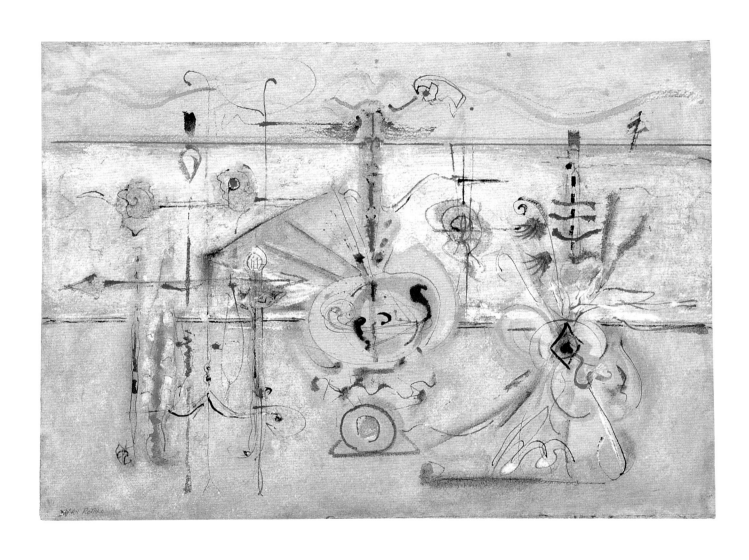

23 *Untitled*, c. 1944 – 1945
 watercolor on paper
 76.2 x 55.9 (30 x 22)
 The Metropolitan Museum of Art, New York,
 Gift of The Mark Rothko Foundation, Inc., 1986
 estate no. 1009.44

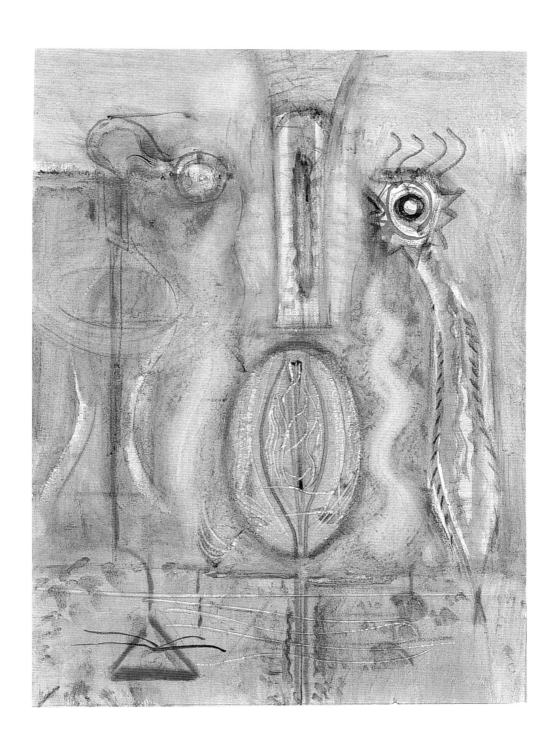

24 *Fantasy [Untitled]*, 1945
 oil on canvas
 134.9 x 98.7 (53 ⅛ x 38 ⅞)
 Private Collection, New York
 estate no. 3026.45

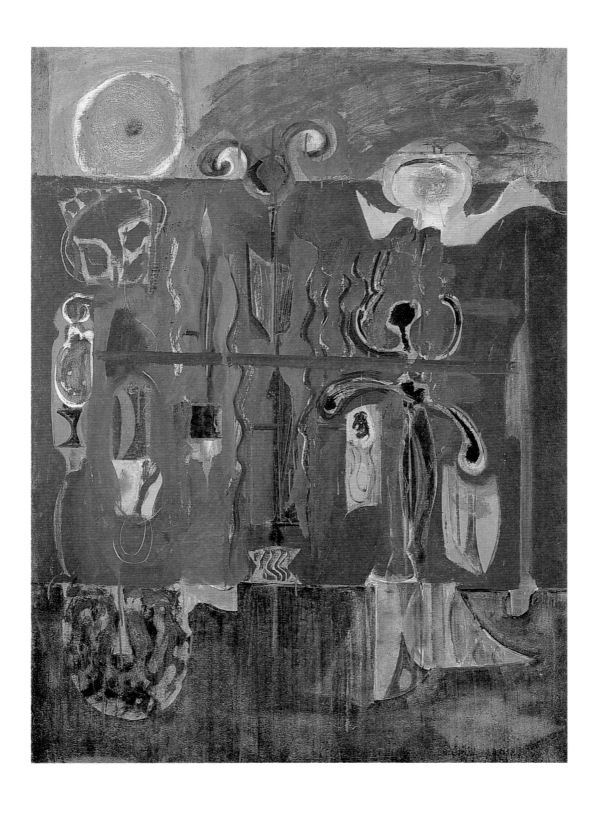

25 *Untitled,* 1944
 chalk, watercolor, pen and ink on paper
 66 x 99.1 (26 x 39)
 Mr. and Mrs. Richard S. Fuld Jr.
 estate no. 1021.44

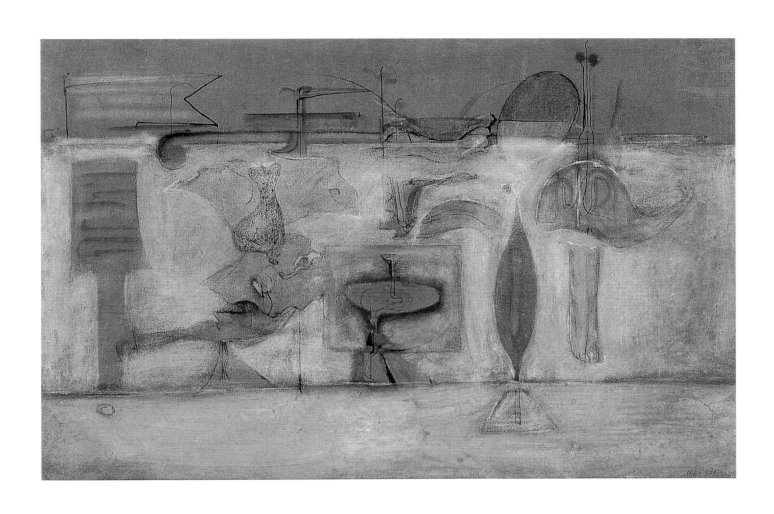

26 *Tentacles of Memory,* c. 1945 – 1946
 watercolor and ink on paper
 55.3 x 76.2 (21¾ x 30)
 San Francisco Museum of Modern Art,
 Albert M. Bender Collection,
 Albert M. Bender Bequest Fund Purchase

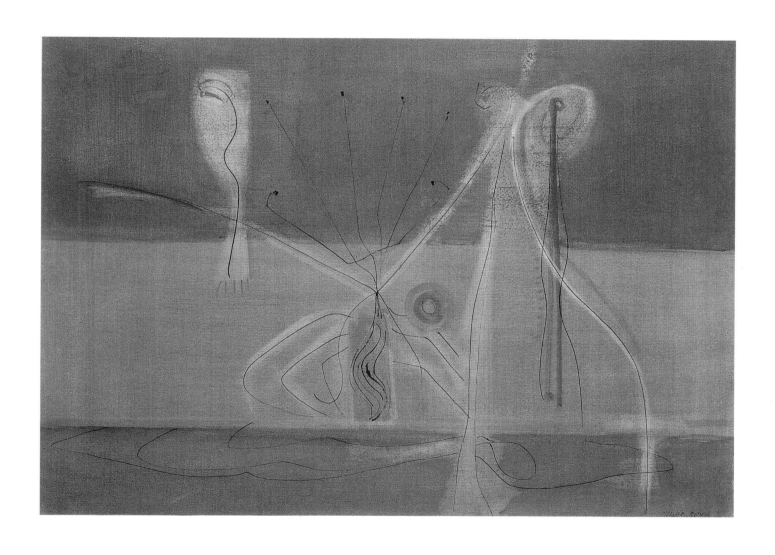

27 *Rites of Lilith,* 1945
 oil and charcoal on canvas
 208.3 x 270.8 (82 x 106⅝)
 Collection of Kate Rothko Prizel
 estate no. 3016.45

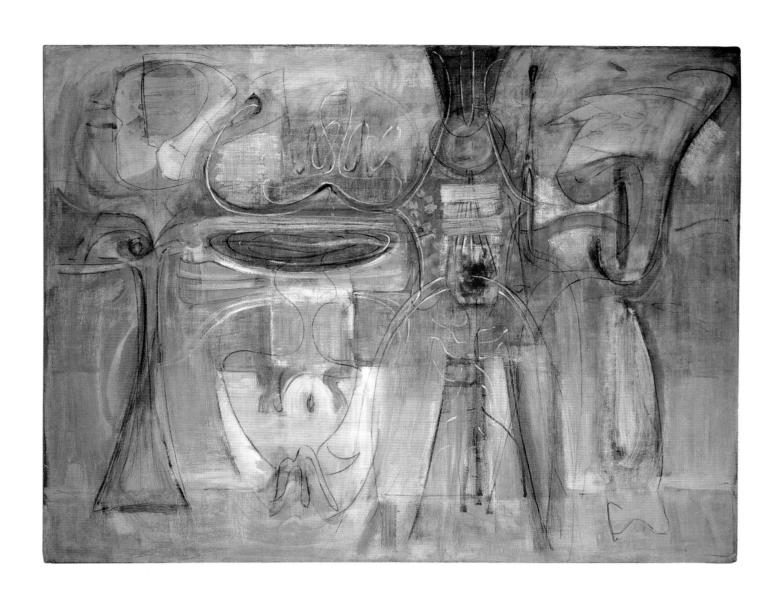

30 *Untitled*, 1946 (**PAGE 74**)
 watercolor on paper
 98.4 x 64.8 (38 ¾ x 25 ½)
 Collection of Ambassador and Mrs. Donald Blinken, New York City

31 *Vessels of Magic*, 1946 (**PAGE 75**)
 watercolor on paper
 98.4 x 65.4 (38 ¾ x 25 ¾)
 Brooklyn Museum of Art, Museum Collection Fund

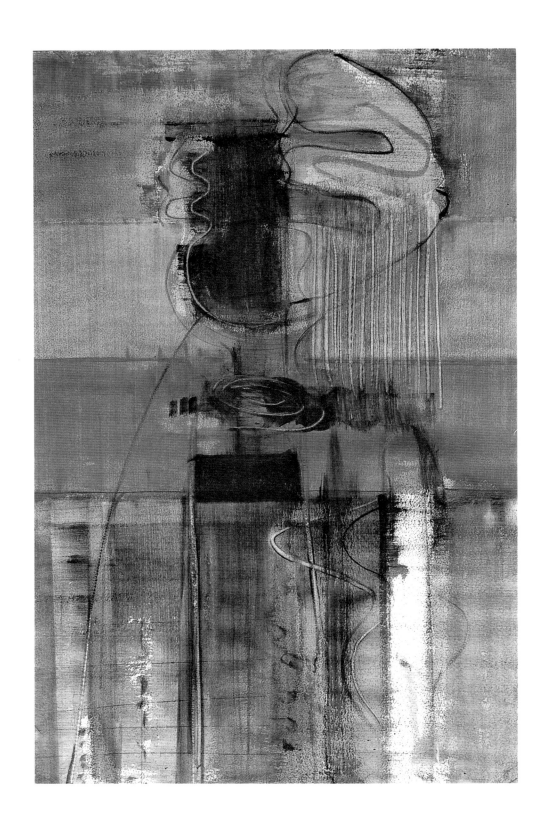

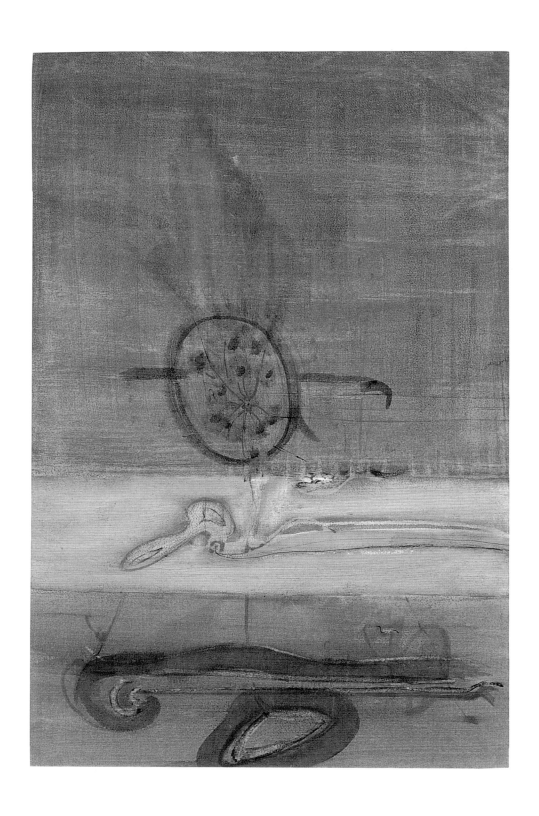

32 *Untitled,* 1947
 oil on canvas
 96.2 x 53 (37 ⅞ x 20 ⅞)
 National Gallery of Art, Washington,
 Gift of The Mark Rothko Foundation, Inc., 1986
 estate no. 3041.47

33 *No. 21 [Untitled]*, 1947
 oil on canvas
 99.7 x 97.8 (39 ¼ x 38 ½)
 Collection of Christopher Rothko
 estate no. 3242.47

34 *Untitled,* 1948
 oil on canvas
 127.6 x 109.9 (50 ¼ x 43 ¼)
 Collection of Kate Rothko Prizel
 estate no. 4003.

35 *Untitled,* 1948
 oil on canvas
 114 x 85.4 (44 ⅞ x 33 ⅝)
 Private Collection
 estate no. 4002.49

36 *No. 1 (No. 18, 1948), 1948 – 1949*
 oil on canvas
 171.8 x 142.6 (67 ⅝ x 56 ⅛)
 The Frances Lehman Loeb Art Center, Vassar College, Poughkeepsie, NY,
 Gift of Mrs. John D. Rockefeller 3rd (Blanchette Hooker, Class of 1931)

37 *Untitled [Multiform]*, 1948
 oil on canvas
 226.1 x 165.1 (89 x 65)
 Collection of Kate Rothko Prizel
 estate no. 5007.47

38 *No. 9 [Multiform]*, 1948
 mixed media on canvas
 134.6 x 118.4 (53 x 46⅝)
 National Gallery of Art, Washington,
 Gift of The Mark Rothko Foundation, Inc., 1986
 estate no. 5094.48

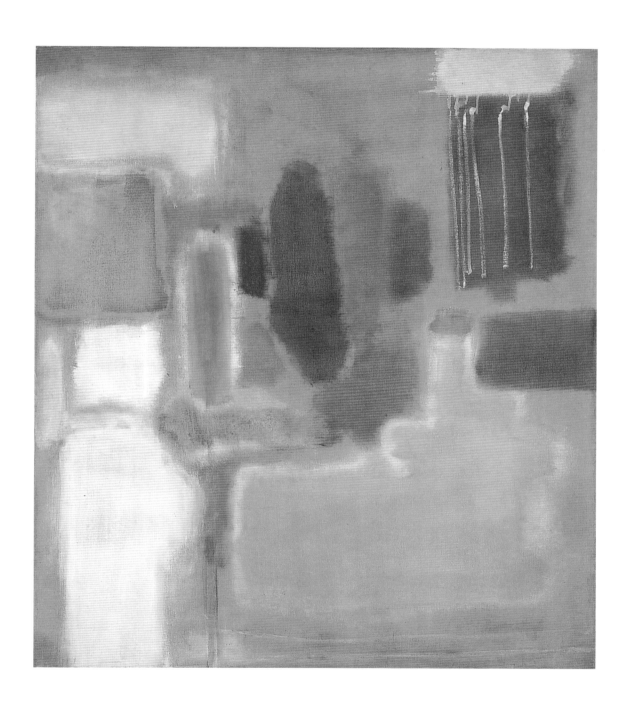

39 *No. 19, 1949*
oil on canvas
172.7 x 101.9 (68 x 40 ⅛)
The Art Institute of Chicago,
Gift of Mr. and Mrs. Heyward Cutting

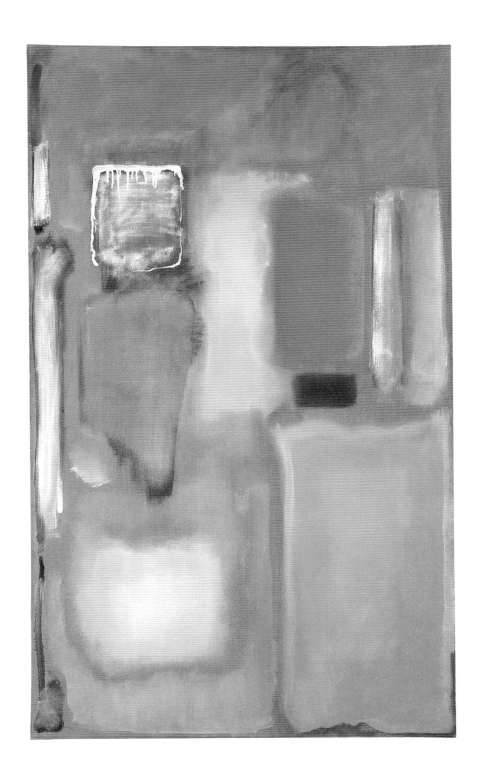

40 *No. 8 [Multiform]*, 1949
mixed media on canvas
228.3 x 167.3 (89 ⅞ x 65 ⅞)
National Gallery of Art, Washington,
Gift of The Mark Rothko Foundation, Inc., 1986
estate no. 5117.49

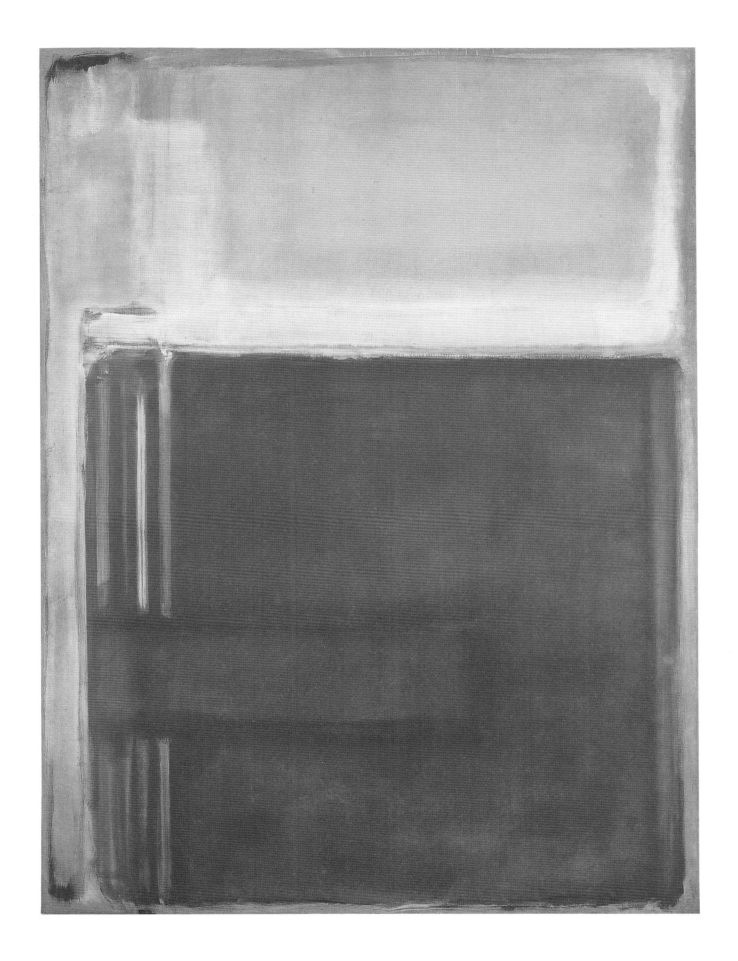

41 *No. 5 [Untitled]*, 1949
 oil on canvas
 215.9 x 160 (85 x 63)
 The Chrysler Museum of Art, Norfolk, Virginia,
 Bequest of Walter P. Chrysler Jr.

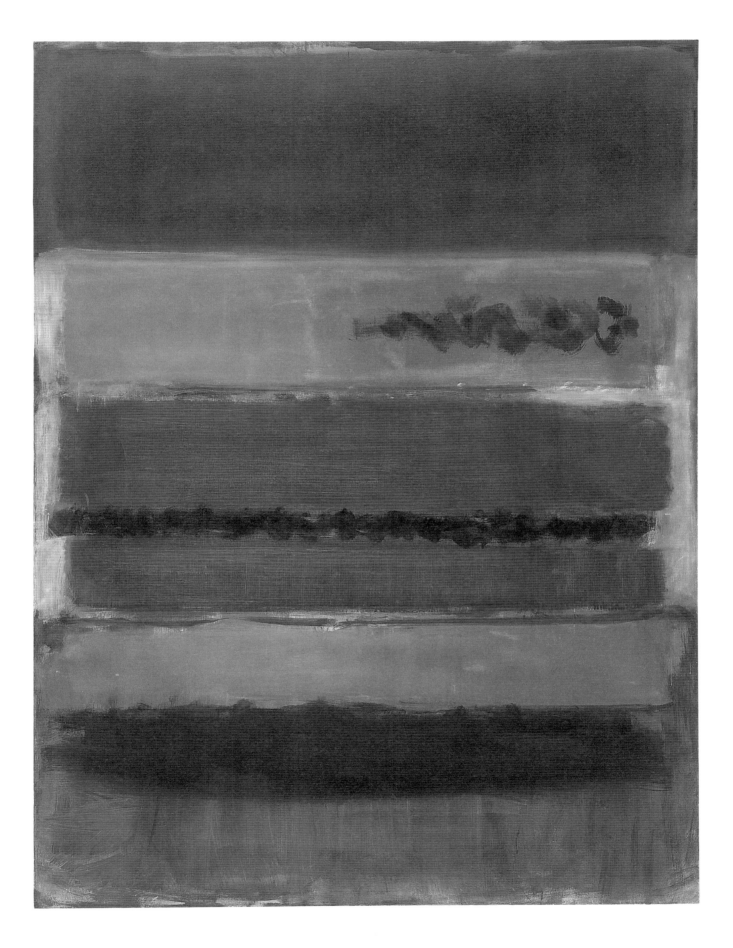

42 *Untitled,* 1949
watercolor and tempera on paper
107.6 x 72.1 (42 ⅜ x 28 ⅜)
Collection of Kate Rothko Prizel
estate no. 1238.49

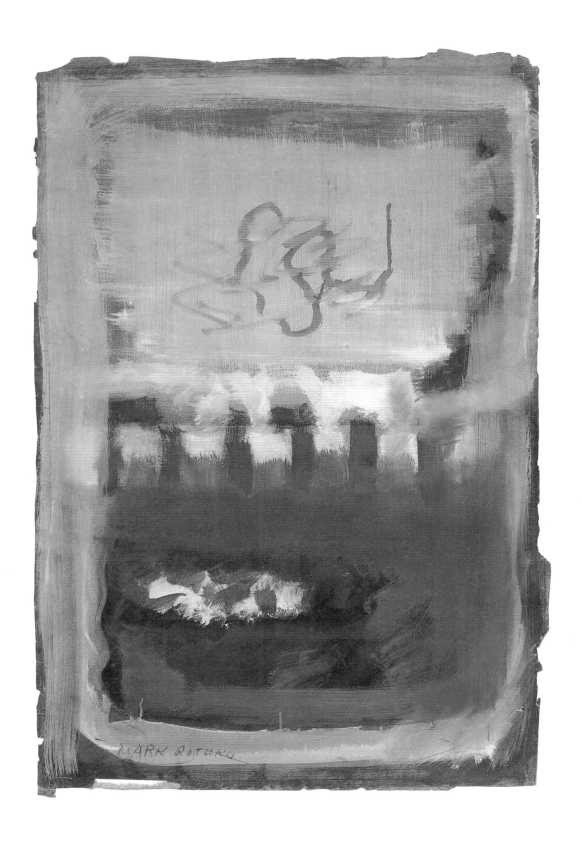

43 *No. 3 (No. 13) [Magenta, Black, Green on Orange]*, 1949
oil on canvas
216.5 x 163.8 (85 ¼ x 64 ½)
The Museum of Modern Art, New York,
Bequest of Mrs. Mark Rothko
through The Mark Rothko Foundation, Inc., 1981
estate no. 5032.49

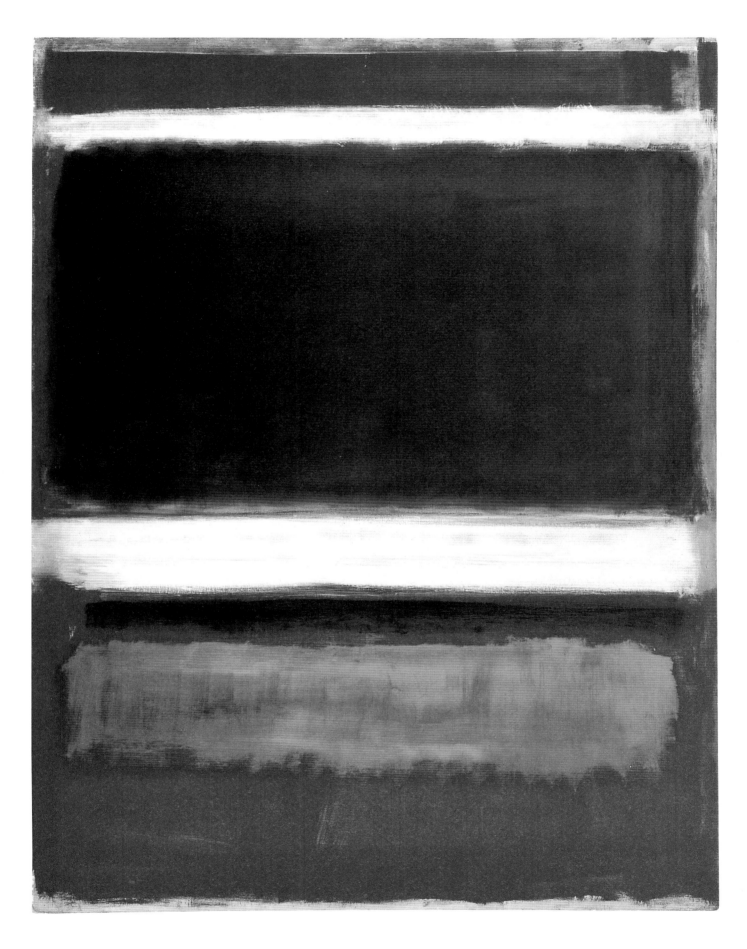

44 *Untitled*, 1949
oil on canvas
204.2 x 168.3 (80 ⅜ x 66 ¼)
National Gallery of Art, Washington,
Gift of The Mark Rothko Foundation, Inc., 1986
estate no. 5068.49

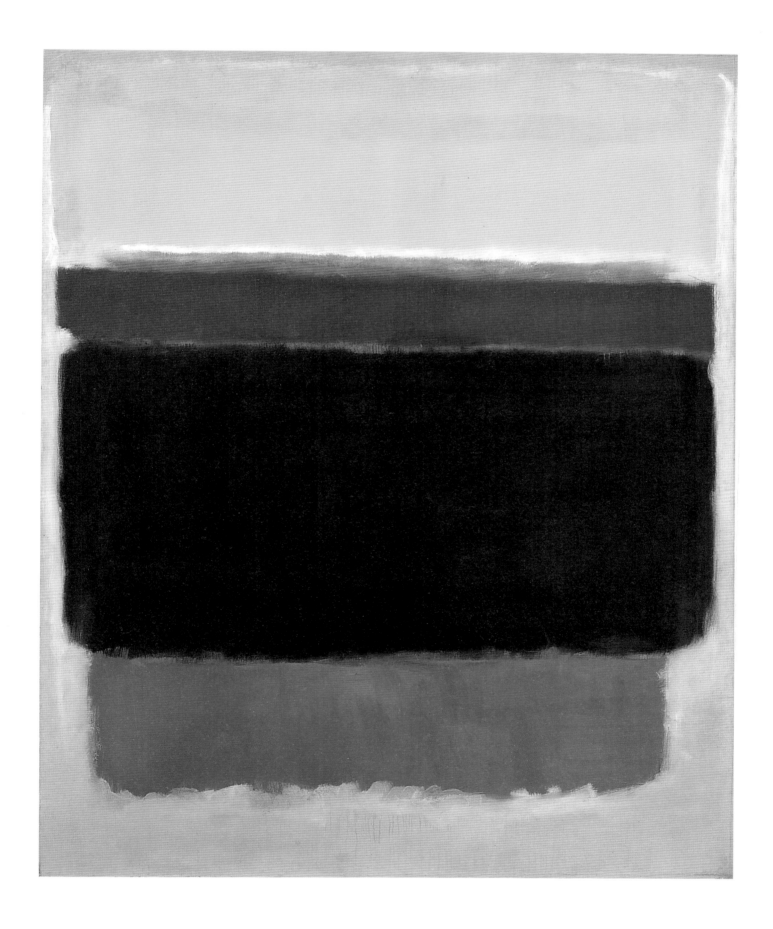

45 *Untitled [Violet, Black, Orange, Yellow on White and Red]*, 1949
 oil on canvas
 207 x 167.6 (81 ½ x 66)
 Solomon R. Guggenheim Museum, New York,
 Gift of Elaine and Werner Dannheisser and The Dannheisser Foundation, 1978
 estate no. 5069.49

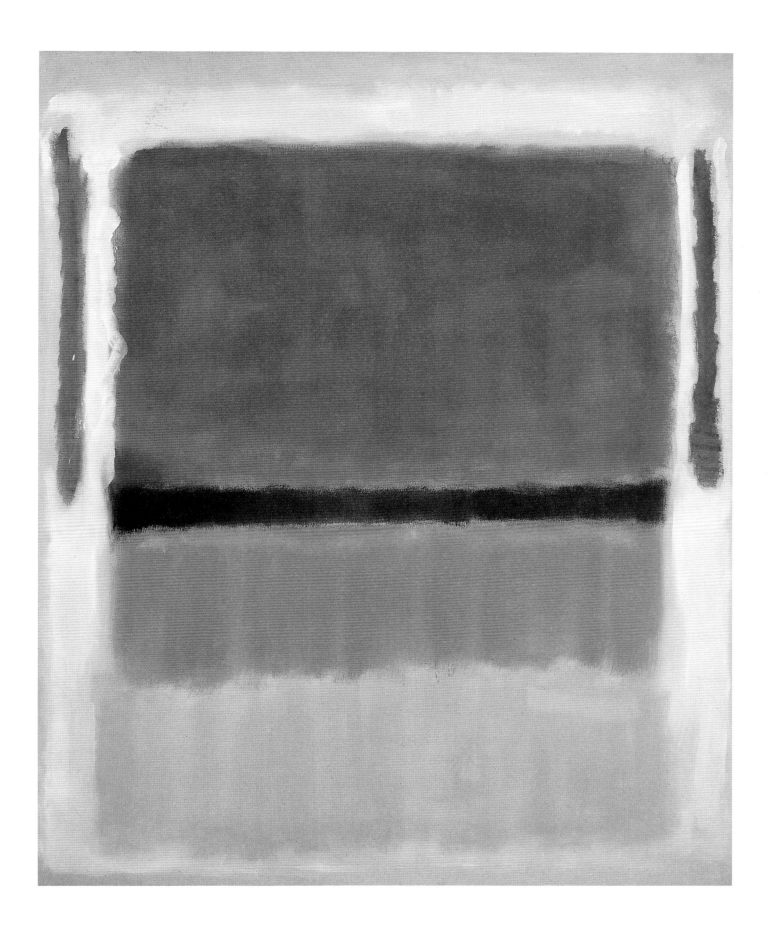

46 *No. 5 (No. 22)*, 1950 (alternatively dated to 1949)
 oil on canvas
 297.2 x 272.1 (117 x 107 ⅛)
 The Museum of Modern Art, New York, Gift of the Artist, 1969
 estate no. 5200.49

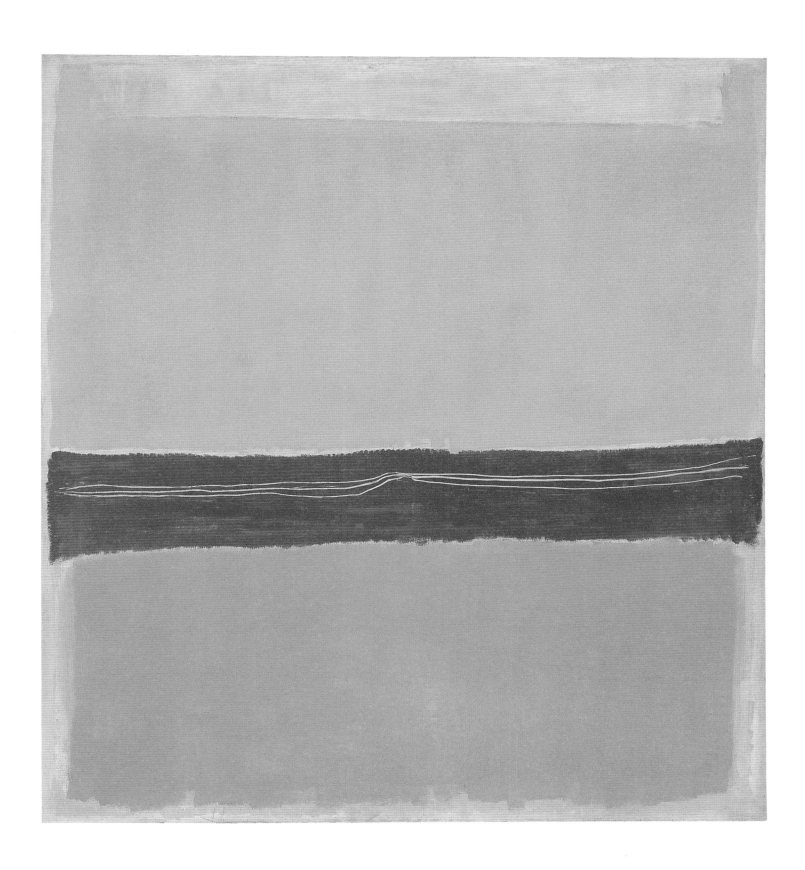

47 *White Center,* 1950
oil on canvas
205.7 x 141 (81 x 55 ½)
Private Collection

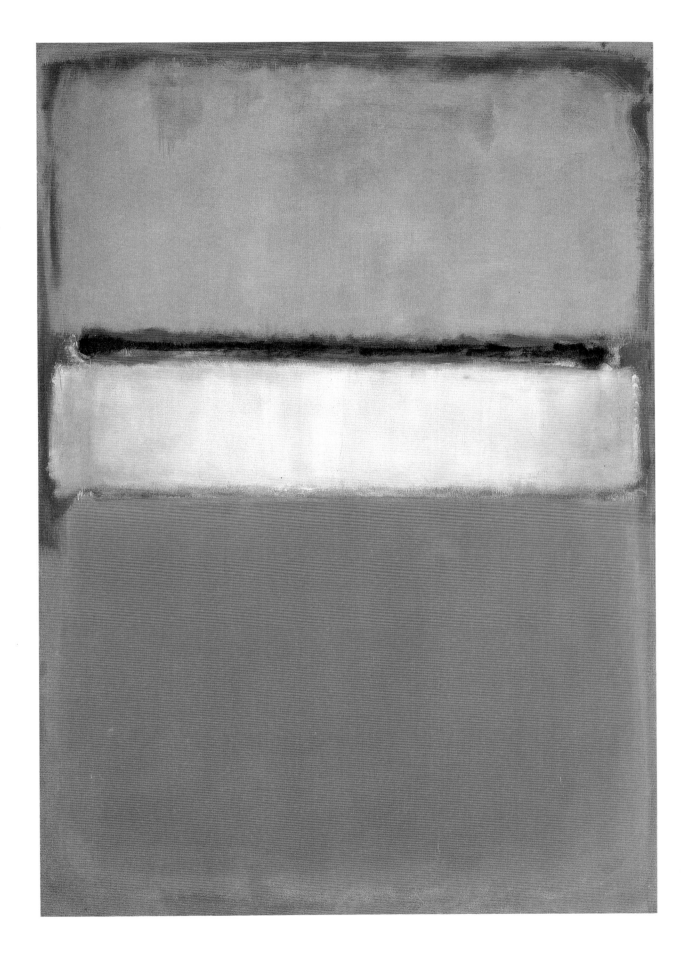

48 *No. 10*, 1950
oil on canvas
229.2 x 146.4 (90 ¼ x 57 ⅝)
The Museum of Modern Art, New York,
Gift of Philip Johnson, 1952

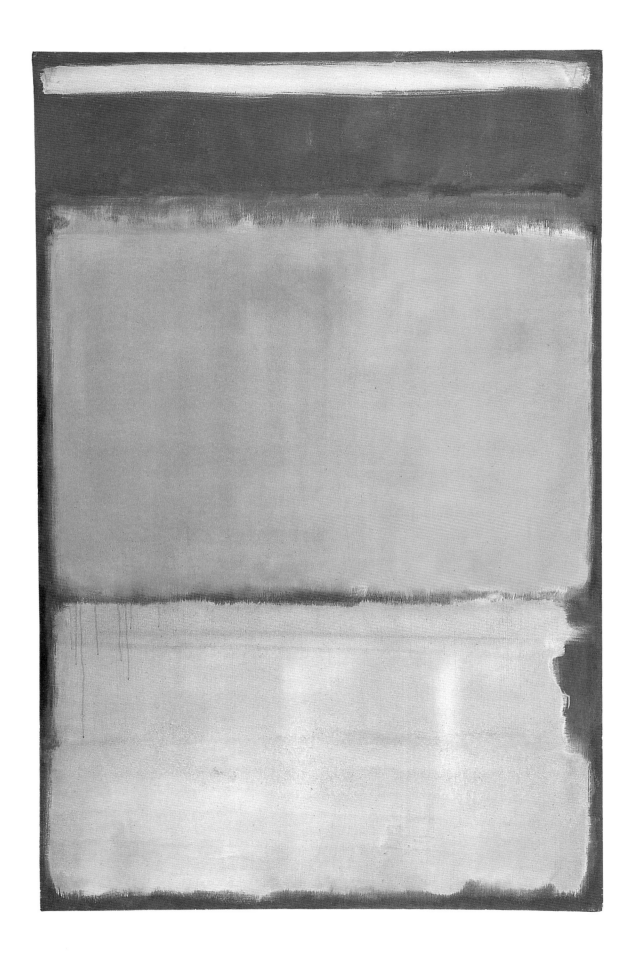

49 *Untitled*, c. 1951
 oil on canvas
 188.6 x 101 (74 ¼ x 39 ¾)
 Tate Gallery, London,
 Presented by The Mark Rothko Foundation, Inc., 1986
 estate no. 5165.

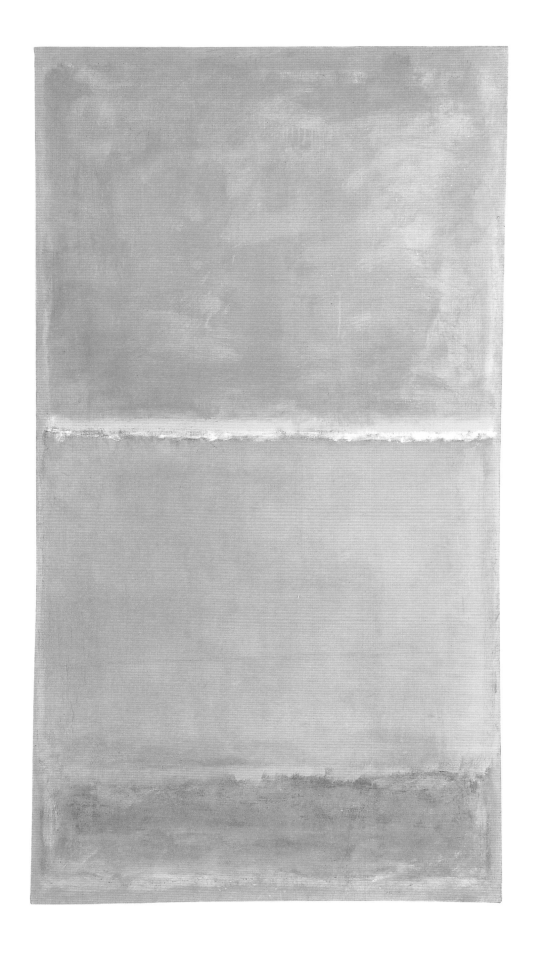

50 *No. 7,* 1951
 oil on canvas
 240.7 x 138.8 (94 ¾ x 54 ⅝)
 Collection of Linda and Harry Macklowe, New York

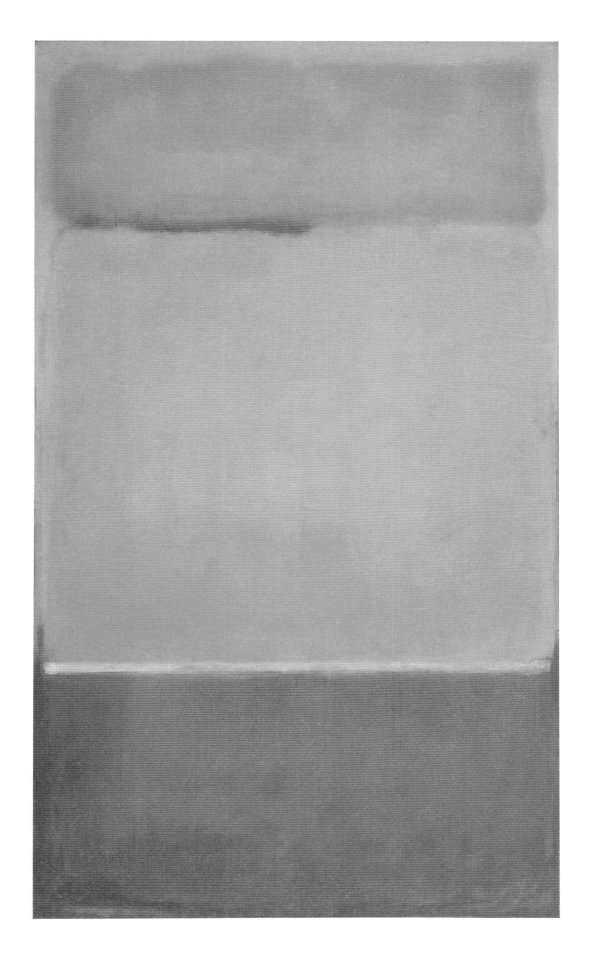

51 *No. 2 (No. 7* and *No. 20),* 1951 (alternatively dated to 1950)
oil on canvas
295.3 x 256.9 (116 ¼ x 101 ⅛)
Collection of Mrs. Paul Mellon, Upperville, Virginia
estate no. 5202.49

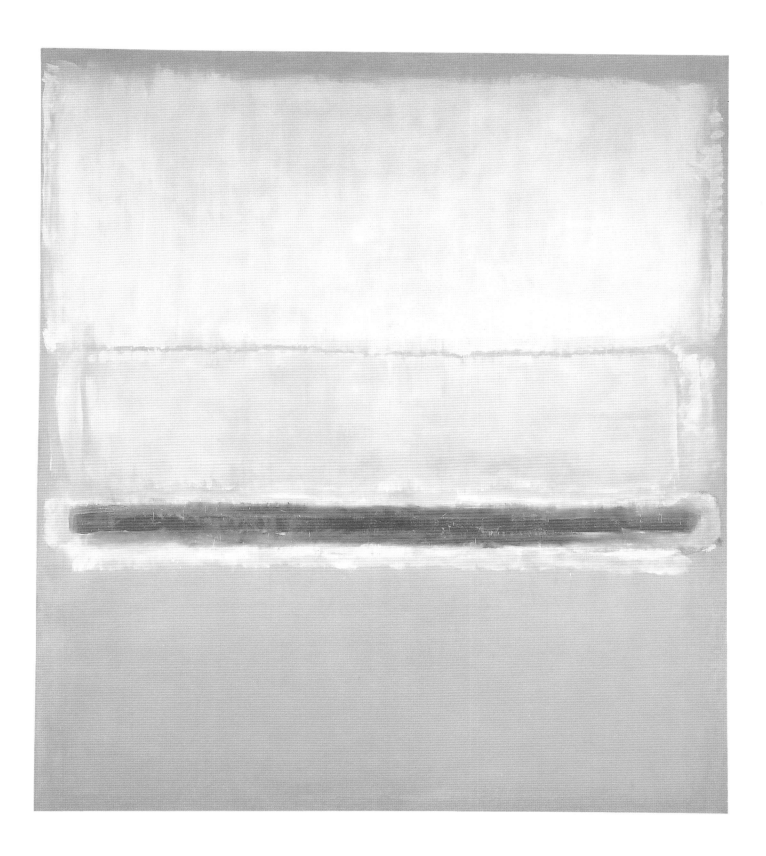

52 *No. 25 [Red, Gray, White on Yellow]*, 1951
oil on canvas
295 x 232.4 (116 ⅛ x 91 ½)
Private Collection, Seattle, Washington,
Courtesy Jeffrey Hoffeld and Company, Inc.
estate no. 5138.54

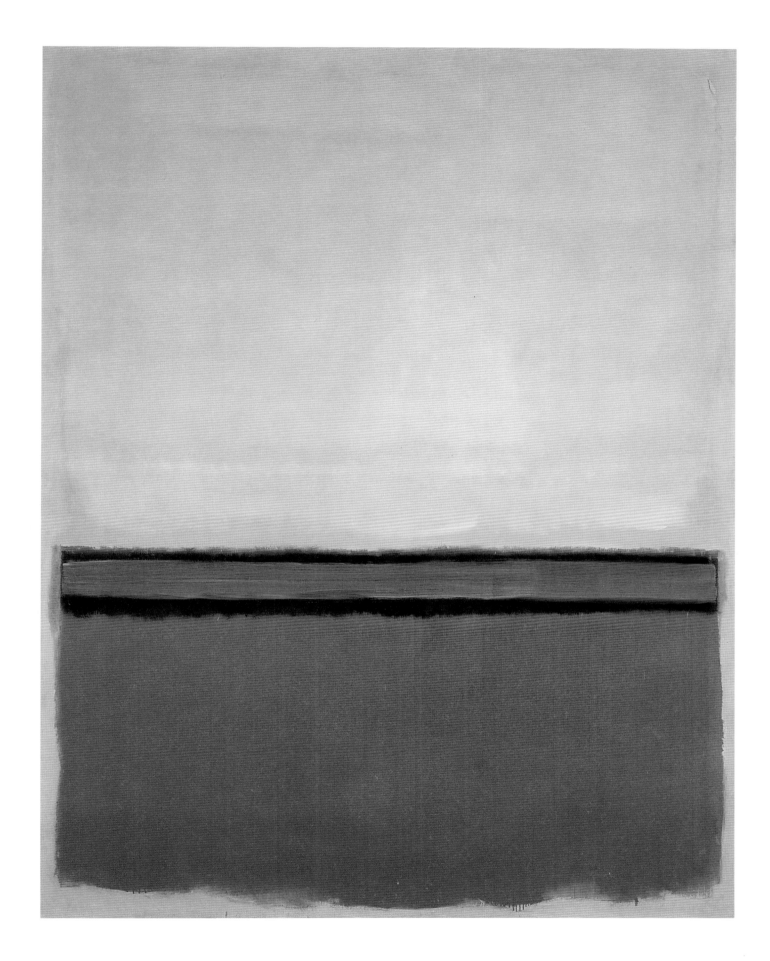

53 *No. 18*, 1951
oil on canvas
207 x 170.5 (81 ½ x 67 ⅛)
Munson-Williams-Proctor Institute
Museum of Art, Utica, New York

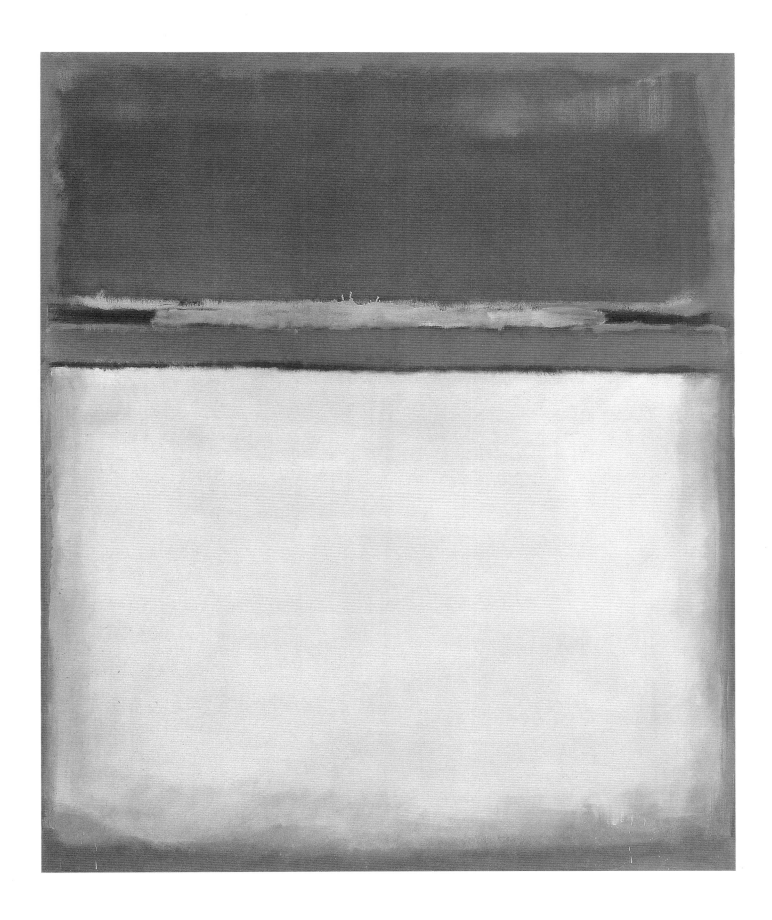

54 *Untitled [Blue, Green and Brown],* 1952 (alternatively dated to 1951)
oil on canvas
261.6 x 211.5 (103 x 83 ¼)
Collection of Mrs. Paul Mellon, Upperville, Virginia
estate no. 5139.51

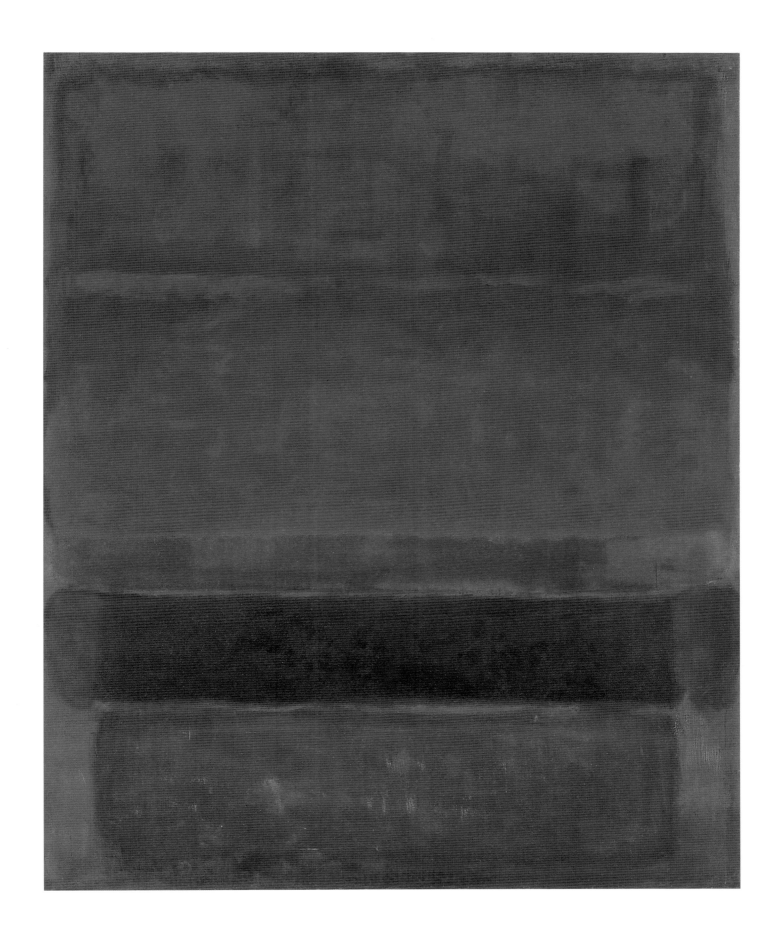

55 *No. 10, 1952*
oil on canvas
208.3 x 108.3 (82 x 42 ⅝)
Bagley and Virginia Wright

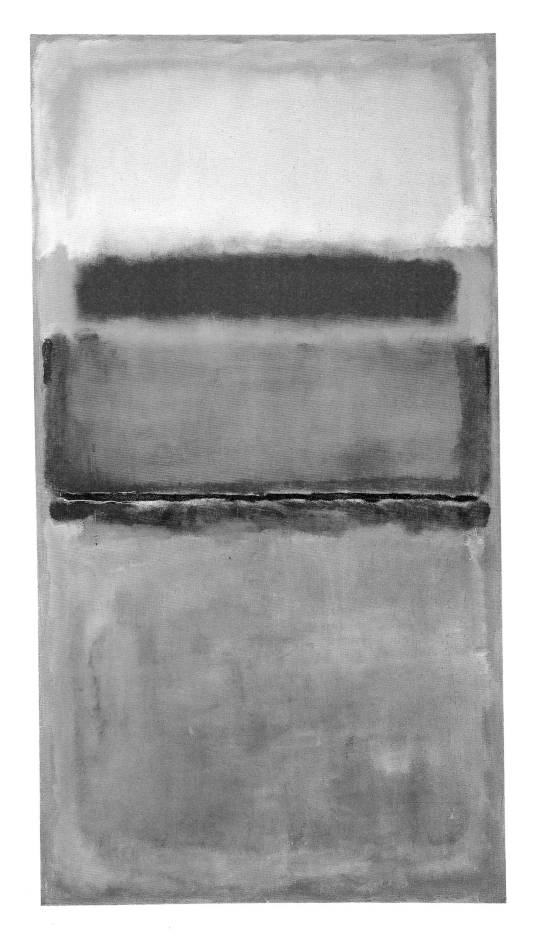

56 *Untitled [Red, Black, Orange, Yellow on Yellow]*, 1953
oil on canvas
238.4 x 121.6 (93 ⅞ x 47 ⅞)
Walker Art Center, Minneapolis,
Gift of The Mark Rothko Foundation, Inc., 1986
estate no. 5063.53

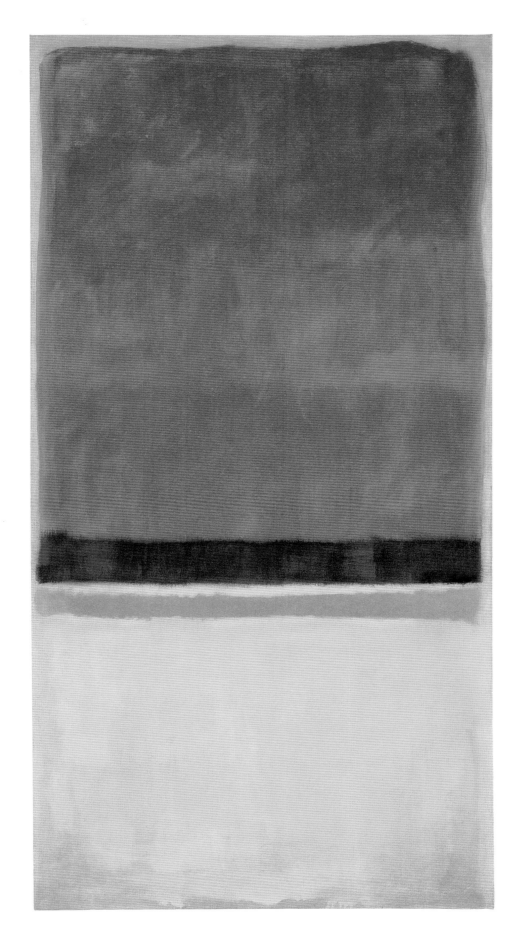

57 *Untitled*, 1953
oil on canvas
195.1 x 172.3 (76 ¾ x 67 ¾)
National Gallery of Art, Washington,
Gift of The Mark Rothko Foundation, Inc., 1986
estate no. 5028.53

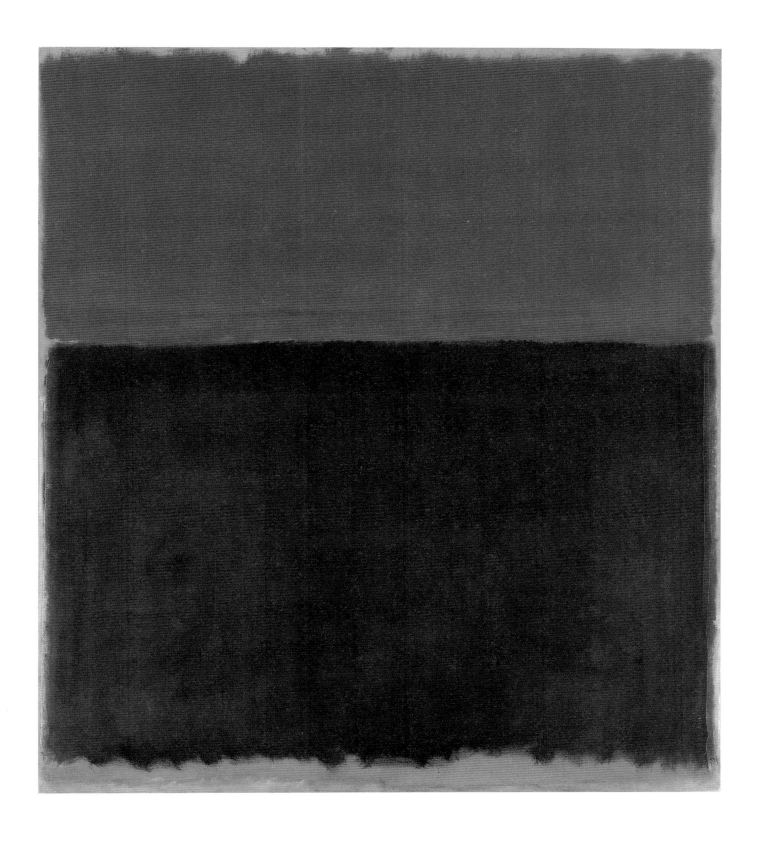

58 *Untitled,* 1953
 tempera on paper mounted on board
 100.3 x 67.3 (39 ½ x 26 ½)
 Private Collection
 estate no. 1276.53

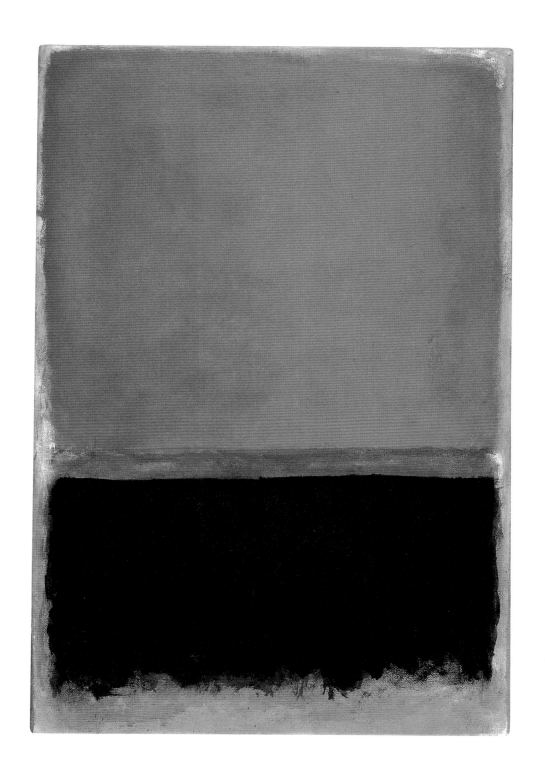

59 *White, Orange and Yellow*, 1953
 tempera on paper mounted on panel
 100.7 x 67.3 (39 ⅝ x 26 ½)
 Private Collection, Atherton, California

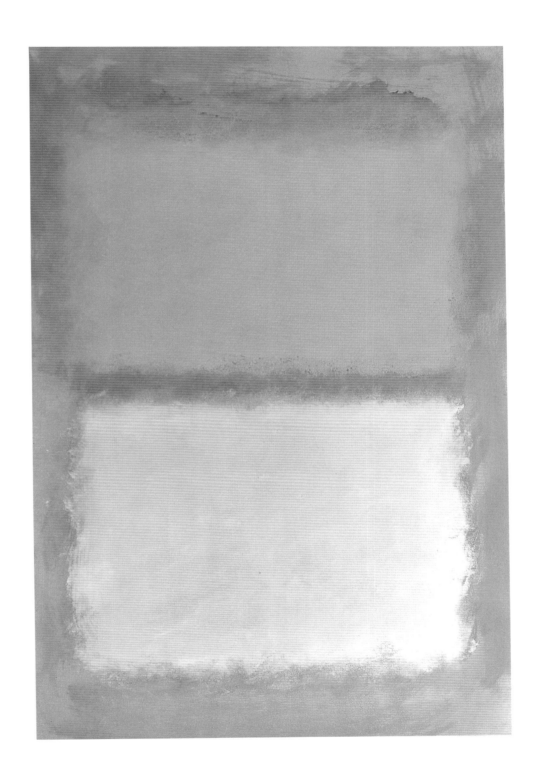

60 *Untitled,* 1953
oil on canvas
166.1 x 143.8 (65 ⅜ x 56 ⅝)
Mr. and Mrs. Gilbert H. Kinney
estate no. 5179.53

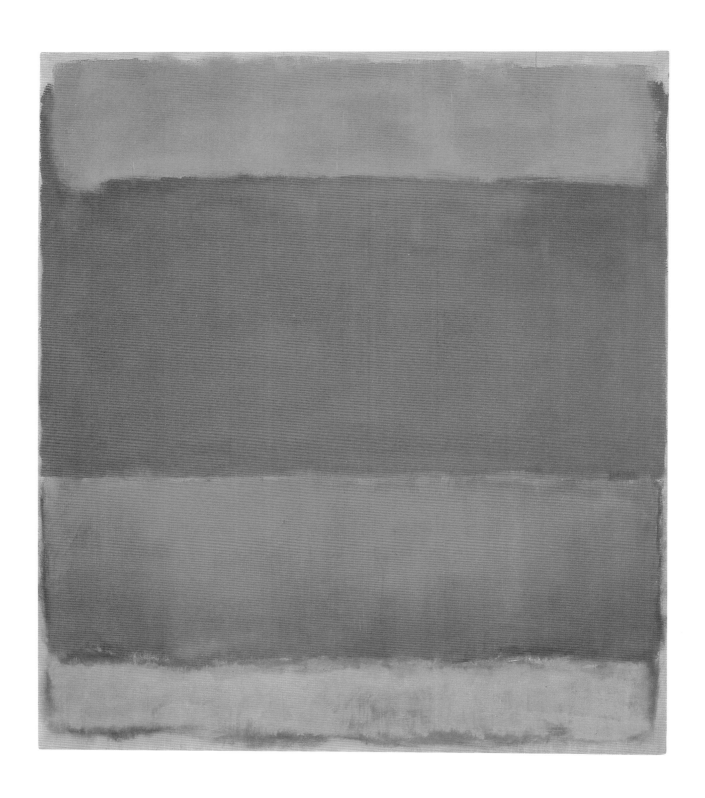

61 *No. 61 (Rust and Blue) [Brown, Blue, Brown on Blue]*, 1953
 oil on canvas
 294 x 232.4 (115 ¾ x 91 ½)
 The Museum of Contemporary Art, Los Angeles,
 The Panza Collection

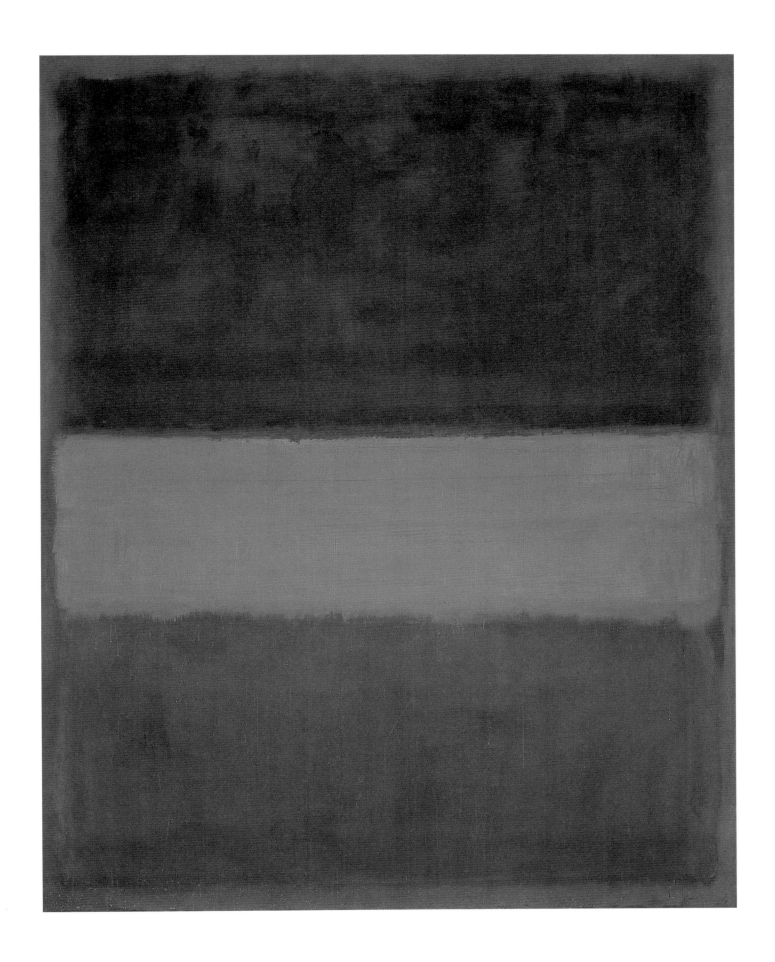

62 *Untitled [Purple, White and Red]*, 1953
oil on canvas
197.2 x 208.3 (77 ⅝ x 82)
The Art Institute of Chicago,
Gift of Sigmund E. Edelstone
estate no. 5017.53

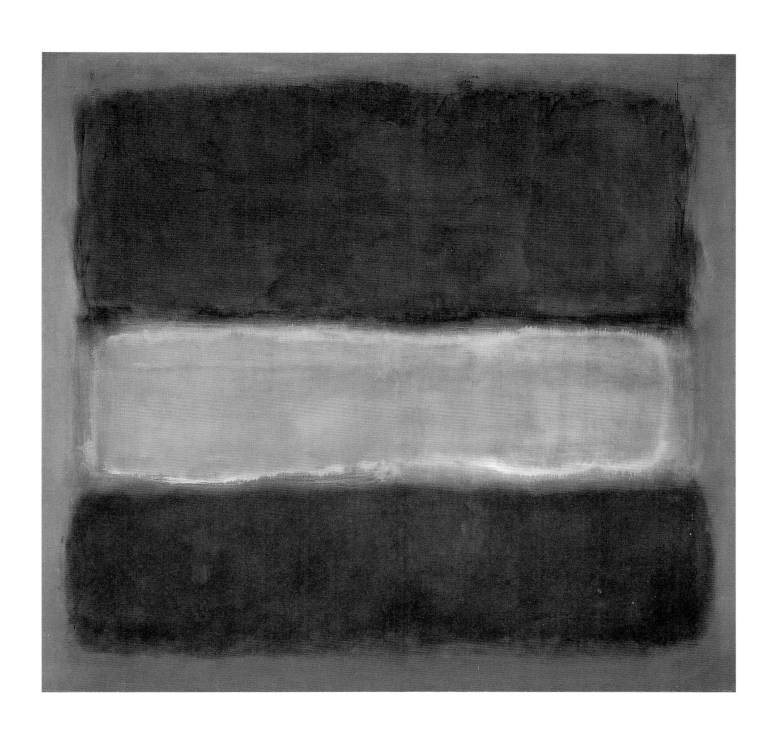

63 *No. 27 (Light Band) [White Band],* 1954
 oil on canvas
 205.7 x 220 (81 x 86⅝)
 Private Collection

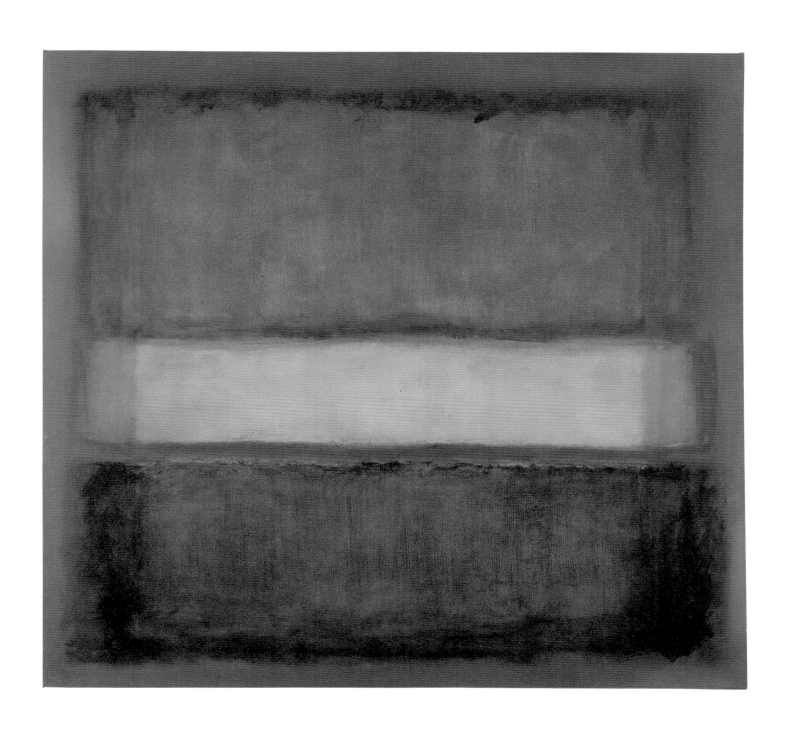

64 *No. 1 (Royal Red and Blue) [Untitled]*, 1954
 oil on canvas
 288.9 x 171.5 (113 ¾ x 67 ½)
 Private Collection
 estate no. 5018.54

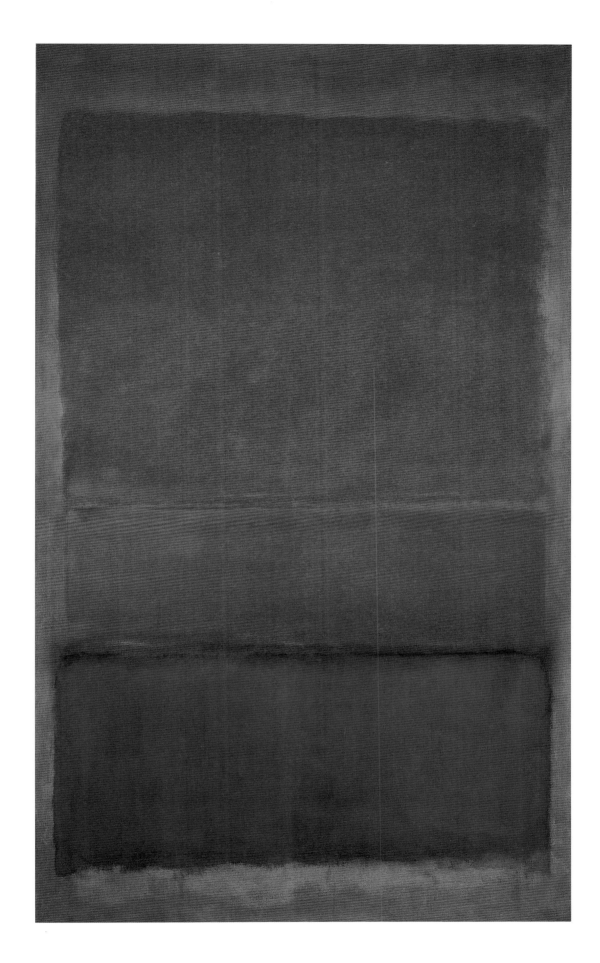

65 *Untitled [Red, Black, Orange and Pink on Yellow]*, 1954
oil on canvas
230 x 139.7 (90 ½ x 55)
Private Collection
estate no. 5170.54

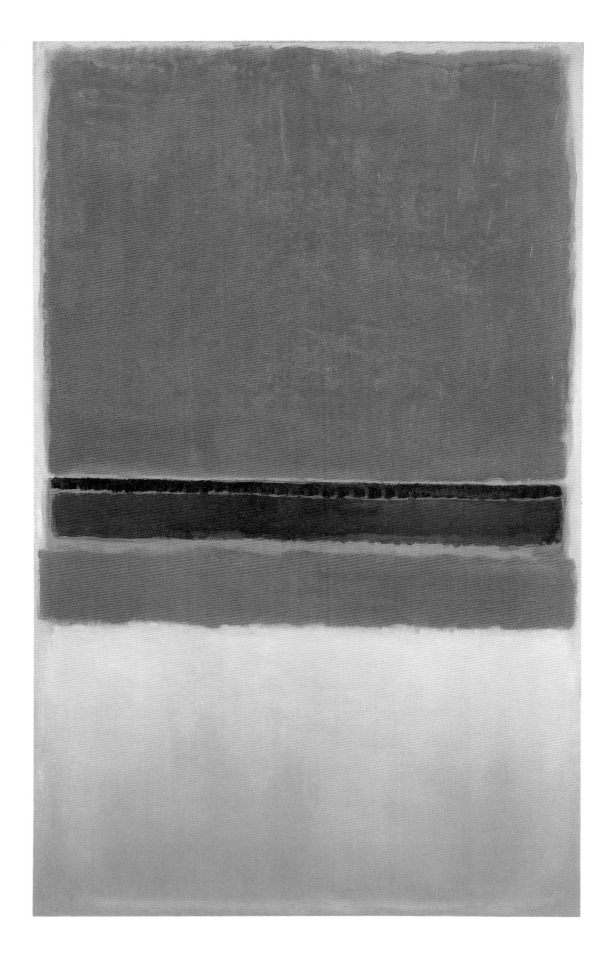

66 *Untitled [Blue, Yellow, Green on Red]*, 1954
oil on canvas
197.5 x 166.4 (77 ¾ x 65 ½)
Collection of Gisela and Dennis Alter
estate no. 5153.54

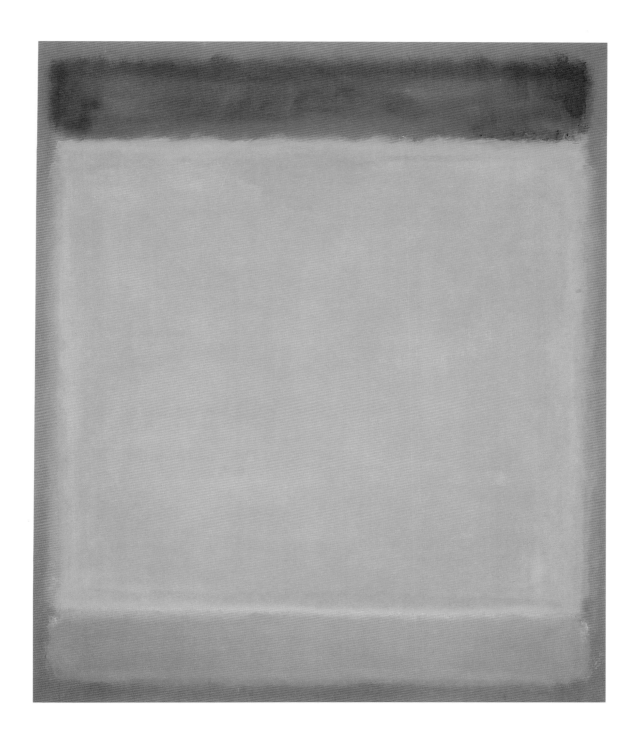

67 *Untitled,* 1954
mixed media on canvas
235.5 x 142.9 (92 ¾ x 56 ¼)
Yale University Art Gallery,
The Katharine Ordway Collection
estate no. 5171.54

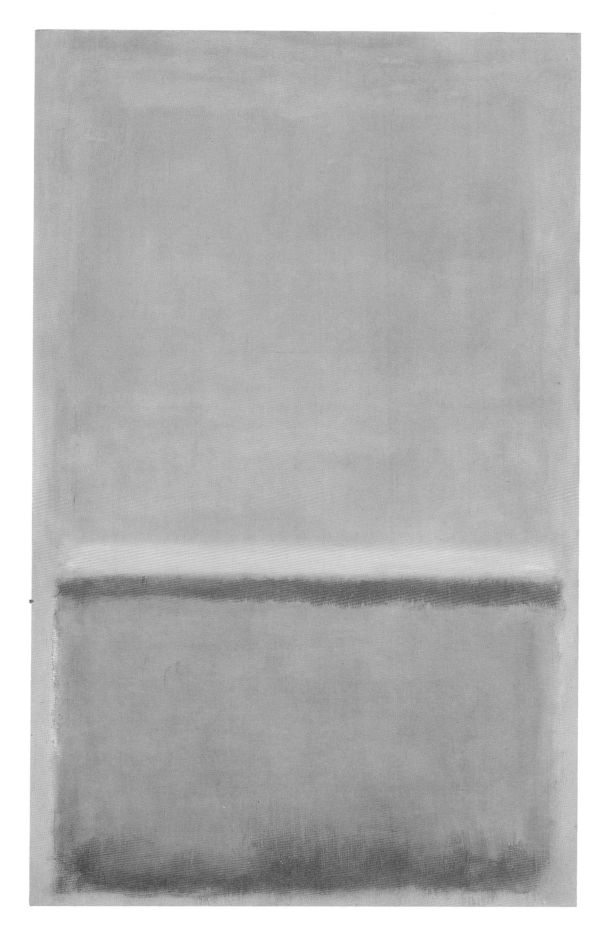

68 *The Ochre [Ochre and Red on Red]*, 1954
 oil on canvas
 235.3 x 161.9 (92 ⅝ x 63 ¾)
 The Phillips Collection, Washington, DC

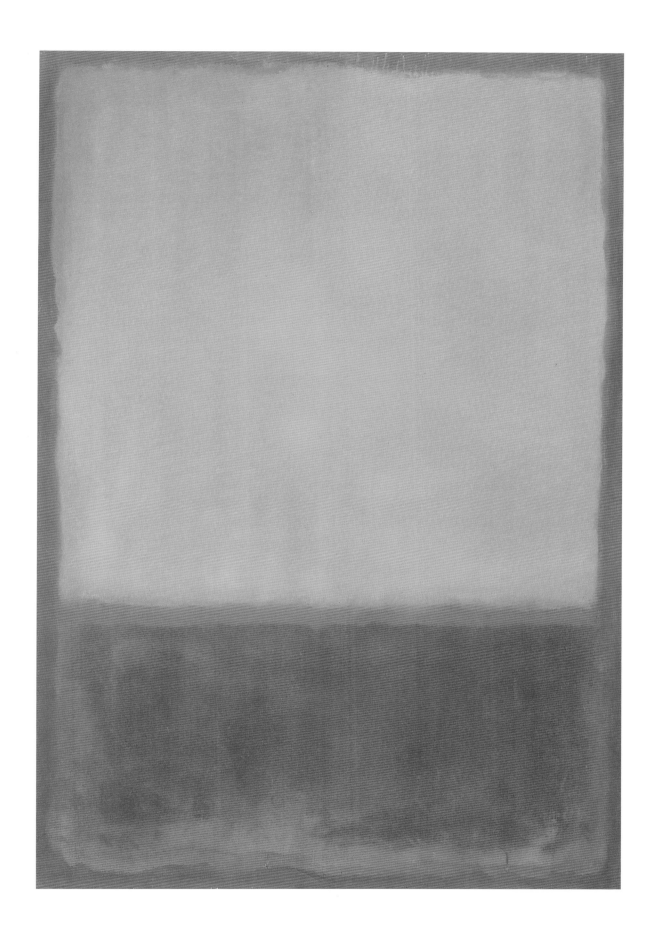

69 *Yellow and Blue [Yellow, Blue on Orange]*, 1955
 oil on canvas
 259.4 x 169.6 (102 ⅛ x 66 ¾)
 Carnegie Museum of Art, Pittsburgh,
 Fellows Fund, Women's Committee Acquisition Fund,
 and Patrons Art Fund, 1974
 estate no. 5107.55

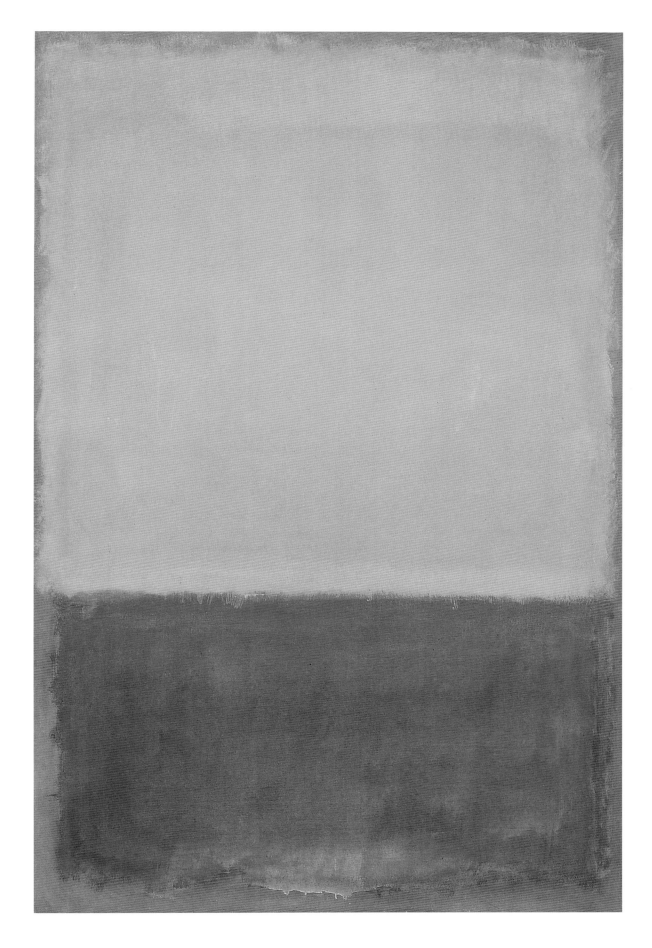

70 *Green, Red, Blue*, 1955
oil on canvas
207 x 197.5 (81 ½ x 77 ¾)
Milwaukee Art Museum,
Gift of Mrs. Harry Lynde Bradley

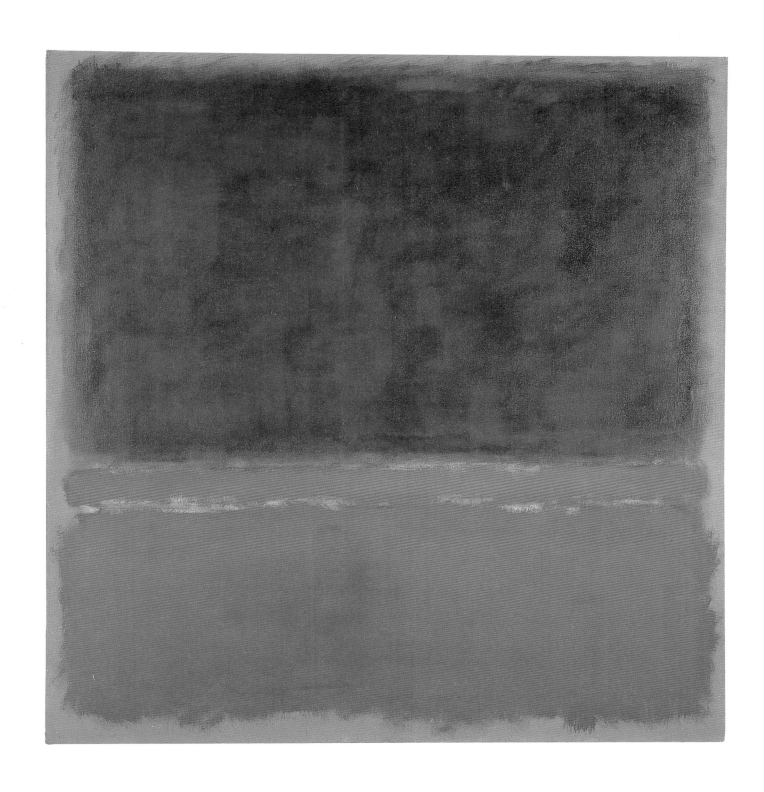

71 *No. 15 [Black Greens on Blue with Green Bar]*, 1957
oil on canvas
261.6 x 295.9 (103 x 116 ½)
Collection of Christopher Rothko
estate no. 5133.57

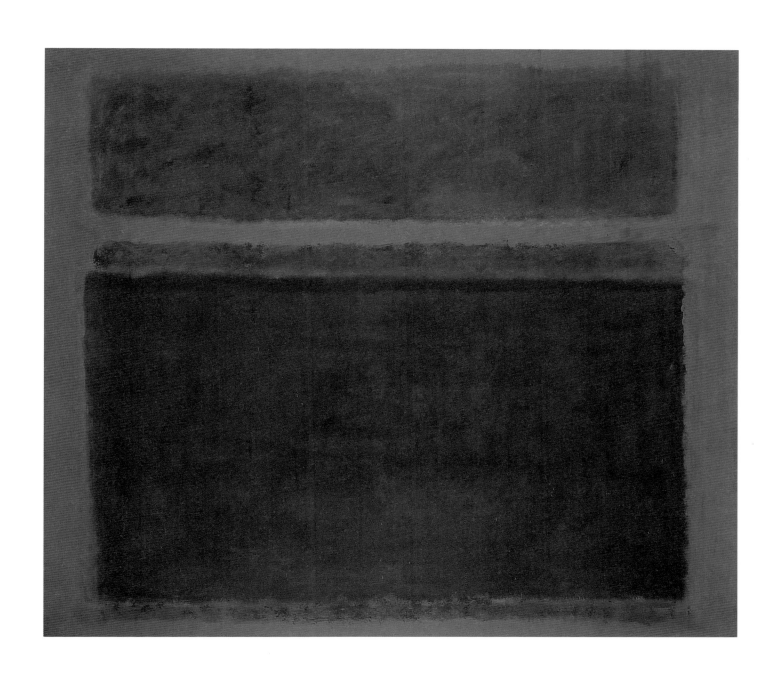

72 *No. 16 (Two Whites, Two Reds)*, 1957
oil on canvas
265.4 x 292.4 (104 ½ x 115 ⅛)
National Gallery of Canada, Ottawa

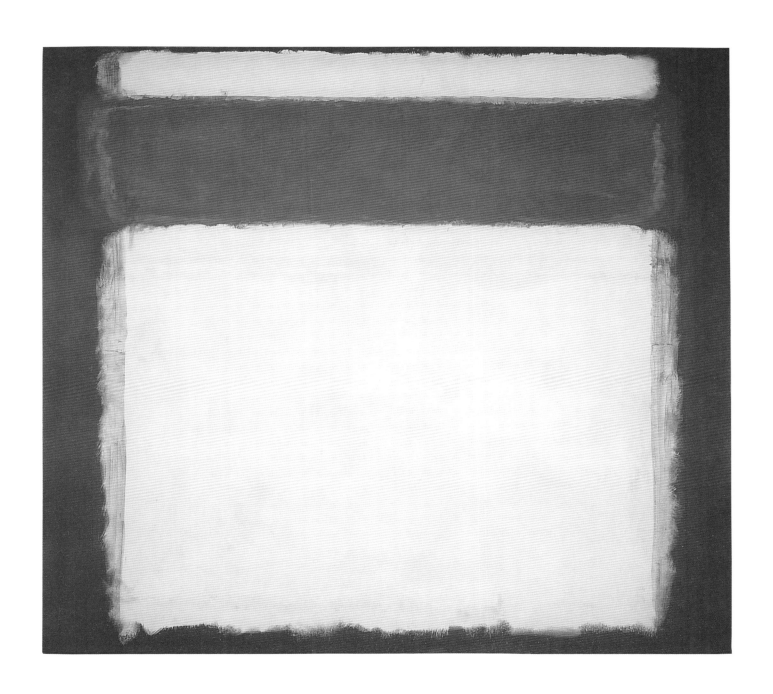

73 *No. 46 [Black, Ochre, Red over Red]*, 1957
oil on canvas
252.1 x 207 (99 ¼ x 81 ½)
The Museum of Contemporary Art, Los Angeles,
The Panza Collection

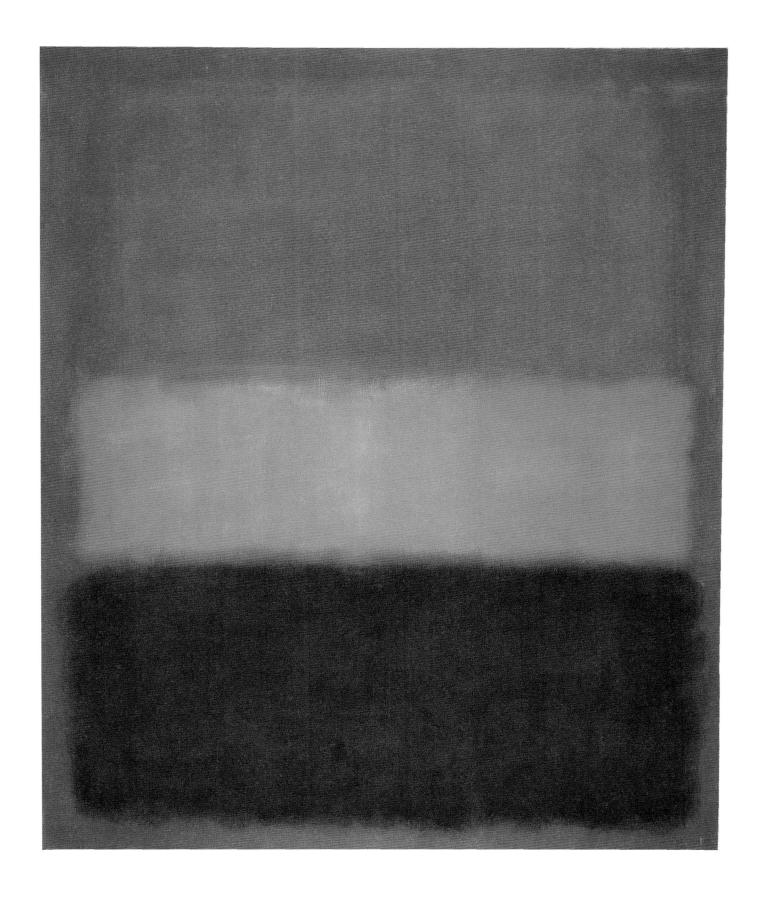

74 *Black over Reds [Black on Red]*, 1957
 oil on canvas
 241.3 x 207 (95 x 81 ½)
 The Baltimore Museum of Art,
 Gift of Phoebe Rhea Berman, Lutherville, Maryland,
 in Memory of Her Husband, Dr. Edgar F. Berman

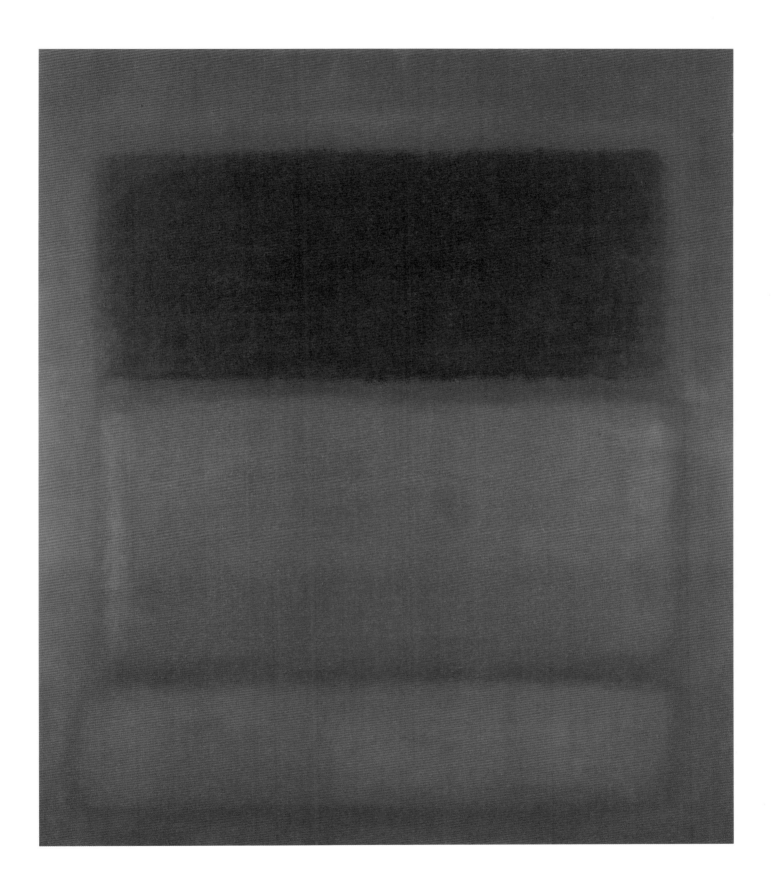

75 *No. 13 [White, Red on Yellow]*, 1958
oil on canvas
242.3 x 206.7 (95 ⅜ x 81 ⅜)
The Metropolitan Museum of Art, New York,
Gift of The Mark Rothko Foundation, Inc., 1985
estate no. 5121.58

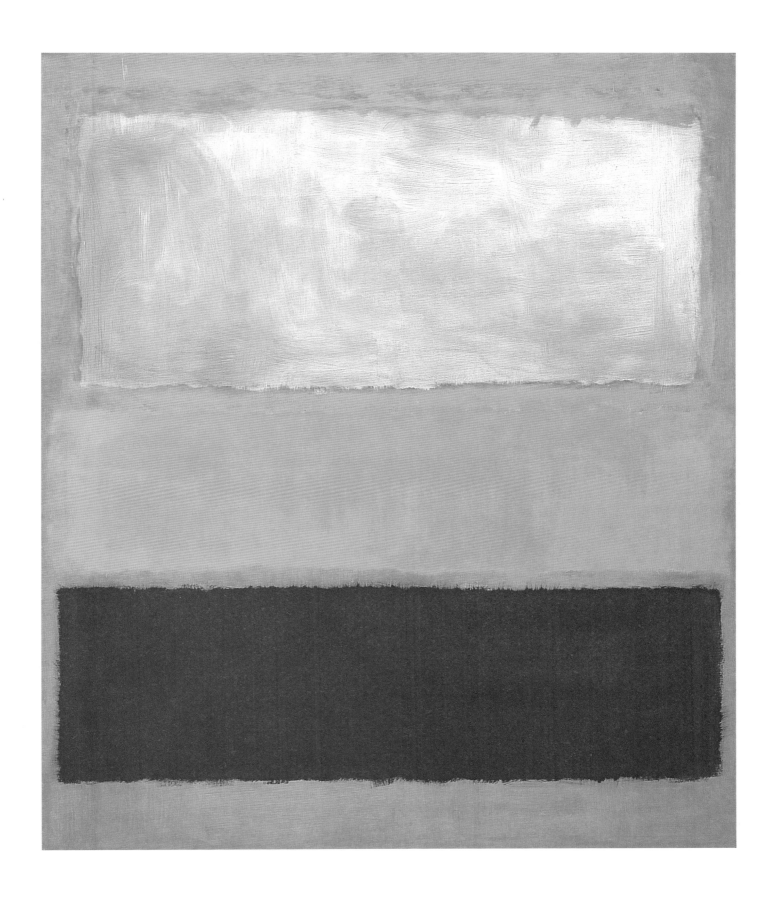

76 *No. 10, 1958*
 oil on canvas
 239.4 x 175.9 (94 ¼ x 69 ¼)
 Private Collection
 estate no. 5011.58

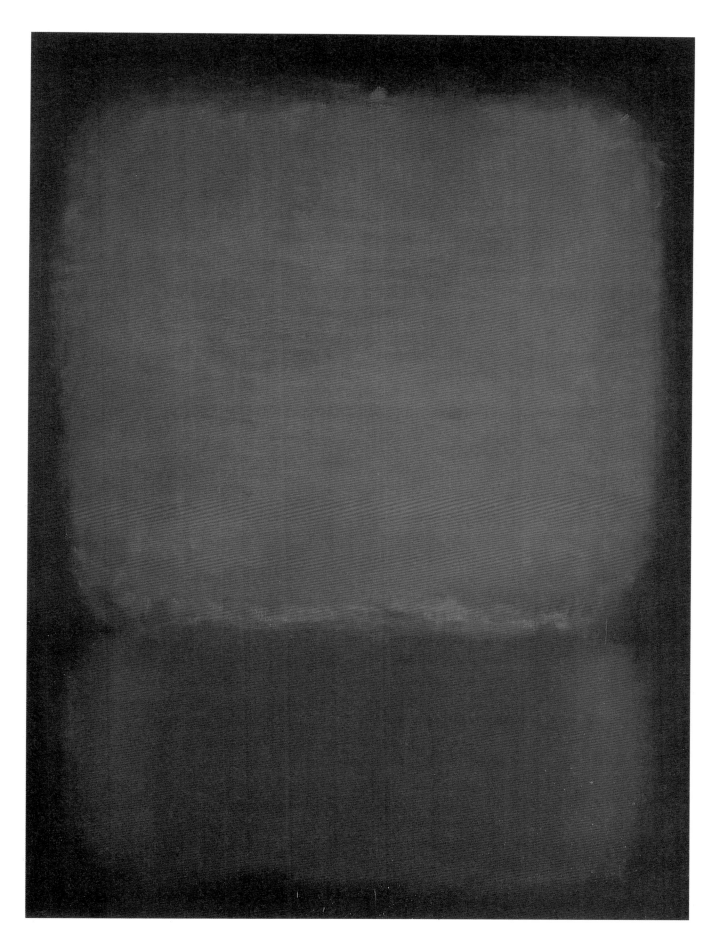

77 *No. 24 (Brown, Black and Blue)*, 1958
oil on canvas
176.5 x 152.4 (69 ½ x 60)
Private Collection

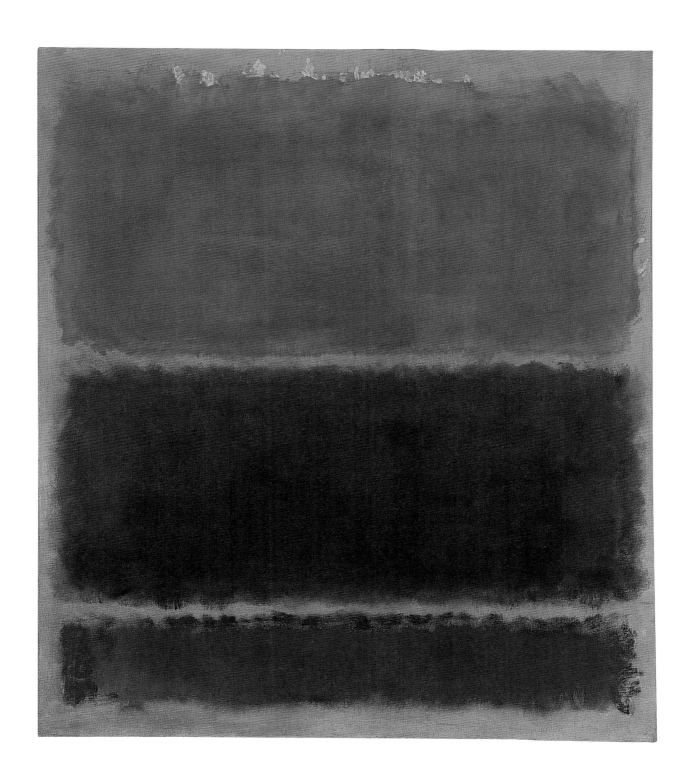

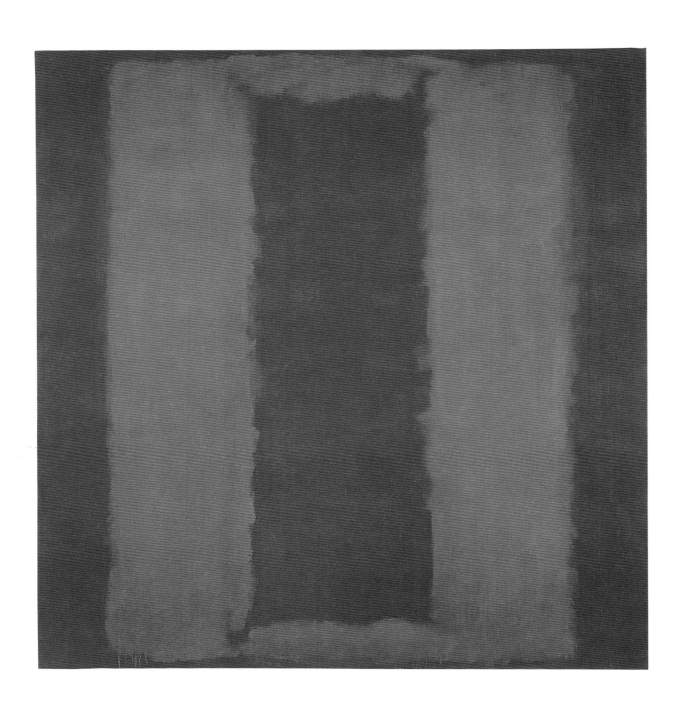

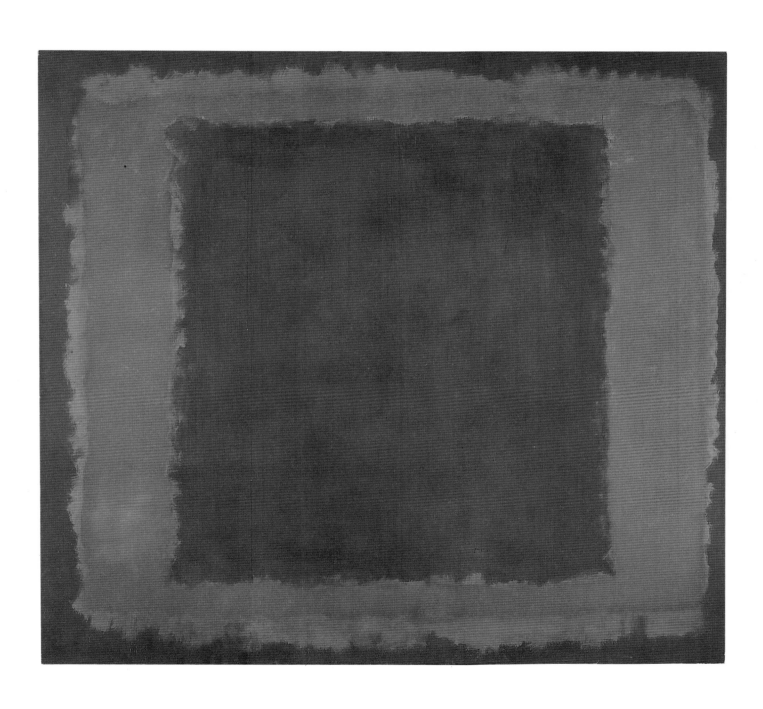

80 *Lavender and Mulberry*, 1959
 oil on paper mounted on wood fiberboard panel
 95.9 x 62.9 (37 ¾ x 24 ¾)
 Hirshhorn Museum and Sculpture Garden, Smithsonian Institution,
 Gift of Joseph H. Hirshhorn, 1966

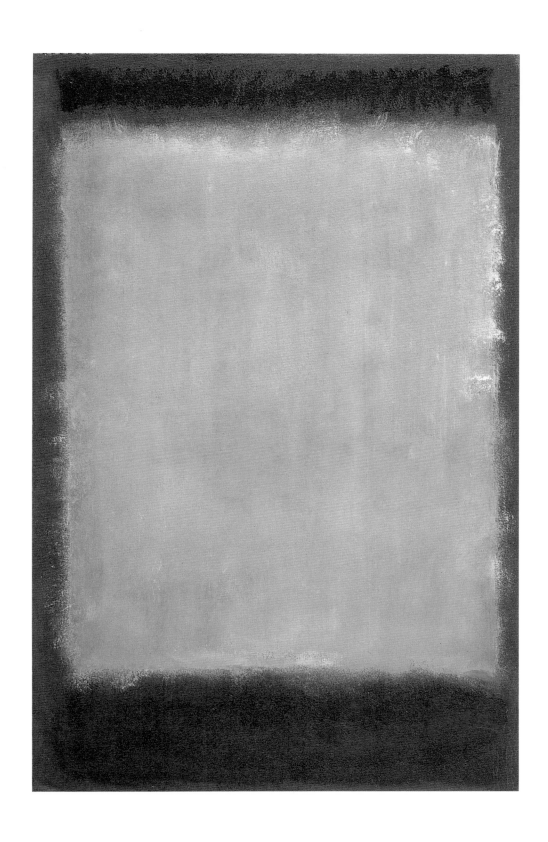

81 *Untitled,* 1959
 oil on paper mounted on wood fiberboard panel
 60.6 x 47.9 (23 ⅞ x 18 ⅞)
 Ealan Wingate, New York

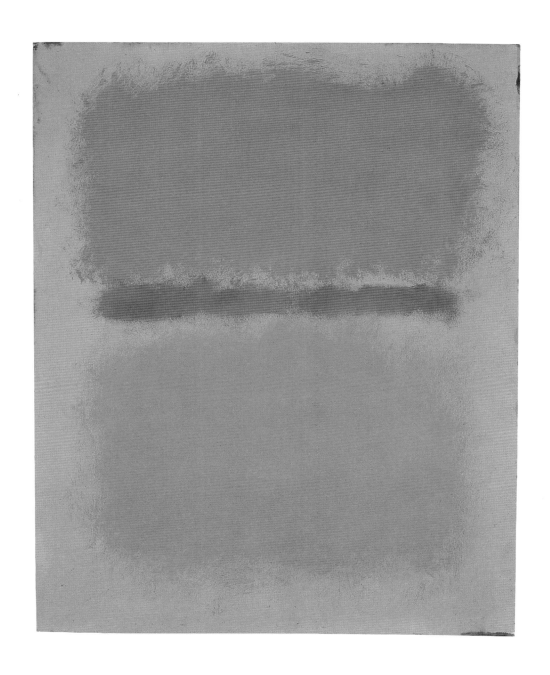

82 *Untitled*, 1960
 oil on canvas
 235.9 x 205.7 (92 ⅞ x 81)
 Adriana and Robert Mnuchin
 estate no. 5023.60

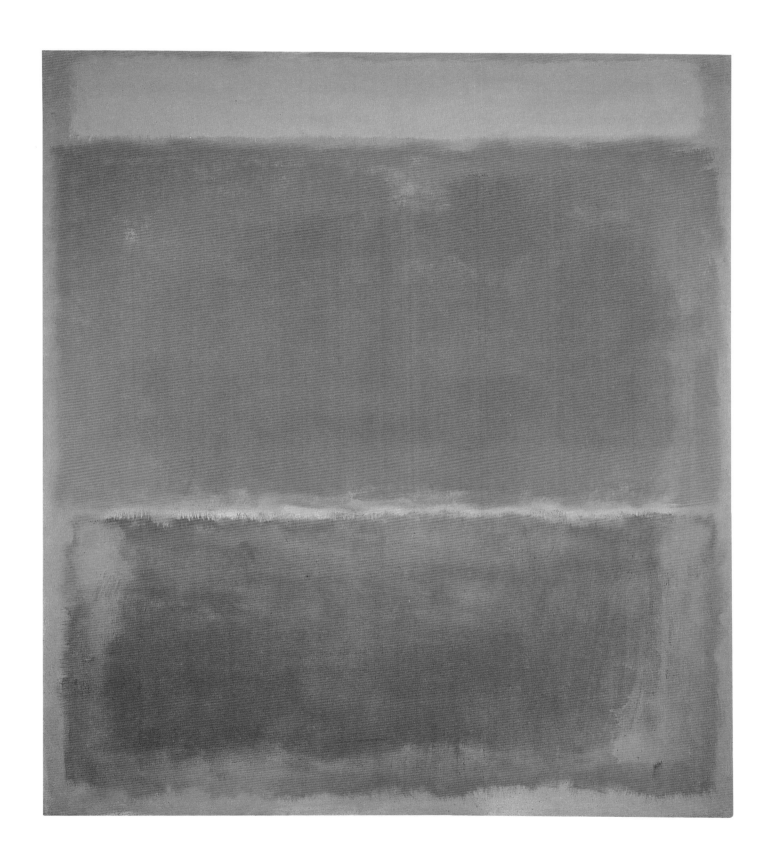

83 *No. 7*, 1960
 oil on canvas
 266.7 x 236.2 (105 x 93)
 Sezon Museum of Modern Art, Karuizawa
 estate no. 5203.60

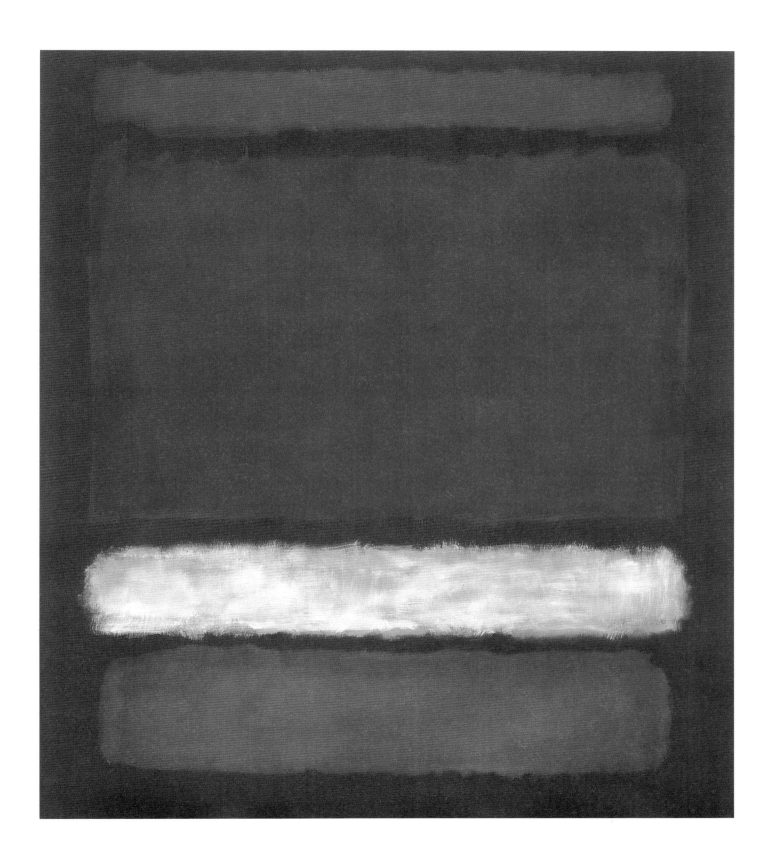

84 *Untitled,* 1960
 oil on canvas
 236.2 x 206.4 (93 x 81 ¼)
 The Toledo Museum of Art,
 Purchased with funds from the Libbey Endowment,
 Gift of Edward Drummond Libbey
 estate no. 5008.60

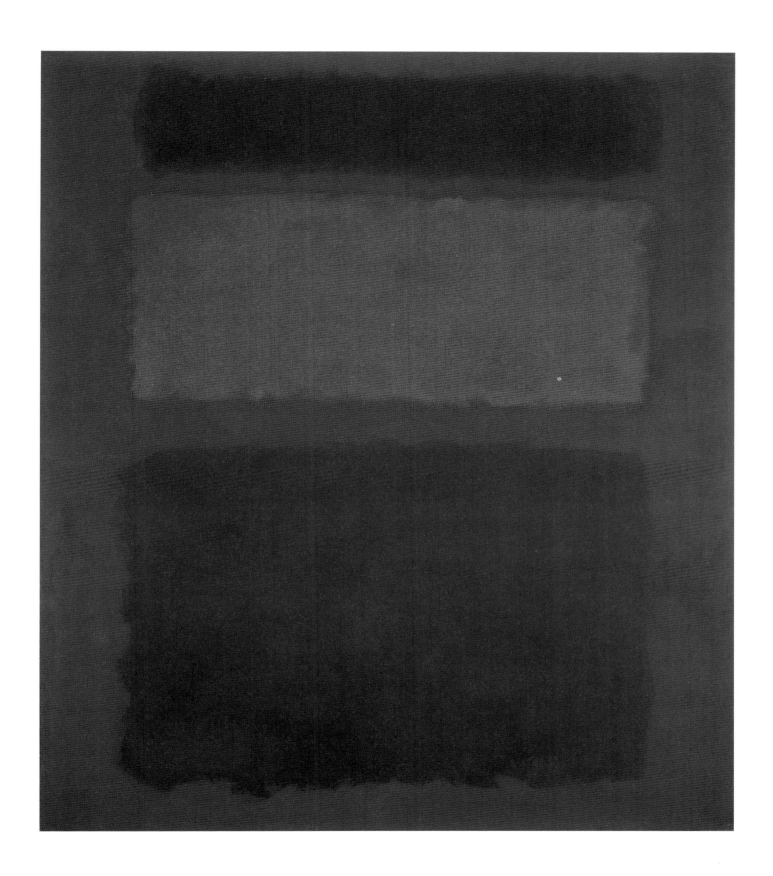

85 *No. 14, 1960*
oil on canvas
289.6 x 266.7 (114 x 105)
San Francisco Museum of Modern Art,
Helen Crocker Russell Fund Purchase
estate no. 5201.60

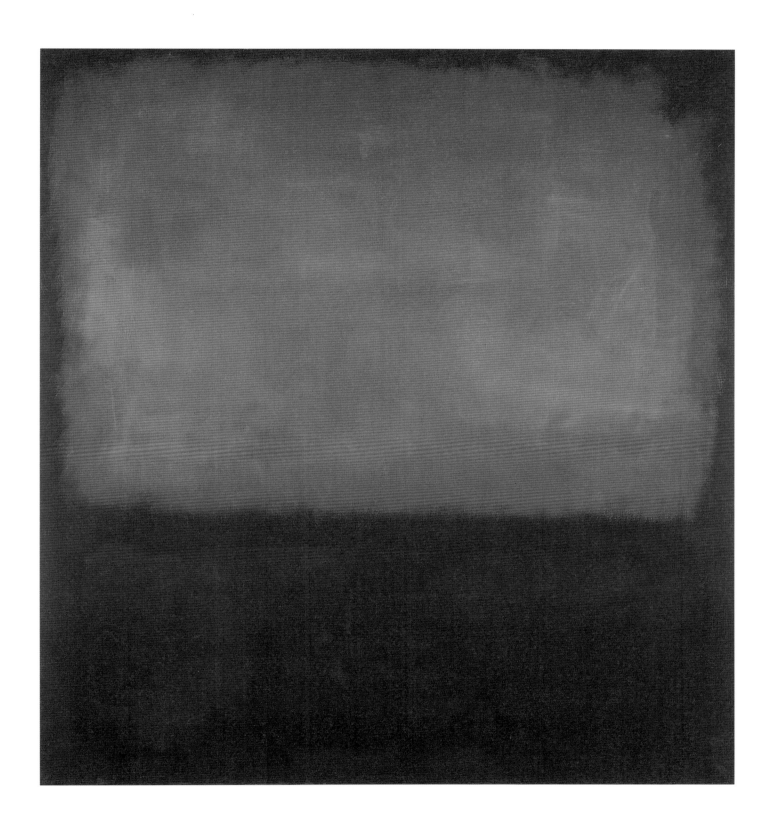

86 *No. 207 (Red over Dark Blue on Dark Gray)*, 1961
oil on canvas
235.6 x 206.1 (92 ¾ x 81 ⅛)
University of California, Berkeley Art Museum

87 *No. 2 (No. 101), 1961*
oil on canvas
200.7 x 206.1 (79 x 81⅛)
Private Collection

88 *No. 1 (White and Red),* 1962
oil on canvas
258.8 x 228.6 (101 ⅞ x 90)
Art Gallery of Ontario, Toronto,
Gift from the Women's Committee Fund, 1962

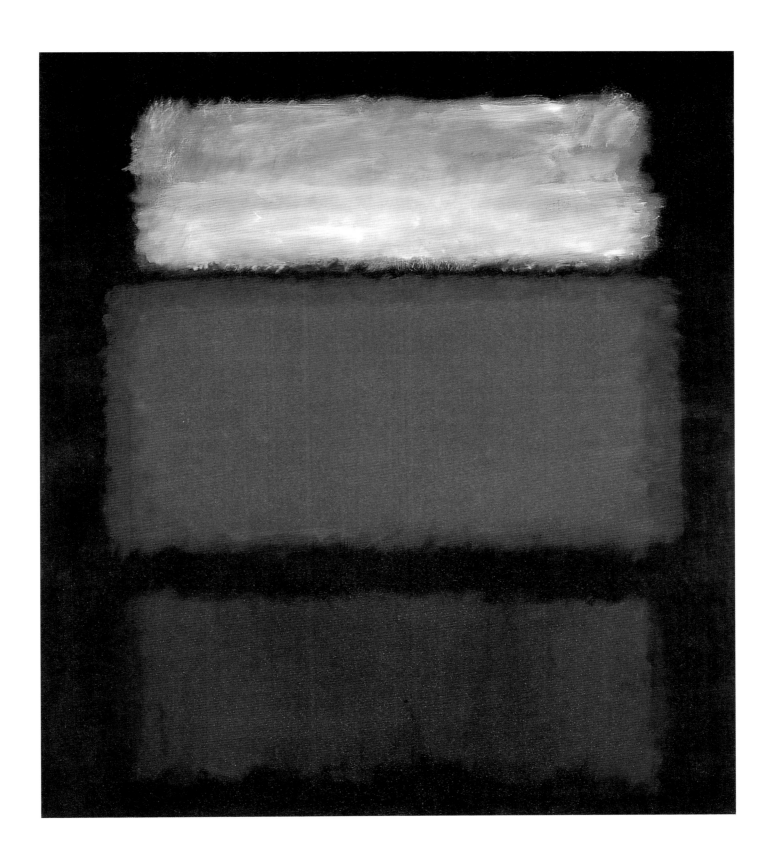

89 *Untitled*, 1961 (PAGE 191)
 pen and ink on paper
 28.1 x 21.8 (11 x 8 ½)
 National Gallery of Art, Washington,
 Gift of The Mark Rothko Foundation, Inc., 1986
 estate no. H23.8

90 *Untitled*, 1961 (PAGE 192)
 pen and ink on paper
 28.1 x 21.8 (11 x 8 ½)
 National Gallery of Art, Washington,
 Gift of The Mark Rothko Foundation, Inc., 1986
 estate no. H23.3

91 *Untitled*, 1961 (PAGE 193)
 pen and ink on paper
 28.1 x 21.8 (11 x 8 ½)
 National Gallery of Art, Washington,
 Gift of The Mark Rothko Foundation, Inc., 1986
 estate no. H23.2

92 *Blue and Gray,* 1962
oil on canvas
201.3 x 175.3 (79 ¼ x 69)
Fondation Beyeler, Riehen/Basel

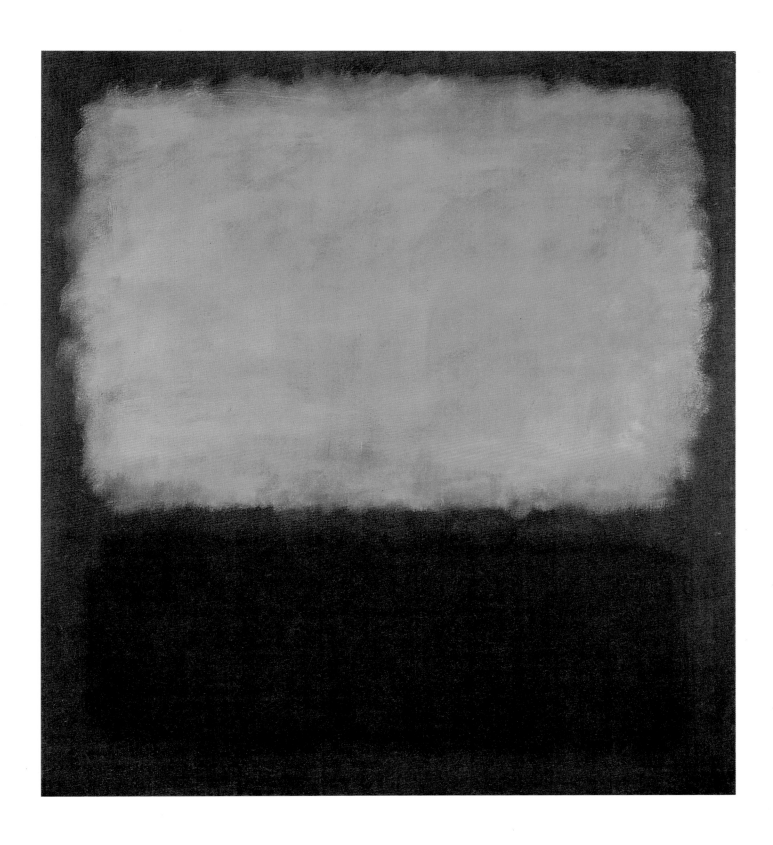

93 *No. 3 (Bright Blue, Brown, Dark Blue on Wine)*, 1962
mixed media on canvas
205.7 x 193.7 (81 x 76 ¼)
Robert and Jane Meyerhoff, Phoenix, Maryland
estate no. 5049.62

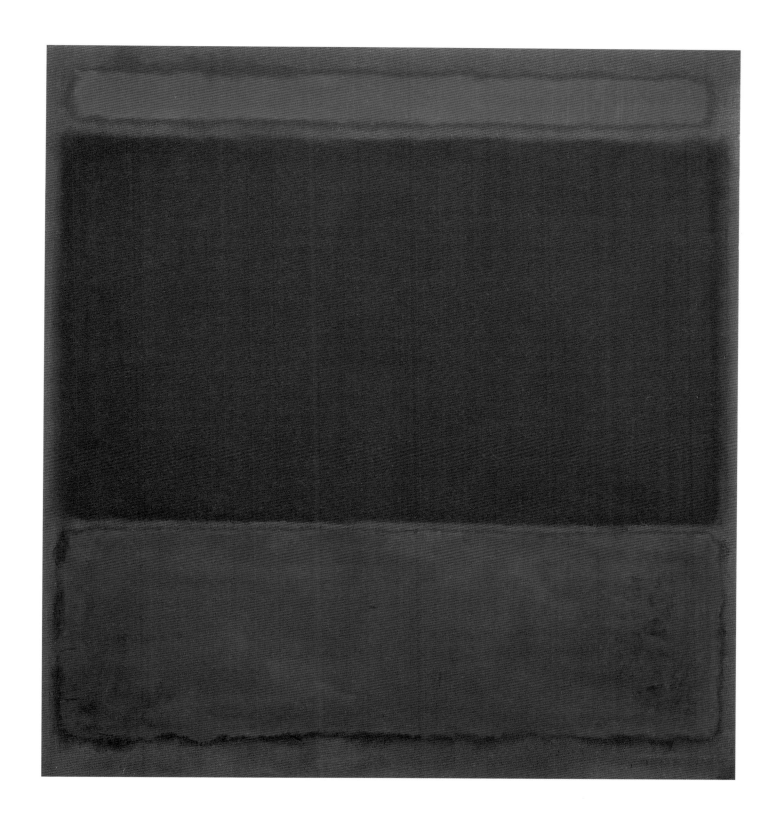

94 *No. 2 [Untitled]*, 1963
mixed media on canvas
203.8 x 175.6 (80 ¼ x 69 ⅛)
Walker Art Center, Minneapolis,
Gift of The Mark Rothko Foundation, Inc., 1985
estate no. 5037.63

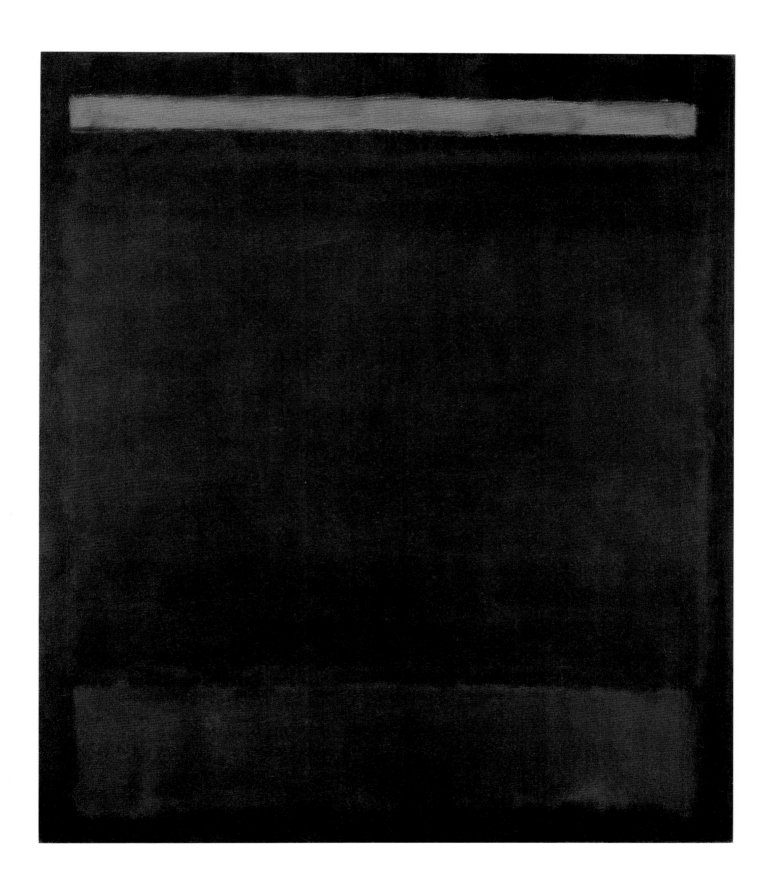

95 *Untitled*, 1963
 oil on canvas
 175.3 x 228.6 (69 x 90)
 Jane Lang Davis and Richard Lang Collection,
 Medina, Washington
 estate no. 5026.63

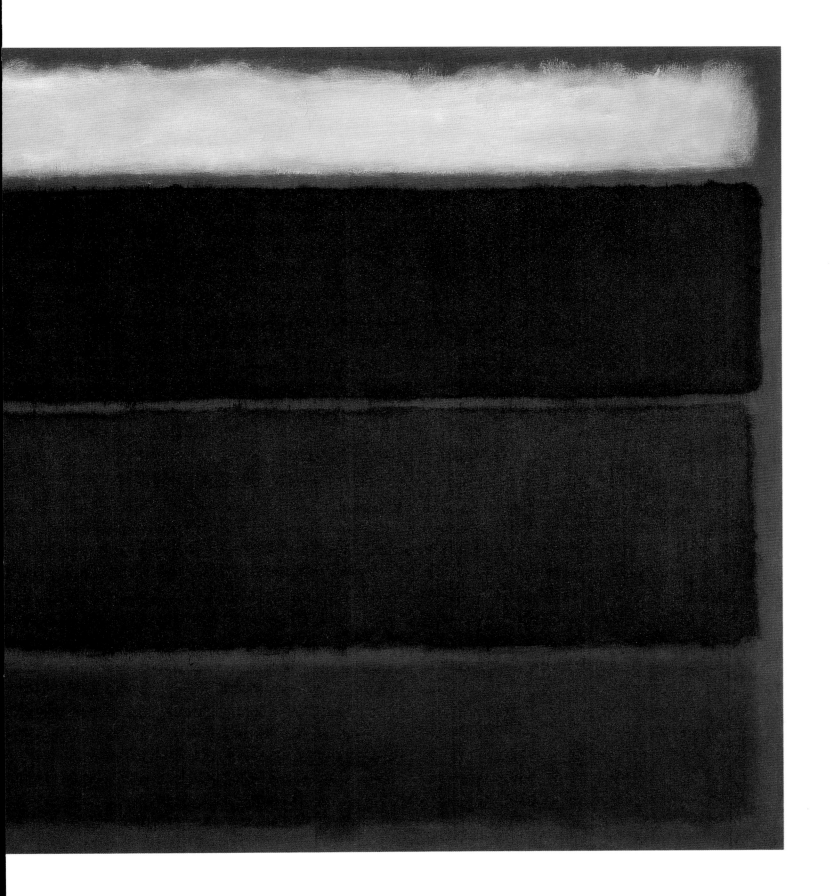

96 *Untitled [White, Blacks, Grays on Maroon]*, 1963
oil on canvas
228.6 x 175.3 (90 x 69)
Kunsthaus Zürich
estate no. 5035.63

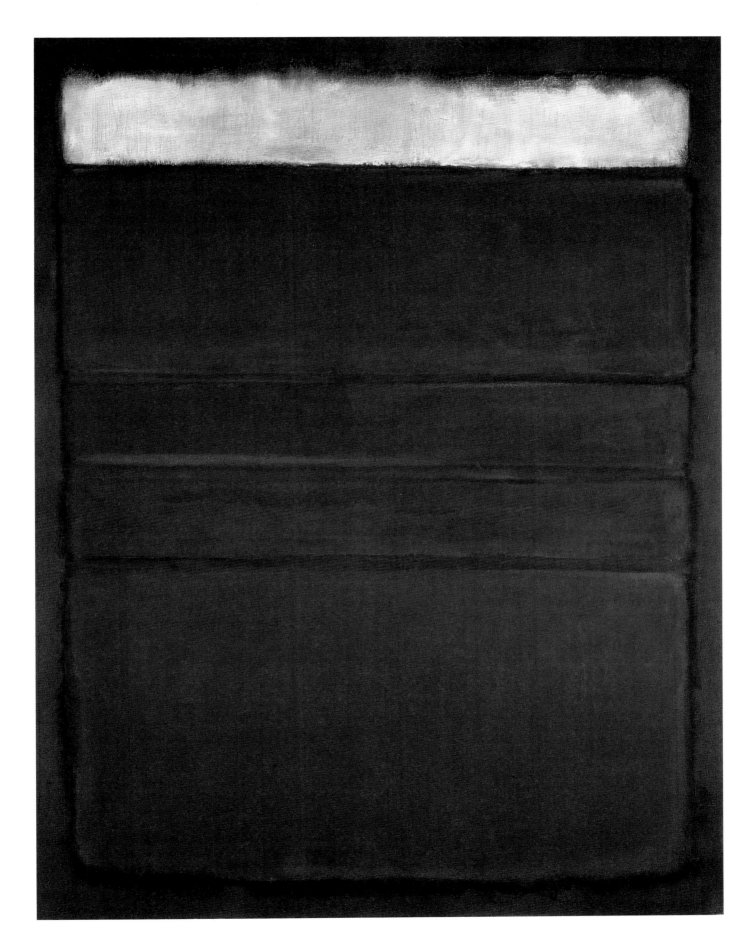

97 *Untitled*, 1964 (alternatively dated to 1961)
mixed media on canvas
236.2 x 203.2 (93 x 80)
The Metropolitan Museum of Art, New York,
Gift of the American Art Foundation, 1995
estate no. 5047.61

98 *No. 2 [Black on Deep Purple]*, 1964
 mixed media on canvas
 266.7 x 203.2 (105 x 80)
 Robert and Jane Meyerhoff, Phoenix, Maryland
 estate no. 5080.64

99 *No. 5,* 1964
mixed media on canvas
206.1 x 193.8 (81 ⅛ x 76 ¼)
National Gallery of Art, Washington,
Gift of The Mark Rothko Foundation, Inc., 1986
estate no. 5021.64

100 *No. 8*, 1964
 mixed media on canvas
 267.3 x 203.8 (105 ¼ x 80 ¼)
 National Gallery of Art, Washington,
 Gift of The Mark Rothko Foundation, Inc., 1986
 estate no. 5079.64

101 *Untitled,* 1968
 oil on canvas
 233.7 x 175.3 (92 x 69)
 Private Collection
 estate no. 5036.68

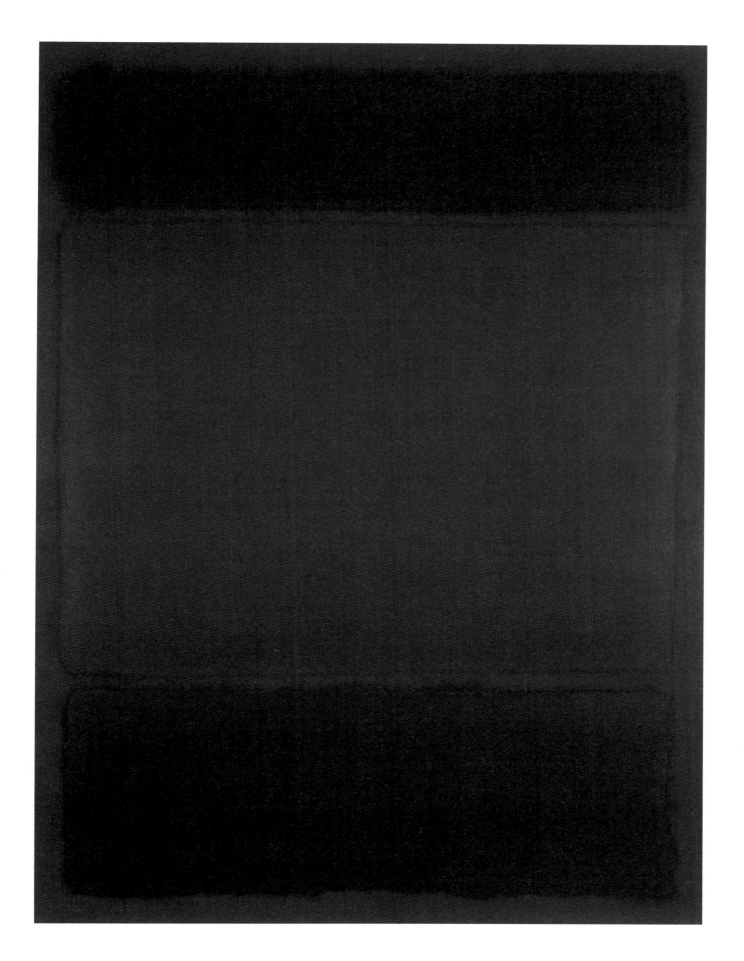

102 *Untitled*, 1968
 acrylic on paper mounted on wood fiberboard panel
 99.1 x 64.8 (39 x 25 ½)
 Collection of Kate Rothko Prizel
 estate no. 1176.68

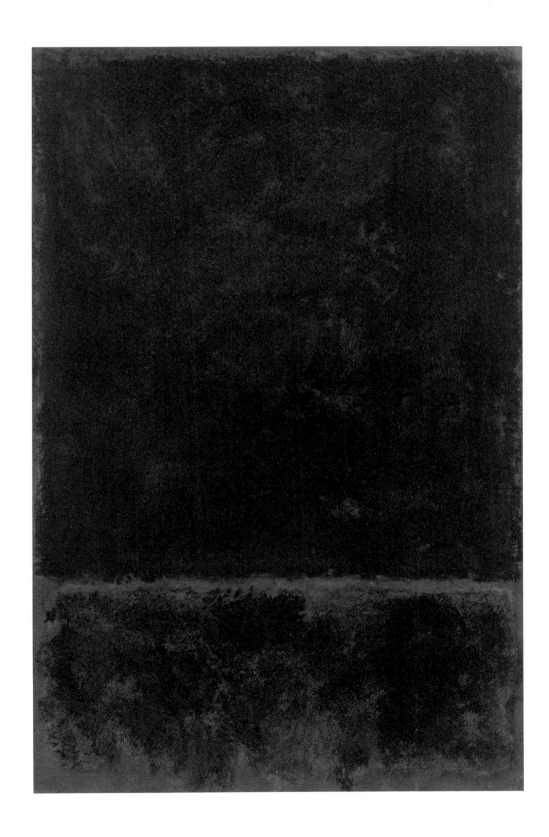

103 *Untitled*, 1968
 acrylic on paper mounted on wood fiberboard panel
 103.2 x 67 (40 ⅝ x 26 ⅜)
 National Gallery of Art, Washington,
 Gift of The Mark Rothko Foundation, Inc., 1986
 estate no. 1184.68

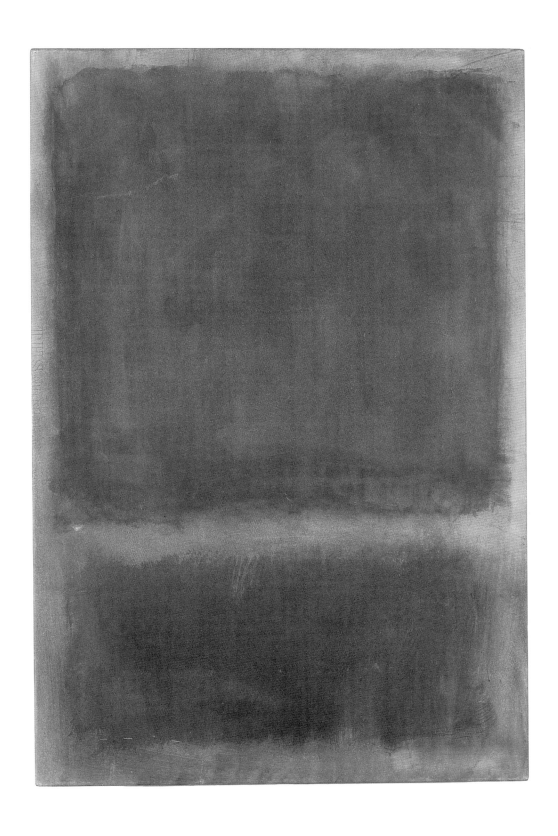

104 *Red, Orange on Pink,* c. 1968
 oil on paper mounted on canvas
 85.4 x 65.1 (33 ⅝ x 25 ⅝)
 Ivan Reitman/Genevieve Robert

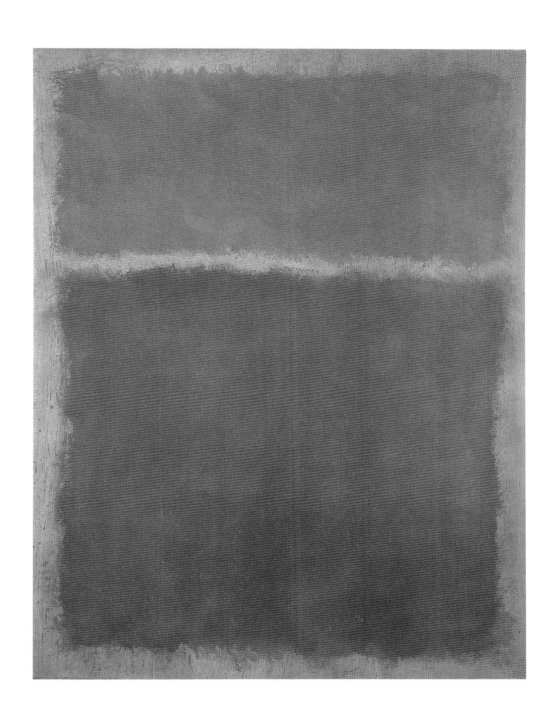

105 *Untitled,* 1968
 acrylic on paper mounted on canvas
 76.2 x 57.2 (30 x 22 ½)
 Barbaralee Diamonstein and Carl Spielvogel
 estate no. 2112.68

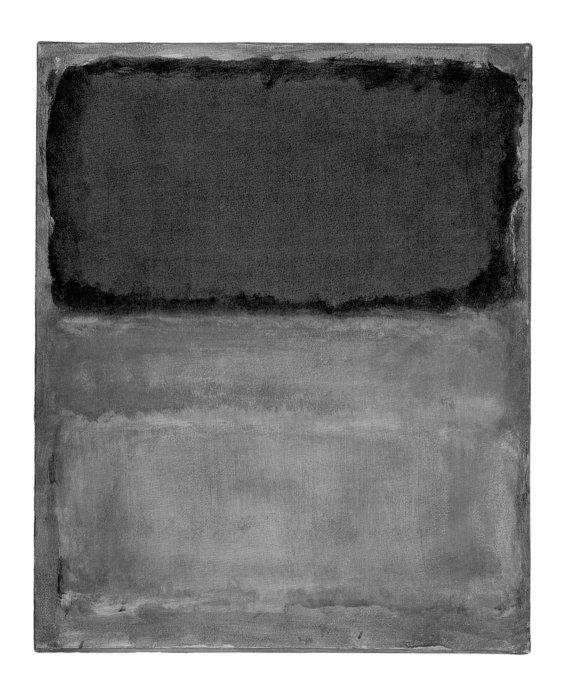

106 *Untitled,* 1968
oil on paper mounted on canvas
61 x 45.7 (24 x 18)
Aaron I. Fleischman

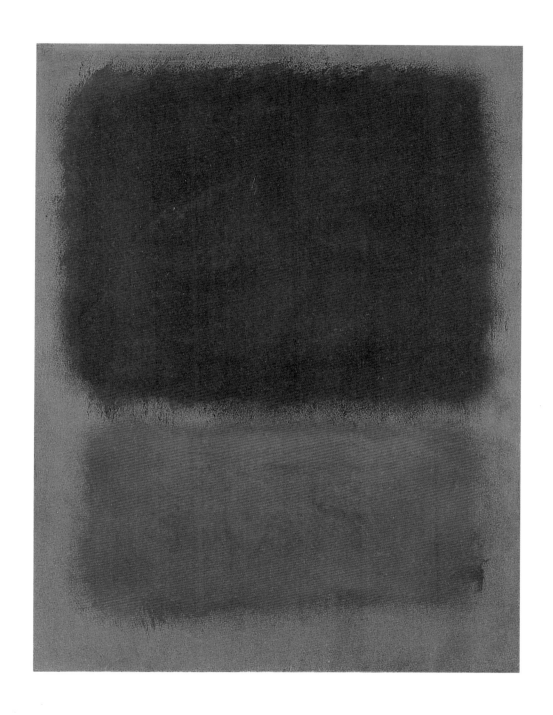

107 *Untitled*, 1969
oil on paper on board
123.2 x 102.9 (48 ½ x 40 ½)
Courtesy Peter Blum, New York
estate no. 2013.69

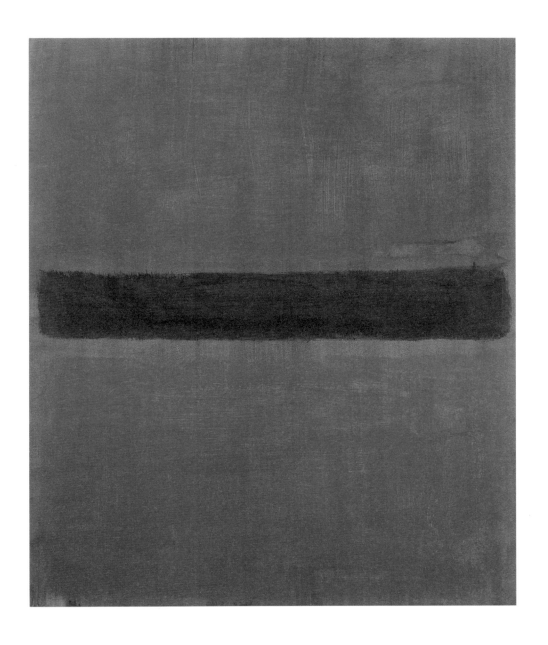

108 *Untitled,* 1969
 acrylic on paper mounted on canvas
 136.5 x 108 (53 ¾ x 42 ½)
 Collection of Kate Rothko Prizel
 estate no. 2066.69

109 *Untitled,* 1969
 acrylic on paper mounted on canvas
 137.2 x 107.5 (54 x 42 ⅜)
 Collection of Kate Rothko Prizel
 estate no. 2070.69

110 *Untitled,* 1969
 acrylic on paper mounted on canvas
 137.2 x 107.3 (54 x 42 ¼)
 Collection of Christopher Rothko
 estate no. 2069.69

111 *Untitled,* 1969
 acrylic on paper mounted on canvas
 183.4 x 98 (72 ¼ x 38 ⅝)
 Collection of Christopher Rothko
 estate no. 2062.69

112 *Untitled*, 1969
acrylic on paper mounted on canvas
183 x 107 (72 x 42 ⅛)
Collection of Kate Rothko Prizel
estate no. 2030.69

113 *Untitled*, 1969
acrylic on canvas
172.7 x 152.4 (68 x 60)
John and Mary Pappajohn, Des Moines, Iowa
estate no. 5211.69

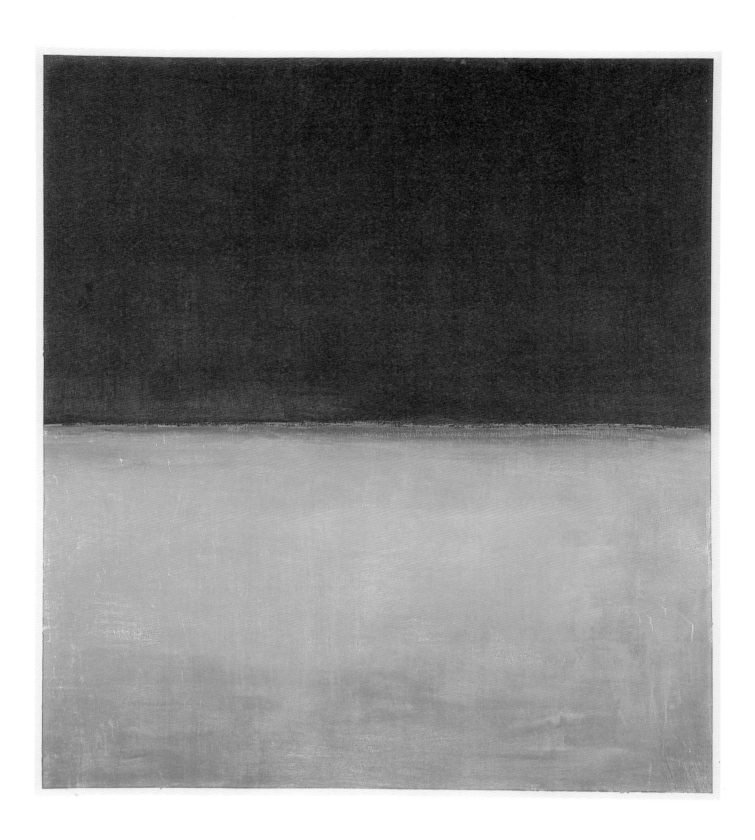

114 *Untitled [Black on Gray]*, 1969 – 1970
acrylic on canvas
203.8 x 175.6 (80 ¼ x 69 ⅛)
Solomon R. Guggenheim Museum, New York,
Gift of The Mark Rothko Foundation, Inc., 1986
estate no. X3.70

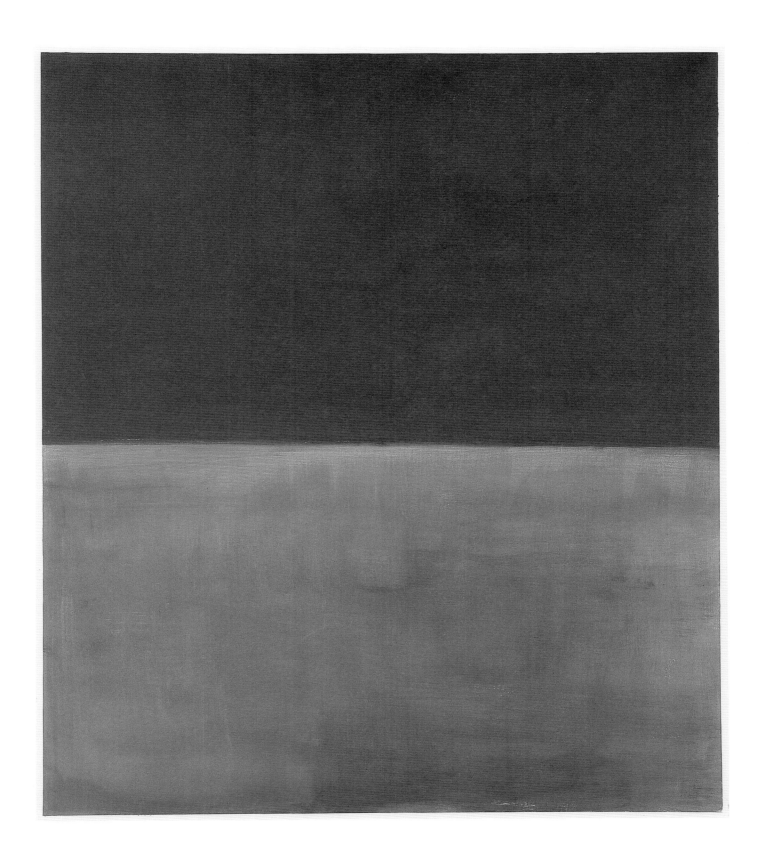

115 *Untitled,* 1969
 acrylic on paper mounted on canvas
 157.5 x 122.2 (62 x 48 ⅛)
 Collection of Kate Rothko Prizel
 estate no. 2086.69

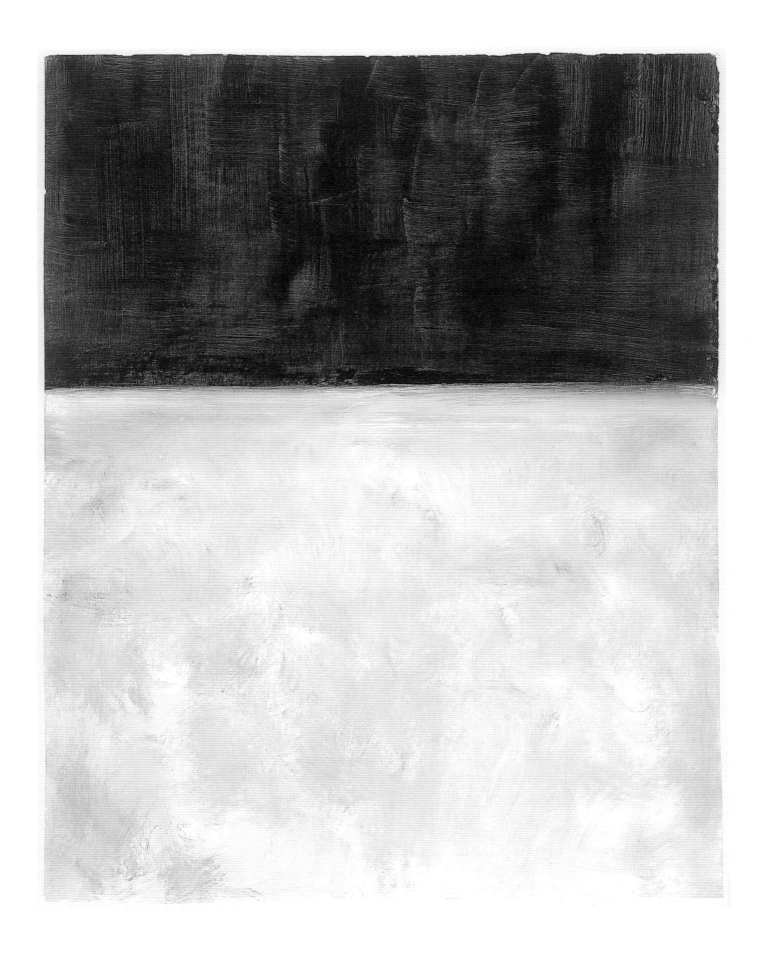

116 *Untitled [Black on Gray],* 1969
acrylic on canvas
206.4 x 236.2 (81 ¼ x 93)
Collection of Kate Rothko Prizel
estate no. 5218.69

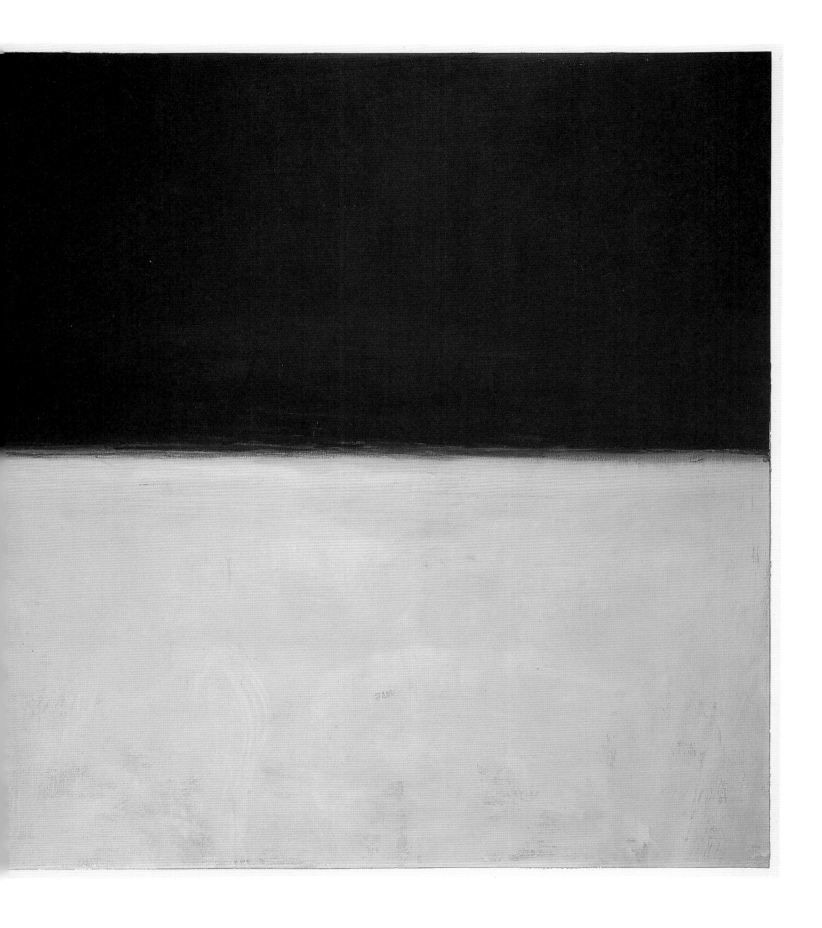

ESSAYS

Rothko: Color as Subject

It is now more than a quarter of a century since Mark Rothko ended his life, and half a century since he settled on the winning format of his late and definitive style. Rothko's paintings live, but their context—the circumstances of their making—is history; and the critical question "what?" is yielding to, or at least being supplemented by, the historical questions "how?" and "why?" Historians have so far confined themselves largely to the examination of Rothko's art in terms of its imagery, its biographical and cultural resonances, or its place in the economics and politics of "American-type painting." They have taken their cue from the painter's own silence and have scarcely been concerned with how his work came to be and was made. This gap is nowhere more strongly felt than in the area of Rothko's color.

Rothko's attitude toward color was famously at odds with the attitude of his public. "Rothko claims," wrote the American critic whom the painter considered to be the most sympathetic to his aims, "that he is 'no colorist,' and that if we regard him as such we miss the point of his art. Yet it is hardly a secret that color is his sole medium....Rothko's concern over the years has been the reduction of his vehicle to the unique colored surface which represents nothing and supports nothing else."[1] Thus Robert Goldwater, designated by Rothko as his future biographer. But even a critic whom the painter distrusted, Harold Rosenberg, placed a similar emphasis on color in his characterization of Rothko's mature work, and it is an emphasis that has been echoed ever since.[2] It impressed not only Rothko's critics but also his

1 Robert Goldwater, "Reflections on the Rothko Exhibition" [1961], reprinted in *Mark Rothko, 1903–1970* [exh. cat., Tate Gallery] (London, 1987), 32. For Rothko's enthusiasm about this article see Dore Ashton, *About Rothko* (New York, 1983), 165; also 190 for the designation of Goldwater as Rothko's biographer.

2 According to Rosenberg, "Rothko had reduced painting to volume, tone, and color, with color as the vital element" [1972]; see David and Cecile Shapiro, eds., *Abstract Expressionism: A Critical Record* (Cambridge, 1990), 414. For Rothko's dislike of Rosenberg's pomposity and over-interpretation see James E.B. Breslin, *Mark Rothko: A Biography* (Chicago and London, 1993), 385. For a later view that Rothko's intention was to give significance to color alone see Rainer Bothner, "Mark Rothkos Modulationen," *Pantheon* 45 (1987), 173, 175.

3 Marjorie Phillips, *Duncan Phillips and His Collection* (Washington, DC, 1982), 288.

4 Anna C. Chave, *Mark Rothko: Subjects in Abstraction* (New Haven and London, 1989), 13; Dan Rice, interview by Arnold Glimcher, 1978, in Marc Glimcher, ed., *The Art of Mark Rothko: Into an Unknown World* (New York, 1992), 68. Reinhardt too spoke of his "preoccupation with symmetry and colorlessness"; see Barbara Rose, ed., *Art as Art: Selected Writings of Ad Reinhardt* (Berkeley and Los Angeles, 1991), 21.

5 See Ann Gibson, "Regression and Color in Abstract Expressionism: Barnett Newman, Mark Rothko, and Clyfford Still," *Arts Magazine* 55, no. 7 (1981), 144–153, one of the very few published discussions of color in abstract expressionism. I am grateful to Jeffrey Weiss for a copy of this article. For a recent discussion of the history of the design-color debate see John Gage, *Color and Culture: Practice and Meaning from Antiquity to Abstraction* (Boston, 1993), chap. 7.

6 Exh. cat. London 1987, 33.

7 Chave 1989, 18.

8 Ashton 1983, 134; also 179. And see Selden Rodman, *Conversations with Artists* (New York, 1957), 93–94.

9 Breslin 1993, 395. Toward the end of his life Rothko sometimes returned to the more gestural handling of paint so conspicuous in his surrealist period.

10 Dore Ashton, "Introduction," in Bonnie Clearwater, *Mark Rothko: Works on Paper* (Washington, DC, 1989), 11.

patrons. Duncan Phillips, for example, who had arranged four of his five paintings by Rothko in "a little chapel for meditation" at the Phillips Collection in Washington, reflected, "In the two soft-edged and rounded rectangles of Mark Rothko's matured style there is an enveloping magic, which conveys to receptive observers a sense of being in the midst of greatness. It is the color of course." For the painter himself this was far from being a matter of course, and he told Phillips that "not color, but *measures*" were of greatest importance to him.[3] To another inquirer he claimed that he was "not interested in color." And in the late 1950s he told studio assistant Dan Rice that his Seagram murals were "no-color paintings—not dealing with color."[4] Were these protestations no more than a sign of Rothko's residual humanism, his endorsement of the traditional humanistic privileging of "drawing" over "color?"[5] Goldwater certainly argued in this vein that Rothko was resisting the enjoyment of his color "for its own sake, the heightened realization of its purely sensuous dimension."[6] Yet it is clear that Rothko was no enemy of the sensuous, what he characterized in his lecture to the Pratt Institute in 1958 as "a lustful relation to things that exist" and identified as one of the chief ingredients of his art.[7] Colorism, however, seems to have become identified in his mind with conventional notions of formal relationship, with "arrangement"; and when he saw "arrangement" in his own painting—for instance, in the short series of "multiforms" of the late 1940s—he vowed that it had to be "scrapped."[8] Rothko's new symmetry replaced the two-dimensional dynamic of the asymmetrical multiforms—sometimes so reminiscent of late Mondrian—with a three-dimensional, if shallow, movement of the surface akin to breathing. At the Pratt Institute he admitted that color was "all there is, but I am not against line. I don't use it because it would have detracted from the clarity of what I had to say."[9] So color was after all a sort of clarity, and painting was "saying." How then was Rothko able to make color speak?

INNER LIGHT

Dore Ashton, a long-time friend of Rothko's and one of his most perceptive critics, remarked that the painter never talked much about technique.[10] Perhaps this was because he knew that she was not much interested in technique herself, or perhaps it was due to a developing suspicion of any attempt to verbalize visual practices: the tongue-in-cheek list of "seven ingredients" of painting that Rothko outlined in his Pratt lecture consisted entirely of moral qualities.[11] But it had not always been so. In a notebook of the 1930s relating to his teaching of children, Rothko had itemized a set of the characteristics of painting that he had arranged as a set of binary contrasts: absorbent versus nonabsorbent surfaces, glazes versus opaque color, painting wet-in-wet versus around a contour, and so on. The list also mentions tonal and atonal

painting, "decorativeness as well as austerity," "lushness versus acidity," "sharp silhouette or indefinite merging," and it says that "color must be sensuous or functional."[12] Here Rothko's thought looks forward to the taxonomy of his mature work, a taxonomy that was far from simple, even in its formal elements, and that was more complex than that of any abstract expressionist except Pollock in its range of coloristic effects.

Rothko's preferred format from about 1949 was of course the upright rectangular canvas or paper, stacking two or three more-or-less regular rectangular forms, varying in area but free of the picture edge, and in the early years, as in *Untitled* of 1949 (cat. 45), occasionally including a pair of flanking, detached stripes. But the parameters of his handling of color were far wider than those of his handling of forms. To an unusual range of hues— sometimes contrasting, sometimes closely assimilated—Rothko added lightness or darkness, translucency or opacity, high or low saturation, smooth or brushy textures, "warmth" or "coolness," contrasts of color area, sharp or soft edges, and above all the creation of scarcely definable tones in depth by the layering of several paints. In this last respect Rothko was almost alone among his contemporaries, and he defined his objective as the creation of "inner light."[13]

It is not clear when the essentially formalist notion of inner light became a commonplace in the criticism of Venetian painting of the sixteenth century, but it was certainly a major concern of the Bavarian painter Max Doerner, whose handbook *The Materials of the Artist and Their Use in Painting, with Notes on the Techniques of the Old Masters* (1921), had been published in an English translation in New York in 1934 and came to be much used in the circle of the abstract expressionists.[14] Although Rothko has the reputation of having been a poor technician, it is striking that he adopted a number of the thoroughly traditional materials and techniques discussed in Doerner's book, notably the grinding of his own pigments and the use of a variety of egg tempera.[15] In addition to Doerner's particular interest in traditional methods, as implied in his title, he felt able to recommend some of the new synthetic materials, such as the titanium white and the coal tar "lithol fast scarlet," which were later used so disastrously by Rothko in his Harvard murals.[16] On the other hand, Rothko showed none of Doerner's concern for the careful construction of stretchers, and he adopted the late medieval technique of interposing an isolating egg-white glaze between layers of pigments or varnish, which Doerner had specifically discouraged since egg white becomes very brittle with time and turns brown.[17] Yet these examples too suggest that Rothko was quite familiar with Doerner's book.

Doerner's concept of inner light was elaborated in the context of an examination of the technique of Titian, but he also associated Titian's slow

11 Breslin 1993, 389–391. See also Ann Gibson, "Abstract Expressionism's Evasion of Language" [1988] in Shapiro and Shapiro 1990, esp. 195– 196; but Gibson is not concerned with technical ideas.

12 For two slightly different selections from these notes see Michael Compton, "Mark Rothko: The Subjects of the Artist," in exh. cat. London 1987, 41; and Breslin 1993, 134.

13 Cited in exh. cat. London 1987, 88. Jules Olitski, a younger artist whose methods were close to Rothko's, also felt that color should be seen "*in* and throughout, not solely *on* the surface"; see his "Painting in Color" [1967], in Ellen H. Johnson, *American Artists on Art from 1940 to 1980* (New York, 1982), 52.

14 Max Doerner, *The Materials of the Artist,* trans. Eugen Neuhaus (New York, 1934), esp. 166, 347. See Dana Cranmer, "Painting Materials and Techniques of Mark Rothko: Consequences of an Unorthodox Approach," in exh. cat. London 1987, 190. This was seconded by the supplier of synthetic paints to the abstract expressionists, Leonard Bocour (interview by Paul Cummings, 8 June 1978, p. 17, Archives of American Art, Washington, DC).

15 See Breslin 1993, 245, and Cranmer in exh. cat. London 1987, 193–194 (cf. Doerner 1934, 143–149, 155, 213–215). For other correspondences see Susan J. Barnes, *The Rothko Chapel: An Act of Faith* (Austin, 1989), 61. Cranmer (p. 189) characterizes Rothko as "a relatively conventional technician" and "almost academic" in comparison with his abstract expressionist contemporaries.

16 See Doerner 1934, 45, 57–58, 75, 90–91, 92; and Marjorie B. Cohn, ed., *Mark Rothko's Harvard Murals*, Center for Conservation and Technical Studies, Harvard University Art Museums (Cambridge, MA, 1988), 17. In the present context the instability of some of Rothko's materials is less important than the claims for durability put forward by Doerner.

17 Cohn 1988, 10; and Doerner 1934, 236. Cennino Cennini had described an isolating layer of egg white in *The Craftsman's Handbook* [c. 1390s], trans. David V. Thompson Jr. (New Haven, 1933), 110.

18 Doerner 1934, 365–373; also 371–372 for the link with Titian. For Rothko's self-identification with Rembrandt see esp. Breslin 1993, 283, 339; and Ashton 1983, 34.

19 Doerner 1934, 369.

20 Breslin 1993, 291; Doerner 1934, 366, 372.

21 Doerner 1934, 166, 189, 345. Doerner alludes repeatedly to a claim attributed to Titian himself that he used thirty to forty glazes in a single picture, an astonishing suggestion that I have not been able to substantiate.

22 Doerner 1934, 345–346.

23 Doerner 1934, 49, 73, 189, on mixtures with white; 372, on Rembrandt.

buildup of many glazes with Rembrandt, to whom Rothko felt especially close.[18] Rembrandt's technique, said Doerner, "is truly spiritualised handicraft, and to trace this in his paintings is always a thrilling experience."[19] In the course on "contemporary art" that Rothko taught at Brooklyn College in the early 1950s, he began perversely with Rembrandt, as an artist who, for the first time in history, "painted whatever he felt like doing." This was a judgment very much in harmony with Doerner's expressionist conception of the Dutch master, who had completed his picture when he had "realized his intentions."[20]

Doerner outlined the way in which Titian "was concerned with the multiplicity of variations possible within one color" and how "the picture was gradually deepened by the use of intermediate modulations, and became colorful and mysterious."[21] In his discussion of Titian's late work, where the painter sacrificed all detail to "broad pictorial effect," Doerner's descriptive powers were given full rein:

The light body of the underpainting, perhaps a yellow-white as a basis for a fiery red or a green-white for a cooler red, was glazed with a strong color. These glazes were, where necessary, partly wiped off or blended with all sorts of colors in adjacent areas. Analogously colored reflections, often of breath-like thinness, or new scumbles with white to take from color its coarse, material effect, were resorted to, and in this way he created that suggestion of mystery which constantly engages the eye anew and never tires it.[22]

If Rothko read this, he would surely have savored Doerner's enthusiastic evocation of Titian's mystery, and he would have recognized in the Venetian painter a mastery of white akin to his own. Rothko's practice of mixing white into his hues is noticeable from the 1930s onward, quite apart from white paintings such as *No. 7 (No. 11)* of 1949 (National Gallery of Art, Washington) and the recurrent use of important white elements in many paintings of the classic period, where it was used as a color in its own right, clearly hovering in front of the ground (see *No. 18* of 1951, cat. 53). And white of course was introduced abundantly even into the somber paintings of the last years. Doerner recommended mixing small quantities of white into glazing colors, particularly if they were to be covered, and he argued that Rembrandt's close harmonies were partly the result of his handling of white: "Rembrandt created his magnificent color harmonies out of the 'friendly' colors of yellow ochre to brown and brown-red by merely balancing transparent, glazed tones with the dull effects of the same tones mixed with white, and conceived them all in a sense as variations of the one dominant tone."[23]

Rothko developed his method of creating inner light partly from his practice in watercolor. It was a medium to which he had been attracted since his earliest years as a painter, so much so that he thought at one time that he

might become a watercolor specialist. [24] His early Marin-like watercolors make great play with transparency, although from the late 1940s he introduced mixed-media techniques, which align his works on paper more closely with his works on canvas. But these smaller-scale paintings, in which Rothko came to make freer use of the synthetic pigments such as Magna and acrylics, generally had a simpler structure, paradoxically more concerned with surface than depth, and not designed to induce the sense of envelopment that is so clearly felt in the large canvases. [25] With respect to the works on paper, we are concerned inevitably with what Meyer Schapiro characterized as the semiology of the field in which "the distinctive values of the different places of the field and the different magnitudes re-inforce each other." [26] At this scale we are dispassionate observers of these interrelationships, not participants in the drama of Rothko's large spaces, which, as he put it in a famous statement of 1951, we are "unable to command." [27]

However it evolved, Rothko's "inner light" was no mere technical device but was clearly developed to serve an expressive purpose. Was this also the case with his highly idiosyncratic approach to hue?

ROTHKO'S CHROMATICS

In the course of teaching color at Brooklyn College in the early 1950s, Rothko "never did color charts or color wheels or anything of that sort, and we'd just work with color. In a way he wanted us to do little Matisses and little de Koonings and little anybodys, but just to understand what color was about through the use of it." [28] "Learning by doing" was deeply rooted in the American approach to teaching art in the first half of this century, but a resistance to theory was also noticeable in the program of that professor of technique at the Munich Academy, Max Doerner. Doerner was particularly unhappy about the influence of the leading German color theorist of his day, the Nobel Prize-winning chemist Wilhelm Ostwald, who had a notable following in the English-speaking world of the 1930s and 1940s. Ostwald had devised a series of diagrams and charts and had promoted sets of standard pigments and colored papers to support his theory of harmony, based on the balancing of the light/dark content of hues. As Doerner wrote:

The value of color charts and colorimeters is limited because the color harmonies derived from them are very restricted. In the realm of color the painter should proceed in the most subjective way, entirely in accordance with the feelings; and these everyday, commonplace harmonies are after all too ordinary to be followed profitably. To measure color and to build the color scheme of a picture on these measurements, as Ostwald recommends, is such a repugnant idea to an artist that it should be promptly rejected. Any standardisation reducing the use of color to a formula would be the death of the art of painting. [29]

24 Clearwater 1989, 30–31.

25 For the techniques of the works on paper see Clearwater 1989, 39, 42.

26 Meyer Schapiro [1969], cited in Chave 1989, 158.

27 Mark Rothko [1951], reprinted in exh. cat. London 1987, 85.

28 Rothko's pupil Celina Trief, cited in Breslin 1993, 615 n. 44.

29 Doerner 1934, 182. For the influence of Ostwald see Gage 1993, 257–262. It is ironic that the principles and requirements of painting enunciated by Rothko while teaching at the California School of Fine Arts in the late 1940s have a distinctly "Bauhaus" flavor: "universal elements," "basic truths" to be achieved by "general understanding of psychology, philosophy, physics, literature, the other arts, and writings of the mystics" (Breslin 1993, 260–261).

30 Breslin 1993, 292.

31 See Hajo Düchting, *Farbe am Bauhaus: Synthese und Synästhesie* (Berlin, 1996), 19, 37, 60, 96, 104, 125, 142–143, 159.

32 In chapter XXIV of *Interaction of Color* (New Haven, 1963) Albers stated that he had originally introduced his course with theory but later reversed the practice: "We learned that their [the theories'] often beautiful order is more recognized and appreciated when eyes and mind are—after productive exercises—better prepared and more receptive." For Albers and theory see Gage 1993, 264–266.

33 Breslin 1993, 301.

34 See especially Hans Hofmann, *The Search for the Real in the Visual Arts*, (1948; repr. Cambridge, MA, 1989), 43–45; also 46–47 on the Bauhaus.

35 Breslin 1993, 93.

36 Doerner 1934, 167–168.

37 On *Nuit de Noël* see John Elderfield, *Matisse in the Collection of the Museum of Modern Art* (New York, 1978), 158–161. Rothko's palette in *Homage to Matisse* is generally closer to Matisse's *Woman in Blue* (1937) in the Philadelphia Museum of Art.

38 Doerner 1934, 169.

39 For the "tragic" *No. 5 (No. 22)* see Ashton 1983, 135–137; and Chave 1989, 123, which points to the unusually aggressive linear element in this painting. For the "malicious" Seagram murals see Michael Compton in *Mark Rothko: The Seagram Mural Project* [exh. cat., Tate Gallery, Liverpool] (Liverpool, 1988), 10.

Rothko scathingly characterized the design-oriented program at Brooklyn College, to which he was expected to accommodate his teaching, as "Bauhaus ideology." [30] And an opposition to color theory—particularly Ostwald's—had already been marked among the imaginative artists, as opposed to the designers, at the German Bauhaus. [31] Even Josef Albers, who might well have been expected to import Bauhaus ideas about color into the United States in the 1930s, firmly located theory (including Ostwald and his American rival Albert Munsell) after practice in his *Interaction of Color* of 1963. [32]

But Rothko was clearly concerned to articulate color through contrast and assimilation, which constitute the basic language of hues in his mature style. It was a language of dynamism: as he told Alfred Jensen in 1953, "either their surfaces are expansive and push outward in all directions, or their surfaces contract and rush inward in all directions. Between these two poles you can find everything I want to say." [33] This sounds very like the celebrated *push* and *pull* of another American opponent of the Bauhaus, Hans Hofmann. [34] But Hofmann's visual language was of course very unlike Rothko's in its assertion of the active two-dimensionality of the picture surface as well as its depth. Rothko's approach may well have had much to do with his early discussions at Milton Avery's in the 1930s: as Sally Avery recalled, they would look over her husband's paintings and talk "about the color and the shapes and the forms and how Milton could make a brilliant color recede when it would normally come forward and things like that." [35] In a canvas of 1962 in the collection of Robert and Jane Meyerhoff, *No. 3 (Bright Blue, Brown, Dark Blue on Wine)* (cat. 93), Rothko demonstrated that blue might be dazzling and advancing or muted and receding and that it could be manipulated to serve either of these functions.

This sort of color dynamics through contrast was a major theme of the short section on color theory that Doerner inserted, somewhat incongruously, into his discussion of the technique of oil painting:

Warm colors seem to advance, cold ones to recede. In addition strong colors also seem to advance, likewise colors used as glazes and very opaque color passages.... The effectiveness of red in a picture may be heightened by its surroundings, by the presence of its complementary color, as also of a neutral tone, a colorful gray—but also a red of reduced or heightened intensity.... Complementary colors of equal strength in juxtaposition and covering equal areas, as, for example, yellow alongside of an equally strong blue, are offensive to sensitive eyes. This harsh contrast may be ameliorated by having one color very high in key and the other more saturated, and by making the areas very unequal in size. Imperfectly complementary colors give a better effect in the picture, as, for example, a yellow related to gray instead of to blue. [36]

Rothko definitely had a feeling for the more modern (additive) complemen-

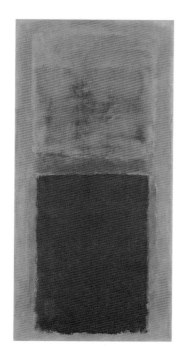

taries yellow and blue. In a painting of 1955, *Yellow and Blue* (cat. 69), he sets off a large yellow rectangle against a narrower and more irregular blue strip, using contrast effects where the sharp edges of the yellow and blue abut. Yet although the more variegated blue is rather pale, it forms a "natural" tonal contrast with the brilliant yellow, so that this is a painting as much concerned with tone as with hue itself.

Complementary contrasts of the sort that may be derived from the color circles in the usual handbooks—red and green, blue and orange, yellow and violet—are rare in Rothko. His *Green, Red, Blue* of 1955 (cat. 70) has a "green" that is very blued by its ground and a "red" that is a very orange, salmony pink. His *Homage to Matisse* of 1954 (fig. 1) has a strong blue set against a shifting series of orange yellows and oranges. Here, as so often elsewhere, the optical effects of simultaneous contrast are inhibited by the softening of color boundaries or by the introduction of an intermediate buffer color between the tones. In this canvas the blue rectangle is flanked by narrow stripes of a translucent grayish green. The tall, narrow format, although certainly not unique in Rothko's work at this time, recalls Matisse's late cutout designs for stained-glass windows. Indeed the window designed for *Life* magazine, *Nuit de Noël* of 1952 (fig. 2), which was presented together with its maquette to the Museum of Modern Art in June 1953, has at its base a blue rectangle flanked by green stripes in a very similar way. Rothko's translucent glazing technique suggests that he may well have been thinking of the window itself, which had been displayed at the Time-Life Building in New York the previous December.[37]

If Rothko's colors were themselves far from standard, so were his contrasts, and in this too he was close to Doerner's emphasis on originality: "Contrast, opposition of colors, gives life to a picture. The painter is here not concerned simply with the coarser, all too common contrasts, such as green-red, blue-yellow etc., of the various 'color-circles,' but with the color combinations which are his own, and which have not been seen and felt by others. He can harmonize in this way seemingly impossible contrasts, and, relying on his own emotions, create new color values."[38] That Rothko was less concerned to "harmonize" than to create discordant, uneasy effects through the juxtaposition of the related fiery reds, yellows, and oranges of *No. 5* (*No. 22*) of 1950 (cat. 46), for example, or the somber blackened reds and blacks of the Seagram murals, is no less a witness to his uncommon command of an expressive gamut of colors.[39]

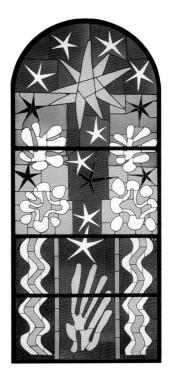

40 Breslin 1993, 292, 587 n. 37.

41 For Tofranil and Valium see
Lee Seldes, *The Legacy of Mark
Rothko* (London, 1978), 92, 345.

42 Friedrich Nietzsche, *The Birth
of Tragedy out of the Spirit of
Music* [1871], trans. S. White-
side, intro. M. Tanner (London,
1993), 17. For Rothko's re-
peated reading of this text see
Breslin 1993, 174–176. Tobacco
amblyopia and alcohol may
affect one's discrimination
between red/green or yellow/
blue; see J. Pokorny, V. C.
Smith, G. Verriest, A. J. L. G.
Pinckers, *Congenital and
Acquired Color Vision Defects*
(New York, 1979), 310, 337–
339. Yet Philippe Lanthony,
"Les Yeux des peintres,"
*Bulletin de la Société ophthal-
mologique française* 96 (1996),
437, points to a number
of painters, such as Toulouse-
Lautrec, whose sight does
not appear to have been
impaired by alcohol.

43 Seldes 1978, 100, may refer
only to the artist's last years.
For the effect of myopia on
color vision see Pokorny
et al. 1979, 170, 250, 269; and
for cautious assessments of
myopia in relation to painting
see Patrick Trevor-Roper, *The
World through Blunted Sight:
An Inquiry into the Effect of
Defective Vision on Art and
Character*, 2nd ed. (London,
1988), 36–44 (42 on color);
and Lanthony 1996, 437–438.

44 See Breslin 1993, 43, where
a link is also made with the
mature paintings.

45 Cited in exh. cat. London
1987, 82; see also his comment
to William Seitz in 1952 that
he always painted "realisti-
cally," in Breslin 1993, 330;
and see Chave 1989, 103, 194.

When Rothko was moving into his definitive phase in the late 1940s, he included a knowledge of psychology among the accomplishments he felt were needed by the artist of the future. His own psychological concerns seem to have been largely with Freudian psychoanalysis,[40] yet despite his inclination to talk and the many reminiscences of his conversations by friends and acquaintances, we have very few records of Rothko's interior life. Professional etiquette may account for the fact that two psychiatrists close to the painter toward the end of his life, Bruce Ruddick and Nathan Kline, have not commented in any detail on his personality. During the last two years of Rothko's life Kline treated his severe depression with drug therapy, and the side effects of some of this medication might well have included blurred vision.[41] But the work of these years was both sharper in contour and largely monochromatic. On the other hand, Rothko had long been a heavy smoker and a hard drinker, "under the influence," as Nietzsche put it in one of the painter's favorite books, *The Birth of Tragedy*, "of the narcotic potion hymned by all primitive men and peoples." And the modifying effects of alcohol and tobacco on color vision can be considerable.[42] When we deal with an art whose language depends on a very precise and refined sense of color relationships, we cannot but take notice of these circumstances, even though, since the links between vision and perception are extraordinarily complex, it is not easy to interpret them in terms of painting. The same goes for Rothko's myopia, established, like Matisse's, from an early age, and certainly acute. If he took his glasses off and moved up close to his surface to paint, as he did to read,[43] this is likely to have had a marked effect on his attitude toward viewing distance (see below). And his preference for soft, blocky shapes, as seen in his well-known *Self-Portrait* of 1936 (cat. 1)—a preference that seems to have been interrupted only during his more graphically oriented surrealist period of the early 1940s—may also have something to do with the shifting aspect of the world presented to myopics by their corrected and uncorrected sight. James Breslin quotes an early poem by Rothko that includes images of Heaven, "like a lamp in the fog" and "the mist of my dreams," which suggest that he gave these effects the positive value of experience.[44]

In one of his often-repeated yet more paradoxical statements, for a Washington exhibition in 1945, Rothko claimed, "I adhere to the material reality of the world and the substance of things."[45] It is thus entirely in order to interpret the psychological dimension of his painting in terms of phenomenology, not in the ontological sense of a Husserl or a Merleau-Ponty,[46] but in the context of the experimental psychology current in Rothko's time. One of the most radical developments in the phenomenology of color took place

in Germany in the first quarter of this century and was welcomed in the United States in the 1920s and 1930s: the amplification, in Gestalt psychology, of the traditional triad of perceptual variables—hue, value (light and dark content), and saturation (degree of chroma, or colorfulness)—by three further "modes of appearance," namely, surface, volume, and "film" or "free" color. These phenomena had been examined by a number of German psychologists since the early years of the century, but they received their classic formulation in a study of 1911 by David Katz, *The Modes of Appearance of Colors and Their Conditioning by Individual Experience.* Katz' work was well known in the United States, and the second (1930) edition of his book was translated into English in 1935 as *The World of Colour.* His research is important here, because it established "film" color (perceived by observing a colored surface through a small hole) as the dominant mode of appearance and the mode closest to "colorist" painting (he cited the work of the impressionists).[47] Film color was always perceived as on a plane frontal to the spectator, although it was extremely difficult to locate precisely in space. Rothko's emphasis on frontality, on translucent glazes, on soft contours, and on a generally featureless surface texture aligns his handling of color closely with the film mode,[48] which was described vividly by a group of subjects reexamining Katz' data at Cornell University in the early 1920s. Some characteristic responses were that "the darker [colors] are always more like looking into a colored hole, whereas the brighter ones seem glowing"; "I could look into the color but not through it"; "self-radiant somehow"; "yellow circle on a red background, which seemed at first to be surface; but as I looked that seemed to be red air or space, not filmy enough for air. Momentarily it looked as if the yellow were in front of it, floating."[49] These responses are of course very like many characterizations of Rothko's mature paintings, and the translucent, rather grainy film mode was particularly evident in a series of almost monochromatic paintings of about 1964, such as the brown *Untitled* canvas in the Metropolitan Museum of Art, New York (cat. 97).

It is of no great consequence whether or not Rothko was aware of these developments in psychology, although it is not inconceivable that he might have been, since psychology was among his subjects at Yale. It is merely impressive that his idiosyncratic approach to color in the late work reflected attitudes that were also much on the minds of the most innovative perceptual psychologists of the day. Yet, however much technique may signal a direction of thought and feeling in some general way, it can tell us rather little about the specifics of meaning. To pursue these we must turn from Rothko's methods to the far more contentious area of what Lawrence Alloway once called the "iconography of color as sensibility."[50]

46 Gibson 1981, 149, accepts the highly idiosyncratic account of the phenomenology of color offered by Merleau-Ponty. But see P. K. Kaiser, "Physiological Response to Color: A Critical Review," *Color Research and Application* 9 (1984), 29–36. Ashton 1983, 120–123, notes that Merleau-Ponty was part of the postwar environment in which Rothko functioned, but Chave 1989, 92, notes that he was probably unknown to Rothko.

47 David Katz, *Die Erscheinungsweisen der Farben und ihre Beeinflussung durch die individeelle Erfahrung* (Leipzig, 1911), 210–211; David Katz, *The World of Colour,* trans. R. B. MacLeod and C. W. Fox (London, 1935), 148. This was also the conclusion of G. J. von Allesch, "Die ästhetische Erscheinungsweise der Farben," *Psychologische Forschung* 6 (1925), 22.

48 Professor Sanford Wurmfeld has made the link in a chapter on "Color in Abstract Painting," for a forthcoming study of color in science and art, edited by Kurt Nassau. I am grateful to Sandy Wurmfeld for showing me an advance copy of his text. Rudolf Arnheim in *Art and Visual Perception: A Psychology of the Creative Eye, The New Version* (Berkeley, 1974), 326, has, interestingly, related the "glow" created by film color to Rembrandt's technique.

49 M. F. Martin, "Film, Surface, and Bulky Colors and Their Intermediates," *American Journal of Psychology* 33 (1922), 460, 465.

50 Alloway [1970], cited in Chave 1989, 120–121.

In his outline for a treatise on art that he was developing in the 1930s and early 1940s but never finally wrote, Rothko listed three headings related to color: its objective or subjective use, its decorative use, and its sensuous use.[51] Conspicuously absent from this agenda was color's symbolic function (it may be implicit in "subjective"). And although Rothko occasionally gave hints about his notions of the meaning of color, some of which will be examined below, he never suggested the possibility of any systematic approach of the sort that had been articulated, for example, by Kandinsky. In this he was perhaps well advised, for in Kandinsky's own day German experimental psychology had already begun to undermine the whole project of a possible color language, and this development was reported in some detail in the American literature of experimental aesthetics.

The chief agent in this process of deconstruction was the Berlin psychologist G. J. von Allesch, who, working over many years with an unprecedentedly large and varied sample of subjects—including artists, art historians, professionals, working people, children of many nationalities—was able

FIG. 3 / MARK ROTHKO, *NO. 16 (GREEN AND RED ON TANGERINE)*, 1956, OIL ON CANVAS, 237.4 X 175.5 (93 ½ X 69 ⅛), THE PHILLIPS COLLECTION, WASHINGTON, DC.

to find no consistent pattern either for color preferences or for color associations.[52] Von Allesch's most enthusiastic American supporter, A. R. Chandler, after a detailed review of this work in his own book *Beauty and Human Nature* (1934), concluded that "the human organism is not so constituted as to react in a definite way to each color or each combination of colors. No color is invariably and unconditionally pleasant or unpleasant, exciting or soothing, dignified or tawdry. Such effects depend on a multitude of factors that vary with individual observers and changing circumstances." Yet Chandler was not inclined wholeheartedly to endorse von Allesch's negative results: "Nevertheless there is not complete chaos. It is not true that every effect is equally likely to arise from every color. Saturated reds are not cold, nor are the darkest colors cheerful." And he identified a stabilizing effect in the interpretation of colors in reference to nature and to long-standing cultural usages such as those of the Christian Church.[53]

Rothko was clearly sympathetic to both of these possibilities: he included a hint of nature when, in a rare moment of expansiveness about *No. 16 (Green and Red on Tangerine)*, 1956 (fig. 3), he proposed that the tan-

gerine might be read as "the normal, happier side of living" and the dark blue green above as the "black clouds or worries that always hang over us." He clearly knew his patrons: Duncan Phillips himself observed that "the weather his colors create can be ominous."[54] In this case at least high color and warmth suggested joyfulness, and dark color, moral gloom.

Cultural factors were also of some interest to Rothko, who told the president of Harvard University in 1962 that his somber monumental triptych for the university was intended to convey Christ's suffering on Good Friday, whereas the brighter panels represented Easter and the Resurrection.[55] It is, on the other hand, far from easy to reconcile the low-toned browns and reds of the "apse" in the Rothko Chapel in Houston with the "inviting and glorious apse" and its "celestial vision of the Madonna and Child" in the cathedral at Torcello, which Rothko suggested to his patron Dominique de Menil as some sort of a stimulus to his own conception.[56]

We have seen above how Rothko was concerned to counter a familiar perception of his color in the case of *No. 5 (No. 22)* (cat. 46) as "a glorious Apollonian outpouring of consoling yellow and orange light" by asserting its intensely tragic connotations.[57] Here, of course, he was following Nietzsche in conceiving of tragedy as more essentially related to the holistic Dionysian than to the Apollonian, the principle of individuation. He may indeed in this instance have taken his cue specifically from a passage in *The Birth of Tragedy* where Nietzsche alluded to the then quite recently investigated phenomenon of the negative afterimage:

The language of Sophoclean heroes surprises us with its Apolline precision and lucidity, so that we immediately imagine we can see into the innermost core of their being, somewhat astonished that the way to that core is such a short one. But if we leave aside the characteristics of the hero—who is basically merely a light-image cast on a dark screen, *appearance* through and through—that come to the surface and attain visibility; if we instead penetrate the myth projected in these bright reflections, we suddenly experience something that is the opposite of a familiar optical phenomenon. If we make a concerted effort to stare into the sun and turn away blinded, we have dark-coloured patches before our eyes as what we might call remedies. The light-image manifestations of the Sophoclean hero—the Apolline mask, in short—are the inevitable products of a glance into the terrible depths of nature: light-patches, we might say, to heal the gaze seared by terrible night. Only in this sense can we imagine that we correctly understand the serious and meaningful concept of "Greek cheerfulness"—while today, of course, we constantly encounter this concept of cheerfulness wrongly understood as a state of untroubled contentment.[58]

As Rothko moved away from the image and toward a more musical conception of color, his art was inevitably more bound up with the Dionysian,

51 Breslin 1993, 588 n. 42.

52 Von Allesch 1925. Using a far more discursive statistical method, H. J. Eysenck later attempted to bring order to the question in "A Critical and Experimental Study of Color Preferences," *American Journal of Psychology* 54 (1941), 385–394; his conclusions that blue is the most preferred color and yellow the least have passed into orthodoxy.

53 A. R. Chandler, *Beauty and Human Nature: Elements of Psychological Aesthetics* (New York, 1934), 114–115. Chandler summarizes Von Allesch's work on preference (87–91), and on color expression (103–114). Another American supporter of von Allesch's conclusions was Robert S. Woodworth of Columbia; see his *Experimental Psychology* (New York, 1938), 382–384.

54 Phillips 1982, 288.

55 Seldes 1978, 51; but see in Chave 1989, 213 n. 8, that President Nathan Pusey later gave a rather more secular gloss to this explanation.

56 Chave 1989, 180.

57 Ashton in Chave 1989, 123.

58 Nietzsche 1993 ed., 46. The fullest discussion of Rothko as a Nietzschean is in Ashton 1983, 51–57, although the emphasis here—in the context of the surrealist period—is on Rothko's adoption of Nietzsche's balance of the Apollonian and the Dionysian. See also Breslin 1993, 357–359, 499. Chave 1989, 178–180, on the other hand, sees in the often stark light/dark oppositions in the mature paintings a continuation of the Apollonian/Dionysian duality.

59 Nietzsche 1993 ed., 104.

60 Breslin 1993, 359.

61 Nietzsche 1993 ed., 98.

62 Breslin 1993, 398.

63 Compton in exh. cat. Liverpool 1988, 14.

64 Ashton 1983, 115, 147, stresses Rothko's interest in the Boscoreale set, but without analyzing it. Vincent J. Bruno, "Mark Rothko and the Second Style: The Art of the Color Field in Roman Murals," in R. T. Scott and A. R. Scott, eds., *Eius Virtutis Studiosi: Classical and Postclassical Studies in Memory of Frank Edward Brown*, Studies in the History of Art, Symposium Papers 23, National Gallery of Art (Washington, DC, 1993), 251, emphasizes the "accurate intuitive reading" of the Villa of Mysteries murals. In 1961 Rothko planned to visit Roman monuments with Peter von Blanckenhagen, an expert on ancient painting at the Metropolitan Museum, but he was too ill to travel to Europe.

65 For red as a divine color in antiquity see Gage 1993, 26.

for, according to Nietzsche, "Apollo finally speaks the language of Dionysus, and thus is attained the supreme goal of tragedy and of art in general."[59]

In a text drafted (but not published) in the early 1950s, Rothko spoke of his close relationship to Nietzsche's ideas and argued that the modern artist, unlike the Greeks, could only show Apollo and Dionysus at "the moment of their greatest antagonism," and the result was "intensity…the fire of this terrible constraint."[60] His occasional use of the maximal complementary contrasts of red and green may be particularly expressive of this antagonism, and they may indeed evoke a passage in *The Birth of Tragedy* where Nietzsche conjured up the impact of Dionysian magic on the desert of modern culture:

A storm seizes everything decrepit, rotten, broken, stunted; shrouds it in a whirling red cloud of dust and carries it into the air like a vulture. In vain confusion we seek for all that has vanished, for what we see has risen as if from beneath the earth into the gold light, so full and green, so luxuriantly alive, immeasurable and filled with yearning. Tragedy sits in sublime rapture amidst this abundance of life, suffering and delight, listening to a far-off, melancholy song which tells of the Mothers of Being, whose names are Delusion, Will, Woe.[61]

Here too destructive, cleansing red stands at the negative pole of experience.

Nietzsche's book took Rothko's thoughts back to the ancient world, but it was to be many years before he engaged with ancient painting. On his second trip to Europe, in 1959, he visited Pompeii and sensed a deep affinity between his own project for the Seagram Building and the murals of the Villa of Mysteries: "the same broad expanses of somber color."[62] "Somber" seems a surprising epithet for the rather vivid orange red ground of the paintings in Pompeii, and the word may have misled at least one modern commentator into thinking that these works were preoccupied with death.[63] The Mysteries, however, are those of Dionysus and include musicians, initiation and sacrifice, and an orgiastic dance. They may indeed throw light on the deep but occasionally also fiery reds that kindle unexpectedly in the Seagram series. Rothko had long known the more decorative Second Style murals from Boscoreale in the Metropolitan Museum in New York, which also have red grounds; but it was surely the Dionysian theme at Pompeii that most impressed him at this point.[64]

Rothko's recourse to red—the most divine of ancient colors in the West[65]—however ambivalent his attitude, was at least consonant with a well-established notion of the symbolic value of individual colors. But his paintings were not usually composed of individual colors, and for groups of colors, outside the limited realm of flags and heraldry, there are no iconographical rules at all. How can groups of colors have meaning? Certainly, as

in the case of complementary contrasts, some color systems have reflected or even generated ideas of the opposition and affiliation of hues, usually identified in a circular scheme. Color circles had been developed in the eighteenth century, largely in the interest of plotting harmonic combinations. But harmony implies dissonance, and Nietzsche, very much under the sway of Wagner at this stage in his career, placed musical dissonance at the center of Dionysian art: "The pleasure produced by the tragic myth has the same origin as the pleasurable perception of dissonance in music. The Dionysiac, with its primal pleasure experienced even in pain, is the common womb of music and the tragic myth."[66] According to Dominique de Menil, Rothko said of the Houston series that "he would have liked to use more beguiling colors. He tried…but he had to renounce those pleasurable options."[67]

Rothko's reference, also in connection with Houston, to the mosaic decoration of the Cathedral at Torcello, with its "Last Judgement at the door and the inviting and glorious apse,"[68] must be one of his very few references to early Christian art. And since the twelfth-century mosaics on the west wall locate the sobering episodes of the Last Day within rectangles that are sometimes brightly colored in reds and blues and sometimes black (fig. 4), we may well ask whether this sort of art may offer further hints toward the interpretation of Rothko's color. The artist's first visit to Torcello was not before 1950,[69] but there is reason to believe that he had some interest in the early medieval art to which he had had access for many years in New York, and that Clement Greenberg's linking of Rothko's work of the 1950s with the Byzantine move "toward a vision of full color in which the role of light and dark contrast was radically diminished"[70] points to a far from casual analogy.

66 Nietzsche 1993 ed., 115.

67 Cited in Chave 1989, 196.

68 Chave 1989, 180.

69 Rothko spent eight or nine days in Venice that year (Breslin 1993, 283).

70 Clement Greenberg, "Byzantine Parallels" [1958], reprinted in *Art and Culture* (Boston, 1961), 169.

FIG. 4/DETAIL OF THE LAST JUDGMENT MOSAICS FROM THE CATHEDRAL OF TORCELLO.

Some of the most impressive documents of medieval color abstraction are to be found among the more than twenty illuminated manuscripts illustrating the eighth-century commentary on the Apocalypse by the Spanish priest Beatus. One preeminent authority on these books was Meyer Schapiro, who wrote compellingly of the tenth-century versions, calling them "an art of color bound to a visionary text. On great framed fields divided into bands of contrasted color are set the equally vivid figures who enact the Apocalypse of John with its grandiose revelations of last things: the splendors

FIG. 5/FOLIO FROM THE BEATUS
OF LIEBANA COMMENTARY
ON THE APOCALYPSE, *THE GREAT
WHORE OF BABYLON*, C. 950,
THE PIERPONT MORGAN LIBRARY,
NEW YORK, M.644, FOL. 194V.

FIG. 6/MARK ROTHKO,
UNTITLED, 1953, OIL ON CANVAS,
166.1 X 143.8 (65 ⅜ X 56 ⅝),
MR. AND MRS. GILBERT H. KINNEY.
SEE ALSO CAT. 60.

71 Meyer Schapiro, "The Beatus
Apocalypse of Gerona" [1963],
reprinted in *Late Antique,
Early Christian, and Mediae-
val Art: Selected Papers* (New
York, 1979), 322.

72 Schapiro 1979, 326.

73 Ashton 1983, 34. Ashton sur-
mises that the lecture was
much discussed at meetings
of the Ten, of which Rothko
was then secretary.

74 Breslin 1993, 155. Schapiro's
close association with New
York artists was especially im-
portant for Robert Mother-
well; see Sidney Simon, "Con-
cerning the Beginnings of
the New York School, 1939–
1943" [1967], reprinted in
Shapiro and Shapiro 1990, 34.

of heaven and earth, the coming end of the world, the wars of angels and demons, the trumpetings and scourges, the saved and the damned, the cosmic catastrophes and the final Salvation."[71] Two of the surviving Beatus manuscripts are in the Pierpont Morgan Library, and Schapiro noted that he had looked at the earlier one with painters and had "observed with satisfaction their strong response to this art."[72] He detected its effect in the New York work of Fernand Léger in the early 1940s, but Léger had already been in the city for some years, lecturing on abstraction at the Museum of Modern Art in 1935, when he argued that "color has a reality in itself, a life of its own." Rothko's close friend Joseph Solman persuaded *Art Front,* of whose editorial board he was a leading member, to publish the lecture.[73] Schapiro was also close to the New York abstract expressionists in the early 1940s and, with Rothko, helped establish the Federation of Modern Painters and Sculptors in 1940 "to promote the welfare of free progressive artists working in America."[74] It seems entirely likely that Rothko was among the New York painters who looked at the Morgan's Beatus manuscripts with particular interest in these years, adapting their stacked colored bars as a background for his own figurations in his surrealist works and their highly saturated palette of reds and yellows, greens and purples, for his mature style (see figs. 5 and 6).[75] As in the case of the Pompeian frescoes, the crucial link is between strong contrasts of color and a significant iconographical program.

SEEING ROTHKO

Although Rothko's approach to color and subject has something in common with, for example, Barnett Newman's, perhaps his closest affinities among contemporary artists were with the work of Ad Reinhardt, whose adoption of

near-monochromatic color groupings from the late 1940s and exclusive concentration on symmetrical composition from around 1950 have clear parallels in Rothko's work. Yet Rothko, concerned in the context of the hard-edged Houston murals with the finite as well as the infinite, was unhappy with what he saw as Reinhardt's mysticism: "...his paintings are immaterial. Mine are *here.* Materially. The surfaces, the work of the brush, and so on. His are untouchable."[76] Rothko was alluding to the impeccable surfaces of Reinhardt's late paintings, which had sometimes been seriously damaged by exposure to touching in public displays. In the mid-1960s the black paintings were roped off at one exhibition to keep the spectators at least three feet away from them,[77] and although the canvases of this time are uniformly five-feet square, this gave the public an overview that was anathema to Rothko's own conception of intimacy.

The modern painting to which Rothko felt most deeply attached was Matisse's *Red Studio* (fig. 7), which he recalled studying every day for months following its acquisition by the Museum of Modern Art in 1949, until he saw it as the source of all his painting. When you looked at it, he said, "you became that color, you became totally saturated with it"; it was like music.[78] This sense of immersion in color is something Rothko referred to repeatedly in connection with his own painting. In 1954 he asked Katharine Kuh to hang his largest pictures at a Chicago exhibition "so that they must be first encountered at close quarters, so that the first experience is to be within the picture." They were also to be hung low, "for that is the way they were painted."[79] He

75 For good color reproductions see John Williams, *Early Spanish Manuscript Illumination* (London, 1977), pls. 12–22. There is an even more Rothko-like treatment of banded color, this time with soft contours, in the image of Chaos in a twelfth-century Byzantine Octateuch in the Vatican Library (Vat. Gr. 746 fol. 19v); see J. Lassus, "La Création du monde dans les Octateuques byzantins du XIIe siècle," *Monuments Piot* 62 (1979), pl. IIA; see also the Newman-like division of light and darkness on fol. 20v (pl. IIB). But there is no reason to think that this manuscript was known to New York artists.

FIG. 7 / HENRI MATISSE, *THE RED STUDIO,* 1911, OIL ON CANVAS, 181 X 219.1 (71 ¼ X 86 ¼), THE MUSEUM OF MODERN ART, NEW YORK, MRS. SIMON GUGGENHEIM FUND.

76 Ashton 1983, 179. Reinhardt of course himself had problems with his reputation for being a mystic; see Yve-Alain Bois, "The Limit of Almost" in *Ad Reinhardt* [exh. cat., Museum of Contemporary Art] (Los Angeles, 1991), 28–29. Yet he was far readier than Rothko to adduce symbolic connotations for the trio of colors he used after 1950: *red*—fire, blood, hot riot, revolution, passion, energy, fear, jealousy, deceit; *blue*—"color of villains, ghosts, and fiends," hope, heaven, sky; *black*—heroism, patriotism, criminal death, doom, darkness, and in many cultures morbidity, despair, negation, evil; see Margit Rowell, *Ad Reinhardt and Color* [exh. cat., Solomon R. Guggenheim Museum] (New York, 1980), 24.

77 Rose 1975, 84.

78 Ashton 1983, 187; Breslin 1993, 283. For Matisse's painting see Elderfield 1978, 86–89.

79 Chave 1989, 199–200 n. 12.

80 Breslin 1993, 660 n. 34.

81 Cohn 1988, 15.

82 Ashton 1983, 191.

83 Katz 1935, 113.

84 Robert C. Hobbs and Gail Levin, *Abstract Expressionism: The Formative Years* (New York, 1981), 116.

85 Chave 1989, 183, 213 n. 15.

86 Bryan Robertson [1970], cited in Breslin 1993, 412. See also Hobbs and Levin 1981, 26 n. 28, on Rothko's insistence (with Newman and Reinhardt) on dim lighting at a Sidney Janis show.

told his audience at the Pratt Institute that "small pictures since the Renaissance are like novels; large pictures are like dramas in which one participates in a direct way."[80] On one occasion about this time Rothko recommended a viewing distance of as little as eighteen inches.[81] The painter and critic Andrew Forge has characterized the psychological effect of such intimate viewing conditions admirably precisely: "a painting sufficiently large so that when you stand close, the edges are grayed off to one's peripheral vision, takes on a presence in its surface that renders internal relationships irrelevant. The moment color and scale begin a dialogue, a close viewing range is like opening a door into an internal realm."[82] It was an effect of total-field *(Ganzfeld)* viewing, which had also been studied by Gestalt psychologists, who had found that it gave the surface an apparent increase in brightness of many hundred times over the same tone on a small field.[83]

Rothko was fastidious about presenting his works at a distance that would increase their perceived luminosity, and of course the level of ambient light was also fully implicated in this endeavor. Robert Motherwell reported that Rothko worked in the early morning under intense lights arranged like stage lights,[84] and in the early 1950s the lighter paintings were to be exhibited under the brightest possible gallery lights.[85] But during the course of that decade, as the canvases themselves often became lower in key, Rothko adopted a much more subdued level of lighting, "normal" lighting as he called it in a memorandum to the director of the Whitechapel Gallery in London in 1961. The director, Bryan Robertson, described the effect when, late on a winter afternoon, the painter had the gallery lights turned off: "suddenly Rothko's color made its own light: the effect, once the retina had adjusted itself, was unforgettable, smouldering and blazing and glowing softly from the walls."[86] I well remember my own first experience of seeing Rothko's work, in 1970, passing from the blinding summer sunlight of California into the cool, dim interior of the Pasadena Art Museum and joining the meditative spectators cross-legged on the floor before his paintings. The adaptation of the eye to twilight vision, from cones to rods, has, like peripheral vision, the effect of transforming the appearance of colors from the surface to the film mode.[87] And although Rothko's unification of tone was never as radical as Reinhardt's, whose demands on the spectator became increasingly imperious,[88] Rothko, whether intuitively or not, was clearly determined to secure all the unusual viewing conditions necessary to create the appearance of film.

The same went for the display of his works in series. At his 1961 New York retrospective, Rothko had been impressed by the effect of grouping together the light pictures—yellow and orange—out of chronological sequence, and he hoped that a similar arrangement could be found when the

show proceeded to London, with the mural panels in a separate room. [89] When, toward the end of 1965, the Tate Gallery began to negotiate with Rothko for a group of his works, he proposed that the whole of the Whitechapel show (which he said he had already offered to the Museum of Modern Art without a response) could be available for their acquisition, although they had agreed only on a group of Seagram murals by the time of the painter's death. [90] It was in 1965–1966 that the Museum of Modern Art was preparing for and showing its first-ever exhibition of an old master, Lawrence Gowing's *Turner: Imagination and Reality,* which drew very largely on late and unfinished paintings and watercolors from Turner's bequest to the British nation, now housed in the Tate Gallery. Rothko was quick to see a parallel with his own art and, according to the Tate's director, Sir Norman Reid, "responded warmly to the possibility of his work being in the same building as Turner's paintings." [91]

In his catalogue to the Turner show Gowing drew attention to the English painter's wish to have his work shown as a whole: "Turner rarely spoke of his own works. Ruskin described him as 'generally, respecting the movements of his own mind, as silent as a granite crest.' Almost the only thing he said about them was, 'keep them together.' 'What is the use of them but together?' It was in the early eighteen-thirties that Turner made a will leaving the whole contents of his studio to the public, with a gallery to contain them. His consciousness of his role as an artist guided him in everything." [92] By his choice of loan objects, as well as in his commentary, Gowing underlined Turner's links with modern painting and tellingly quoted a remark by Motherwell about the "tragic quality in Turner's art, which painting seeks again now." [93] It is no surprise that Rothko joked at the opening in 1966 that "that chap Turner learned a lot from me." [94]

But of course the urge to show work in carefully differentiated series, like the urge to adjust the levels of lighting differentially, and, most of all perhaps, the urge to bring the spectator close in until she or he is no longer "in command"—all of these expectations run up against modern museum requirements for security and display. It is hard to escape the conclusion that, at least outside the infrequent anthologies of Rothko's work such as the present exhibition, his color has, since his death, and more than that of most of his contemporaries, taken on a life of its own.

87 Katz 1935, 178–180, 203, 211–212.

88 It has been estimated that the viewing time for each of Reinhardt's "black" paintings increased from a few minutes to half an hour between 1958 and 1967; see Bois in exh. cat. Los Angeles 1991, 28.

89 Exh. cat. London 1987, 88.

90 The fullest account of these transactions is in Breslin 1993, 513–517.

91 Breslin 1993, 513.

92 Lawrence Gowing, *Turner: Imagination and Reality* [exh. cat., Museum of Modern Art] (New York, 1966), 31.

93 Gowing 1966, 53.

94 Breslin 1993, 666 n. 1. Sir Norman Reid recalled that the remark was made in reference to "one of the most abstract sky and sea watercolors," possibly the most Rothko-like of the series, *The Pink Sky,* c. 1820s (Tate Gallery, London), to which Gowing had devoted a full-page color reproduction in his exh. cat. New York 1966, 29.

Rothko's Dark Paintings: Tragedy and Void

The tragic has lurked in the vicinity of Rothko's work since the early 1940s. Dark paintings appear intermittently since about 1949 and receive an impetus with the Seagram paintings of 1958–1959, then in the middle to late 1960s, stimulated by the Rothko Chapel commission in Houston, they become dominant. Unlike the bright paintings, which have an expansive, even radiant diffusion, the dark paintings are contracted, meditative, somber. The signature colors in the work up to and including the chapel pictures are dark browns, maroons, and blood reds in which the typical rectangles engage in slow transactions, consistent with the delayed perception induced by the general darkness. Perhaps it is this property that allows them to be read in terms of slow rhythms, pauses, and lulls, with intimations of ritual.

There is a point—and it has arrived in Rothko's case—when an artist's intellectual history begins to invade the perception of the work. Rothko, whose view of himself was as one engaged in a cultural enterprise of the highest seriousness, chose his reading—and his historical companions—accordingly. His respect for high culture may have been implanted, indeed stamped in him from childhood.

He remembered the family sitting shivah for Tolstoy (presumably on the anniversary of his death).[1] He read Dostoevsky, Kierkegaard, and, with profound results, Nietzsche,[2] whose *Birth of Tragedy* deeply influenced the artist, both by its content and, we suggest, by Nietzsche's modes of thinking: daring, contradictory, paradoxical in mood, original. That cast of mind may

1 Mark Rothko in conversation with Brian O'Doherty.

2 See Anna C. Chave, *Mark Rothko: Subjects in Abstraction* (New Haven and London, 1989), 207 n. 30, where the suggestion is made that Rothko "may first have read Nietzsche at Yale, as a misspelled mention of the philosopher's name appeared in the 28 April 1923 issue of the Pest." See also James E. B. Breslin, *Mark Rothko: A Biography* (Chicago and London, 1993), 131, 174. The general consensus is that Rothko read Nietzsche's *Birth of Tragedy* in the late 1930s.

3 Mark Rothko in conversation with Barbara Novak. Rothko's concern to raise art to what he conceived of as the higher level of music and poetry thus not only engages the long-standing issue of *ut pictura poesis* but seems in its exalted ambition to echo the subject hierarchy so explicitly endorsed by Sir Joshua Reynolds in his late eighteenth-century *Discourses* to the Royal Academy in London. The notion of the Grand Style pervades Rothko's work, and in this sense his art could be said to be a form of abstract History Painting. See Sir Joshua Reynolds, *Fifteen Discourses* (London, 1928), 37: "it is not the eye, it is the mind, which the painter of genius desires to address; nor will he waste a moment upon those smaller objects, which only serve to catch the sense, to divide the attention, and to counteract his great design of speaking to the heart. This is the ambition which I wish to excite in your mind; and the object I have had in my view, throughout this discourse, is that one great idea, which gives to painting its true dignity, which entitles it to the name of a liberal art, and ranks it as a sister of poetry."

4 See Friedrich Nietzsche, *The Birth of Tragedy and the Genealogy of Morals,* trans. Francis Golffing (Garden City, NY, 1956), 47; also 98, where Nietzsche, speaking of the universality of music, contends that "in this respect it resembles geometrical figures and numbers, which are the universal forms of all possible objects of experience and applicable to them all *a priori,* and yet are not abstract but perceptible and thoroughly determinate."

have appealed to the orthodoxies of Rothko's childhood. Indeed Rothko's resolution of contradictions—the instability of which he felt intensely—may also be a shadow of such paradoxical thinkers as the second-century sage Rabbi Ishmael, some of whose exegeses at times seem like program notes to Rothko's work.

Rothko's tragic sense, which manifested itself as a degree of pathos in his everyday life, had little traffic with the distancing ironies of modernism. The grand irony of existence and its vicissitudes excluded trivialities he felt were beneath one engaged in a program of such high moral seriousness. His ambitions for visual art went beyond its conventional limits. He desired, he said, to raise painting to the "level of poignancy of music and poetry."[3] In Nietzsche's view—following Schopenhauer—music had a privileged status, inaccessible to the "illusions" of visual art. Tragedy, says Nietzsche, "arose out of the tragic chorus."[4] Rothko's musical tastes are well documented: his devotion to Mozart, his respect for Wagner,[5] his partiality to the music of his friend Morton Feldman.[6] Rothko's distrust of language may owe something to Nietzsche's comment that "language, the organ and symbol of appearance, can never succeed in bringing the innermost core of music to the surface."[7] "The Dionysiac musician," Nietzsche says elsewhere, "himself imageless, is nothing but original pain and reverberation of the image. Out of this mystical process of un-selving, the poet's spirit feels a whole world of images and similitudes arise, which are quite different in hue, causality, and pace from the images of the sculptor or narrative poet."[8] The Apollonian, in Nietzsche's definition, is primarily the province of the painter and sculptor; the Dionysian, that of the musician. The Apollonian deals with illusion, the Dionysian with the energies of darkness and formlessness. Visual art that does not feel the destabilizing pressures of the Dionysian, in Nietzsche's—and Rothko's—opinion, fails. Nietzsche repeatedly speaks of Apollonian classicism retaining vitality only to the degree that it negotiates with and experiences the disruptive pressures of the Dionysian, or, as Rothko called it, "the wild." The mutual interaction, qualification, shading, and impersonation of these two components are the dialectic to which Rothko submitted his art.

The language Nietzsche uses to characterize the discourse of the Apollonian and Dionysian may have had a seductive power for Rothko: "illusion," "hallucinations," "dream," "veils," "mirror," "reflections," "essence and appearance," "the *sublime,* which subjugates terror by means of art." The character of the hero is "at bottom no more than a luminous shape projected onto a dark wall, that is to say, *appearance* through and through."[9] Explicit in the philosopher's writing is a recurrent desire to make contact with "the depth of being," an egoless transcendence: The "'I' is not that of the actual waking man, but the 'I' dwelling, truly and eternally, in the ground of being."[10]

Nietzsche brings the idea to its logical conclusion: "Music alone allows us to understand the delight felt at the annihilation of the individual. Each single instance of such annihilation will clarify for us the abiding phenomenon of Dionysiac art, which expresses the omnipotent will behind individuation, eternal life continuing beyond all appearance and in spite of destruction."[11] Aspiring to the rejection of personal individuation, Rothko denied that the work was made by his secular, everyday self, and he referred to the "not-self" that generated it.[12] Throughout, Nietzsche acknowledges "the ghastly absurdity of existence," "the horror of individual existence," and "the somber wisdom of suffering which always accompanies artistic talent."[13] These harsh views contributed significantly to the development of Rothko's world view, and they descend in various formulations into his pronouncements.

Nietzsche's polemic in *The Birth of Tragedy* coached the persona that Rothko adapted, the fierce, complex, and uncomfortable presence that guarded his art and imposed on him the most wearing vigilance. The dark powers of the Dionysian, as defined by Nietzsche, became a force in Rothko's daily life, and he spoke of "the way in which I could achieve the greatest intensity of the tragic irreconcilability of the basic violence which lies at the bottom of human existence and the daily life which must deal with it." Breslin, Rothko's biographer, had access to the pages in the Rothko papers in which he "attempted to compose an essay or talk on his debt to Nietzsche." "I found in this fable," Rothko wrote, "the poetic reinforcement for what I inevitably knew was my inevitable course: that the poignancy of art in my life lay in its Dionysian content, and that the nobility, the largeness and exaltation are hollow pillars, not to be trusted, unless they have as their core, unless they are filled to the point of bulging, by the wild."[14]

The single-minded energy with which Rothko attempted to realize the tragic idea may be seen as a relentless testing of the conventional boundaries of the artistic enterprise. For this aim to be successful, Rothko needed something more than the formalist criticism that, to his satisfaction, was effectively applied to his work in two pioneering reviews (by Max Kozloff and Robert Goldwater).[15] Rothko needed an audience that would have some acquaintance with the high stakes for which he was playing, that could see more than "art." He thus wanted to invent the tragic sign and an audience for it—a grand folly, perhaps, but one of which he was fully conscious.[16] He was, in the dark paintings, a tragedian without a tragic audience, the lack of which caused him much anxiety: hence his prescriptions about how the work should be shown and how it should avoid unsympathetic contexts (including a Whitney "Annual," a restaurant, and unknowing audiences).[17]

The signs that would confirm that his aims had been realized were missing. He placed an inordinate amount of importance on the value of fol-

5 Novak: In 1967, when Rothko, Ron Kitaj, Brian O'Doherty, and I were teaching a summer quarter at Berkeley at Peter Selz' invitation, Rothko happened in on my lecture on the luminists. I was surprised when he did not seem to respond to their transcendent luminosity. But in 1969, when my *American Painting of the Nineteenth Century* was published, he phoned to indicate his approval (very rare for him) of my remarks relating him to Albert Ryder. I had not realized, when writing of the two together, that as one of the founders of the Ten, Rothko could be counted as an admirer of Ryder. Some time later I attended a performance of Wagner's *Flying Dutchman* with Rothko. He loved the opera (as had Ryder) and the sets, which seemed to derive from Ryder's famous painting.

6 Feldman in turn often compared Rothko's Chapel paintings to Beethoven's Ninth Symphony (conversations with Novak and O'Doherty). Feldman's composition for viola, chorus, and percussion, commissioned by the Menil Foundation, was performed at the chapel in memory of Rothko on 9 April 1972.

7 Nietzsche 1956 ed., 46.

8 Nietzsche 1956 ed., 39.

9 Nietzsche 1956 ed., 59.

10 Nietzsche 1956 ed., 38–39.

11 Nietzsche 1956 ed., 101–102.

12 See David Anfam, "Dark Illumination: The Context of the Rothko Chapel," in *Mark Rothko: The Chapel Commission* [exh. cat., The Menil Collection, Houston] (Austin, 1996), 8.

13 Nietzsche 1956 ed., 51, 102, 32.

14 Quoted in Breslin 1993, 358, 357.

15 See Max Kozloff, "Mark Rothko's New Retrospective," *Art Journal* 20, no. 3 (Spring 1961), 148–149; and Robert Goldwater, "Reflections on the Rothko Exhibition," *Arts Magazine* (March 1961), 42–45.

16 Rothko reported to O'Doherty that he had said to a collector: "Now you have to pay for the folly of wanting it, just as I had to pay for the folly of making it." See Brian O'Doherty, *American Masters: The Voice and the Myth* (1973; repr. New York, 1988), 146.

17 See *Mark Rothko, 1903–1970* [exh. cat., Tate Gallery] (London, 1987), 85–86.

18 Entering an exhibition of contemporary abstract art, Rothko gestured expansively and claimed to Novak: "These are all my children."

FIG. 1/MARK ROTHKO IN HIS LONG ISLAND STUDIO, SUMMER 1964, PHOTOGRAPH BY HANS NAMUTH.

lowers, which in his case were virtually absent.[18] In addition, Rothko, like Joseph Cornell, spoke to sophisticated sensitivities that he felt were being phased out of the modern world. The time—the 1960s—did nothing to lessen such anxieties; nor did the visit Rothko made as a resident artist to the University of California, Berkeley, in 1967, when he was seen by most of the students as an anachronism who had little to teach them.

Rothko contemplating his work has become one of the iconic tropes of his generation.[19] His practice recalls a scene described by Goethe in his *Theory of Colours:*

An excellent artist…had built himself a painting-room for large as well as small works. …The variations of the favourable and unfavourable light had their periods during the day. Early in the morning the light appeared most unpleasantly grey and unsatisfactory; it became better, till at last, about an hour before noon, the objects had acquired a totally different appearance. Everything presented itself to the eye of the artist in its greatest perfection, as he would most wish to transfer it to canvas. In the afternoon, this beautiful appearance vanished—the light became worse, even in the brightest day, without any change having taken place in the atmosphere.[20]

Most artists scrutinize their work to make sure it is in the vicinity of their intention. Rothko, however, emphasized this process to the point of self-harassment. When he was seated before the work (fig. 1), subjecting it to his habitual hypnotic stare, he studied how the waxing and waning light

veiled and unveiled incident, content, and moods that appeared like so many chimeras. He gave the impression, as one watched with him, that the painting, particularly if it were a dark painting, was unknowable, and unknowable precisely because he could not foresee or experience the infinite complexions of the painting as it equivocated in different lights. Rothko's concentration at such times filled every part of the silent studio. The intensity of his gaze shaped itself into a form of listening and vice versa.

There was an element of necromancy to Rothko's comments on the process of making and observing: how the work sprang into life at the last moment; how an eighth of an inch at the edge of a vast canvas made a critical difference;[21] how a change in the light would deliver an epiphany. Forced to

join his own audience as another witness to what he had done, he resided in a state of uncertainty, anxiety, and hypersensitivity. At such times it seemed as if Nietzsche's and Kierkegaard's ideas and rhetoric had infused his person. This bundle of contradictions, yearning, poignancy, and authoritarianism made life difficult for him and for his friends. With the dark paintings, including the bipartite penultimate works, he required some reassuring returns from an audience that he considered to be at best unreliable, and at worst missing.

The musical connotations of color have a long history, and color as phenomenon, as symbol, as light, as physics, as language and as unit of perceptual discourse, as psychological shorthand (in terms of mood) has a formidable literature. The abstract nature of color may rhyme with the abstract nature of geometry, together constituting the basis of Rothko's vocabulary. Tradition has sanctioned the use of color in music criticism to describe varieties of shading, tonality, and mood. Reciprocally, music has offered, less profitably, its vocabulary to describe color in painting. Appropriately for one to whom music was the supreme art, Rothko viewed color as capable of expressing a comparable profusion of moods in painting. Color was never just color, but a mood in potency, an expressive energy waiting to be deployed in new situations. It is not surprising that Rothko was unenthusiastic about color-field painting and went so far as to say he was not a colorist. [22] Color, however, brought him to the threshold of the many moods that he pursued, by their nature elusive and fugitive, often recognized *before* being categorized by language. Is it too fanciful to say that in the delay between the recognition of a mood and its verbal translation Rothko's most successful work is poised?

Every color has a history, and such histories are inflected variously in different cultures. The semiotics of color comprise an interesting playground of signifiers in which contradictions and slippage occur in the realm of the signified. Colors in each culture are surrounded by an echo chamber of associations. Rothko's darker works repeat several variations on a maroon that became identified with a dramatic or tragic ambition. This color was not specifically mentioned by Nietzsche in his mobilization of Greek statuary out of Winckelmann's white paralysis. But its similarity to the color of the grape is appropriately Dionysian. For some this wine color has assumed ceremonial and ritualistic associations in our culture, though the time for such ceremony seems to be disappearing, as indeed it disappeared from the black and gray paintings that announced a decisive shift in Rothko's thinking. Red/maroon/brown and black with gray constitute the dominant colors of his later work.

Rothko marked 1957 as the beginning of his long devotion to dark colors. But as has been pointed out, there was previous, intermittent use of

19 In the last year of Rothko's life we spent many hours in the crepuscular half-darkness of the studio on East 69th Street looking at the black on gray pictures with Rothko and Rita Reinhardt, to be followed by dinner, either at a French restaurant or a fish restaurant around the corner. Through those long spells of looking, accompanied by long silences, our opinions were solicited with a deceptive humility. Newly evicted from the paintings, Rothko shared the spectator's puzzlement: What are these about? How did they come to be? Why did I make them? What, if anything, do they mean?

20 See Johann Wolfgang von Goethe, *Theory of Colours*, trans. Charles L. Eastlake, intro. by Deanne B. Judd (1840; repr. Cambridge, MA, 1970), 396–397.

21 Rothko in conversation with Novak.

22 See Goldwater 1961, 43. Again like Sir Joshua Reynolds, Rothko disdained "ornamental" or "decorative" color.

23 See Anfam in exh. cat. Houston 1996, 7.

black.[23] One remarkable painting, *Untitled* (The Metropolitan Museum of Art), was executed in 1949, when Rothko was searching for a format that would bear the weight of an encyclopedia of moods. Two sloppily edged rectangles (a dark charcoal above, advanced almost to the edge of the canvas; a blackish purple below) occlude a red field, squeezing between them a grayish white that escapes occasionally to edge the rectangles, while defining a spectral zone between them. The prophetic nature of this work—the standard reductive format established, a new and darker mood explored, if somewhat imprecisely—is borne out by the Seagram paintings of 1958–1959. At times in work from the earlier period a black rectangle in a field of lyric color so forcibly announces itself that it induces a kind of shock. The paradoxes peculiar to this artist assert themselves. His black seems opaque, comes out, becomes a void, is penetrable, but never becomes atmosphere—or so it seems, for reporting on one's perceptual experience of Rothko's work, it is prudent to allow other eyewitnesses their valid and often contrary testimony. Between the 1949 painting and the Seagram paintings, rectangles of black and darkened colors are fitted into various roles without being called to strenuous tragic duties (see *Black over Reds,* 1957; cat. 74). A deeper concern does make a periodic appearance (see *Earth and Green,* 1955, Museum Ludwig, Cologne) in which colors are sunk into grounds of almost equal value. The result is a somewhat delayed perception, as with the work of Rothko's friend Ad Reinhardt. At times different rectangles disclose themselves at different rates of perception (see *Untitled,* 1955, estate no. 5161). In these works, in contrast to the immediate, almost cheerful presentation of lyric afflatus in the brightly colored paintings, there are intimations of a turning inward, a secrecy and privacy, mediated by a double and contrary movement of seduction and rejection.

This voyage inward, perilously sustained by increasingly reduced means, would become a theme, perhaps *the* theme, of Rothko's later career. It found its first major contemplative station with the Seagram paintings (see fig. 2). Secret, moody, tragic, these paintings purchase their profundities with relatively scanty means—means that offer their own quota of contradictions and self-cancelling ambiguities. What is certain is that they are very ambitious paintings.

The titles of these paintings now in the Tate Gallery, such as "Black on Maroon" and "Red on Maroon," are surely inadequate to indicate Rothko's first attempt to accommodate his art to a controlled environment, a "place" where his works could reflect, augment, and support the ensemble's theme. By what bizarre rationalization Rothko initially agreed that a restaurant would be an appropriate context for these paintings remains puzzling. Although Rothko had once rather unwisely allowed as how the shapes in his paintings were actors in a drama, the drama of these works, if present, is fru-

FIG. 2 / MARK ROTHKO, *MURAL, SECTION 3 [BLACK ON MAROON],* 1959, OIL ON CANVAS, 266.7 X 457.2 (105 X 180), TATE GALLERY, LONDON.

gal, tentative, and approaches the contemplative fallacy: at a certain threshold of perception, virtually any blankness (or blackness), given an appropriately solemn context, may return to the watcher self-generated illusions that he or she mistakes for profundities. Both of the artist's major environmental projects—the Seagram murals and the Rothko Chapel in Houston—are liable to this fallacy. This is a function of effect over evidence. It betrays a change in Rothko's thinking about the relation of viewer and artwork.

The Seagram paintings launch the viewer on a sea of paint stretched laterally over vast canvases, searching in the darkness for whatever incident may be offered. The degree of process is minimized, and in favorable lights these works have an apparitional quality. They are certainly impressive. The dominant forms are pairs of lighter hue on the dark ground. Some contain a rectangle; some are horizontal, some vertical. The forms do not have the same authority, intimacy, and power of those in Rothko's previous easel paintings. His most successful works of around this time are those that follow the earlier format, including an almost completely dark work painted in 1964 (*No. 5,* estate no. 5013.60).

The issue of effect over evidence is crucial in discussing the Seagram and chapel paintings. Rothko's easel paintings may suggest to the viewer a vision of the artist intimately at work on a canvas scaled to his dilemmas. The easel paintings generally maintain a connection between what was painted and the response it provokes, a connection mediated by carefully produced quotas of atmosphere, opacity, color, and stroke. Rothko's two major commissions necessitated his covering enormous canvases—a physically difficult task—while maintaining some consistency of surface. The intimacies of the easel painting are hard to preserve in such a situation. This led to a disparity between what was painted and its effect. That is, these commissions involved a more theatrical solicitation of mood. They formally request a situation and

24 See Rothko's statement "The Romantics Were Prompted," *Possibilities* 1 (1947–1948): "the solitary figure could not raise its limbs in a single gesture that might indicate its concern with the fact of mortality and an unsatiable appetite for ubiquitous experience in face of this fact. Nor could the solitude be overcome.... It is really a matter of ending this silence and solitude, of breathing and stretching one's arms again." Reprinted in exh. cat. London 1987, 84.

25 In his lecture at the Pratt Institute in 1958 Rothko listed as one of the ingredients in his recipe for art: "A clear preoccupation with death. All art deals with intimations of mortality." Reprinted in exh. cat. London 1987, 87.

26 See Sheldon Nodelman, *The Rothko Chapel Paintings: Origins, Structure, Meaning* (Austin, 1997), 33.

27 Nodelman 1997, 305.

28 See Brian O'Doherty, "The Rothko Chapel," *Art in America* 61 (Jan.–Feb. 1973), 15–16: "At one point he [Rothko] said that he could have filled the [Chapel] commission with blank canvases 'and made it work'—a boast that would have exactly isolated the side of his art that had to do with legerdemain, that inspired charlatanry he could bring off through light alone."

site that will augment their effect, that is, they request a producer. Rothko was always eager to isolate his work in controlled environments, but the results have been ambiguous. Rothko was a great easel painter whose common sense about that tradition is rarely cited. He was clear-headed about how he wanted his paintings to be shown and seen; there was a degree of intelligent stage-managing in his instructions. His gifts as a producer dealing with an architectural environment are more in question.

The format of the Seagram canvases was imposed by the architecture of Philip Johnson's design for the Four Seasons restaurant: thus the long horizontal canvases. A case can be made that Rothko was not at his best in canvases that extended laterally. (The vertical canvas, his standard format, "answers" the viewer, returning his or her stare, and recalls Rothko's touching image of a figure stretching its arms before his paintings. [24]) The slim forms within the paintings seem tentative in their relation to edge and scale. And the oceans of painted space seem to switch between a hard surface and dense atmosphere without equivocating between them, which is where Rothko and the viewer usually harvested their rewards. In Rothko's easel paintings every casual, apparently careless stroke had a precise effect. This allowed for a well-considered degree of latitude or indeterminacy. Nothing of the precise geometries of Mondrian or Malevich would be recalled. In his large commissions there are considerable stretches of this indeterminacy. This contributes to the effect, and some might consider that effect to be unearned.

Despite such reservations, the Seagram paintings are indispensable to tracing not just Rothko's formal adventure but his spiritual quest. Seen in the context of this pursuit, the works have a tonic, indeed thrilling presence that overcomes any formal insufficiencies, for they represent Rothko's first sustained voyage into darkness, his most unguarded confrontation with the tragic construed as mortality. As it was for anchorites, the contemplation of life's unavoidable end was a stimulus to this artist. This shadow accompanied him, [25] and in his last years, when illness, stresses, aesthetic frustrations, and a sense of an uncaring world converged, it was never far from his mind. The tenebrous mood of the Tate paintings offers the first extended opportunity to ponder the implications of this shadow. While doing so, it is important to remember that Rothko approached the tragic on appropriately elevated terms. This, he had learned from Nietzsche, was to be achieved apart from any personal vicissitudes. Pursuing direct connections between his personal life and his tragic quest transgresses the integrity of that lifelong vision.

Among the reciprocal paradoxes of the Seagram paintings at the Tate is their resistance to a lax diffusion of effect. The sheer extension of the horizontal paintings circumscribes them with the contours of an idea. This conceptual counterforce would become insistent with the chapel project and

dominant in the last black paintings. A degree of distance is introduced into the contemplation of paintings, which detain the viewer as they slowly release their content. Rothko's perceptual strategies sought to usher the spectator into the penumbra of a powerful idea. That idea would, according to his intention, initiate an experience that drew on spiritually sanctioned habits of contemplation.

This is a fragile area to demarcate and maintain, and Rothko accepted what shelter an unbelieving age could provide. Thus he welcomed the opportunity to place his work in religious contexts, including the climactic Rothko Chapel site, made available to him through inspired patronage.[26] The chapel was to be a place of Roman Catholic worship; eventually it became an ecumenical symbol of religious desire. How much Rothko thought about the original New Testament context for his paintings remains uncertain. It does not seem to have bothered him.[27] The chapel paintings (1964–1967) are a testament to Rothko's faith in the power of art — "imageless" art — to meet, create, and transform an audience one by one, to place each person in contact with a tragic idea made urgent by the contemplation of death. Whatever the ecumenical services within, the chapel is about a dark God, more Old Testament than New. Here Rothko's obsession with the tragic experience has its most organized expression. The program, alternating single canvases with three sets of three and reasonably married to its space, is clear, ingenious, and rich (fig. 3). Problems of surface, lighting, occlusion, extension, and process return to qualify the perception of the grand scheme. The issue of effect versus evidence restates itself[28] in a light that tends to muffle the richness of the paintings seen as they were painted in the carriage house studio in New York. Yet in one unequivocal way the chapel is a complete success. Through an immense effort of will, Rothko moved the entire critical discourse into an

FIG. 3 / ROTHKO CHAPEL INSTAL-
LATION, HOUSTON. PHOTOGRAPH
1974.

evaluation of his enormous ambitions at a time when what might be called "secular formalism" dominated critical thinking and post-Christian secularism devalued religious belief. The chapel series is Rothko's most effective affirmation of his work as something beyond or outside art, and an attack on art that resided comfortably within that category. The magnitude of this ambition now attaches itself to the chapel paintings and is their context and content. That is their myth, nourished in the absence of mythic subjects.

The darkness of the chapel paintings marks a powerful watershed in Rothko's thinking. In painting them, he stretched himself—both physically and mentally—to the limit. In this ensemble he posed for himself questions (how to coerce the spectator while insisting on his/her freedom?) and issues (when does faith end and the void begin?) that typically superimposed formal ingenuities and philosophical yearnings. In doing so, he chose a future that he followed almost to the end. From the twilight of the Rothko Chapel, viewers emerge with different readings of their emotions. But all seem to have a sense of an important transaction, a communication—or communion—that has placed them in touch with large verities. Whatever the content of this experience, a long tradition associates the experience of darkness with complex and often paradoxical insights into the mortal estate.

The various moods the chapel paintings invoke—through changes of format, spacing, lulls, internal composition (or anti-composition), repaintings, degrees of opacity and atmosphere, absorption and reflection—occur within a narrow limit that invites them to be seen as a single, capitalized Mood. These paintings, moving into the precincts of "a humbling and all-fathering darkness,"[29] could be seen, particularly when still blinded by the aftereffects of the Texas light, as imaging Dionysian formlessness. As eyes become dark-adapted, the paintings overlay this blindness, first with the classical "answering" of formats on opposing walls, then with the perception of color, then with the sustained effort after whatever structures are discernible within. There is perhaps a sequential reading within the ensemble that in this context has a solemn, quasi-ritualistic echo. More to the point, this process involves two conflicting modes of Rothko's practice: disclosure and withdrawal, the dialectic of his construction of mystery through equivocation. This has stimulated valuable speculation on Rothko's practice of using black as "blocked vision,"[30] and of writing/painting as signifying "presence/absence."[31] Rothko's method in these works could also be seen as masking and unmasking, perhaps more consonant with the tragic idea. What is behind the tragic mask? Another mask, a fallible human presence—or nothing?

The tragic idea reveals itself as time is spent in the chapel. The outline of that idea is at times literal: in the format and ratios of each of the paintings, which insist on "not being murals" but large easel paintings; in the hard

edges of shapes within; in the random horizontal streaks in the end-wall triptych; in the affecting painterliness of the single facing canvas; in the tight arrangement of the two opposing triptychs, each with raised centerpieces; in the indeterminate lulls of the corner canvases. Each surface could be seen as a calm, featureless mask, which quietly removes itself to reveal intimations of process and strictly delineated darkness. The calm of the chapel, its contemplative aura, may be delusive, for calm, which accompanies ritual, also can accompany hysteria, and hysteria's smooth surfaces suppress violence. The notion of the calm of the chapel as a mask may be relevant if one finds within the chapel the hysteria implicit in ritual as it subsumes the anxieties and terrors of nothingness, death. The positive energies of the chapel pictures are countered by their opposing negatives. Visitors searching for an act of faith may suddenly find themselves in a solemn necropolis of ideas. Traces and whispers of process are overtaken by blankness/silence. Such psychological oppositions may be echoed in the symmetries by which all but two of the paintings are disposed. The most ambitious and intense reading of the chapel pictures is that proposed by Sheldon Nodelman. Implicit in his reading is an assumption about the nature and powers of abstract painting.

Since its inception modernist abstract painting has been asked, and has asked itself, several fundamental questions: How does it relate to "reality"? How effective is it as an expressive means? Is it capable of posing the issues and profundities that can be summoned through the manipulation of overt subject matter?[32] In the past two decades abstract painting has acquired a somewhat "period" appearance and status, its prestige as a privileged genre much reduced. As the last great "abstract" ensemble of paintings set in a specially designed physical and spiritual site, the Rothko Chapel, at modernism's end, makes a claim stated differently but no less vigorously by Malevich at modernism's beginning: that abstract painting—that is, painting with what Rothko paradoxically called "nothing but content"[33]—is capable of communicating, through its means, matters deeply relevant to the human estate. Ultimately, the stakes for abstraction as a convincing genre rest in considerable part with the Rothko Chapel.

Throughout his career Rothko, as mentioned earlier, made the highest claims for his art, rejecting descriptions of his work as abstract painting, denying that he was a colorist, and declaring the category of art insufficient for his purposes. In doing so, he pressed to the limit, indeed beyond the limit, the accepted conventions within which abstract art existed previous to him. If he was successful, then the chapel paintings legitimize the intellectual histories brought to bear on them by him and by sympathetic commentators. Rothko implicitly demands that his name be added to and spoken with those of Nietzsche, Kierkegaard, Mozart, and other intellectual and artistic figures

29 Dylan Thomas, "A Refusal to Mourn the Death by Fire of a Child in London," in *Collected Poems, 1934–1952* (London, 1955), 101.

30 See Anfam in exh. cat. Houston 1996, 10. See also Leo Bersani and Ulysse Dutoit in *Arts of Impoverishment: Beckett, Rothko, Resnais* (Cambridge, MA, 1993).

31 See Chave 1989, 196.

32 See Irving Sandler in exh. cat. London 1987, 17.

33 Quoted in Chave 1989, 193.

he admired, and by this implication he makes a case for the powers of "image-less" abstract or nonobjective art. It is a formidable claim. The debate on this matter is far from complete.

The chapel paintings are a fulcrum across which Rothko's thinking devolved into a darker, less comforting matrix, the implications of which were met in the last year or so of his life in the so-called black (or black on gray) paintings.

In Odilon Redon's words, "Black should be respected. Nothing prostitutes it. It does not please the eye and does not awaken sensuality. It is the agent of the spirit much more than the splendid color of the palette or the prism."[34] In 1947, early in the same year that Rothko's famous "Romantics Were Prompted" statement appeared, both Rothko and Barnett Newman were included in an exhibition at the Betty Parsons Gallery in New York. Newman wrote in the catalogue of "the idea-complex that makes contact with mystery —of life, of men, of nature, of the hard black chaos that is death, or the grayer softer chaos that is tragedy."[35] If this equation is literally transferred, Rothko's black on gray paintings = chaos bracket death over tragedy close bracket raised to the power of an "idea-complex," with attendant powers of life, men, and nature. This inclusive mathematics is pertinent to the new role of the conceptual in Rothko's black on gray paintings of 1969. It was immediately obvious that these paintings were different from anything the artist had done before. Most of Rothko's work has now achieved a critical consensus, attacks serving merely as annotations to confirm its pedigree. But the black on gray paintings have not yet settled into the steady state of acceptance that follows argument and counterargument. What is certain, however, is that they could not have appeared without the long, difficult passage through the chapel paintings. The chapel paintings, in their various physiognomies, ultimately earn their tragic and deliberately flawed sublimity. The black paintings are outside the familiar precincts of the tragic as a modernist idea, an idea that was rapidly becoming dated in the mid-1960s. No time could have been more inimical to elevated expressions of the tragic (or indeed of the transcendental), a fact that caused Rothko much pain. The black paintings are, however, among the most affecting and mysterious works in postwar art.

The riskiness of the black paintings is somewhat difficult to reconstruct now. Rothko himself was aware that he was taking an unprecedented step, one that he hoped would place his art at the center of contemporary discourses about painting. The practice that had governed his art for over twenty years was abandoned in a process of serial divestitures: no underpainting, no seductive color, no painting around the edge, no objecthood,

no banks of rectangles, no solicitation of environmental aids, no rhetoric. What remains after this are two rectangles, dark above gray, with occasional flushes of color like memory traces. Around the edges is a thin white margin, isolating and flattening the painted surface. Some of what Rothko called "turbulence"—painterly process—is discernible, particularly in the lower, lighter rectangle.

As a result, the paintings are forced to manage their content—whatever that content might be—directly, without invoking the surrounding atmosphere, without the intimacies of overwhelming size. Two touching rectangles, dark and less dark, enclose a dialectical question within a unitary image, one so bare and unprotected that it issues more from the absurdism of Samuel Beckett than from the amplitude of tragedy. Black and white works, wrote Goethe, "inasmuch as they can attain form and keeping, are estimable, but they have little attraction for the eye, since their very existence supposes a violent abstraction."[36] These black paintings do violence to the civilities of Rothko's previous work and may be seen as a carefully negotiated engagement of his obsession with death—not as a tragic idea and not as a sign of depression, as some have been pleased to regard them, but as an unavoidable fact. The black paintings announce a profound change in the artist's thinking, a double movement beyond the chapel paintings into two previously unexplored areas, which might be called, on the one hand, post-tragic, and on the other, prior to myth. A modernist quest has ended in a version of the void, the tragic in a version of the absurd, myth in a version of the darkness that precedes it.

Having speculated thus, we are forced to contemplate the disparity between such claims and the frugality of the black paintings. How can such works elicit stark meditations on life and the two darknesses that enclose it? One of Rothko's many subversive comments was that his art was not "art"— a limiting category—but communication on an exalted level of experience. His activity and its issue, paintings, aspire to transcend their category even as they are detained by it. The paintings remain subject to the vicissitudes of what Rothko most despised: the politics of reputations, the unavoidable museums, the charades of the auction house, the eternal critical murmur. The black paintings fully assemble their meanings within carefully constructed historical and cultural contexts. These, with the artist's ideas, references, precedents, and concerns, compose a fragile armature within which the paintings stir into life. The black paintings are thus texts the reading of which, for all their declarative appearance and conceptual rigor, is elusive and provisional.

Of all colors black is of course the one that invites the most categorical of cultural and individual responses. Blackness is both color and absence of color, and both conceptions have formidable traditions. The black on gray

34 See Odilon Redon, *To Myse Notes on Life, Art, and Artis* trans. Mira Jacob and Jeanne L. Wasserman (New York, 1986), 103.

35 Barnett Newman, "The Ideographic Picture," in *Theories of Modern Art: A Source Book by Artists and Critics*, ed. Herschel B. Chipp (Berkeley, 1968), 550.

36 Goethe 1970 ed., 334.

37 See Brian O'Doherty "Rothko's Endgame," in *Mark Rothko: The Dark Paintings, 1969–1970* [exh. cat., Pace Gallery] (New York, 1985), 5. See also Breslin 1993, 525.

38 Rothko in conversation with O'Doherty.

39 Quoted in George Sebouhian, "A Dialogue with Death: An Examination of Emerson's 'Friendship'" in *Studies in the American Renaissance* (1989), 222.

40 Rothko in conversation with Novak, who walked through the exhibition with him.

41 See Lawrence Gowing, *Turner: Imagination and Reality* (New York: Museum of Modern Art, 1966), 13.

paintings reside in a different universe of communication than do the quasi-tragic red/black/browns, which came to a conclusion in the Rothko Chapel. Blackness as substance ("palpable" darkness) and as void (infinite extension) immediately summons the coordinates of other senses to map its silence, and Rothko, it is fair to assume, felt he was on a perilous journey, for which he required more than the usual reassurances: thus the extraordinary party given by the artist in December 1969 at his 69th Street studio,[37] at which the most educated eyes in New York were invited to alight on the black works set around three walls. His desire to have these works seen and contemplated was deflected by the buzz and random peregrinations of his guests, further evidence of Rothko's frequent lack of prudence in advancing his aims.

If Rothko wanted to declare a new terminus for his work, and to have that work talked about, he succeeded. But since the situation was inimical to serious study and contemplation, the results fell short of his expectations. Was he impelled by a need to show a sophisticated awareness of current developments in painting and to solicit some echo of his own practice in the work of younger colleagues? The notion of "influence" was something he both disdained and desired. He must have been acquainted with the many complexions of black in postwar art, from Franz Kline's concussive swatches to Robert Rauschenberg's black collage-paintings and the monochrome practices of, for instance, Brice Marden. More important, however, was the example of the one artist who had spent much of his career in darkness and its penumbra: the ghost that hovers over Rothko's black paintings is that of his friend Ad Reinhardt, whose work attracted Rothko's interest and ultimately competition.

The darkness of Reinhardt's work was of an entirely different order, and it was not one that Rothko always admired. Speaking of Reinhardt's art, Rothko once said that he could not admire work that rejected sensuality.[38] In this late stage of his career, however, Rothko, having abandoned the organic heats and sensualities implicit in the tragic, regarded Reinhardt's work with a more accepting eye. The two artists were poles apart in their senses of themselves. Unlike Rothko, Reinhardt was absolutely certain of himself. He had set the terms of his art and met them with perfect confidence. The polemic with which Reinhardt invested his work was declarative, often epigrammatic, and in its oppositional tactics, it was witty and subversive. His verbal constructs are, like the paintings themselves, remarkable propositions, which frequently clarify a point by a relentless process of negative definition (which allowed some purchase for those partial to quasi-mystical speculations). Rothko could not find it within his practice to match Reinhardt's reductive, smooth surfaces. But his move into his black on gray phase in 1969 was supported by looking afresh at Reinhardt's work (which was exciting interest among some

young avant-garde artists), by his awareness of monochrome painting, by the advice of Rita Reinhardt (Reinhardt's widow), and by his desire to strip himself of all impediments as he reached into farther, unvisited territory.

Despite—perhaps because of—their scanty means, the black on gray paintings invoke darkness, opacity, negation, as sensuality is replaced by the harshness of an uncompromising idea. The tragic scenarios implicated to a greater or lesser degree in the two major commissions now seem very far away. The tragic proceeds inevitably to the death of the hero. Through suffering, the tragic teaches a moral lesson. A possibility of transcendence is expressed as awe. The notion of a quest is intrinsic to the tragic and presumes at least the hope, if not the attainment, of meaning.

As modernism declined, the redemptive apparatus of the tragic became ramshackle. Rothko realized this and, as noted earlier, moved into another darkness, which can be read as either pre- or post-tragic. The pre-tragic relates to origins; the post-tragic to the absurd. The darkness of the pre-tragic and that of the post-tragic seem to effect some primal dialectic in the black paintings. In them, Rothko realized an experience of mortality also familiar to so reputedly optimistic a figure as Emerson: "I grope in greater darkness & with less heed," wrote Emerson after the death of his brother; "Night rests on all sides upon the *facts* of our being."[39]

At the Turner exhibition at the Museum of Modern Art in 1966, Rothko was particularly taken with two paintings: *Shade and Darkness—the Evening of the Deluge* and *Light and Color (Goethe's Theory)—The Morning After the Deluge—Moses Writing the Book of Genesis* (fig. 4).[40] The two paintings are consonant with the division within his own work between darkness and color/light. Hazlitt's famous comment on Turner comes to mind: "The artist delights to go back to the first chaos of the world, or to that state of things, when the waters were separated from the dry land, and light

from darkness, but as yet no living thing nor tree-bearing fruit was seen on the face of the earth. All is without form and void. Someone said of his landscapes that they were *pictures of nothing and very like.*"[41]

The eerie proto-landscapes of Rothko's black on gray paintings can be seen as elemental night over a slightly luminous, slowly roiling wasteland. As such, they may locate themselves in the unstable genesis described by Tur-

42 See Wilhelm Worringer, *Form in Gothic* (New York, 1964), 60, 17. See also Rothko's joint comment with Adolph Gottlieb as early as 1943: "All primitive expression reveals the constant awareness of powerful forces, the immediate presence of terror and fear, a recognition and acceptance of the brutality of the natural world as well as the eternal insecurity of life." Reprinted in exh. cat. London 1987, 81.

43 See George Kubler, *The Shape of Time* (New Haven, 1962), 17.

44 See *Merriam-Webster's Collegiate Dictionary*, 10th ed. (Springfield, MA, 1994), 5.

45 Rothko in conversation with O'Doherty.

46 O'Doherty lent Rothko a copy of Cioran's *The Temptation to Exist* around this time. Whether he read it or not is problematical.

47 Nietzsche 1956 ed., 61.

ner and Hazlitt: the biblical chaos that is "without form and void," anterior to myth and thus prior to language. Some classic art historians afford us glimpses of this—a space perceived but not inhabited. Wilhelm Worringer in *Form in Gothic* stresses the unsettling characteristics of *actuality,* and contrasts the "chaos of the actual" with the "cosmos of the natural." Worringer claims that primitive man finds an absolute in geometric ornament, which appeases "his condition of deep spiritual distress." [42] Primitive man, according to Worringer, carved out his absolutes with geometry to ward off the chaos of the actual. Was Worringer's actuality related to George Kubler's later use of the term when he commented "actuality is when the lighthouse is dark between flashes…it is a void interval slipping forever through time"? [43] The space of such conceits is chilling. How close to this "actuality" did Rothko come when he painted the black pictures? Certainly he was in the precincts of a darkness and chaos that had a distinguished intellectual history, a darkness and chaos of which he became, in his last black paintings, the image maker and laureate.

Whatever such speculations about the pre-tragic, Rothko, having abandoned the romantic aporias of the tragic, moved also to the only available post-tragic territory, the absurd: "the state or condition in which humans exist in an irrational or meaningless universe, and in which human life has no ultimate meaning." [44] Such a notion was sometimes expressed by Rothko in his half-humorous comment that the God who made the world simply went away and forgot he had done so. [45] The cartography of this bleak terrain is surveyed by Beckett in theater, by Cioran in philosophy, [46] and by Rothko in the black on gray paintings. To negotiate with the absurd involved a degree of courage in Rothko's psychic history that has been grievously misinterpreted by those finding in these works a premature requiem. Consistent with his lifelong quest in the dark paintings, he finally inscribed his concerns on the void that remained after the eviction of the tragic idea. The black on gray paintings place an enormous weight on the reduced means. A thin membrane of paint is silhouetted against a harsh marginal light, which limits and defines both the viewer's attention and the reduced repertory of means within. The dark rectangle above, usually assigned the more generous space, is unannotated and mute. The lower lighter rectangle offers fugitive and somewhat futile traces of activity, futile in the sense that they seem painted with that indeterminacy and apparent lack of purpose codified in the chapel pictures. The horizons where the two rectangles meet is of course the main incident in these pictures, but a close examination of them announces a kind of tautology: they meet where they meet, and they do so bluntly, without equivocation or rhetoric. At the most, perhaps, there is a distant memory of that violence to which Goethe referred.

All is subjugated, arranged, and coached to advance a single idea, one that can be expressed formally—how to create a unitary image from two components; psychologically—how to present the vicissitudes of the psyche in its dark and lighter complexions; and philosophically—how to achieve the absolute through dialectical method. Such interpretations can be defended with varying degrees of conviction. But perhaps the most convincing interpretation lies in the vicinity of Newman's comment on "the hard black chaos that is death, and the grayer softer chaos that is tragedy." There is something unyielding, harsh, and confrontational about these black on gray paintings, something that acknowledges without distress the terrible departure of meaning (absurdity) that places them in a context deprived of myth, against the darkness out of which myth and language eventually come. In making such speculations, we find ourselves, somewhat uncomfortably, in the company of Rothko's insistent will, on which he gambled everything: the will insisting that with minimal abstract means he could engage matters of the deepest consequence. Whatever the interpretations, ultimately it is perhaps enough to say that Rothko had in fact sought something new and found it.

The long arc of Rothko's engagement with darkness came to ground in the black on gray paintings. The reading proposed for them here places them very high among the achievements of postwar art. There is nothing else like them, nothing that issues so resolutely from an obsession with the grand irony of existence. And of course they are, as Rothko's work often is, very close to nothing. Poised near this void, which is their content and their abstract substance, forced to be assertive through negative cancellations, they are profound and vulnerable.

After the black paintings Rothko provided a coda to his career. Again he was engaging the poetics of color through a more scanty and adventurous method, while retaining the binary format of the black on gray paintings. This last burst of color promised yet another phase in an extraordinary and durable career. All that is left is the beginning of another journey, unfortunately eclipsed by his premature departure. In the lightness of these last works there is a sense of all passion spent, of a promise that remains, to use a word Rothko often employed, deeply "poignant." Or, as Nietzsche put it, these last works may be "the luminous afterimage which kind nature provides our eyes after a look into the abyss."[47]

Material and Immaterial Surface: The Paintings of Rothko

But [Titian at ninety] kept on painting Virgins in that luminous light, like he'd just heard about them. Those guys [Titian and Michelangelo] had everything in place, the Virgin and God and the technique, but they kept it up like they were still looking for something. It's very mysterious.

WILLEM DE KOONING

1 Letter from Mark Rothko to Dominique and John de Menil, 1 January 1966, The Menil Collection Archives, Houston.

Such seems to be the case with great artists, who continue to explore and refine that which has engaged them from the beginning of their signature styles. Mark Rothko provides no exception. Even though he was nearing what would be the end of his life, in 1966 he wrote to John and Dominique de Menil, patrons of the Rothko Chapel, "The magnitude, on every level of experience and meaning, of the task in which you have involved me, exceeds all my preoccupations. And it is teaching me to extend myself beyond what I thought was possible for me."[1] The chapel commission was Rothko's last. Yet it was hardly a denouement. So often an artist's late work is overlooked in favor of the power of the earlier groundbreaking contributions or the familiar beauty of the classic work. The later paintings of Mark Rothko, however, reward the viewer with a distillation and refinement of the earlier work taken to another level, especially in terms of the complexity of the surfaces.

In keeping with de Kooning's observation, Rothko continued to explore the impact of every facet of his painting in terms of the physical object. Deploring the use of varnish, which would diminish or even obliterate certain effects, he used the color, transparency, viscosity, and reflectance of paint

2 Robert Goldwater, "Rothko's Black Paintings," *Art in America* 59 (March–April 1971), 62.

3 Unpublished address by Domenique de Menil, 26 February 1971, in the Rothko Chapel, Houston.

4 Mark Rothko, "The Romantics Were Prompted," *Possibilities* 1 (Winter 1947–1948), 84.

5 Rothko, in "A Symposium on How to Combine Architecture, Painting, and Sculpture," *Interiors* 10 (May 1951), 104.

6 Unlike a stretcher, which incorporates bars that may be adjusted by inserting a key at the miter joints, a strainer is a fixed system of bars that cannot be expanded.

7 With regard to a point made later in this paragraph, there are stretcher-bar marks in the dark rectangles that now characterize this painting, presumably because it was repainted after the crossbars were inserted. The author would like to thank Alison de Lima Greene, Robert Montgomery, and Wynne Phelan of the Museum of Fine Arts, Houston, for allowing her to examine the painting.

in a relentless pursuit of the refined surfaces of his later work. Taken as a whole, these paintings embody a preoccupation with technical issues that Rothko never abandoned—not even in his last black and gray paintings, where, according to Robert Goldwater, "It was not the expressive mood embodied that occupied him but the construction—the means."[2] If indeed it was the physicality of paint that particularly engaged Rothko, then it should be instructive to consider the surface effects of selected paintings in an effort to comprehend the development of his technical insights and governing thoughts, keeping in mind their culmination in his last commissioned murals. Such a study would elucidate that which was persistent and particular with regard to the genius of this artist.

Dominique de Menil, in her penultimate address at the opening of the Rothko Chapel in 1971, described the paintings within as "intimate and timeless. They embrace us without enclosing us. Their dark surfaces do not stop the gaze....But we can gaze right through these purplish browns, gaze into the infinite."[3] A close examination of these panels reveals a sophistication of technique born of years of experience, for, as Rothko said himself, "The most important tool the artist fashions through constant practice is faith in his ability to produce miracles when they are needed."[4] Spiritual connotations aside, Rothko created for the chapel two categories of painting: the transparent, actively brush-marked surfaces of the purple so-called monochromes; and the opaque, quiet surfaces with restrained brush marks of the black-form paintings. The two types could hardly be more distinct or more representative of the range of Rothko's earlier work. Yet what unites them is their consistent and monumental scale and their integration into a single overall scheme (see p. 273, fig. 3; and p. 351).

Rothko had painted large pictures before, notably the murals for Harvard University and the Seagram Building in New York. Comfortable with large formats, he noted, "The reason I paint them...is precisely because I want to be very intimate and human....However you paint the larger picture, you are in it. It isn't something you command."[5] Intimacy was what Dominique de Menil felt when she looked at the chapel paintings and what the artist claimed he could not command. What Rothko could command, however, were the materials responsible for eliciting the emotion, and that he did brilliantly.

Among the chapel paintings are seven monochromes that include a triptych on the north wall and single paintings on each of the four diagonal walls. Like the seven black-form paintings that constitute the rest of the ensemble, they are painted on cotton duck canvas attached to wooden strainers, the depth of which possesses a certain importance given the absence of a frame.[6] Although ultimately increased to the current depth of 3 inches, the

original supports for these canvases were constructed of a much narrower stock. For years the artist had ordered from Lou Sgroi a type of strainer that incorporated four bars that were approximately 1½ inches deep, a measure seemingly favored by the artist. Although of standard dimension, these strainers were distinguished by the crossbars' temporary attachment to the back of the sidebars rather than their insertion into the perimeter: hence in profile the crossbars protruded behind the painting, causing the canvas to be distorted as it was stretched over them on the edge and onto the reverse for fastening (fig. 1). Once the artist had completed the painting, the crossbars were removed and cut to fit flush between the sidebars of the strainer, inserted in the usual way, and secured in place with metal plates.

Apparently Rothko followed this procedure as a matter of course in constructing the strainers for many of his paintings. Occasionally, as with one pair of spare black-form paintings associated with the Rothko Chapel and with another 1968 painting (cat. 101), the strainers were left with the crossbars still protruding in back. Usually, however, all that remains of the original configuration is the outline of the former distortion in the fabric, made visible by the irregular pattern of paint that covers the tacking edges. In the chapel paintings one can clearly identify on the tacking margins the areas of fabric that had once been distended but are now relaxed and stretched out to accommodate the deepened strainers.

More than a curious innovation, this technique epitomizes Rothko's unfailing concern with the surface of a painting. It also allows for conjecture about earlier versions of reconceived works. For example, on the excess tacking edges of the predominantly dark *No. 14* (also called *Painting*) of 1961 in the Museum of Fine Arts, Houston, can be seen remnants of an earlier orange ground that extended over the original crossbars that were set back from the sidebars. At some point after the crossbars were cut and inserted into the strainer, thereby finishing the prior work, Rothko created the current painting by covering the orange with a black ground that extends onto the tacking edges, which are now attached to precisely aligned bars.[7] It is not surprising that an artist with Rothko's critical eye would develop such a technique of stretching canvas. The practical benefit was that this system helped retard the development of stretcher-bar marks that so often mar the surfaces of oversized canvases by eliminating the impact of the loaded brush against

8 Unpublished interview with Ray Kelly in Houston, 23 July 1980, The Menil Collection Archives, Houston. The author remains indebted to Ray Kelly for making simulations of the chapel paintings with her in July 1980.

9 Sheldon Nodelman, *The Rothko Chapel Paintings: Origins, Structure, Meaning* (Austin, 1997), 108–109.

10 James E.B. Breslin, *Mark Rothko: A Biography* (Chicago and London, 1993), 382.

11 For a fuller description of this process see Carol Mancusi-Ungaro, "The Rothko Chapel: Treatment of the Black-Form Triptychs," *Cleaning, Retouching, and Coatings,* ed. John S. Mills and Perry Smith (London, 1990), 135; Nodelman 1997, 111–113.

crossbars. Ray Kelly, one of Rothko's assistants for the chapel commission, confirms that this precaution was the artist's motivation,[8] and indeed the chapel paintings, despite their enormous size, are virtually free of stretcher-bar cracks.

In his typically deliberate manner, Rothko carefully considered every variable that would affect what was seen. Rather than accept standard equipment and methods, he devised this innovative way of stretching fabric in deference to his keen regard for surface. Likewise, in wielding a brush, he did not restrict himself to a single orientation of the canvas but modified his technique as he worked through a series of paintings—or even as he completed a single work. The monochromatic panels in the Rothko Chapel consist of multiple layers of ground pigments mixed with rabbit-skin glue, modified by coats of additional pigment in clear synthetic polymer. In a recent publication Sheldon Nodelman convincingly argues that these paintings were completed in two successive campaigns, separated by several months, and with the help of different studio assistants.[9] In the first effort the large canvases of the apse triptych were executed by Rothko applying paint atop a ladder and an assistant, William Scharf, working simultaneously below—an arrangement familiar to Dan Rice, who worked with Rothko in the late 1950s.[10] Employing *two* assistants during the second campaign, Rothko had the oversized canvases propped on their sides and instructed the assistants to apply paint simultaneously from top to bottom and from the sides inward while he orchestrated the activity.[11] Although the action, and presumably the energy, differed considerably in the making of the seven monochromes, Rothko was undeniably satisfied with the variation of stroke produced by the unorthodox technique—an effect that may have intentionally contributed to the schema of the chapel, as Nodelman proposes.

A willingness to change the orientation of a canvas in process or after the completion of a painting characterizes Rothko's earlier work as well. In a 1960 painting in Düsseldorf (see fig. 4) the orientation in which Rothko painted the picture is obvious, as drips emanate from two of the three black rectangles and flow onto the bluish ground. Nonetheless, Rothko thought it necessary to affirm his intent by drawing an arrow with the word "up" on the back of the canvas. Then, apparently changing his mind, he turned the painting upside down, crossed out the earlier instruction, and drew in a revised directive. The increased authority of the densely painted black rectangles now at the top of the painting evidently far outweighed, in Rothko's view, the anomaly of upward drips.

In fact, a disregard for the direction of drips is so prevalent in Rothko's work that one wonders if the artist allowed them to remain visible more for effect than as an unavoidable result of technique. In an arrestingly soph-

FIG. 2 / MARK ROTHKO IN HIS
STUDIO IN 1964 WITH *UNTITLED*,
1963 (CAT. 96), HELD UPSIDE
DOWN. PHOTOGRAPH BY HANS
NAMUTH.

isticated untitled painting of 1963 at the Kunsthaus Zürich (cat. 96) drips may
be seen running in three directions, and in at least two 1964 paintings (cat. 97;
and estate no. 5112.64) unmistakable drips run horizontally across the width
of the dominant form. Stopping short of the ground, they not only draw
attention to the interface of form and field but accentuate the difference in
paint layers. The implication is that some strata were painted with the can-
vases on their sides, while others were painted with the canvases upright.
Although it is not obvious on the black-form triptychs in the chapel, where
the brushwork appears unremarkable in its directional path, Roy Edwards,
another of the artist's assistants, once asserted that Rothko also painted these
forms with the canvases on their sides.[12] Clearly the artist's willingness to
change orientation, to leave contradictory drips visible on a highly worked
surface, and to accept the hand of different assistants only serves to affirm the
certainty of his critical eye.

Rothko was not the only painter of his generation to challenge the
traditional relationship of artist to canvas. Perhaps the most notable was
Jackson Pollock, in whose early work drips tend to follow one direction and
thereby almost direct the eye to the floor where his subsequent and more
famous campaigns were to take place. By 1948 in *Number 1* (The Museum of
Modern Art, New York), and certainly by 1950 in his classic works, Pollock
was approaching the horizontal canvas from all directions. The only vertical
drips in *One* of 1950 (The Museum of Modern Art, New York) appear toward
the bottom of the painting. Undoubtedly subsidiary, these curious brownish
drips remain inexplicable given the technique, until it is remembered that
Autumn Rhythm (The Metropolitan Museum of Art, New York) was painted

12 "Working with Rothko: A
 Conversation between Roy
 Edwards and Ralph Pomeroy,"
 New American Review 12
 (1971), 115.

13 The author would like to thank Jeffrey Weiss for sharing this observation, among other insights included in this essay.

14 Edwards and Pomeroy 1971, 115.

15 Breslin 1993, 317.

16 Breslin 1993, 317.

17 Edwards and Pomeroy 1971, 115.

18 Dore Ashton, *About Rothko* (New York, 1983), 179.

on the floor of Pollock's small studio while the freshly painted *One* hung on the wall. So the inauspicious drips in *One* probably resulted from studio accident rather than predetermined design, and their acceptance by Pollock seems almost casual.

Although perhaps equally unplanned, the vertical drips in some of Rothko's late 1940s paintings achieve a visual eminence that the artist clearly exploited. Recalling the etched white lines of earlier 1940s work, the white drips and deliberate brushwork in *Untitled* of 1948 and *No. 19* of 1949 (cats. 37 and 39) become significant design elements. Not only do they offer a directional weight to the picture plane but they confirm the working orientation of the canvas. It is tempting to suggest that, like the vertical drips in Pollock's early *Magic Mirror* (1941, The Menil Collection, Houston), the drips in these two works confirm Rothko's conventional approach to the canvas as a younger artist in a way that the conflicting drips in his later paintings suggest the opposite. [13] Regardless of technique, what is irrefutable is that in his panoply of surface effects Rothko understood and intuitively appreciated the visual impact of drip marks.

Yet as marks of process, drips are merely remembrances of the brush —that tool responsible for the varied effects Rothko so powerfully achieved. According to Roy Edwards, Rothko's "brushes were a big thing with him. They felt like velvet, those brushes, because they were very old and they'd been so well taken care of. I would wash those brushes every day after painting. First in turpentine and then in detergent. For about an hour. Washing and rewashing, rewashing, rewashing." [14] The more the brush was used, the more malleable it became—and, as an extension of the artist's hand, the more expressive. The range of effects was practically limitless; as Dan Rice remembers: "Often, just the very tip of the brush, a big 5-inch housepainting brush, would just sort of flicker over the surface, so the area was not covered as rapidly." [15]

Countless examples speak of Rothko's dexterity with the brush, but two particularly dramatic instances immediately come to mind. In the 1951 painting *No. 25* (cat. 52) the familiar tripartite arrangement of rectangles floats on a yellow ground. A whitish rectangle occupies the upper register, while a red one commands the bottom. Between is a black shape that has been carefully constructed with the tip of the brush defining edges with short vertical strokes, while broader horizontal swathes of color establish the body of the rectangle. The artist completed the image with a bold, even gutsy stroke of white paint on top of the black. Brushwork, very apparent in this painting, is celebrated in the lightly touched edges of the black form, which appear free and lively, as well as in the controlled and continuous white over black. The white was applied with a dry, weathered brush so that each hair of

the brush is articulated. In the 1963 painting in Zurich (cat. 96) Rothko similarly accentuated the uppermost dark rectangle at the last moment with a band of rich white paint that sits up on the underlying black with sharp peaks of impasto created by swerves of the brush.

The brush again becomes the definitive player in a 1957 painting in Houston (fig. 3), where Rothko dragged a relatively dry brush across the canvas as a final gesture in completing the dominant central form. In this work the uppermost bright orange rectangle results from such vigorous brushwork that bits of broken hairs remain embedded in the paint and the edges of the form reveal accumulations of paint, forced outward by the edge of the brush. Noting Rothko's command of tempo in applying paint, Dan Rice remembers that "when he worked out closer to the edges or where he wanted thin spots for the ground to come through…he would necessarily slow up a little, so the paint wouldn't go on either as thickly or as quickly."[16] Indeed, in the form at the bottom of this painting the orange paint is thinly applied over a red underlayer with just enough authority to suggest the rectangular shape. Similarly, the central shape appears to have been first brushed in with a pigment-rich, matte red paint, but then boldly and broadly brushed over with a shiny purple paint. The way in which the medium is carried by the brush and applied to the surface suggests that the purple is oil paint as opposed to the egg/oil emulsion paint of the underlying red. Regardless of media distinctions, the handling of the purple undeniably distinguishes the form, with the central portion resulting from quick up and down movements that are contained by deliberate strokes defining the perimeter. "No, it was all done with brushes," concludes Roy Edwards. "That's the marvelous thing. He had such a *touch* with a brush."[17]

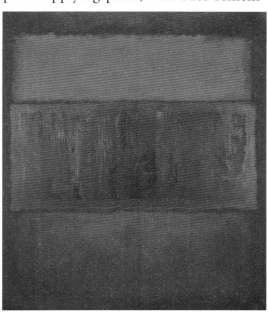

FIG. 3 / MARK ROTHKO, *UNTITLED*, 1957, OIL AND EGG/OIL EMULSION ON CANVAS, 236.2 X 203.2 (93 X 80), PRIVATE COLLECTION, COURTESY OF THE MENIL COLLECTION, HOUSTON, SHOWN IN LIGHT THAT EMPHASIZES THE DIFFERENCES IN REFLECTANCE.

Even Rothko acknowledged the importance of brushwork to his surfaces: "The difference between me and Reinhardt is that he's a mystic. By that I mean that his paintings are immaterial. Mine are *here*. Materially. The surfaces, the work of the brush and so on. His are untouchable."[18] Leaving aside issues pertaining to the facture of Reinhardt's surfaces, Rothko's own interests remain clear. The surface of a painting records the play of dissimilar media, the relative amounts of material, and the ways in which they are applied to variously absorbent supports to create the visual whole. The

artist's involvement with the surface can be tactile—as with a brush, palette knife, or fingers—or it can be more detached, as in Pollock's pouring of paint onto a flat plane or Rothko's orchestrating the activity of assistants. The importance of the touch may be such that the artist chooses to depersonalize it by mechanical means, using a spray gun, or deliberately subdue it in favor of visual unity for some monochromatic painting. Whatever the means, the serious artist never loses contact with the surface. The artist may ultimately decide to unify the complexity of the surface with a varnish coating, as did many old master painters, or may choose to enliven it with the incorporation of collaged elements, as did the cubists. Regardless, the surface is the final playing field; it is where the energy is expended and where the victory is won or lost. As such, it embodies the artist's governing thoughts in that it reflects his or her judgments, energy, expertise, and level of engagement; it is what the artist is looking at when he or she concludes that the work is finished.

Rothko's paintings bespeak a complete engagement with the surface. From his imagistic works of the 1940s, which relied less on media contrast than on handling of paint, the artist left manifest the marks of the process. In *Astral Image* of 1946 (The Menil Collection, Houston) the paint layer is brush-marked throughout, yet the local application of white paint still provides a counterpoint of sharp impasto. The white ground has been colored and then scraped with a palette knife in a fashion reminiscent of the incised lines and scraping in his earlier work. Rothko continued to scrape grounds selectively in paintings leading up to the chapel commission, and a refinement of that technique may be seen in *No. 16 (Two Whites, Two Reds)* of 1957 (cat. 72). In this painting the two white rectangles that flank the central orange one on a red ground are characterized by the artist's discriminating use of a palette knife in the forms. Rothko adroitly scraped through the white paint on the edges of the bottom rectangle to expose the red underneath and to square up the shape. The effect is similar to that of the purple overlay on Houston's painting of 1957 (fig. 3), except that here a palette knife rather than a brush defines the form. In both instances, however, the surfaces have been manipulated, in the full sense of the term, for optimum visual effect.

Rothko orchestrated the employment of every structural element toward a focus on the picture plane. Abandoning the frame as a device on his classic pictures and murals, he consistently painted the exposed tacking edges of his canvases. Usually he would stretch the fabric around the sides and secure it with staples to the reverse of the strainer. Sometimes, however, in response to a shortage of fabric or economy of means, he would staple the canvas to the sides of the strainer. Either way, the tacking edges were almost always painted, even if the paint was applied over the staples, as in *No. 13* of 1958 (cat. 75). Rothko's insistence on the importance of the painted edge may

be seen as early as 1950 in *No. 10* (cat. 48), for which the artist did not have fabric wide enough to cover the sides of the strainer completely: he carefully stapled one selvage of the fabric to the right side, secured the remainder to the left, then painted the exposed wood where necessary.

That Rothko regularly left tacking edges unframed but painted indicates his intention that they be part of the visual scheme, both in terms of color and in terms of the role they play in subtly setting the picture plane apart in three-dimensional space. The consonance of color on the edges with that on the frontal plane minimizes the distinction made between the two by the existence of the strainer, and it returns the focus to the picture plane. This is particularly evident in certain mounted works on paper, such as *Untitled* of 1969 (estate no. 2042.69), where the brilliant purple of the edge and ground of the picture join to free up the dominant black forms. The dark shapes almost float off the surface, in part because the structural underpinning is minimized.

Rothko also methodically exploited the practical benefits of materials for aesthetic effect. He apparently understood the need to coat the canvas with a sizing and/or ground in order to protect it from the oil medium and to ensure its even plane after stretching by capitalizing on the stiffening effect of the preparations.[19] Traditionally, a ground consists of an inert white material suspended in a glue or oil medium. In Rothko's case, however, the term "ground" has been used to refer to a mixture of pigments in natural and synthetic media. Among Rothko's contemporaries a favored preparation was Rivit glue, a polyvinyl acetate emulsion that was often applied to the canvas for its preservation. Pollock regularly sized his drip paintings with Rivit glue before applying paint,[20] and Barnett Newman used Rivit glue as a sealant for his exposed cotton canvases.[21] Although Pollock also occasionally dripped paint onto unprimed canvas, as in *One* (1950), and color-field painters by and large eliminated the use of sizing and grounds in order to maximize absorption of the paint into the fabric, the painters of Rothko's generation typically used some type of preparation.

Accordingly, it was Rothko's custom to brush an aqueous solution of warm rabbit-skin glue onto a stretched canvas, allow it to penetrate the fibers and dry, then repeat the process as necessary. Although glue itself is a hygroscopic material, surprisingly even oversized canvases when so impregnated have held up well to the vagaries of humidity and temperature. Indeed, the Rothko Chapel paintings, which are among the artist's largest, ranging upward in size to 177½ by 135 inches, show absolutely no sign of the draws or ripples that often plague monumental pictures. Although not exceedingly taut, the paint layers have remained in perfect plane for more than twenty-five years. In addition to the obvious benefit to the preservation of these works, Rothko's attention to the ground layer helped ensure the absence of

19 Sizing can also refer to a material that is used in the processing of yarns during the manufacture of fabrics. In this context, however, it is meant to refer to a substance applied by the artist to his canvas before painting to make it more impervious to moisture. The author would like to thank Leni Potoff for his clarification of this point among others regarding the practices of color field painters.

20 B. H. Friedman, "An Interview with Lee Krasner Pollock," in *Jackson Pollock: Black and White* [exh. cat., Marlborough-Gerson Gallery Inc.] (New York, 1969), 8, 10.

21 Private conversation with Annalee Newman, 3 June 1991.

22 A. P. Laurie, *The Painter's Methods and Materials* (New York, 1967), 150.

23 Breslin 1993, 468.

24 Dana Cranmer, "Painting Materials and Techniques of Mark Rothko: Consequences of an Unorthodox Approach," in *Mark Rothko* [exh. cat., Tate Gallery] (London, 1987), 189. The author would especially like to thank Dana Cranmer for graciously sharing her insights about Rothko's materials and techniques gleaned from years of assessment and treatment of the paintings.

planar distortions that otherwise would have diminished the integrity of the picture plane.

Artists have long exploited the visual potential of a ground layer while also acknowledging its structural desirability. The old masters, for instance, often used white grounds to heighten the translucency of oil paint or to achieve certain effects through contrast, as did Velázquez in *The Rokeby Venus* (c. 1651, National Gallery, London), wherein the traditional white layer is covered by a deep red paint except in the figure of Venus, which "stands out luminous against the dark background." [22] Rothko, among other modern painters, took this practice a step further not only by coloring the ground with the addition of dry pigments to the mixture but also by allowing the exposed ground to participate fully as a design element. Thus the colored ground serves to unify the surface by visually holding the painting together. This technique was perfected by Rothko and became a hallmark of his style.

Naturally, when covered with other paint, the colored ground affects the perception of the layers above. Rothko fully explored this phenomenon in his classic works, through a masterful engagement of color, and even in his muted pre-chapel paintings of 1964 in which somber tones are painted on top of dark grounds to create an ethereal effect. At least one of these 1964 paintings (estate no. 5048.61) was reminiscent of old master paintings, in effect if not technique: reversing the process, the artist applied a pervasive bluish purple ground, then selectively scraped away much of the color, leaving barely a stain on the tacking edges. Later, with a light overlay of ocher paint, he allowed the uneven saturation of the interrupted color underneath and the exposed white fibers to define the form. William Scharf remembers Rothko's trying different media and techniques in the summer of 1964, "even to the point that one day he wanted one canvas painted and scrubbed off to see how it behaved and if it could be used again. He was rather happy with the results." [23] Without a doubt, the sophisticated versatility of Rothko's later use of multilayering with minimal color reflects his assimilation of the technique from years of practical experience and success in his classic paintings.

Ever curious, thoroughly engaged with the surface, Rothko continued to reconsider materials and their effect throughout his career. His grounds were essentially a water-based medium with the addition of powdered pigments. As such, the medium that served Rothko from the late 1940s onward, as both a sealant and a paint, was not unlike watercolor or gouache. Summing up years of judicious examination of Rothko's paintings as conservator for the Mark Rothko Foundation, Dana Cranmer concludes, "Rothko's great innovations were focused not on methods but on the physical components and quality of the paint film itself and the variety of effects possible in the manipulation of the medium." [24] She further asserts that during the artist's

surrealist period (1944–1946) "a remarkable symbiosis occurred between the watercolors and the oils" and that "often he applied what he developed in one medium to the other."[25] Perhaps that synergism spawned the artist's broad use of powdered pigments, not only in rabbit-skin glue but also in other media, including synthetic polymer. This effect of disembodied pigment could be similarly achieved by diluting the oil medium to such a degree that the paint appears chalky when dry, as in *No. 10* of 1950 (cat. 48), where the blue ground, brush-marked throughout, looks almost like a pastel. In the same painting are multiple yellow drips that attest to the thinning of medium described by Roy Edwards: "The oil paint had to be very thinned with turpentine. I would stir and stir and stir so that it wasn't lumpy at all, just like soup, you know."[26] In later works such as *Untitled* of 1966 (estate no. 5045.66) the artist attended to the predictable drips of the particularly fluid medium by going back into the paint film once it had begun to set, as in the bottom right quadrant, and briskly brushing them out.

Rothko used whatever combination of materials from his battery of tried media—including oil paint, synthetic polymer, egg, and aqueous glues—that provided the desired effect. He further manipulated the conventional qualities of these materials through multilayering and other techniques. For example, in *No. 13* of 1958 (cat. 75) Rothko created form by varying the thickness of the layers rather than relying solely on the optical properties of the materials. The uppermost white rectangle is the most transparent configuration, defined by fairly thin brushwork over a darker ground. The central yellow form appears more solid, with multiple layers of paint, while the red rectangle at the bottom is the thickest and most opaque. A yellow ground serves to unify the forms with a layer that is comparatively consistent throughout. With the use of color and the handling of paint, the artist created in this painting a dynamism that enlivens the surface. The white form becomes nearly cloudlike. It could almost float away, except that it is anchored by the smaller but more weighty red form. The yellow rectangle in between allows room for the white and red rectangles to counterbalance one another. This middle form, slightly redder and denser than the yellow ground, almost seems to reflect the glow of the red rectangle below. The subdued surface of harmonious brushwork and relatively even reflectance serves as a counterpoint to the brilliant interplay of variously layered colored forms.

For another painting of the late 1950s, described above (fig. 3), Rothko took a different tack. He exploited the contrast of transparent and opaque layers to characterize the differently colored and attenuated forms, but he heightened the effect through manipulation of the inherent reflectivity of the materials. The rectangles again occupy a homogeneous ground, which has been applied to the unsized cotton duck fabric "so that the paint would

25 Cranmer 1987, 189, 191. An undeniable correlation exists between the materials and techniques of Rothko's works on paper and paintings from the mid-1940s onward. Undoubtedly, an artist of Rothko's breadth would cogently glean insights from one application that could be innovatively applied to the other. This interesting topic certainly warrants fuller discussion in another context.

26 Edwards and Pomeroy 1971, 113.

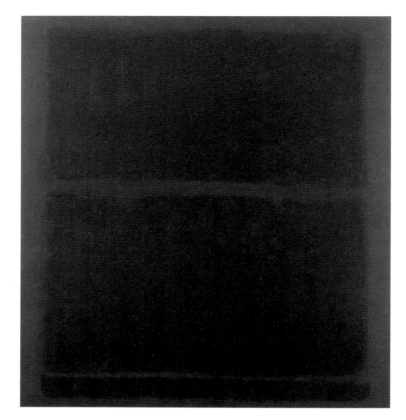

be absorbed into the canvas with minimal gloss," as Roy Edwards later explained.[27] In the uppermost orange form the weave of the canvas is readily visible, while in the bottom reddish orange rectangle the topography of the fabric is completely hidden under an opaque paint layer. Judging from the sporadic blips in the paint, which are in fact membranes that once surrounded the yolk of an egg, one can surmise that Rothko added eggs to this mixture to increase its body and opacity, then covered that layer with a thinned orange paint reminiscent of oil, which moderates the slightly more reflective surface of the underlying red. Undoubtedly, the most distinct among the forms is the central rectangle, which is first delineated with a red egg/oil emulsion paint, then covered with a shiny purple paint. In addition to the obvious differences in color, the contrasts in topography and reflectance in this painting are staggering and suggestive of what would ultimately consume Rothko's attention in the chapel paintings.

Apparently already contemplating a course away from brilliant color in the early 1960s, Rothko completed two paintings that presage what came later in the decade. Specific elements of these paintings have been discussed above, but when considered more broadly, they also shed light on the visual effects that Rothko would expertly orchestrate in the chapel paintings. In the 1960 painting in Düsseldorf (fig. 4) three black forms float on a matte dark blue ground, which continues onto the tacking edges. Almost in response to the diminished importance of color in this painting, it is the number of layers and quality of paint that define the variously attenuated black rectangles. For

example, the two uppermost rectangles consist of several layers of paint, increasing in gloss as they approach the picture plane, whereas the bottom rectangle is made up of one layer of purely matte paint. Although similar in gloss, the saturation of the two uppermost rectangles can appear quite different, depending on the viewing angle, in part because of the vagaries of handling and in part because of the inconsistency of the ad hoc paint mixture.[28] By comparison, the five rectangles in the 1963 picture in Zurich (cat. 96) reflect light similarly, but the bands at the interfaces of the rectangles differ considerably in gloss (fig. 5). Again, the various thicknesses of the forms result from multilayering or reworkings, prompted as much by a desire for certain visual effects as by changes of mind. Even the occasional impression of weave in the thinner paint contributes to the subtle dynamism of the forms.

What is glorious about the Zurich painting is the manner in which Rothko solidifies the dark rectangles through media manipulation, enlivens them through differential reflectance, then releases them in an ethereal space. The ground, which in other paintings holds the forms in place by extending beneath them and onto the tacking edges, here is covered by a moderating tone with a relatively satiny sheen that stops abruptly at the edge of the picture plane and hovers around the dark forms without actually touching them. What offers the connective tone, then, is the insistently matte black underlying ground that extends onto the tacking edges and becomes a recessive halo around the rectangles. By its very presence on the tacking edges, this omnipresent black void not only envelops the dark forms but also diminishes the weightiness of the work, while the purplish paint on the picture plane almost seems to float unattached to its support. The creation of halos around floating forms by the interplay of different layers and colors was a device long favored by Rothko. Here, however, the artist has unequivocally returned the focus to the surface with the diminution of color in favor of a celebration of differential reflectance. Also, because the media of the dark rectangles differ from those of the other darks, these shapes read as a coherent unit separate from the ground. Capitalizing on the striking power of contrast and brushwork, the artist, in a final gesture, added a swath of white oil paint on top of the uppermost rectangle. Not surprisingly, the way in which he conjoined the dark forms into one ele-

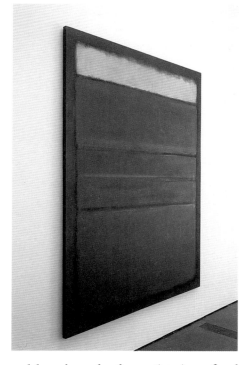

27 Roy Edwards, unpublished interview with Dominique de Menil, April 1977, The Menil Collection Archives, Houston.

28 For a complete discussion of the egg/oil emulsion paint see Mancusi-Ungaro in Mills and Smith 1990, 135–136. In the Düsseldorf painting Rothko may have altered the relative amounts of oil in the egg/oil mixture in order to differentiate gloss. Although the paint has a sheen characteristic of oil, it has sporadic blanching, which suggests the inclusion of egg. Furthermore, in the uppermost two rectangles intermittent rounded spots of shiny material interrupt the otherwise fluid paint surface. These irregularities seem to be in the mixture but may be a product of chemical incompatibility.

FIG. 5/THE ZURICH PAINTING (CAT. 96) IN RAKING LIGHT, SHOWING DIFFERENCES IN REFLECTANCE BETWEEN THE FORMS AND GROUND.

ment through media manipulation and heightened the drama through bold brushwork portended what came to fruition in the chapel paintings.

In 1996, for the first time since leaving Rothko's studio, a sequence of numbered paintings dating from 1964 was brought together at the Menil Collection as part of an exhibition.[29] Started just before the artist received the commission for the Rothko Chapel, these paintings bear an undeniably close relationship to the black-form paintings in that each bears a single black form floating on a plum ground. Furthermore, there is a definite progression within the set from the techniques and concerns of Rothko's earlier work toward a refinement of both in the chapel. For instance, in *No. 1* (Öffentliche Kunstsammlung Basel, Kunstmuseum) the dominant rectangle is constructed of various layers of egg/oil emulsion paint and sits atop a dark ground of rabbit-skin glue and dry pigments. As in the Zurich painting (cat. 96), the ground around the form has been selectively toned down on the surface by a slightly glossier pigmented medium to define a halo around the rectangle. Typical of the earlier work, the black rectangle is sketchily painted, with the interface of form and ground left indistinct yet dynamic. Slightly more complicated in construction, *No. 2* (cat. 98) includes a similar black rectangle that covers underlying brown layers in egg/oil emulsion paint. Although the form is freehand, it is tighter than that in *No. 1*: it has a straighter edge, but not taped, and its interface with the ground is less painterly than before. The halo created at the juncture of form and ground is dark reddish brown here, introducing a bit of color that is not present in *No. 1*. The underlying brown also affects the color of the black.

The progression in the rest of the series is toward an even tighter form and away from the dance of opposing media effects that characterizes *No. 1* and *No. 2*. Although Rothko still starts with brown for the form in *No. 3* (estate no. 5006.64), it is the last such experiment in the set. With one of the two *No. 5*s (estate no. 5013.60), the artist turned away from questions of material—as the work is simply executed, without layering—and toward questions of proportion. That direction continues for the rest of the set, where in *No. 7* (National Gallery of Art, Washington) and the final work, *No. 8* (cat. 100), there is comparatively little variance in reflectance between the plum borders and the more precise black forms, both of them painted in egg/oil emulsion. Indeed, in *No. 8* attention is focused almost exclusively on the scale of the form, with its many permutations and alterations still visible on the surface. (Incidentally, the same experimentation may also be seen to a lesser degree in other members of the set.) Yet *No. 8* is the only painting in the numbered set that has a vertical rectangle, which foreshadows the elongated shape in the black-form painting that has been identified by Nodelman as the first that the artist completed and kept for the chapel.[30]

Issues of proportion engaged Rothko throughout his career. One need only consider *No. 21 (Untitled)* of 1949 (The Menil Collection, Houston) wherein the artist adroitly joined two smaller vertical rectangles on the surface of the painting with flamboyant brushwork to create one floating horizontal form. Deliberations on proportion continued to absorb Rothko as he proceeded to create the chapel paintings—so much so that in October 1967, when asked about the subtle color differences in the finished chapel panels, he confided, "Who can tell?…It is all a study in proportion."[31] Working toward that end with full-scale studies in 1965, Rothko instructed his assistants to take a typical plum ground and use charcoal to lay in forms, which he directed them to alter many times before they ultimately covered the forms with paint. At the same time he ordered minute changes in the overall dimensions of the strainers. The movement of painted tape from the tacking edges to the reverse of the strainers and the identification of former fold lines on two full-scale studies (estate nos. 6015.65 and 6016.65) are evidence of this action. Aside from various marks of process on these studies, the most obvious distinction is the differing shapes of the prevailing charcoal forms. While refining the scale of the form to within ½ inch, the artist still seems to have been coming to terms with the broader issue of the configuration of the form.

Apparently this dilemma, which required considerable experimentation before resolution, continued to occupy Rothko during the construction of three pairs of paintings known as the "spares" for the chapel. To create the form, Rothko instructed his assistants to mark the shape with masking tape and fill it in with layers of black egg/oil emulsion paint over the plum ground. Although initially prepared the same way, pairs A and B are distinguished from the third by their consistent size and by the depth of their strainers—3 inches, as for the paintings in the chapel. The panels of pair C are wider, and their strainers recall the 1½-inch-deep working strainers with temporarily dislocated crossbars discussed above (fig. 1). While obviously continuing to resolve questions of proportion, Rothko was also manipulating a far more subtle and sophisticated variation among the pairs, which harks back to the interplay of media in his earlier work. In pair A, for example, the glimmer of clear polymer over rabbit-skin glue characterizes the plum ground, while the subdued surface produced by egg/oil emulsion paint differentiates the black rectangles. In addition to color, medium, and reflectivity, the black forms in this pair are further set apart from the plum borders and grounds by their density. In contrast, both the black form and the plum borders in pair B are painted in egg/oil emulsion and separated from one another only by a linear gap where the sharpness of the formerly taped edge of the black form meets the irregularity of the freely applied plum paint on the border. Hence the carefully wrought distinctions between form and

29 David Anfam first identified the complete numbered set of 1964 and described its significance in "Dark Illumination: The Context of the Rothko Chapel," in *Mark Rothko: The Chapel Commission* [exh. cat., The Menil Foundation, Inc.] (Houston, 1996). The author remains grateful to David Anfam for sharing this information, which allowed for the assembly of the set in the exhibition.

30 Nodelman 1997, 108.

31 Ulfert Wilke papers, diary entry for 14 October 1967 (p. 40), Archives of American Art, Smithsonian Institution, Washington, DC.

32 For a fuller discussion of these material differences see Carol Mancusi-Ungaro, "Nuances of Surface in the Rothko Chapel Paintings," in exh. cat. Houston 1996.

33 Edwards 1977, 4.

34 Wilke papers 1967, 40.

35 Breslin 1993, 473–474.

36 Edwards and Pomeroy 1971, 113–114.

37 Edwards 1977, 2.

38 Edwards 1977, 4.

39 Edwards 1977, 4.

ground that characterize pair A are absent in pair B, with its more physically, and reflectively, unified surfaces. [32]

The visual effect of this technical variation is that, despite remarkably muted tones, forms interact with the grounds in significantly different ways, as indeed they do in the chapel, where the technique of the single black-form painting on the south wall is comparable to that of pair B, whereas the lateral triptychs resemble pair A. Roy Edwards remembers that Rothko was "pleased with the slight sheen visible on the completed canvases, caused by the oil paints in the paint mixture." [33] Rothko also appreciated that the black-form paintings "appear similar but are not the same…the borders might have sheen and the dark inside is mat or vice versa." [34] It almost seems that as the artist removed himself physically from producing the paintings, with the employment of assistants, he allowed carefully orchestrated nuances of reflectance created by diverse materials to furnish the personal character that might earlier have been provided by his own hand.

Certainly in the chapel paintings Rothko brought to a culmination those subtleties of technique and interplay of media that he had spent years perfecting. At the same time, he boldly introduced monochromatic panels and hard-edged rectangles about which he was nervous, according to a studio neighbor. [35] Although clearly innovative for Rothko, the so-called mono-chromes celebrate brushwork in a way that is very much in keeping with the artist's earlier interests. Throughout, Rothko persisted in an endless fascination with the surface. As Edwards recalls, "But he didn't want it *exactly* even —just enough so it didn't look sloppy. A little bit of play, but not too much. It had to be just right. A couple that we did he didn't like and discarded." [36] Edwards further believes that "Rothko did not want the paintings to be too flat. He felt that the works of Noland and Stella, for example, were too cool and had no signs of involvement of the artist." [37]

Be that as it may, with the black-form paintings, at least, one could hardly say the hand of the artist is dominant. In fact there seems to be no physical sign of Rothko in them except in the most fundamental way. The black forms consist of many layers of egg/oil emulsion paint applied on top of a plum ground. In the course of painting, the assistants would "extend the outline of the rectangle, often by fractions of an inch," [38] as in the full-scale studies mentioned above. Naturally "traces of these rectangles are visible, especially in the eastern triptych," and Edwards also remembers that "Rothko accepted this appearance as the tracks of his involvement and control." [39] Years later these "tracks" became more visible as whitish *pentimenti,* which correlated directly with several small drawings that Rothko made and pre-sumably altered in the evenings after the assistants were dismissed. That the studies are made on black paper with graphite pencil, which becomes more

legible in the raking light of an incandescent bulb, corroborates the speculation that Rothko pondered the minute changes of each form at night, then had them realized the next day on the surface of the paintings. [40]

This slow, deliberative process is fitting for an artist who would customarily wait to see how a surface dried before he proceeded. According to William Scharf, "as beautifully as we might plan, we never really knew how a surface was going to dry, how it was going to turn out. And if it ever did dry uniform, he might decide he wanted it two colors lighter or two colors darker. It could be a perfectly magnificent black or a deep wine surface, but after a few days he might decide, no, it's not right, beautiful as it is." [41] Even with his earlier work Rothko "would sit and look for long periods, sometimes for hours, sometimes for days, considering the next color, considering expanding an area." [42] Is it not appropriate then that in the seemingly more minimal black-form paintings the "hand" of this artist, so prone to meditative silences, resides not in the obvious facture of the works but in the record of his thoughts?

Many years earlier, in 1953, Rothko explained, "Maybe you have noticed two characteristics exist in my paintings; either their surfaces are expansive and push outward in all directions, or their surfaces contract and rush inward in all directions. Between these two poles you can find everything I want to say." [43] That dialectic assumes a broader significance in Sheldon Nodelman's eloquent assessment of the meaning of the chapel installation where he identifies the carefully wrought "tensions of inwardness and outwardness, of soul and matter, and of centered unity and proliferating dispersion" in which Rothko envelops the viewer. [44] By skillfully demoting the sophisticated materiality of these massive paintings, the artist strives to diminish references to himself, the painter, while confronting who and what he is in a way that becomes, as he said earlier, "very intimate and human." Standing in the same place as the artist, without benefit of associative allusion, the viewer shares that experience. [45]

Rothko believed that "the progression of a painter's work, as it travels in time from point to point, will be toward clarity: toward the elimination of all obstacles between the painter and the idea, and between the idea and the observer....To achieve this clarity is, inevitably, to be understood." [46] Perhaps this is the aspect of Titian's engagement that so intrigued de Kooning. Renaissance painters replicated images within the confines of Christian iconography, just as Rothko persistently explored rectangular form within increasingly narrow, self-determined parameters. Even color, a hallmark of his classic work, was toned down in his later paintings. It seems that for an artist of such intellect and passion as Mark Rothko the search was for clarity of thought while the goal was clarity of expression.

40 The author would especially like to thank Elizabeth Lunning, paper conservator of the Menil Collection, for her insights in the discussion of these studies on paper.

41 Breslin 1993, 468.

42 Breslin 1993, 317.

43 Breslin 1993, 301.

44 Nodelman 1997, 329.

45 The author thanks William Steen for the many insights provided in private conversations.

46 Mark Rothko, "Statement on His Attitude in Painting," *The Tiger's Eye*, no. 9 (October 1949), 114.

47 Goldwater 1971, 62.

48 Goldwater 1971, 62.

49 Michael Kimmelman, "Two Who Define Today Amble into the Past," *New York Times,* 21 February 1997, B 28.

50 Mark Rothko, "The Ides of Art: The Attitudes of Ten Artists on Their Art and Contemporaneousness," *The Tiger's Eye*, no. 2 (December 1947), 44.

In addition to those thanked elsewhere in this article, I would like especially to acknowledge the contribution of the late Harris Rosenstein whose articulate appreciation of the genius of Mark Rothko profoundly affected my understanding of the artist's creative process.

Serious artists continue to paint and to stay engaged with the challenge that initially seduced them. It is not enough to look just at the fruit of their labor; one must wonder as well. With important works of art the vitality of a visual statement is often so overpowering that one hesitates to pause and evaluate the causal elements and energy. Heartless scrutiny is rarely in order, but curiosity and the appreciation it engenders often is. Of the last group of paintings, Robert Goldwater writes: "The paint, though still applied in many complicated layers to a deceitfully simple end, now lies flat and airless on the surface. Rothko's characteristic transparency, the breathing, floating disembodiment of pigment freed from its physical support, is gone. In its stead there is a mat and opaque plane altogether without that space filling quality which is nowhere more important than in the darkest of the Chapel murals."[47]

Even so, Goldwater cannot deny that "the insistent surface, seemingly uniform at first view, holds the attention by its subtlety of proportion and nuance of tone, and by the interaction of edge and area."[48] How reassuring that those qualities of surface, so apparent from the earliest of Rothko's classic paintings, remained vital for the artist until the end. As Bruce Nauman recently said with regard to de Kooning, "as you get older, it's valuable to see other people continuing to try to figure out why they're doing what they're doing."[49] Mark Rothko knew exactly what he was doing in paint but left much to the astute viewer to discern, for he believed that "a picture lives by companionship, expanding and quickening in the eyes of the sensitive observer. It dies by the same token."[50]

Rothko's Unknown Space

Fullness is emptiness given direction. JEAN-PAUL SARTRE

While Rothko's art invites extended contemplation, it has long proven diffi-
cult to describe. This is largely due to an inherent formal ambiguity in works
of the so-called classic period. Distinguished by expanding dimensions and a
dramatic compression of means, they are unadorned by figuration of any
kind yet possess an elusive quality of plenitude or depth. This simultaneity
of absence and presence has encouraged many observers to fill the vacancy
left by disappearing subject matter with a new body of images that serve a
descriptive or rhetorical role. As a result, the literature on Rothko, especially
from the artist's lifetime, tends to be metaphorical: these nonobjective paint-
ings are typically (if loosely) described in a quasi-representational way. Above
all, the experience of the works has often been portrayed as being one of both
an object and a *place*. Landscape, in particular, is most commonly invoked.

Rothko himself was known to repudiate interpretations of his art that
isolate formal elements such as color or space, denying, on separate occa-
sions, that he was primarily concerned with either of these.[1] He did, however,
accept and even perpetuate a metaphorical and affective response to form. In
fact, during a time when Rothko's manner of painting was new and unfamil-
iar, the metaphor was a useful device. At the very least, it represented a way in
which to begin addressing the question of meaning or content, a question
that the artist himself had provoked by sometimes alluding in written state-

1 Rothko denied he was a color-
ist in a conversation with
Robert Goldwater; see Gold-
water's "Reflections on the
Rothko Exhibition," *Arts
Magazine* (March 1961), 43.
The artist had already admon-
ished another interlocutor,
William Seitz, for responding
to his work in formal terms
such as space, insisting, "I
want pure response in terms
of human need"; see Rothko
interview, 22 January 1952,
William Seitz papers, Archives
of American Art, Smithsonian
Institution, Washington, DC,
box 15.

ments and interviews to large themes such as tragedy and death. If metaphoric imagery fills the "empty" pictorial spaces of Rothko's work, however, it also bears on the precise formal and conceptual nature of that space, especially when the metaphors conflict. Landscape, which is paramount in the literature on Rothko, suggests the impression of immense depth. A second, less familiar metaphor evokes another realm: that of architecture and, secondarily, urban space. Substituting structure for color or light as a chief concern, this image expresses the liminal nature of Rothko's work in physical terms—the center versus the margin, the portal, the wall—that belong (more closely than landscape) to the realm of the two-dimensional picture plane and to the roomlike scale of his most important canvases. Moreover, the architectural metaphor is one that was partly drawn from certain pictorial continuities that exist between Rothko's early and late work. Ultimately, in contrast to landscape, it is less an image than a device, establishing expressive principles of space in paintings of the classic and late periods, while permitting them to remain abstract.

Beginning in 1949, Rothko's technique was distinguished by the reductive application of color in translucent layers on canvases of gradually increasing size. Rothko's motif—stacked shallow rectangular forms that almost fill a shallow pictorial field—enabled color to attain a novel presence. This element, the fullness of color, certainly governs much Rothko criticism, although the exact function of color remains a difficult topic. In 1965, addressing color in Rothko, Max Kozloff described the artist's paint handling itself as "metaphorical," or suggestive of sensation. Specifically, Kozloff identified Rothko's color as being situated between pure hue and luminosity, an effect or "illusion" that the critic termed "color-light."[2] Kozloff included the dark paintings, with which Rothko was exclusively occupied by that time. Despite deeper values, he noted, Rothko's use of gray and maroon was not characterized by a corresponding increase in material density. Further, while the conventional juxtaposition of light and dark can optically diminish the chromatic identity of a dark color, Rothko was able to layer high and low values in such a way as to maintain the identity of the deeper hue. For Kozloff, Rothko's paintings are "auto-luminous," achieving a radiance that belongs to the canvas alone rather than to the realm of representation. But Kozloff's allusion to the metaphorical handling of paint, in which pigment—inert matter—is made to elicit "a variety of sensations," can also be taken to account for a much less rarefied appreciation of Rothko's work.

As noted above, a broad share of Rothko criticism demonstrates frequent recourse to metaphors that are derived from various conventions of pic-

torial representation. During the 1950s and 1960s landscape, above all, was commonly recalled, with varying degrees of literalness. Allusions to landscape are a function of Rothko's profoundly original implementation of color as well as his horizontal division of the canvas into an upper and lower zone, suggesting a horizon line. This is so despite the fact that, as Anna Chave has discussed, the forms do not extend all the way to the edge of the canvas; they are not cropped by the frame the way the horizon is in conventional landscape painting.[3] Nonetheless, the lure of landscape in Rothko's work is strong, and its relevance implies the impression of three-dimensional space, for which the most useful rhetorical equivalent is understood to lie beyond the confines of the canvas. Landscape, or nature in general, is also used to establish the role of emotion or mood in Rothko's work.

In 1958 Elaine de Kooning described Rothko's large paintings as being possessed of tension or impending threat, which she likened to the physical experience of "atmospheric pressure" and the "ominous, pervasive light" that precedes a hurricane. Rothko's shapes inhabit illusory space: they "loom," "expand," and "approach."[4] This was the sort of conceit that Robert Rosenblum drew on, in a now classic formulation from 1961, when he described paintings by Rothko, as well as Jackson Pollock, Barnett Newman, and Clyfford Still, as having descended from the eighteenth-century romantic concept of the Sublime (as it was discussed by Burke and Kant among others), a quasi-religious state of awe induced by the experience of nature on a vast scale.[5] According to Rosenblum, representations of boundless space in the work of painters such as J.M.W. Turner and Caspar David Friedrich already map Rothko's pictorial coordinates of shapeless expanse, where a remote and un-named presence is similarly concealed by hushed stillness and radiant depth. Standing before a Rothko canvas, the viewer is a surrogate for the minuscule figures that appear in romantic landscape painting, as in Friedrich's *Monk by the Sea,* where they lend the impression of vast scale.[6] The lineage of Friedrich to Rothko is an arresting one, in which the depiction of landscape as an object of emotional or spiritual awe is the prototype for a kind of abstract painting that evokes grand space on a canvas of large but obviously limited dimensions. Rosenblum refers to this as the "Abstract Sublime." "We ourselves are the monk before the sea," he wrote, "standing silently and contemplatively before these huge and soundless pictures as if we were looking at a sunset or a moonlit night."[7]

The Abstract Sublime is the sophisticated extension of an existing trope, that of landscape. It posits a solution to the elusive question of content in Rothko's work, about which the artist's most explicit statements almost all predate his development as an abstract painter. The urgency of the landscape comparison (which inspired a bicentennial exhibition of American landscape

2 Max Kozloff, "The Problem of Color-Light in Rothko," *Artforum* (September 1965), 39–44.

3 Anna C. Chave, *Mark Rothko: Subjects in Abstraction* (New Haven and London, 1989), 128–132. Chave's book-length thesis concerns yet another metaphorical characterization of subject matter in Rothko's work, that of the human figure.

4 Elaine de Kooning, "Two Americans in Action: Franz Kline, Mark Rothko," *Artnews Annual* 27 (1958), 176.

5 Robert Rosenblum, "The Abstract Sublime," *Artnews* (February 1961), 38–41, 56–58. For later references to the sublime in Rothko's work see Irving Sandler, "Mark Rothko," in *Mark Rothko: Paintings, 1948–1969* [exh. cat., Pace Gallery] (New York, 1983), 7–8, 13 n. 20; and Brian O'Doherty, "Mark Rothko: The Tragic and the Trans-cendental," in *American Masters: The Voice and the Myth* (1973; repr. New York, 1988), 208–209. Sandler notes that Rothko approved of Rosenblum's reference to the Burkean sublime; he also cites Robert Hughes' arch skepticism on the subject, in Hughes' "Blue Chip Sublime," *New York Review of Books* (21 December 1978), 16.

6 Brian O'Doherty would later relate the nineteenth-century heritage of the sublime void and "etheric space" in Rothko's work to the romantic concept of pictorial "vagueness." On large-scale painting and the absent figure see O'Doherty 1988, 207–212.

7 Rosenblum 1961, 40, 56.

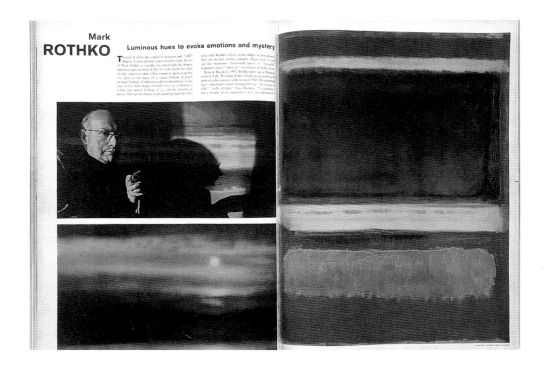

8 See Kynaston McShine et al.,
 The Natural Paradise [exh.
 cat., Museum of Modern Art]
 (New York, 1976), which was
 preceded by a less ambitious
 exhibition based on a related
 premise, *Landscapes, Interior
 and Exterior: Avery, Rothko,
 and Schueler* [exh. cat., Cleve-
 land Museum of Art] (Cleve-
 land, 1975). Rosenblum also
 expanded his thesis as a series
 of Slade Lectures at Oxford
 University, which were pub-
 lished as *Modern Painting and
 the Northern Romantic Tradi-
 tion: Friedrich to Rothko* (New
 York, 1975).

9 Dorothy Seiberling, in
 "Abstract Expressionism.
 Part II," *Life* (16 November
 1959), 82.

painting at the Museum of Modern Art in 1976 in which Rothko was fea-
tured[8]) partly derives from its similarity to descriptions of Rothko's work in
the popular press. Most conspicuously, in a color spread published in 1959
(fig. 1), *Life* magazine had already employed explicit "analogies with nature"
to "explain" Rothko's paintings, juxtaposing a photograph of the artist sitting
before a canvas (which was also reproduced on the facing page) with one of
an actual sunset: "Just as the hues of a sunset prompt feelings of elation min-
gled with sadness or unease as the dark shapes of night close in, so Rothko's
colors stir mixed feelings of joy, gloom, anxiety or peace. Though the forms
in the painting opposite…seem simple at first glance, they are in fact subtly
complex. Edges fade in and out like memories; horizontal bands of 'cheerful'
brightness have 'ominous' overtones of dark colors."[9]

 If Rosenblum's sunset is Sublime, *Life* magazine's is perhaps Pictur-
esque. In this case color (more than space) is the touchstone for Rothko's
naturism, although landscape is the preferred setting. By 1971, however,
shortly following Rothko's death, Robert Goldwater revived the spatial meta-
phor of landscape in a discussion of the artist's last paintings, produced
between 1968 and 1970. For Goldwater landscape is pertinent solely in refer-
ence to the late works, which are distinguished by relatively opaque upper
and lower fields of black and brown or gray that extend to the white margins
of the picture, forming an explicit "horizon" line where they meet. Trans-
parency and color had previously imbued Rothko's classic forms with an
active, advancing presence; now Rothko summons the "naturalism of deep
space," which leaves both an optical and psychological impression of reces-
sion and withdrawal. Landscape also permits Goldwater to apply a kind of
pathetic fallacy to the paintings, which are now said to reflect the somber iso-

lationism of Rothko's final year.[10] While the metaphor of landscape was not Rothko's own, Goldwater claimed that it had been approved by the artist with respect to the late work. Yet ten years before, Rothko had publicly sanctioned Goldwater's review of his 1961 retrospective at the Museum of Modern Art in which Goldwater spurned the "literary fancies" that some had seen fit to apply to Rothko's work, including expressive references to landscape, the "symbolic action of storm clouds gathering on an immense horizon."[11]

Rothko made few public statements about the mechanics of color or pictorial space in his work, especially after 1949. During the late 1940s, however, he described the conception of a painting in which "shapes"—or "performers"—first emerge as "an unknown adventure in an unknown space."[12] Rothko's remarks from this period, just prior to the development of his ultimate format, reflect the artist's struggle with categorical distinctions between abstraction and representation and his ambition to invest nonfigurative art with transcendent content, something that would rival the elemental role of myth and ritual in archaic culture. In this regard, "unknown" pictorial space describes a realm that somehow surpasses two dimensions while avoiding the illusive three-dimensional space of conventional representation. One year later Rothko abandoned his reference to the figure of the performer and traded the notion of "unknown space" for the goal of a space that could be experienced instead as intimately known.

As early as 1943 Rothko had shown himself to be uncomfortable with abstract art, declaring his adherence to the "substance of things."[13] By 1949, when urban, classical, tribal, and primordial imagery had been successively eliminated from his work and his shapes gradually enlarged, Rothko devised the concept of pictorial "clarity" as "the elimination of all obstacles between the painter and the idea, and between the idea and the observer. As examples of such obstacles, I give (among others) memory, history or geometry, which are swamps of generalization from which one might pull out parodies of ideas (which are ghosts) but never an idea in itself. To achieve this clarity is, inevitably, to be understood."[14] For Rothko clarity in painting represented visual apprehension unmediated by subject matter ("memory, history") and style ("geometry"). Less than two years later, in 1951, this was formulated as a physical, rather than merely perceptual, relationship between the canvas and the body of the observer, in terms that imply the possibility of conflating real and pictorial space. By this time Rothko was painting on a consistently large scale, and he justified the big canvas as a means by which to achieve "spiritual communion": "I realize that historically the function of painting large pictures is painting something very grandiose and pompous. The reason I paint them, however…is precisely because I want to be very intimate and human."[15] By contrast, the artist dismissed small-format painting, compar-

10 Robert Goldwater, "Rothko's Black Paintings," *Art in America* 59 (March–April 1971), 58–63.

11 Goldwater 1961, 42–45. Rothko requested that Goldwater's review replace Peter Selz' essay in the London edition of the exhibition catalogue when the retrospective traveled to the Whitechapel Art Gallery later that year. For a firsthand recollection of Rothko's repudiation of the landscape comparison in his late work see also Brian O'Doherty, "Rothko's Endgame," in *Rothko: The Dark Paintings 1969–1970* [exh. cat., Pace Gallery] (New York, 1985), 5.

12 Rothko, "The Romantics Were Prompted," *Possibilities* 1 (Winter 1947–1948), 84.

13 Rothko, "Personal Statement," in *A Painting Prophecy—1950* [exh. cat., David Porter Gallery] (Washington, DC, 1945). See also "The Portrait and the Modern Artist," radio interview with Adolph Gottlieb and Mark Rothko, WNYC New York, 13 October 1943; reprinted in *Adolph Gottlieb: A Retrospective* [exh. cat., Corcoran Gallery of Art] (Washington, DC, 1981), 170.

14 Rothko, "Statement on His Attitude in Painting," *The Tiger's Eye* (October 1949), 114.

15 Rothko, in "A Symposium on How to Combine Architecture, Painting, and Sculpture," *Interiors* 10 (May 1951), 104.

16 Marcelin Pleynet, "L'Exposition Mark Rothko," *Tel Quel* (Winter 1963), 40.

17 See Jonathan Harris, "Mark Rothko and the Development of American Modernism, 1938–1948," *Oxford Art Journal* 1 (1988), 40–50. For accounts of Rothko's artistic activity during the 1930s, see also Dore Ashton, *About Rothko* (New York, 1983), chaps. 3 and 4.

18 Lucy Embick, "The Expressionist Current in New York's Avant-Garde, 1935–1940: The Paintings of 'The Ten,'" *Rutgers Art Review* (Spring 1984), 56–69; and Isabelle Dervaux, "The Ten: An Avant-Garde Group in the 1930s," *Archives of American Art Journal* 31, no. 2 (1991), 14–20.

19 Diane Waldman, "Mark Rothko: The Farther Shore of Art," in *Mark Rothko, 1903– 1970: A Retrospective* [exh. cat., Solomon R. Guggenheim Museum] (New York, 1978), 28, 30. For a thoughtful discussion of the subway paintings see also Breslin 1993, 127–130.

20 David Anfam, "Notes on the Art of Marcus Rothkowitz: Between Time Past and Future," in *Against the Stream: Milton Avery, Adolph Gottlieb, and Mark Rothko in the 1930s* [exh. cat., Katonah Museum of Art] (Katonah, NY, 1994), 24–31.

ing it in mechanistic terms to the diminutive view through a "stereopticon" or "reducing glass." The painter—Rothko specifies himself rather than the viewer *per se*—physically "commands" the small painting, while he experiences the large one from within.

Whereas the small painting is only an object, the large one is also a place. Rothko emphasized the dimensions of the canvas in actual space, rather than an illusion of depth and breadth beyond the picture plane. Yet characterizations of Rothko's pictorial space commonly reveal a distinct impression of illusive depth. Reviewing a Rothko retrospective in 1963, for example, the French critic Marcelin Pleynet referred to the emergence between 1945 and 1950 of an *espace habitable* in Rothko's work, which he equated with the unforgettable "presence" of the classic canvases.[16] This is not the deep space of landscape, but something akin to Rothko's own vision of paintings that can be experienced close up and from within. As opposed to landscape, the metaphor or model of architectural and urban space accommodates the dimension of Pleynet's habitable space, which is itself tropological, but seeks to correspond to the scale of the paintings themselves and their physical relationship to the beholder. This alternate analogy is also one to which Rothko referred, and its relevance can be traced back to the artist's own early work.

Rothko's paintings of the New York scene have long been credited with motifs and compositional devices that seem to anticipate the artist's later pictorial concerns. In particular, works from the middle to late 1930s are taken up with interiors as well as subjects lifted from the subway and the city street in which figures—represented in a spare, unrefined expressionist idiom—are placed in a variety of measured spaces (fig. 2). Defined by walls, doors, and other architectural elements, depicted space in these paintings is compressed by the artist's simplified manner, producing a shallow pictorial realm that is only occasionally relieved by pockets of plunging depth. Typically isolated or in pairs, Rothko's actors occupy segregated zones, within which they can only be described as having been sequestered or constrained.

Rothko's urban settings are generally vague, but the subway clearly engrossed him as a unique realm of experiential space. By the time he took it up, it already belonged to a list of gritty, unglamorous urban subjects that typified depictions of Manhattan during the period, especially among artists of the Ashcan School and related tendencies in realist art. Rothko's numerous subway paintings stand apart, however. While the subject is usually treated by Rothko's contemporaries as one of human interest, his own images display a sustained emphasis on the peculiar coordinates of subway space. Painters and

illustrators such as Reginald Marsh and Raphael Soyer feature the inside of the densely populated passenger car for its local color; Rothko remains on the station platform. There he experienced the subway as a measured yet eccentric place, containing a dramatic contrast of perspectival extremes: walls and railings are represented as flat screens, while tracks recede sharply. Figures can be identified by anecdotal details of dress as commuters, shoppers, or schoolchildren, but they are largely attenuated, faceless, and flat. Ultimately, Rothko's characters are remote ciphers that establish scale. As such, they possess a haunted air, as if existing solely to inhabit the border that separates real and pictorial space.

The active, often oppositional, role Rothko played in left-wing artists' groups during the 1930s would suggest that his striking portrayal of the city is an ideological one, all the more since the artist's disregard for "social realism" has been taken to account for his eventual eschewal of subject matter—but

not "content"—during the late 1940s, a shift that has itself been accounted for in expressly political terms.[17] If Rothko's street scenes and subway pictures have been compared to examples of Depression-era realist and expressionist painting, however—including works by members of the Ten, an exhibition group of the 1930s that he cofounded[18]—they are rarely more than generically identified as such. Diane Waldman has instead observed that Rothko's apparitional subway paintings in particular suggest a "nether-region" that anticipates his subterranean surrealist imagery of the mid-1940s, and she has detected a timeless quality that suffuses his later work.[19] David Anfam has more specifically addressed the expressive and metaphorical implications of framing devices in these and other works of the 1930s in relation to the window, the wall, the door, and the street itself as thresholds or zones of passage, among which the subway is a supreme example.[20] Preoccupied by an apprehensive physical and perceptual experience of space, these devices are not unrelated to the artist's later "obsessive" concern with the relationship between the painting and its beholder. In Anfam's interpretation the works also belong to the culture of the modernist city, as reflected, for example, both in Depression-era photographs of New York by Paul Strand and Aaron Siskind, which sometimes capture the spaces of the city street as post-Baudelairean

21 This proclivity may be related to Rothko's innate preference for the city over the country as a place to live and work, which was later attested to by friends and family members. See James E.B. Breslin, *Mark Rothko: A Biography* (Chicago and London, 1993), 87, 379–381.

22 Alfred Kazin, *A Walker in the City* (New York, 1951), 5–50.

23 Elmer L. Rice, *The Subway* (New York, 1929). Concerning Rice's play, I am also indebted to Anthony F.R. Palmieri, *Elmer Rice: A Playwright's Vision of America* (Rutherford, NJ, 1980), 77–86; and Frank Durham, *Elmer Rice* (New York, 1970), 69–74.

24 Richard Gehman, "Nether World" [1951], reprinted in Alexander Klein, ed., *The Empire City* (New York, 1955), 143.

zones of estrangement and unease, and in the literature of the Jewish immigrant experience, which represents the city as a disorienting and literally alien world.

Of course, Rothko's early work also includes landscapes, most often in watercolor and gouache, executed in the style of John Marin and Milton Avery. These scenes of Portland, Oregon, and Gloucester, Massachusetts, are largely devoid of the sort of atmospheric perspective that one would expect to encounter in an artist whose later work has been taken to suggest barometric pressure and the luminosity of natural light. If anything, they are distinguished only by the occasionally bold use of man-made elements, such as a fence or a building, which tend to possess a raw geometric presence. Rothko's images of the city demonstrate a much more idiosyncratic and searching examination of physical milieu, revealing that his affinity lies less with the open vision of landscape than with urban perspective, which is an alternately channeled and obstructed space.[21] Subsequent works show him developing these qualities. In the mythological and religious paintings that the artist created between 1941 and 1943, a series of symbolic works that directly followed his images of the city, Rothko openly extrapolated from his compartmentalization of urban space. Direct comparisons—between *Entrance to Subway* and an untitled painting that incorporates disembodied anatomical elements related to the Crucifixion, for example (cats. 9 and 12)—are inevitable. Certain sketchbook drawings for the subway pictures, in which the figural element is often highly obscure, also demonstrate a resemblance between Rothko's approach to the city and his later, more abstract or symbolic idiom. In one example (fig. 3) pillars, turnstiles, and a doorway are virtually unrecognizable as such, although framing elements ultimately demarcate an illusion of interior space. The passage on the left is also vaguely inhabited (its counterpart may be the torso niche on the right side of the Crucifixion); marked "exit," it remains a representational crossing.

If, as Anfam observes, Rothko's New York is the city of both a modernist and an immigrant outsider, then the intellectual history of urban space should reveal a quality of experience that Rothko might be said to have inherited or shared. Anfam cites Henry Roth's *Call It Sleep* (1934), in which an overlay of Old World memories and New World experience creates a haunting elasticity of time and place. As a genre, the Jewish immigrant memoir does reflect certain anecdotal parameters of cultural life that pertain to Rothko. One example even alludes to the specific trajectory of Rothko's career, beginning with the city pictures and culminating in the Houston chapel commission of 1964–1967, the most explicit expression of metaphysical content in his oeuvre: this is the first chapter of Alfred Kazin's memoirs of the immigrant experience in Brooklyn during this period, entitled "From the

Subway to the Synagogue."[22] But do specific spatial coordinates emerge within this context, and do they pertain to Rothko's work? In Kazin's account the subway ride from Manhattan to Brownsville quantified the vast physical and social distance that existed between the Jews of Brooklyn and the "real" New York. Brownsville itself is remembered as a peripheral province, the "margin of the city, the last place," where immigrants were "of the city, but somehow not in it." Unused lots populated by weeds, scattered trash, and fresh lumber are "Brownsville's great open door, the wastes that took us through to the west"; a stone quarry at night, filled with faceless gray slabs destined to be carved into tombstones, was "oppressively…mysterious and remote, though it was only just down the block." This "monument works" offered an alluring *frisson,* a rush induced by exhilaration and fear (a friend of Kazin's had fallen to his death there playing hide-and-seek). Other literature of the period further confirms that the subway, in particular, could be an obvious object of darker dramatic interest. In an early play by Elmer Rice, *The Subway* (originally produced in New York in 1929), various subway settings form the backdrop for an overwrought quasi-expressionist theater piece about the wages of sin.[23] Here the subway (in tandem with the skyscraper) is both extolled as a wonder of the modern world and decried as a place of ennui and finally despair. Scenes transpire both in the car and on the platform (fig. 4), where figures "try vainly to read tightly folded newspapers" or, "for the most part, stand silent, immobile, staring vacuously…." In the course of the play Sophie, the protagonist, who will bring

FIG. 4 / SCENE FROM *THE SUBWAY*, A PLAY BY ELMER RICE, PUBLISHED 1929.

down the final curtain by leaping to her death on the tracks, inspires a coworker to propose an "epic of industrialism" entitled "The Subway"; this visionary work would portray the subway as a "sepulchre" to which millions flee during an apocalyptic war, only to be discovered by future archeologists as a "heap of bones" (among which the body of a young girl, "miraculously preserved," remains as a startling vision of eternal beauty). Rice's mythic subway, even as it prefigured the doomsday scenarios of postwar/postnuclear urban fiction of the middle to late 1940s, was sustained by the sociologist's underground. In a later report on conditions in this "nether world" one reads that the "dim-lit, damp, stretching caverns of the subway seem to attract people intent on doing away with themselves."[24] The darker implications of the subway were in turn easily extended to the underground life in general: "Up above there something was always doing," mused the subway guard in a crime

25 Cornell Woolrich, "You Pays Your Nickel," in *Argosy* (22 August 1936), 54.

26 See Gerdt A. Wagner, "Decoration of a Subway Station," *Beaux-Arts Institute of Design* (January 1936), 6–8; and "Underground Art," *Art Digest* (December 1936), 12.

27 For exhibition reviews see "New Materials and Projects in Subway Decoration," *Artnews* (19 February 1938), 13–14; "Burrowing Artists," *Art Digest* (1 March 1938), 10; "Underground Art," *Magazine of Art* (March 1938), 173; and "Subway Art," *Design* (April 1938), 26.

28 "Underground Art," *Art Digest* (December 1936), 12.

29 See Stephen Polcari, *Abstract Expressionism and the Modern Experience* (Cambridge, 1991), 123–133.

thriller by Cornell Woolrich from 1936; "down here below ground where he was, nothing ever happened—you were like in your grave already."[25]

Any allegorical appreciation of subway space during the period lies in contrast to the issue of beautification. In 1936 the United American Artists, working under the New York Federal Art Project, proposed a large campaign of subway mural decoration, with the intention of prettifying the "drab gray caves" of underground transit.[26] Special forms of enamel and glazing were developed to resist vibration, dirt, and variations in temperature and humidity. Studies and models for the project were actually exhibited at the Museum of Modern Art in 1938 (see fig. 5), provoking a certain amount of debate in the art press.[27] Appropriate subject matter was one concern, and the relative merits of realism and abstraction were also raised. It was generally agreed that the murals should be both easy to see at a glance and essentially decorative or escapist. Although a number of exhibited entries included images of the subway platform and construction workers excavating underground space, the subway itself appears to have been an unpopular subject among the critics. According to a report in the *Art Digest,* opponents of the project argued that many platforms were already decorated with polychrome enameled tiles and plaques. Supporters believed that mural decoration was long overdue in most stations: "The sight of a few dozen tired New Yorkers, staring bleakly at dirty girders, foul skylights and chewing-gum paved floors is enough to turn a normal man into a sad minor poet of despair," one observer wrote in 1936.[28] Of course, poets of despair might be said to have been uncovering—rather than beautifying—an existential truth; at least they would have observed this of themselves. While Rothko's vision of the subway (unlike

FIG. 5 / G. WILDER, SUBWAY MURAL DESIGN, SUBMITTED TO THE NEW YORK FEDERAL ART PROJECT, 1936.

Rice's) is devoid of melodrama, it does correspond to a downbeat mythology of urban space, especially that of the underground, which would have been mitigated by decoration.

The iconography of Rothko's subsequent work would correspond to his interest in the subway as, in Rice's words, a "sepulchral" realm. As Stephen Polcari has discussed, Rothko's paintings and watercolors of the mid-1940s are further devoted to the allegorical underground: the motif of entombment represents the theme of death and regeneration, while the substrate realm of geology and paleontology (in works with titles such as *Geologic Reverie* and *Prehistoric Memory*) alludes to a Jungian domain of primitive myth and the primordial recesses of the unconscious mind.[29] Of course geology denotes

FIG. 6 / MARK ROTHKO, *VESSELS OF MAGIC*, 1946, WATERCOLOR ON PAPER, 98.4 X 65.4 (38 ¾ X 25 ¾), BROOKLYN MUSEUM OF ART, MUSEUM COLLECTION FUND. SEE ALSO CAT. 31.

FIG. 7 / YVES TANGUY, *EXTINCTION OF USELESS LIGHTS*, 1927, OIL ON CANVAS, 92.1 X 65.4 (36 ¼ X 25 ¾) THE MUSEUM OF MODERN ART, NEW YORK.

nature, and it is during this period that the allusion to landscape in Rothko's abstract work is especially pronounced. Here Rothko also frequently partitioned the pictorial ground into two or three horizontal zones, a device that can be likened both to the banded and subdivided spaces of the city pictures and to the compositional format of later work. In this case Rothko drew primarily on the subaqueous surrealist images of Yves Tanguy (figs. 6 and 7), whose pictures were understood to represent inner landscapes of the mind. [30] Tanguy's work was accessible during 1945–1946 in two exhibitions at the Pierre Matisse Gallery in New York, which published an illustrated monograph with English translations of texts by André Breton. Conflating landscape and cityscape, the subway was, in retrospect, already an earthwork of sorts, an excavation that literally and figuratively lay below.

As both a theme and a type, the urban substrate was embedded in the contemporary mythology of New York City, and this allows us to establish a scheme within which Rothko's own interest accumulates meaning. In 1938 the photographer Walker Evans descended into the subway as an anonymous portraitist, shooting passengers with a hidden camera—like a "spy" and a "voyeur." While the results, a remarkable series of deadpan images, were not made public for fifteen years, they demonstrate just how convenient the subway had become as an index of the urban psyche. In the subway car (rather than the platform) Evans also found a compartmentalized setting of window frames that was heightened both formally and expressively by cropping (fig. 8) but that equally corresponded to the separation of frames on a negative and a proof sheet. [31] That is to say that Evans, like Rothko, discovered a manner of framing pictorial space in which the subject and the medium could interact. Evans demonstrates that if subterranean space is a kind of

30 André Breton, *Yves Tanguy* (New York, 1946), 78.

31 See Sarah Greenough, "Many Are Called and Many Are Chosen: Walker Evans and the Anonymous Portrait," in *Walker Evans: Subways and Streets* [exh. cat., National Gallery of Art] (Washington, DC, 1991), 13–46.

FIG. 8/WALKER EVANS, *SUBWAY PORTRAIT*, 1938/1941, GELATIN SILVER PRINT, NATIONAL GALLERY OF ART, WASHINGTON, GIFT OF KENT AND MARCIA MINICHIELLO.

genre, its metaphorical implications for Rothko's later work cannot be idiosyncratic to Rothko alone. Further indication of this can be found in a surprisingly pertinent image by Diego Rivera, a mural-like fresco panel from 1931 entitled *Frozen Assets* (fig. 9), which the artist created for a retrospective of his work at the Museum of Modern Art. Part of a seven-panel suite that allegorizes abuses of capital and the subjugation of the working class, *Frozen Assets* shows a three-tiered cross section of New York in which the (sleeping?) bodies of the proletariat are entombed beneath the soaring cityscape, while presumably vast wealth is inaccessibly interred in a bank vault below.[32] Rivera's crosscut portrays urban space as a vertical realm, both above and below ground, a place that is darkly (if somewhat tritely) symbolic of the modern human condition as a socioeconomic consequence of the forces that shaped the city itself. The result, a symbolic use of space, cannot be denied its resemblance to Rothko's format of the early to middle 1950s.

It would be difficult to claim that Rothko's laconic New York scene paintings openly exemplify the motif of the fated or abandoned city, which David Reid and Jayne L. Walker have traced from the "doomsday chic" of T.S. Eliot's *Waste Land* to the cultural pessimism of pulp fiction during the Depression and the postwar tradition of the *roman noir*.[33] That Rothko's images possess a distopian air during a post-utopian era of economic decline does require us to account for them in relation to the desolate culture of the urban scene, a conception of the city that is often expressed in turn as the experience of a peculiar space. Although the subway paintings are particularly germane, Rothko's street scenes are also characterized by claustrophobic buildings and somber, sparsely inhabited city squares (see cat. 4). The early work of Giorgio de Chirico is generally acknowledged to have left an imprint on these images, although Rothko's idiom has little in common with the modernist's deadpan technique. Indeed, de Chirico shows up perhaps even more convincingly in Rothko's ensuing series of mythology paintings, which seem to be partly indebted to de Chirico's works of the early to middle 1930s. Shown and reproduced in New York at the Julien Levy Gallery in 1936,[34] these depict neoclassical figures inhabiting stagy, often askew architectural settings, and the application of paint is (appropriate to Rothko) somewhat loose and flat.

In any case, the street is no less susceptible than the subway to contemporary narratives of urban space, apart from de Chirico's example. From

32 For a discussion of Rivera's *Frozen Assets* see Alicia Azuela, "Rivera and the Concept of Proletarian Art," in *Diego Rivera: A Retrospective* [exh. cat., Detroit Institute of Arts] (New York, 1986), 126; and Peter Conrad, *The Art of the City* (New York, 1984), 150–151.

33 David Reid and Jayne L. Walker, "Strange Pursuit: Cornell Woolrich and the Abandoned City of the Forties," in Joan Copjec, ed., *Shades of Noir: A Reader* (New York, 1993), 69–72.

34 For de Chirico in New York see Emily Braun, ed., *Giorgio de Chirico and America* [exh. cat., Hunter College] (New York, 1996).

about 1910 to 1920, for instance, municipal zoning regulations were instituted to control the random development of the city, and set-back laws were initiated to prevent the skyscraper boom from depriving urban streets of light and air.[35] Tall buildings "rear[ed]…to heroic height on a relatively insignificant area" would now be conceived in terms of massing, according to which some—such as the RCA Building at Rockefeller Center from 1932—took on the appearance of an undifferentiated "slab." "It is an employment of the same basic element that is used by the painter in his hovering planes," wrote Sigfried Giedion in 1956.[36] In retrospect, new formulae such as these are revealing not only for what they accomplish but for what they portend. Although New York was reconceptualized in theory as a rational metropolis of visionary dimensions, utopianism was outpaced by the congestion it was conceived to forestall, and the soaring development of the city created margins, shadowy corridors, and pockets of eccentric space that subverted the premise of the rational plan. The dark, maze-like, "defamiliarized" street of detective fiction—usually set in New York or Los Angeles—certainly exploits this phenomenon. And, as Reid and Walker observe, a taste for *film noir* partly accounts for the way in which New York would soon be portrayed by visiting French existentialists during the war. In "Manhattan: The Great American Desert," published in 1946, Jean-Paul Sartre experiences New York in disquieting spatial terms.[37] Sartre wrote that his glance "encountered only space," with "nothing to focus on but the vanishing point." Avenues consist not of neighborhoods, but "atmospheres—gaseous masses extending longitudinally without well-defined beginnings or endings." Where the huddled houses of European cities are conceived as a "protection against space," New York is "traversed" by space. Here, "pure space suddenly appears." Sartre gradually learns to appreciate New York not as a conglomeration of individual parts, but as "massive ensembles and great perspectives"; rows of buildings "achieve their fulfillment below, at the end of the avenue, in simple harmonious lines, and a patch of sky flows between them." Skyscrapers, symbols of an obsolete faith in progress, are neglected, suggesting "that New York is about to acquire a history, that it already has its ruins."

The disorientation of urban space infiltrates the epoch at many levels. Rothko shared with the French an appetite for urban crime fiction, and big

35 For an overview see Carol Willis, "Zoning and Zeitgeist: The Skyscraper City in the 1920s," *Journal of the Society of Architectural Historians* (March 1986), 47–59.

36 C. Matlack Price, "The Trend of Architectural Thought in America," *Century Magazine* (September 1921), 712; and Sigfried Giedion, *Space, Time and Architecture: The Growth of a New Tradition* (Cambridge, MA, 1956), 750.

37 Jean-Paul Sartre, "Manhattan: The Great American Desert," originally published in *Town & Country* in 1946; reprinted in Klein 1955, 451–457.

FIG. 9 / DIEGO RIVERA, *FROZEN ASSETS: A CROSS SECTION THROUGH THE CITY*, 1931, FRESCO, 239 X 188 (94 ⅛ X 74), PRIVATE COLLECTION.

noir themes such as destiny and chance are not without relevance to his philosophical interests. According to Elaine de Kooning among others, Rothko and members of his circle were avid readers of Raymond Chandler and Dashiell Hammett,[38] sad minor poets of despair who probably come closer to a form of true mythmaking than do the likes of Eliot (sometimes cited as the essential model) or immigrant-novelists such as Roth: in this regard, perhaps *Call It Sleep* is less relevant than *The Big Sleep*. Yet if the metaphor of urban space pertains in any useful or legitimate manner to the development of pictorial space in Rothko's classic work, it does so in an encoded way. After all, Rothko's primary idiom remains an abstract one, and the role of the city—of architectural and interior space in particular—should not encourage us to overfamiliarize works of such commanding nonobjective presence. Instead, elements of poetic space in the urban narrative of Rothko's generation, some of which can be observed in his images of New York, must be required to inhabit a broader and less literal concept of pictorial space, although one that, in Rothko's case, is also not irreducibly formal.

In "Les Mosquées de New-York, ou l'art de Mark Rothko," a review of the Museum of Modern Art's 1961 Rothko retrospective (published the same year as Rosenblum's "Abstract Sublime"), the French critic Michel Butor gave serious consideration to the role of the city in the artist's later work.[39] Butor begins by cataloguing the differences between Rothko and Mondrian, who were sometimes compared: Mondrian's small format as opposed to Rothko's large one; asymmetry versus symmetry; a limited range of contrasting colors applied in maximum density as distinct from a large range of colors transparently applied, often in barely perceptible contrast to one another; and the ability of Mondrian's works to be assimilated at a glance against the slowly unfolding perceptual experience of paintings by Rothko. Extrapolating from his dichotomy, Butor goes on to define both bodies of work in relation to the context of New York. Mondrian, who arrived there in 1940, found recent architecture and the urban grid to be the fulfillment of a utopian geometrical scheme on which his work had long been based, a scheme that had, nonetheless, originally emerged from within the confines of his paintings. For Rothko, who had been in New York since 1925, the rectangularity of the canvas was imposed by an urban geometry (Giedion's "slab") that by the 1950s had failed to realize its utopian promise; the canvas was now a "rampart" struggling to subjugate the crass profusion of modern culture. "Rothko's art responds to an encumbered city," Butor wrote, where the utopian rectangle is a shop window in which things of value are impossible to recognize among

base goods and false claims. Within this cacophony of words and things, Rothko's paintings transform the post-utopian rectangle into an "empty space" or "blank page"; in this way their function is comparable to that of a mosque, a "cube of silence" amid the commotion of small streets and congested bazaars in an Islamic city—a place of "aeration, of purification, of judgment."

Again we return to the metaphor of the painting as both an object and a place, now in the context of American urban culture at midcentury. While works produced before 1945 were excluded (by the artist himself) from the 1961 retrospective, Butor could still observe that Rothko's work prior to 1950 was characterized by a clear distinction between object and ground. Even in the multiforms one glimpses "objects in space," an impression that Butor compares to landscape. A last vestige of drawing remains in *No. 5* (*No. 22*) from 1950 (cat. 46), with three white lines that extend across the canvas and almost touch in the center. Subsequently, according to Butor, one must speak of Rothko's paintings in terms of frontality and chromatic movement, effects that are comparable to the transparent projection of light on a screen. And one encounters a dynamic experience in which forms relate not only to each other—within a field and against a margin—but to the beholder. In the context of the "mosque" this kind of reading describes the role of the city as being internal to the experience of the works themselves: as a setting (the place where the paintings were produced), the city has exercised both a physical and an allegorical impact on the shifting role of the canvas and the frame, one that enables the work to function in turn as a rupture within the metropolis. Inside an area of space that bears the imprint of modernist geometry, Rothko establishes an ambiguous domain that represents the very opposite of the rational grid, reinstating a "mythic" or nonrational realm of meaning that had been eradicated by the logic and transparency of modernist style.[40]

Butor addresses Rothko's work, both literally and metaphorically, as representing and embodying what might be referred to as "symbolic space," a term that has been applied to the intellectual history of architecture by Richard Etlin. Etlin observes that, on a symbolic level, architectural space can be made to constitute a "domain that seems qualitatively different from the surrounding world, an area that puts us in contact with something intangible."[41] Historically, this is especially relevant to commemorative architecture during the Enlightenment period in France, although its devices transcend that epoch. In the funerary buildings of Etienne-Louis Boullée, for example, the creation of a symbolic interior space can be said to recall anthropological descriptions of ritual and ceremonial space in which thresholds or divides designate separate domains of meaning, such as the sacred and profane. Etlin's appreciation for the symbolic laws of form is further

38 At the Archives of American Art, Washington, DC, see transcripts of interviews with Elaine de Kooning, 1981 (pp. 6–7); also Herbert Ferber, 1981 (p. 4); and Ernest Briggs, 1982 (p. 11), who recalled that Rothko referred to his compartmentalized classical mythology paintings of the early 1940s, with their fragmented body parts, as "trunk murders."

39 Michel Butor, "Les Mosquées de New-York, ou l'art de Mark Rothko," *Critique* (October 1961), 843–860.

40 I am borrowing this last formulation from a discussion of architecture and modernism by Anthony Vidler, *The Architectural Uncanny: Essays in the Modern Unhomely* (London, 1992), 168–169.

41 Richard A. Etlin, *Symbolic Space: French Enlightenment Architecture and Its Legacy* (Chicago, 1994), xix.

42 See Breslin 1993, 400.

43 See Dan Rice interviewed by Arnold Glimcher, in Marc Glimcher, ed., *The Art of Mark Rothko: Into an Unknown World* (New York, 1991), 68.

44 John Fischer, "Mark Rothko: Portrait of the Artist as an Angry Man," *Harper's Magazine* (July 1970), 22.

based on the notion that the expressive properties of architecture—what he calls architecture's "deep structure"—are grasped through sentient experience. That is, the emotional response to an architectural interior (such as the exhilaration one feels in a cathedral) is also an existential one, as the visitor senses his own physical presence fill the space.

Etlin's characterization of symbolic space establishes terms that are relevant to Rothko's idiosyncratic approach to the representation of architecture in his early work as well as to the way in which the city pictures may have contributed to the pictorial space Rothko created after 1950. This claim is substantiated by various other episodes in Rothko's career, including the mural projects that the artist worked on during the late 1950s and early 1960s, which have been much discussed. It is also brought to fruition in the works of 1968–1970, a new phase for the artist (cut short by his death), bearing implications that are less often addressed.

In 1958 Rothko was commissioned to produce a series of murals for the Four Seasons, an upscale restaurant in the Seagram Building on Park Avenue in New York. Leaving aside his ultimate frustrations with the commission and the fact that the paintings were never to be delivered and installed, the murals—large canvases in vertical, horizontal, and square formats—represent the artist's first formalized attempt to shape and control the experience of a specific room. On this occasion Rothko altered his motif, which was opened to evoke a frame or portal, an effect that would have been reinforced by the intended friezelike horizontal sequencing of canvases on the wall. In reference to the image of the threshold, James Breslin has described the impact of the murals as comprising a drama of entry and exclusion, one that is ultimately claustrophobic in its denial—through the insistent opacity of Rothko's application of paint—of a realm beyond the wall.[42] While an illusion of outside space would never have been possible or desirable given the nature of Rothko's idiom, Breslin's assessment is supported by Rothko's palette, the maroons and blacks that largely prevailed throughout the cycle, which create an enveloping darkness (Rothko's assistant Dan Rice remembered the artist's having referred to this effect as being one of "no-color").[43]

Rothko himself related the overall impression of these works to an historical interior that he visited in 1959. During that summer the artist interrupted his work on the commission to travel with his family to Europe, and his itinerary reveals a preoccupation with architectural sites. "I have been painting Greek temples all my life without knowing it,"[44] he remarked on his visit to Paestum (an ambiguous reference to the depiction of temples as well as to the actual decoration of a sacred space). Yet it is Michelangelo's Medici Library at the cloister of San Lorenzo that is often specifically linked to the

mural cycle. Above all, Rothko was taken by the dramatically compressed three-story vestibule, which featured false doors and blind windows on two sides; he described this space as "the somber vault."[45] The artist had been impressed by this interior when he first visited in 1950, and he is reported to have referred to it in retrospect as an unconscious model for the Seagram panels.[46] We do not have to accept this in order to recognize that the comparison reveals Rothko's belief that the murals do not just decorate a room, but establish an environment that redefines the experience of an existing space, altering its expressive character. Similarly, Rothko's apparent interest in the Villa of the Mysteries at Pompeii bears on his pursuit of a highly charged interior space through the practice of wall painting *per se*. As Vincent J. Bruno has discussed, the villa is decorated in the Roman Second Style, which is typified by essentially abstract monochromatic panels of color that interact with real and illusionistically painted architectural elements, producing a dynamic relationship between actual space and the hypnotic impression of a fictive realm.[47]

Rothko's second opportunity to create an interior came with the mural commission for a dining room at Harvard University, which he was offered in 1961, one year after his retrospective at the Museum of Modern Art. Closely related to the work he had developed for the Seagram cycle, the Harvard murals represent Rothko's further attempt to transform the nature and experience of an existing space. But it is to the so-called Rothko Chapel in Houston, on which he worked between 1964 and 1967, that we must look for the artist's most dramatic achievement of this kind. Here Rothko was able to apply his interest in a controlled environment to a religious setting, which resonated more meaningfully than the Seagram or Harvard sites with his interest in metaphysical content. The fourteen immense paintings that he and his assistants produced for the chapel were executed in various combinations of black and plum, and are characterized by relatively new qualities: a single "straight-edge" form, colors that show an unfamiliar extreme of monochromy, and an application of paint that is less "atmospheric" than uniform and relatively flat. Nonetheless, some of the paintings reveal deliberate internal variations in surface texture; and the texture of the paint and the canvas, along with occasionally visible inflections of the brush, appear to have been of extreme significance to the artist in light of his renunciation of other properties associated with his earlier work. The effect of scale in the chapel, and in Rothko's murals in general, is an extension of the impression that the artist had long intended to achieve with individual paintings. Echoing his characterization of scale in 1951, Rothko later told Katharine Kuh that his canvases were large enough to "envelop" the viewer and resist being absorbed in a glance; that instead, to be properly appreciated, they require one

45 Jacob Kainen, interview with Avis Berman, 10 August 1982 (p. 18), Archives of American Art, Smithsonian Institution, Washington, DC.

46 Fischer 1970, 16.

47 Vincent J. Bruno, "Mark Rothko and the Second Style: The Art of the Color-Field in Roman Murals," in Russell T. Scott and Ann Reynolds Scott, eds., *Eius Virtutis Studiosi: Classical and Post-Classical Studies in Memory of Frank Edward Brown (1908–1988)*, Studies in the History of Art, National Gallery of Art (Washington, DC, 1993), 235–239.

FIG. 10/INSTALLATION VIEW OF
BARNETT NEWMAN'S *CATHEDRA*,
IN NEWMAN'S STUDIO ON FRONT
STREET, NEW YORK, 1958.

48 Katharine Kuh, interview,
 1982–1983 (p. 154), Archives
 of American Art, Washing-
 ton, DC.

49 Harold Rosenberg, *Barnett
 Newman* (New York, 1978), 61.

50 Sheldon Nodelman, *The
 Rothko Chapel Paintings:
 Origins, Structure, Meaning*
 (Austin, 1997), 164–165.
 For the history of the chapel
 see also Susan J. Barnes,
 *The Rothko Chapel: An Act
 of Faith* (Austin, 1989).

51 David Anfam, "Dark Illumi-
 nation: The Context of the
 Rothko Chapel," in *Mark
 Rothko: The Chapel Commis-
 sion* [exh. cat., Menil Collec-
 tion] (Houston, 1996), 6–15.

to "turn in space."[48] Of course, this "environmental" quality of large-scale canvases was idiomatic to New York School painting, particularly the works of Barnett Newman, for whom the big painting was to be viewed up close, compelling the viewer, in Harold Rosenberg's words, to "submit" to the "sense of it as a whole" (fig. 10).[49]

As Sheldon Nodelman has discussed, the Rothko Chapel paintings are arranged in single panels and triptychs, an "interactive system" that instigates a complex visual exchange between virtual depth and fictive space.[50] Unlike traditional mural painting, which is applied directly to the surface of the wall, Rothko's stretched canvases establish an imposing corporeal presence, even as their extreme darkness evokes a disembodied or dematerialized effect. David Anfam has catalogued many literary and art historical metaphors of light and dark that were available to Rothko in relation to the chapel commission and the "black-form" paintings that preceded it.[51] In the context of the chapel setting, however, the paintings belong to their own genre of image and place: simultaneously suggestive of presence and void, they reflect certain physical and expressive properties already at play within the architectural history of symbolic space. In addition to an obvious relationship with the Renaissance tradition of religious murals and altarpieces, the chapel conceptually recalls commemorative monuments (as identified by Etlin) that are designed to conjure a numinous interior space, a "specially designated precinct" through which one is meant to encounter the presence of an abstract concept or high ideal. While mortality is not the sole subject of the Rothko Chapel, the artist's installation, with its thematics of darkness, is especially germane to architectural spaces that entail the symbolization of absence or death. Etlin specifies various types, such as the "temple-like enclosure," the "impenetrable mass," and the "gaping tomb," and he traces them from the eighteenth to the twenti-

eth centuries, including designs by Alvar Aalto, Frank Lloyd Wright, and Louis Kahn.[52] The prototype comes from the funerary monuments of Boullée, who devised a "genre of architecture formed by shadows" in which "negative" spaces cast in deep shadow echo "positive" elements such as columns and pediments. Boullée's conception was inspired by an epiphany, the architect's haunting encounter with shadows—including his own—on a moonlit night in the countryside, where darkness, in the form of darkly illuminated shapes and the shadows they cast, was perceived as both tangible form and negative space. For Etlin the architectural space of absence establishes both an "eternal space of nothingness" and a "larger order"; entering and occupying that space, we experience it as an "alternative mode" of being. Not unlike allusions to "eternal" space in romantic landscape painting, these terms pertain to the Burkean sublime;[53] but they do so with a much more urgent relationship—a conceptualized and constructed one—to the physical scale of the beholder. And this relationship is further germane (in a way that landscape cannot be) to the opposite of sublime space: that of the Freudian uncanny. Anthony Vidler has described the uncanny in relation to architecture (specifically Charles Nodier's romantic period characterization of Piranesi) as being represented by a claustrophobic nightmare space of silence, solitude, and confinement that mirrors the "mental space where temporality and spatiality collapse."[54] Michelangelo "achieved just the kind of feeling I'm after," Rothko reportedly said in relation to the Laurentian Library and his own choice of a dark palette for his mural commissions: "He makes the viewers feel that they are trapped in a room where all the doors and windows are bricked up, so that all they can do is butt their heads forever against the wall."[55]

The realm of Greek temples and shadows sanctions a surprising comparison between Rothko and de Chirico (in this case from the classic period): the curious "notched" portal motif that Rothko devised for the Harvard murals bears a cryptic likeness to the play of positive and negative space in a spectral image of two ionic columns that appear as cast shadows against a dark ground in de Chirico's *Evangelical Still Life,* an image that Rothko certainly knew (see figs. 11 and 12).[56] But even if Rothko's work only inadvertently belongs to the tradition of numinous or symbolic space as it is represented by Boullée and the history of commemorative architecture, this historical legacy presents us with terms that closely account for the way in which Rothko's pictorial space can convey content. Equally pertinent in this regard is the phenomenology of "lived" space as it appeared in psychology and philosophy during Rothko's lifetime. Vidler cites Eugène Minkowski, for example, a psychiatrist who adapted the existential findings of French and German pheno-

52 Etlin 1994, chap. 7.

53 See the discussion of Boullée and the phenomenology of darkness in the eighteenth century in Vidler 1992, 171–172.

54 Vidler 1992, 38–39.

55 Fischer 1970, 16. According to Motherwell, Rothko preferred to paint in artificial light; a number of Rothko's studios had no windows, and in one that did, the artist blacked them out. With reference to symbolic space, Motherwell also describes the last party Rothko gave in his studio, where the artist arranged a group of black and gray paintings in a circle in the middle of the room, within which he stood receiving guests. See Motherwell, "On Rothko," 1970.

56 The painting was shown in the exhibition *Abstract and Surrealist Art in America* at the Sidney Janis Gallery in 1944, which also included a work by Rothko, and was reproduced in the catalogue. I am indebted to Jessica Stewart for bringing this comparison to my attention.

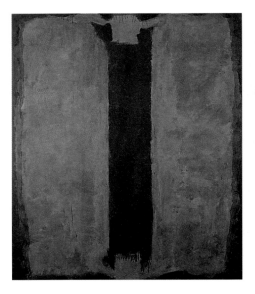

menologists to the pathological study of human personality. In his book *Le Temps vécu* (1933) Minkowski distinguishes between "light space" and "dark space," concepts that characterize actual conditions of perception and the way in which they reflect on our subjective experience of the world. Illuminated by the light of day, light space is dominated by the things that occupy it, which appear to us as if they were set against a backdrop (literally, a *toile de fond*); the observer orients himself in relation to these other occupants of the space. Dark space is experienced instead as "positive," a palpable "presence of the unknown"; rather than spread out before the observer, it envelops or penetrates him, such that his ego is confounded with the darkness. Minkowski compares dark space to the ambient or "auditive" environment of a concert hall (this specific "spatial" quality of music was apparently valued by Rothko in the context of his studio).[57]

In relation to Rothko, the expressive dynamics of commemorative and felt space apply not only to dark paintings in the context of an actual site, such as the Houston chapel, but to the duality of absence and presence that distinguishes individual works throughout the classic and late periods, a quality that was simply maximized in the chapel project. In relation to the sentient experience of space, the phenomenology of absence and presence comes closer still to Rothko's work, both conceptually and historically, in the writings of Sartre, which enjoyed a fairly well defined currency within the New York art scene of the period. In "Manhattan: The Great American Desert" Sartre's setting was an explicitly urban one, to which he brought a symbolic appreciation of New York space. City space—this time Paris—was also the setting for Sartre's canonical definition of the concept of negation in relation to the existential self: in *Being and Nothingness* (1943) he describes negation in anecdotal terms, as an experience of lived space. Waiting in a crowded café, Sartre has an appointment to meet "Pierre," who is late. What does it mean to say of Pierre that "he is not here"? Is such a negation a matter

of judgment or intuition? Sartre begins by noting that perception is a construction of figure and ground and that the relative status of a given object depends on the direction of one's attention. The café, for example, with its patrons and clatter, its light and smoke, could be considered a "fullness of being." Surveyed in the expectation of Pierre's arrival, however, the setting becomes a "ground." Although each figure or thing that occupies the space of the café attempts to isolate itself from the totality of the others, it recedes instead as an object of marginal attention, subsiding into the undifferentiated ground. This "successive disappearance of all the objects which (one) looks at" is what Sartre calls an "original nihilation," establishing the total neutrality of the ground, which is "the necessary condition for the appearance of the principal figure," Pierre. Yet since Pierre is nowhere to be found, his absence haunts the café. Intuited in turn as a "perpetual disappearance," Pierre presents himself as "nothingness on the ground of the nihilation of the café …the nothingness which slips as a nothing to the surface of the ground." For Sartre this intuition constitutes the "apprehension of a double nihilation": an apprehension of nonbeing that preconditions the judgment "Pierre is not here."[58]

Certainly Rothko's almost ineffably subtle manipulation of figure and ground (or the center and the edge) can be characterized in Sartrean terms as a "double nihilation" whereby the absent figure is experienced as presence, or the apprehension of nothingness, and plenitude is experienced as ground. And far from being simply a perceptual device, the implications of this quality in relation to the existential self are potentially profound. Sartre's *Being and Nothingness* was not translated into English until 1956, although his work was familiar in New York intellectual circles beginning in the 1940s and was already being popularized in America for general readers. Above all, the coordinates of absence and presence were applied by Sartre during the 1940s and 1950s to art in his writings—in French and English—about the postwar work of Alberto Giacometti. Giacometti was of extreme significance to painters of Rothko's generation, with special reference to Newman, and his impact on late Rothko, which has been overlooked, is striking. In relation to Sartre, this further enables us to deepen the formal and conceptual setting for Rothko's symbolic space.

Newman's interest in Giacometti dates from a one-man exhibition in 1948 at the Pierre Matisse Gallery in New York, which introduced an American audience to the sculptor's postwar work: coarse and highly attenuated figures in plaster and bronze that incarnate a haunting isolation. Newman was impressed with the mysterious "fullness" of these figures, and it seems likely that the painter's "zip," the motif that would govern his work beginning at this time, was related to the drama of Giacometti's new form—a remote

57 See Vidler 1992, 174–175. For Minkowski see Nancy Metzel, ed. and trans., *Lived Time: Phenomenological and Psychopathological Studies* (Evanston, IL, 1970), xv–xxxvi; Minkowski's discussion of light and dark space occurs on pp. 427–431 in this edition of his text. For further discussion of Rothko's work in the context of French phenomenology with respect to the "spaces" and silences that condition language or speech, see Ashton 1983, 119–122. Concerning Rothko's interest in the way music "fills" space see Stanley Kunitz, interview, 22 March 1984 (p. 8), Archives of American Art, Smithsonian Institution, Washington, DC.

58 Quoted from Wade Baskin, ed., *Jean-Paul Sartre: Essays in Existentialism* (New York, 1995), 87–90. Vidler 1992, 180–182, treats the example of Pierre as a "parable of the dislocation of memory in the modern city."

59 See Polcari 1991, 197–200. For existentialism and the New York School in relation to the magazine *Instead* see Ann Gibson, *Issues in Abstract Expressionism: The Artist-Run Periodicals* (Ann Arbor, MI, 1990), 41–47. For Rothko and Sartre see also William Seitz, *Abstract Expressionist Painting in America* (Cambridge, MA, and London, 1983), 122.

60 Quotations are from Jean-Paul Sartre, "The Search for the Absolute," trans. Lionel Abel, in *Alberto Giacometti* [exh. cat., Pierre Matisse Gallery] (New York, 1948), 2–22.

presence that simultaneously inhabits and divides ambient space. In relation to the philosophical content of Newman's work, Polcari emphasizes the role that Giacometti played in acquainting Newman with existentialism: an essay on Giacometti by Sartre entitled "The Search for the Absolute" was published in the exhibition catalogue, and in it Polcari detects an emphasis on postwar renewal and the modern condition that loosely corresponds to Newman's own philosophy of art. Newman's isolated "zip" (which he used as a motif in sculpture as well as painting and drawing) acquires a humanistic intensity in relation to Sartre's exegesis on Giacometti, whose figures are said to achieve "unity" and "extensity" in a fluctuating universe.[59] Apart from this programmatic reading of existentialist themes, however, Sartre has quite a lot to say about the formal qualities of Giacometti's work, especially with regard to space. In fact, he addresses aesthetic form—and space in particular—in a highly original way, one that draws its gravity from the meaning of space in *Being and Nothingness*. It is this aspect of the writings on Giacometti that we might use to define more clearly Sartre's significance as a critic in relation to Rothko and the New York scene.

In the 1948 essay Sartre characterizes Giacometti's personal relationship to physical space in pathological terms as a "horror of the infinite," or "terror of emptiness"; "for months Giacometti came and went with an abyss at his side."[60] By extension, Giacometti's sculpture is understood to address a conceptual, and ultimately expressive, paradox of perception and space. Conventionally, sculpture is intended to represent the figure as a surrogate for the posing model. But how do we distinguish between our distance from the sculpture as an object and our distance from the figure that the sculpture depicts? Can the "imaginary man" be projected in real space? Can the sculpture convey the artist's impression of the model from ten paces, or does this imply an impossible condition: that the sculpted figure possess the same presence as the model himself? In traditional sculpture certain conventions are employed (for example, selectively omitting details that cannot be seen from far away and adding others that are known to exist), confusing this discrepancy between real and imaginary space. For Sartre, Giacometti bridges the gap between the "relative" and the "absolute." His sculpture is the first to represent the figure as it appears from a distance, a specific distance that remains fixed, thereby abandoning the conceit that one can better grasp its nature by coming close; as one approaches the sculpture, the original distance that separated the sculptor from his model is perceptually maintained. By sculpting the "situated appearance" of a figure, Giacometti achieves an existential truth: "he shows us that man is not there first and to be seen afterwards, but that he is the being whose essence is to exist for others."

In Sartre's terms painting, as opposed to sculpture, largely escapes the

paradox of real and imaginary space because the canvas cannot be approached with the same expectations as the three-dimensional figure. But Giacometti was as much a painter as a sculptor, and Sartre composed a lengthy essay about the painted work, which was published in French and English versions on the occasion of a Giacometti retrospective at the Guggenheim Museum in 1954 and 1955.[61] Space is again Sartre's basic theme. Giacometti's work—at first his sculpture—is characterized in roughly the same terms that were used in 1948: "Giacometti became a sculptor because he is obsessed with the void," "the universal distance of everything from everything." The artist "sees the void everywhere" and carries it with him "as a snail its shell"; in his figures "he creates the void from a starting point of the solid," evoking the sudden appearance of a personage on a deserted street, "a prior emptiness." Remarking on certain sculpture in which the artist envelops his figures in a cage or an architectural box (conceptually not unlike what Rothko had previously achieved in the subway images), Sartre refers to the closed space as a "prefabricated void." "And what is this filled, framed void," he continues, "if not a painting?" Sartre conflates the practices of painting and sculpture in Giacometti's work and identifies the artist as a painter of the void itself, of the layers of emptiness through which we glimpse his sitters; "he would like us to take for a *true* void the imaginary space which the frame limits." From this conception of the canvas, "Giacometti begins by expelling the world," and in this setting the figure does not stand out against the background of a wall, but simply appears. "With each one of his pictures, Giacometti leads us back to the moment of creation *ex nihilo*, each one of them poses again the old metaphysical question: why is there something rather than nothing?" Struggling with the way in which to define the figure pictorially, Giacometti has found that the element of line is a problematic means of establishing the relationship of the figure to space, "the beginning of a negation, the passage of being to non-being"—a transition from being to nothingness where no such conceivable transition exists. Ultimately, representing the figure is "no longer a question of separating the solid from the empty, but of painting plenitude itself."

According to Robert Motherwell, Rothko used to tell the story of meeting Michelangelo Antonioni, the Italian filmmaker, who visited the artist's studio and declared that he and Rothko shared the same subject matter: "nothingness."[62] While the pictorial problem that Rothko posed for himself does not concern appearance, it does address the gap between imaginary and real space, which the large-scale canvas can be said to bridge through its enveloping or "intimate" scale. In speaking of Giacometti's paintings, Sartre conceives pictorial space as a means with which to address the very nature of being, allowing that the canvas can be interpreted as portraying both fullness

61 Sartre's essay was first published without a title in French in *Derrière Le Miroir* (May 1954); it then appeared as "Les Peintures de Giacometti" in *Les Temps modernes* (June 1954), 2221–2232. It was published in English as "Giacometti in Search of Space," *Artnews* (September 1955), 26–29, 63–65.

62 See Robert Motherwell, "On Rothko," 1970, copyright Motherwell Archive, Dedalus Foundation, 1998.

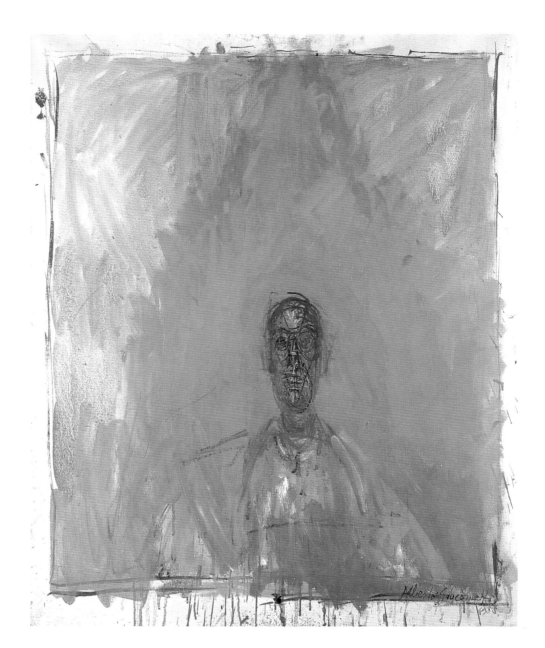

and void. Initiated at roughly the same moment that Giacometti began to produce the paintings and sculpture to which Sartre refers, Rothko's mature painting is related to this idiom, which was otherwise defined in terms of representation.

In this regard it should come as no surprise that Rothko's work reveals rather explicit evidence of an interest in Giacometti, specifically (unlike Newman) in the paintings rather than in the sculpture. This occurred during the last few years of Rothko's life, a period best known for the black and gray or brown paintings, which resemble little else in his oeuvre. One clue comes from Motherwell, to whom Rothko remarked that these works were conceived partly in response to a commission from the UNESCO head-quarters in Paris for a room that would contain sculpture by Giacometti. Motherwell was struck by the fact that Rothko's new palette was not unlike Giacometti's.[63] And in this light one comes close to accounting for another, much less familiar body of pictures produced by Rothko during the same

FIG. 14 / MARK ROTHKO,
UNTITLED, 1969, ACRYLIC ON
PAPER MOUNTED ON CANVAS,
136.5 X 108 (53 ¾ X 42 ½),
COLLECTION OF KATE ROTHKO
PRIZEL. SEE ALSO CAT. 108.

period. A series of sizable works on paper in luminous but grayed hues of pale blue, mustard yellow, and rose on a white ground is no less of a departure for the artist. But the works are in fact almost equally close to Giacometti's color range, which, on careful examination, discloses far more than black, brown, and gray. The comparisons are compelling, even when limited to paintings by Giacometti that were included in the late 1968 exhibition *Giacometti and Dubuffet* at the Sidney Janis Gallery in New York, which Rothko would have seen (see figs. 13 and 14). (The date of the Janis exhibition may even offer a *terminus post quem* for this series of works by Rothko, which were seldom noticed by visitors to the studio and remain somewhat difficult to locate in a precise chronology of the final years.[64]) In addition to similarities of palette and format (either a compact rectangle or an elongated vertical), Rothko and Giacometti also share the pictorial element of the internal margin or frame, which is often uneven and brushed over. In Rothko's case this took the form of a narrow white edge created by masking tape, a con-

63 See Robert Motherwell, "Motherwell Muses," 1969, copyright Motherwell Archive, Dedalus Foundation, 1998. Following Motherwell, Ashton 1983, 189, discusses the late works with reference to the UNESCO commission.

64 Brian O'Doherty, "Chamber Music in the Next Room," in *Mark Rothko: The Last Paintings* [exh. cat., Pace Gallery] (New York, 1994), 5–6.

65 O'Doherty in exh. cat.
New York 1985, 8.

66 In 1969 Rothko presented a
set of nine works from the
Seagram mural commission
to the Tate Gallery, London,
with the stipulation that they
be installed together in a
single room. Perhaps the Tate
Gallery's commitment to
the work of Giacometti was
meaningful to him; the
museum had purchased eight
sculptures and two paintings
from the Giacometti retro-
spective that was held there
in 1965. Later that year, when
the exhibition traveled to the
Museum of Modern Art in
New York, Rothko was among
the artists who attended
a reception in Giacometti's
honor. See James Lord,
Giacometti: A Biography
(New York, 1985), 499.

fining border that is generally ackowledged as a significant break in his approach.[65] For both artists the device was both an enclosure and a thresh-old, serving spatially to fix the image and distance it from the viewer. In the works in color Rothko sometimes doubled the effect with compositional bands along the upper and lower edges of the image, forms adapted from his earlier works that approximate—in terms appropriate to Rothko's idiom—the proportions of the frame in Giacometti's paintings.

The Giacometti room, which was never realized, would have repre-sented Rothko's fourth project in creating a cohesive interior.[66] Giacometti's figures can easily be envisioned as the secular subject for a modern symbolic space. Rothko was notoriously difficult about allowing work by other artists to share space with his own, and his interest in the commission attests to much more than his respect for Giacometti; it signals his belief that they held common goals. If certain large black and gray paintings were to be displayed with Giacometti's sculpture, it is likely that Rothko contemplated the possi-bility that his canvases might recede in this setting, becoming something of a backdrop. In light of Giacometti and Sartre, however, the metaphysical impli-cations of the "ground" could well have been significant to him. In Rothko's works the white margin connotes, for the first time, a blatant allusion to fig-ure and ground. Writing of Giacometti, Sartre again provides the relevant analogy of absence and presence, now in the context of Giacometti's draw-ings: "the void, is it also not represented by the whiteness of the sheet? Pre-cisely. Giacometti rejects both the inertia of matter and the inertia of pure nothingness; emptiness is fullness relaxed and slackened; fullness is empti-ness given direction. The real is a flash of lightning."

Given Giacometti's images, which are all occupied by figures or still-life objects, the UNESCO project allows us to imagine that Rothko's late works represent an evacuated space—not so much a backdrop as a site. Un-derstood as both substance and void, such a realm of "prior emptiness" could, by extension, describe Rothko's classic works overall. In this way Gia-cometti's interiors confirm the viability of the enclosed chamber as a meta-phorical device for abstract yet content-laden pictorial space, from which Rothko—whose works transform or define their environment—extrapo-lated the nature of the painting as an object and a place. In images related to the conception of a commissioned room, Rothko's allusion to Giacometti's paintings allowed him to thematize the absent figure, drawing on his visual and philosophical rapport with an artist for whom the interior as subject was existentially charged. ("These extraordinary figures," Sartre remarked of Gia-cometti's subjects, "are they appearances or disappearances?") The possible relationship between the black and gray paintings and Giacometti's sculp-tures, which are themselves "absent" from our experience of Rothko's can-

vases, intensifies the relevance of this motif. The question of the missing figure has been raised in relation to the metaphor of the nineteenth-century sublime landscape. Sartre's writings on Giacometti show that it was also being formulated within Rothko's generation in reference to a spatial "infinity" that occupies no more room than the artist's studio.

CHRONOLOGY

1903–1909

Mark Rothko is born Marcus Rothkowitz in Dvinsk, Russia, on 26 September 1903, the fourth child of Jacob Rothkowitz, a pharmacist (b. 1859), and Anna Goldin Rothkowitz (b. 1870), who had married in 1886. His siblings are Sonia, age fourteen; Moise (later called Maurice), age eleven; and Albert, age eight. As a child Marcus attends *cheder* (the Hebrew school at synagogue), the first in his family to do so. Both Jacob and Anna are fluent in Hebrew, but the family is more liberal than orthodox, and Russian is spoken at home.

1910

Jacob Rothkowitz immigrates to the United States with the financial assistance of his brother—who had changed his name to Samuel Weinstein—settling in Portland, Oregon, where his brother resides.

1912–1913

Moise and Albert Rothkowitz sail from Bremen, Germany, on 31 December 1912, arriving at Ellis Island on 16 January 1913.

1913

Anna, Sonia, and Marcus Rothkowitz leave Russia on 5 August, sailing second class aboard the *S.S. Czar* from Libau, a port on the Baltic Sea. Arriving in the United States on 17 August, they stay in New Haven for ten days with Weinstein cousins before traveling on to Portland via train; they wear notes to indicate that they do not understand English. They are reunited with Jacob, Moise, and Albert in Portland and move into a house at 834 Front Street. Anna soon takes the name Kate. In September Marcus, age ten, is enrolled in first grade at Failing School, a public school where no English classes are provided for immigrant children.

1914–1920

Jacob Rothkowitz dies of colon cancer on 27 March 1914 at age fifty-five. To support the family, Sonia, Moise, and Albert initially work at the Weinstein family business, New York Outfitting Company, while Marcus sells newspapers on the street. Both brothers eventually shorten their surname to "Roth."

In September 1914 the family moves to 232 Lincoln Avenue, then to 538 2nd Street in 1915. Marcus attends Shattuck Elementary School, entering as a third grader and advancing to fifth grade at the end of that year. He finishes ninth grade in 1918 and enters Lincoln High that fall, where he takes college preparatory courses that include French and dramatic arts; he also works part time at New York Outfitting Company in the shipping department. Although he takes no formal art classes, he does sketch and draw at this time.

1921

Rothkowitz graduates from Lincoln in June 1921, having received a scholarship to Yale University. He enters Yale in the fall along with two Russian immigrant friends from Portland, Aaron Director and Max Naimark, living with Naimark at the home of Dr. Herman Grodzinski on Howard Avenue and often taking meals with his Weinstein cousins. At the end of his freshman year his scholarship is eliminated, as are those of his friends.

1922–1923

Continuing at Yale, Rothkowitz lives in a dormitory on campus. In February 1923 he and classmates Aaron Director and Simon Whitney found an underground, progressive newspaper, *The Yale Saturday Evening Pest*. Rothkowitz is believed to have written at least one of the ten issues, on "False Gods." His studies include prescribed courses in English, French, European history, elementary mathematics, physics, biology, and economics, as well as electives in history of philosophy and general psychology. His initial intention is to become an engineer or an attorney. He supports himself with jobs at the Yale student laundry, at several local dry cleaners, and as a messenger. In the fall of 1923 Rothkowitz leaves Yale, having taken no art classes and having received no degree. He moves to New York and works in the garment district and as a bookkeeper for an uncle, Samuel Nichtberger.

1924

In January Rothkowitz enrolls in George Bridgman's life drawing class at the Art Students League in New York. The first paintings he produces are in a realist style. He takes a room at 19 West 102nd Street with the Goreff family, distant relatives, and stays with them intermittently until 1929. Early in 1924 he returns to Portland, where he studies acting in a theater company run by Josephine Dillon. Later in life the artist enjoys recounting that Clark Gable was his understudy there.

1925

When Rothkowitz returns to New York early in 1925, he applies unsuccessfully for a scholarship to the American Laboratory Theater, then enrolls at the New School of Design, a small commercial art studio, and takes a class in which Arshile Gorky serves as the "monitor." Rothkowitz returns to the Art Students League in October, enrolling in Max Weber's still-life class. He continues to study with Weber until May 1926, working in the manner of Cézanne at Weber's recommendation. From the mid-1920s onward Rothkowitz spends considerable time in New York galleries and museums, particularly the Metropolitan Museum of Art, which he favored for its Rembrandt collection.

1926-1928

In November 1926 Rothkowitz becomes a member of the Art Students League, which enables him to take classes and vote; he remains a member until 1930. After some advertising experience, he is commissioned in 1927 to draw maps and illustrations for *The Graphic Bible: From Genesis to Revelation in Animated Maps and Charts* by Lewis Browne. When he is not credited in the 1928 publication, he sues Browne and the publisher, MacMillan, for $20,000 in damages and a share of the royalties. Though the case goes to the New York supreme court, Rothkowitz loses.

Rothkowitz is reintroduced to the violinist Louis Kaufman, whom he had known in grade school in Portland. Kaufman introduces him to Milton and Sally Avery. Milton Avery, the first "professional artist" with whom Rothkowitz spends time, will have a profound impact on the younger artist's work, particularly his application of paint and treatment of color. The Averys' home is a meeting place for a circle of artists that includes Byron Browne, Louis Harris, and Wallace Putnam. Rothkowitz begins to attend the weekly life drawing sessions there. Bernard Karfiol, an instructor at the Art Students League, includes Avery, Harris, and Rothkowitz in *Group Exhibition: Artists Selected by Bernard Karfiol.* This exhibition, held 15 November– 12 December at the Opportunity Gallery, is Rothkowitz' first, and he shows landscapes, according to contemporary reviews.

1929

The artist, now living at 231 East 25th Street, begins to teach art to fourth-grade and higher-level classes two days a week at the Center Academy of the Brooklyn Jewish Center. He meets artist Adolph Gottlieb, and they begin to spend significant time together and with Milton Avery. The weekly drawing sessions at the Averys' home continue, along with poetry readings that favor T. S. Eliot and Wallace Stevens. The coterie of artists now includes John Graham, Yankel (Jack) Kufeld, Barnett Newman, Louis Schanker, and Joseph Solman at various times.

1930-1931

Gottlieb and Rothkowitz continue to be close to the Averys, stopping by their home on an almost daily basis to see the new work Avery is producing.

1932

Rothkowitz takes part in the first of a series of joint summer vacations with Esther and Adolph Gottlieb at Cape Ann, Massachusetts, and with the Averys nearby in Gloucester. These holidays provide occasions to sketch and paint and critique one another's work. He also travels to Lake George, New York, where he meets Edith Sachar on 2 July while camping at Hearthstone Point. After a brief courtship Sachar and Rothkowitz are married on 12 November at his apartment at 314 West 75th Street and soon move to an apartment at 137 West 72nd Street, very near the Averys' home. In the early years of their marriage Sachar works as a salesperson in a dress shop, and Rothkowitz plays the piano for hours at a time. Though he never studies formally, he is profoundly moved by music— particularly by Mozart— throughout his life.

1933

Rothkowitz and Sachar hitchhike across the country to introduce her to his family. After visiting his brother Albert, who has become the mayor of Dufur, Oregon, they set up camp in a tent in Washington Park outside Portland. Rothkowitz executes numerous watercolors and drawings—primarily landscapes—some of them shown at the Portland Art Museum over the summer, along with earlier pieces and works by his Center Academy students.

Returning to New York in the fall, Rothkowitz and Sachar move to 1000 Park Place in Brooklyn. From 21 November to 9 December *An Exhibition of Paintings by Marcus Rothkowitz* is held at the Contemporary Arts Gallery, New York, with fifteen paintings and ten works on paper. By this time Sachar has likely begun to sculpt and to teach crafts at the Center Academy.

1934

Rothkowitz contributes two works to the *Exhibition of Paintings and Sculpture by Brooklyn and Long Island Artists,* held at the Brooklyn Museum, 29 January–26 February. He organizes another show, with around 150 works by his students, at the Brooklyn Museum, 8–21 February, which travels to four local venues; his related essay, "New Training for Future Artists and Art Lovers," is published in the February–March issue of the *Brooklyn Jewish Center Review.* Rothkowitz becomes one of the two hundred founding members of the Artists Union in New York in February. He participates in five group shows at Robert Godsoe's Uptown Gallery, New York, between May and October.

Rothkowitz and Sachar again spend time with the Averys and Gottliebs in Gloucester over the summer. At a certain point, perhaps this year, Milton Avery curtails his longstanding practice of daily showing his work to Gottlieb and Rothkowitz, instead waiting until the end of the summer to do so. Nevertheless, Rothkowitz' output— primarily nudes and bathing scenes—still reflects the influence of Avery.

Robert Godsoe forms Gallery Secession on 15 December, showing Rothkowitz as well as Ben-Zion, Gottlieb, Harris, Kufeld, Schanker, and Solman in a *Group Exhibition* that runs through 15 January 1935.

C. 1912 / FAMILY PORTRAIT TAKEN
IN DVINSK. FROM THE LEFT:
ALBERT AND SONIA ROTHKOWITZ,
A FIRST COUSIN, AND MARCUS
AND MOISE ROTHKOWITZ.

C. 1921–1923 / ROTHKOWITZ AT
YALE UNIVERSITY. PHOTOGRAPH
WITH HIS INSCRIPTION AT TOP.

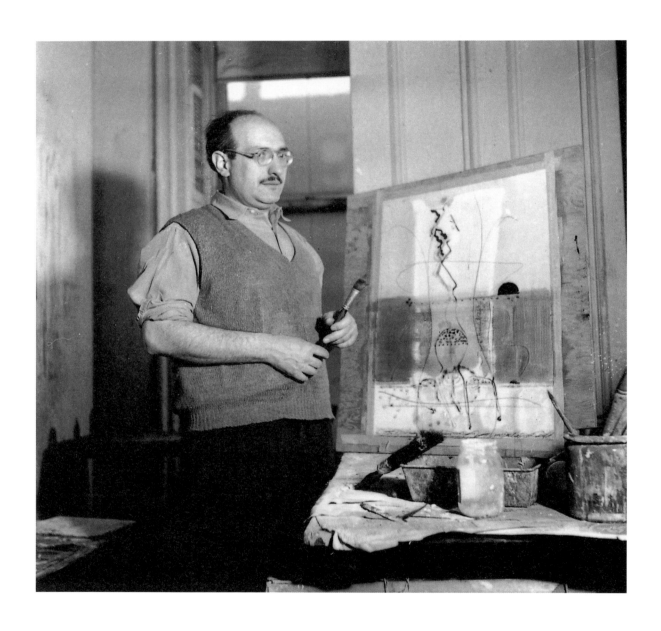

The second *Group Exhibition* at Gallery Secession takes place 15 January–5 February. Rothkowitz and Sachar again vacation with the Averys and Gottliebs in the vicinity of Cape Ann. The Federal Art Project of the Works Progress Administration (WPA) is established in August. Rothkowitz and Sachar move to 3 Great Jones Street in Greenwich Village in the fall. During the mid-1930s Sachar studies metalwork and jewelry-making at the New York School of Arts and Trades, soon establishing a successful business designing silver jewelry. Both Avery and Gottlieb sign the Call for an American Artists' Congress in November; Rothkowitz joins in January 1936.

Ben-Zion, Ilya Bolotowsky, Gottlieb, Harris, Kufeld, Rothkowitz, Schanker, Solman, and Nahum Tschacbasov—all of whom work in an expressionist vein and share "a distaste for conservatism and a desire for experimentation"—unite to form "The Ten" in the fall. The group meets monthly in one of the member's studios, and Rothkowitz acts as secretary. Their first exhibition, *The Ten: An Independent Group*, is held at the Montross Gallery, New York, 16 December 1935–4 January 1936. Each artist selects his own work and typically has four pieces on view. Rothkowitz shows *Seated Nude*; *Woman Sewing*; *City Phantasy* (all c. 1934); and *Subway* (1935). As the member artists number only nine, they fill the tenth space with guest artists and come to be known as "The Ten Who Are Nine."

From 7 to 18 January the Ten, who are joined by a friend of Gottlieb's, Edgar Levy, hold the exhibition *The Ten* at the Municipal Art Galleries, New York, in which Rothkowitz shows *Crucifixion* (1935). The American Artists' Congress holds its first session on 14 February.

Sachar secures a WPA position by June, most likely in the sculpture division. Rothkowitz continues to teach at the Center Academy as well as at a school in Far Rockaway, but he is able to demonstrate a need for "relief" and, having tried to secure a WPA post since at least June, is enrolled in the Treasury Relief Art Project (TRAP) of the WPA in September. When TRAP is phased out in May 1937, he is relocated to the easel division. During the fall he meets Barnett and Annalee Newman at a wedding breakfast given for them by Gottlieb. He also meets the artists Jacob Kainen and Jack Tworkov around this time.

The Ten mount an exhibition at Galerie Bonaparte, Paris, 10–24 November. The Museum of Modern Art's *Fantastic Art, Dada and Surrealism*—which includes Giorgio de Chirico, who will have a powerful impact on Rothko's art—is held 2 December 1936–17 January 1937. *The Ten: 2nd Annual Exhibition* is presented at Montross, 14 December 1936–2 January 1937, with Rothkowitz showing *Interior* (cat. 3), *Music*, and *Portrait* (all 1936). Tschacbasov is no longer with the group; and Lee Gatch exhibits with them as guest artist.

Influenced by the work of Franz Cizek, Wilhelm Viola, and Oskar Pfister, Rothkowitz begins to write extensively on the development of creativity in children and on the relationship between children's art and modern art.

Though many friends and associates recall his writing a book about this time and even having heard chapters of it, the only related document remains the "Scribble Book." It contains excerpts from Viola's text on Cizek and drafts for Rothkowitz' 1938 lecture on creative development at the Center Academy. Several passages read:

Primitivism

Often child art transforms itself into primitivism which is only the child producing a mimicry of himself....

The scale conception involves the relationship of objects to their surroundings and the emphasis of things *or* space. It definitely involves a *space* emotion. A child may limit space arbitrarily and thus heroify his objects. Or he may infinitize space, dwarfing the importance of objects, causing them to merge and become a part of the space world. There may be a perfectly balanced relationship. (Rothko Papers, Archives of American Art, Smithsonian Institution, Washington, DC)

Edith Sachar's WPA position is terminated in January. She and Rothkowitz separate for the summer, reconciling in the fall. Georgette Passedoit Gallery, New York, holds *The Ten*, 26 April–8 May, with Rothkowitz showing *Family* (c. 1936); Gatch is part of this exhibition as well. Adolph and Esther Gottlieb move to Tuscon, Arizona, in November but return to New York after eight months. The Ten hold an art auction to benefit Spanish Civil War children, 3–5 December; Rothko's *Street Scene* and three other works (all 1936–1937) are included.

Rothkowitz becomes a naturalized citizen of the United States on 21 February. He contributes to the *2nd American Artists' Congress Exhibition* at John Wanamaker's Picture Gallery, New York, 5–21 May. The Ten hold a second exhibition at Passedoit, 9–21 May. During the summer Sachar is listed at 119 West 63rd Street; in the fall the couple moves to a brownstone at 313 East 6th Street.

On 5 November *The Ten: Whitney Dissenters* opens at Mercury Galleries to much publicity, closing 26 November. Artists include Ben-Zion, Bolotowsky, Gottlieb, John Graham, Harris, Ralph Rosenborg, Rothkowitz, Schanker, and Solman, with Earl Kerkam as guest. Bernard Braddon and Rothkowitz write the catalogue, which decries the policies of the Whitney exhibition being held concurrently. Mercury's owners propose that they devote their gallery to the Ten for the next year, which the Ten refuse, citing "certain problems of reorganization." By 1 December Rothkowitz is one of seventy-two applicants in a mural competition for the post office in New Rochelle, New York, but he does not receive the commission.

Rothkowitz and Sachar spend time over the summer at Trout Lake, New York, not far from sculptors David Smith and Dorothy Dehner's property at Bolton Landing. Though Rothkowitz and Smith have been friendly for several years, their relationship founders over political debates. Rothkowitz is dismissed from the WPA on 17 August. Over Labor Day he and Sachar visit the writer Joseph Liss in Derby, Connecticut, and Rothkowitz paints Liss' portrait. Gottlieb and Harris do not participate in the Ten's final exhibition at the Bonestell Gallery, New York, 23 October–4 November. The group then dissolves, perhaps for political reasons.

In January the artist shortens his name to Mark Rothko, making the change legal in 1959. Though he occasionally reverts to his full name or to Marcus Rothko, he exhibits under his new name from this point on. The Neumann-Willard Gallery holds an exhibition of Solman, Rothko, and the French expressionist Marcel Gromaire, 8–27 January, at which Rothko shows *Entrance to Subway* (cat. 9) and two other paintings. The increasingly communist leanings of the American Artists' Congress and its sanction of Russia's invasion of Finland lead Rothko, Avery, Bolotowsky, Gottlieb, Harris, and others to sign a statement of secession on 17 April. By June they form the Federation of Modern Painters and Sculptors in New York, which exhibits at the New York World's Fair, 20 June–8 July; Gottlieb serves on the executive board.

Over the course of the year Rothko—working closely with Gottlieb, whom he sees almost daily—begins a new body of work, which addresses mythological subject matter in an attempt at universality. He begins to use titles and motifs redolent of archaism and ritual, with particular emphasis on bird and plant imagery as well as primitive sculptural forms. The artist, earlier fascinated by Plato, now focuses on the tragic in Aeschylus and Nietzsche. Rothko and Sachar separate again, but by December both are living at 313 East 6th Street. In October Rothko enters a mural competition for the Social Security Building in Washington, DC, but his work is not chosen.

Rothko participates in *The First Annual Exhibition of the Federation of Modern Painters and Sculptors* at the Riverside Museum, New York, 9–23 March, showing *Underground Fantasy* (cat. 10) as well as *Craftsman* (1938–1939) and *Subway* (1939). By February he and Sachar are living at 29 East 28th Street. Rothko plans to establish a magazine with another artist and writer to "give a positive form" to their new aesthetic.

Samuel Kootz holds a group exhibition at R. H. Macy Department Store, 5–26 January, at which Rothko first shows the mythological works *Antigone* (1939–1940) and *Oedipus* (1940). The *Federation of Modern Painters and Sculptors: Second Annual* is held at Wildenstein and Company, New York, 21 May–10 June, and Rothko shows *Mother and Child* (c. 1940).

Edith Sachar rents a loft at 36 East 21st Street, with a studio for Rothko in the back, and she employs several people in the production of her jewelry designs. Since at least 1941 Rothko has served, at her insistence, as her salesperson, though this curtails his efforts at both painting and writing. In late October Peggy Guggenheim opens her Art of This Century Gallery, which is devoted to avant-garde and modern art, both European and American.

The Metropolitan continues its exhibition *Artists for Victory*, which opened 7 December 1942 with 1,418 works by contemporary American artists and sparked several "protest" exhibitions. The first of these is *American Modern Artists: First Annual Exhibition* at the Riverside Museum, 17 January–27 February, where Rothko shows four works, including *Sculptor* and *Nude* (both 1938–1939); Barnett Newman writes the catalogue essay. A second is *New York Artists Painters:*

First Exhibition at 444 Madison Avenue, New York, 13–27 February, where Rothko shows four works, including *A Last Supper* (1941) and *The Omen of the Eagle* (1942). He later describes the second of these:

The theme here is derived from the Agamemnon Trilogy of Aeschylus. The picture deals not with the particular anecdote, but rather with the Spirit of Myth, which is generic to all myths at all times. It involves a pantheism in which man, bird, beast and tree — the known as well as the knowable — merge into a single tragic idea. (Sidney Janis, *Abstract and Surrealist Art in America,* 1944)

In the *Federation of Modern Painters and Sculptors: Third Annual,* held at Wildenstein, 3–26 June, Rothko shows his *Syrian Bull* and Gottlieb shows *The Rape of Persephone* (both 1943). As these two works are singled out for criticism by Edward Alden Jewell, art editor of the *New York Times,* Rothko, Gottlieb, and their unsigned collaborator Newman send a letter to Jewell on 7 June in response to his review. The letter is published in the *Times* on 13 June.

Rothko and Sachar separate permanently in June (their divorce is granted 1 February 1944). Apparently suffering a breakdown, Rothko checks into a hospital, then leaves New York to visit his family in Portland. While on the West Coast he travels to Berkeley and meets Clyfford Still, who would exert a profound influence on his work. In August he visits Louis Kaufman and his wife Annette in Los Angeles, and they view the Arensberg collection of European modern art together. He also meets the artist Buffie Johnson at this time.

Returning to New York in the fall, Johnson introduces Rothko to Peggy Guggenheim's advisor, Howard Putzel, who is impressed by his work and convinces Guggenheim to take him into her

gallery. Johnson begins to meet with Rothko, Gottlieb, and Newman approximately once a week for a several years to discuss art and philosophy. By early October Rothko shares a studio at 22 West 52nd Street with the surrealist painter Boris Margo. On 13 October Gottlieb and Rothko speak on "The Portrait and the Modern Artist" on radio station WNYC.

Rothko participates in the *First Exhibition in America of Twenty Paintings* at Art of This Century in the spring, and Peggy Guggenheim begins to represent his work. Through this gallery Rothko meets Hedda Sterne and Max Ernst as well as Betty Parsons, who would become his dealer in 1947. The first one-man exhibitions of the work of William Baziotes, Robert Motherwell, and Ad Reinhardt (at Artists' Gallery and Art of This Century) take place this year. Howard Putzel opens 67 Gallery, and his first exhibition, *40 American Moderns,* 4–30 December, includes Rothko as well as Avery, Baziotes, Hans Hofmann, Motherwell, and Jackson Pollock.

The photographer Aaron Siskind, who had met Rothko as early as 1938 and had photographed his work, introduces him to Mary Alice (Mell) Beistle at a party in December. Beistle, an illustrator at McFadden Publications, had graduated from Skidmore College in 1943 and had been illustrating children's books written by her mother since the age of sixteen. During their courtship the artist paints *Slow Swirl at the Edge of the Sea* (cat. 19), later stating that the painting is extremely important to him because of this association. Rothko gives Mell a copy of Kafka's *The Trial* and is himself reading Dostoyevsky and Kierkegaard. Gottlieb becomes the head of the Federation of Modern Painters and Sculptors, staying in this elected post until 1945.

1950 / ROTHKO AND BETTY
PARSONS AT HIS FOURTH PARSONS
GALLERY SHOW. WORKS INCLUDE
NO. 5 AND *NO. 3*, BOTH 1949
(FAR LEFT, THIRD FROM LEFT).
PHOTOGRAPH BY AARON SISKIND.
SEE ALSO CATS. 41 AND 43.

C. 1953 / MELL AND MARK ROTHKO.
PHOTOGRAPH BY HENRY ELKAN.

Mark Rothko Paintings is held at Art of This Century, 9 January–4 February, with fifteen works, including *Sacrifice of Iphigenia* and *Hierarchical Birds* (cats. 15, 16). The David Porter Gallery in Washington, DC, includes Rothko in *A Painting Prophecy—1950,* 3–28 February; the show then travels to Springfield, Massachusetts, and St. Louis.

Rothko marries Mell Beistle in Linden, New Jersey, on 31 March. The couple stays with Aaron Siskind in Gloucester that summer, also seeing the Averys and the Gottliebs. By July the Rothkos have moved to 1288 6th Avenue, New York. Rothko shows his *Hierophant* (1945) in the fifth annual Federation of Modern Painters and Sculptors exhibition held at Wildenstein, 12–29 September. His *Primeval Landscape* (cat. 17) is chosen for the *Annual Exhibition of Contemporary American Painting* at the Whitney Museum of American Art, New York, 27 November 1945–10 January 1946.

Rothko's *Landscape* (1945) is included in *The 141st Annual Exhibition* at the Pennsylvania Academy of Fine Arts, Philadelphia, 26 January–3 March. His *Baptismal Scene* (1945) is shown in the Whitney's *Annual Exhibition of Contemporary American Sculpture, Watercolors, and Drawings,* 5 February–13 March. Having introduced Clyfford Still's work to Peggy Guggenheim in 1945, he writes the catalogue foreword for Still's one-man show at Art of This Century, 12 February–7 March.

Rothko is described as a "mythomorphic abstractionist" in an April *Artnews* review of *Mark Rothko: Watercolors,* at the Mortimer Brandt Gallery, New York, 22 April–4 May; the show contains eighteen works including *Gethsemane, Tentacles of Memory, Omen,* and *Vessels of Magic*

(cats. 18, 26, 29, 31). Rothko meets Motherwell while hanging the show. The gallery sells enough work that Rothko is able to consider leaving his position at the Center Academy, which he has held since 1929. In April Still suggests to Rothko and Douglas MacAgy the idea of forming a school for young artists at which contemporary painters would teach.

During the summer Rothko rents a cottage in East Hampton, Long Island, and spends time with Baziotes, Motherwell, Pollock, and Harold Rosenberg, who are all enthusiastic about the new work he is producing. He is quite prolific over the summer, but his style continues to evolve. In a phase of work that Rothko later refers to as "transitional," he begins to produce canvases that have been called "multiforms." The new work prompts a falling out between Rosenberg and Rothko in 1947. *Oils and Watercolors by Mark Rothko* at the San Francisco Museum of Modern Art, 13 August–8 September, includes many works from the Brandt exhibition, and the show then travels to the Santa Barbara Museum of Art.

In September Rothko takes Mell to Portland to meet his family; then to visit Douglas MacAgy in California. Still begins teaching at the California School of Fine Arts (CSFA), San Francisco, of which MacAgy is director. Rothko again participates in the annual Federation of Modern Painters and Sculptors exhibition, showing his *Archaic Image* (1945) at Wildenstein, 18 September–5 October. Newman organizes and writes the catalogue text for *Northwest Coast Indian Painting,* the inaugural exhibition at the Betty Parsons Gallery, 30 September–19 October. Rothko's *Room in Karnak* (1946) is part of the Whitney's *Annual Exhibition of Contemporary American Painting,* 10 December 1946–16 January 1947.

Rothko is included in *The Ideographic Picture,* a group show organized by Newman at the Betty Parsons Gallery, 20 January–8 February. He has his first one-man exhibition at Parsons, *Mark Rothko: Recent Paintings,* 3–22 March, showing *Primeval Landscape* and *Rites of Lilith* (cats. 17 and 27) among other works. Through Parsons, Rothko meets artist Herbert Ferber, with whom he becomes close and exchanges works of art.

Rothko serves as guest faculty member for the summer session at the CSFA, 23 June–1 August. He is described in the brochure as an "imaginative painter" and "representative of a new trend which is not to be designated as abstraction." Other faculty include Still, Elmer Bischoff, Edward Corbett, David Park, Hassel Smith, Clay Spohn, and Minor White, while Richard Diebenkorn, then a graduate student, teaches in the evenings. In addition to his painting class Rothko holds a weekly lecture/conversation. In one of these sessions, recorded by Spohn, Rothko states:

The most interesting painting is one that expresses more of what one thinks than of what one sees. Philosophic or esoteric thought, for example. (Spohn Papers, Archives of American Art)

En route to California, the Rothkos had stopped in Chicago, then visited his family in Portland. Rothko later calls Chicago the "most thrilling part" of the journey, as they visit a "bird zoo" there. Although bird-related imagery has been almost eradicated from Rothko's work, he refers to himself as an "ornithologist" in a letter to Newman (Newman Papers, Archives of American Art). After his return to New York, Rothko recalls the summer nostalgically as a "momentous time" he wished to relive.

Rothko does not contribute a work to the seventh Federation of Modern Painters and Sculptors exhibition, held 9–27 September, but he sponsors Still for the show. The October issue of the cultural magazine *The Tiger's Eye* illustrates five of Rothko's works and describes him as a painter of the "plasticity of inner life." The Whitney includes Rothko's *Archaic Fantasy* (1945) in its *Annual Exhibition of Contemporary American Painting,* 6 December 1947–25 January 1948.

The newly founded journal of artists and writers *Possibilities,* which comes out only once, is edited by Motherwell, Rosenberg, Pierre Charea, and John Cage. This publication of winter 1947–1948 includes Rothko's statement "The Romantics Were Prompted," passages from which appear below:

I think of my pictures as dramas; the shapes in the pictures are the performers. They have been created from the need for a group of actors who are able to move dramatically without embarrassment and execute gestures without shame.

Neither the action nor the actors can be anticipated, or described in advance. They begin as an unknown adventure in an unknown space. It is at the moment of completion that in a flash of recognition, they are seen to have the quantity and function which was intended. Ideas and plans that existed in the mind at the start were simply the doorway through which one left the world in which they occur....

The most important tool the artist fashions through constant practice is faith in his ability to produce miracles when they are needed. Pictures must be miraculous: the instant one is completed, the intimacy between the creation and the creator is ended. He is an outsider. The picture must be for him, as for anyone experiencing it later, a revelation, an unexpected and unprecedented resolution of an eternally familiar need.

1948

Rothko shows *Fantasy* (c. 1947) at the Whitney's *Annual Exhibition of Contemporary American Sculpture, Watercolors, and Drawings*, 31 January–21 March. His second one-man show at Parsons, *Mark Rothko: Recent Paintings*, held 8–27 March, marks the first time Rothko exhibits works with number titles, having begun the practice in 1947 following Still's lead.

In the spring Still resigns from the CSFA to move to New York and plan for the school he proposed to Rothko and MacAgy in the summer of 1946. Motherwell has been included in the project since January, and he nominates Baziotes and David Hare. Rothko, Still, Motherwell, and Baziotes meet in June to discuss the proposal, but by the end of summer Still is dissatisfied with the plans and abandons his role, returning to the CSFA. Nevertheless, the first session takes place at 35 East 8th Street with about fifteen students. The school is called "The Subjects of the Artist" at Barnett Newman's recommendation. Baziotes, Hare, Motherwell, and Rothko each teach on one day of the week; as Still was to teach on Fridays, they invite other artists to give evening lectures. The lectures are opened to the public at Newman's suggestion when he begins teaching in 1949.

Through Motherwell, Rothko meets accountant Bernard Reis, who had served as Peggy Guggenheim's financial advisor for Art of This Century, a role he later assumes for Rothko and other artists. Rothko's mother dies on 10 October at age seventy-eight following a long illness. The artist becomes depressed and writes to Clay Spohn that he "hates the life of a painter." He does not utterly abandon painting, but his output declines; he later claims that he did not paint for a year after his mother's death.

1949

The third of Rothko's annual exhibitions at Parsons, *Mark Rothko: Recent Paintings*, takes place 28 March–16 April, and he shows a sequence of works titled *No. 1* through *No. 10*. Rothko withdraws from the Subjects of the Artist School in midwinter, and by spring it closes for financial reasons. "Studio 35," a school occupying the same premises, continues the lectures and devolves into "The Club," a more informal gathering. Rothko's *Brown and Yellow* is included in the Whitney's *Annual Exhibition of Contemporary American Sculpture, Watercolors, and Drawings*, 2 April–8 May.

En route to another summer session at the CSFA, Rothko visits Portland with Mell, driving from New York with his brother Maurice and sister-in-law Clara. At the CSFA, where Edward Weston is now teaching, Rothko gives courses in painting and the philosophy of art; he also offers a lecture/discussion once a week on the work of contemporary artists. The session runs from 5 July to 12 August.

On 18 November he delivers a lecture at Studio 35 titled "My Point of View." The Whitney's *Annual Exhibition of Contemporary American Painting*, held 16 December 1949–5 February 1950, includes Rothko's *No. 19* (cat. 39). *The Tiger's Eye* publishes his "Statement on His Attitude in Painting" in its October issue:

The progression of a painter's work, as it travels in time from point to point, will be toward clarity: toward the elimination of all obstacles between the painter and the idea, and between the idea and the observer. As examples of such obstacles, I give (among others) memory, history or geometry, which are swamps of generalization from which one might pull out parodies of ideas (which are ghosts) but never an idea in itself. To achieve this clarity is, inevitably, to be understood.

1950

Rothko shows *No. 1* (as *No. 12*); *No. 8*; *No. 5*; and *No. 3* (cats. 36, 40, 41, 43) and other works in *Mark Rothko*, held at the Parsons Gallery, 3–21 January.

On 29 March the Rothkos sail to Europe on the *Queen Elizabeth* and travel for five months, having received a small inheritance after the death of Mell's mother. After three weeks in Paris the artist describes the city as "alien and unapproachable" in a letter to Newman; writing to sculptor Richard Lippold, he deems the "crumbling, monstrous, and picturesque" in France attractive but notes that he is "still looking for the fabulous" (Newman Papers and Lippold Papers, Archives of American Art). On the itinerary are also Cagnes-sur-Mer, Venice, Florence, Arezzo, Siena, Rome, a return to Paris, then London. The Rothkos spend a great deal of time looking at old master paintings and cathedrals. Mell becomes pregnant early in their tour, and their daughter, Kathy Lynn (called Kate) is born in New York on 30 December.

While Rothko is traveling, his name is included in a letter of 20 May from eighteen painters and ten sculptors to the president of the Metropolitan Museum of Art, Roland L. Redmond, protesting the planned December exhibition *American Painting Today 1950*, as it was a juried show they felt would discriminate against avant-garde artists. Rothko participates in his last Whitney *Annual Exhibition of Contemporary American Painting*, 10 November –30 December, showing *No. 7A* (1949).

1951

Rothko appears with seventeen other artists in the notorious "Irascibles" photograph in *Life* magazine's 15 January issue, which highlights their refusal to participate in the Metropolitan's contemporary art competition and coincides with the announcement of its winners. Having been recently appointed assistant professor of design at Brooklyn College, where Ad Reinhardt is already on the faculty, he begins teaching 1 February, about the same time Jimmy Ernst is hired. Still will join the faculty in 1952. To prepare to teach a course in graphics, Rothko studies printmaking with Will Barnet at the Art Students League in late January. On 19 March he speaks at a symposium at the Museum of Modern Art on "How to Combine Architecture, Painting, and Sculpture"; his statement is reprinted in the May issue of *Interiors*:

I paint very large pictures. I realize that historically the function of painting large pictures is painting something very grandiose and pompous. The reason I paint them, however — I think it applies to other painters I know — is precisely because I want to be very intimate and human. To paint a small picture is to place yourself outside your experience, to look upon an experience as a stereopticon view or with a reducing glass. However you paint the larger picture, you are in it. It isn't something you command.

The artist shows *No. 5*; *No. 10*; *No. 7*; and *No. 2* (cats. 46, 48, 50, 51) at Parsons in *Mark Rothko*, 2–21 April. This exhibition presents the first of the resolved "classic" Rothko paintings. From 2 June to 12 July the Los Angeles County Museum of Art's *Annual Exhibition: Contemporary Painting in the United States* includes Rothko's *No. 11* (1951). And from 25 October–16 December his *No. 2* (1949) is shown in the Art Institute of Chicago's *Sixtieth Annual American Exhibition*.

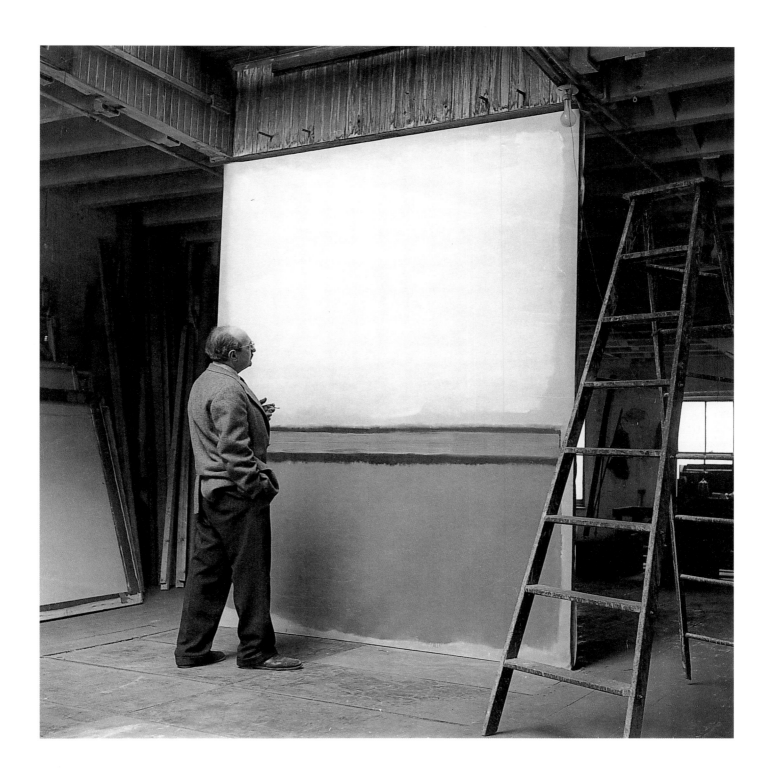

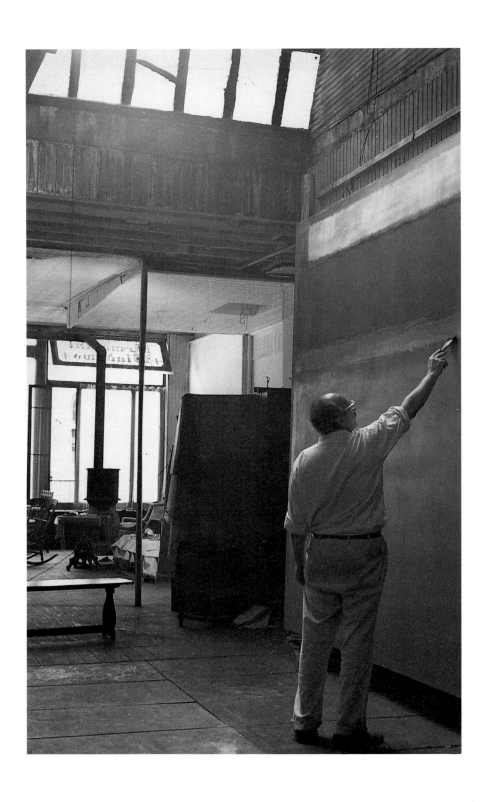

During this year Rothko meets Sally and William Scharf (a painter who will later become his assistant), art historian Dore Ashton, and writer Stanley Kunitz. Kunitz and Rothko later discuss collaborating on a book of poems, but the project is never realized.

Newman withdraws his work from Parsons at the close of his 23 April–12 May exhibition after his "zip" paintings receive disastrous reviews from both the press and other artists.

1952

Rothko moves to a studio at 106 West 53rd Street by at least March, and on 13 March he is invited to teach from 25 June to 22 August at Black Mountain College in North Carolina. He declines the position and instead spends the summer in New York. By now he is no longer working at the Center Academy. Jackson Pollock leaves Parsons for the Sidney Janis Gallery in May, continuing an exodus Rothko will join in 1954.

The Museum of Modern Art's *Fifteen Americans*, organized by Dorothy Miller, is seen in New York 9 April–27 May. The show includes Rothko and Still as well as Baziotes, Herbert Ferber, and Pollock. Both Still and Rothko decide against participating in the European tour of the show, as they would not be able to oversee the installations. Their withdrawal effectively terminates plans to travel the exhibition.

Rothko and Motherwell attend a conference on "Aesthetics and the Artist" in Woodstock, New York, 22–23 August. Speakers include Motherwell, Newman, and David Smith. By this time Rothko is estranged from both Newman and Still.

Rothko declines to participate in the Whitney Annual this year, writing a letter on 20 December to the Whitney's associate director, Lloyd Goodrich, in which he also refuses to have two of his works reviewed by the Whitney purchasing committee, stating that he has a "deep sense of responsibility for the life my pictures will lead out in the world."

1953

Rothko begins to spend more time with artists Philip Guston, Robert Motherwell, and later Theodoros Stamos. Katharine Kuh, a curator at the Art Institute of Chicago, visits Rothko at his studio and is impressed by his work. Still leaves Parsons in December and signs with Sidney Janis; Willem de Kooning also joins Janis this year. In a conversation recorded by Alfred Jensen, Rothko states:

Maybe you have noticed two characteristics exist in my paintings; either their surfaces are expansive and push outward in all directions, or their surfaces contract and rush inward in all directions. Between these two poles you can find everything I want to say. (Breslin 1993)

1954

Rothko is included in the Janis exhibition *9 American Painters Today,* 4–23 January, and leaves Parsons that spring to sign with Janis, where he joins Newman, Pollock, Still, and de Kooning. Rothko loses his position at Brooklyn College on 16 March, and his friendship with Ad Reinhardt suffers for a number of years as a result of Reinhardt's vote to keep Jimmy Ernst on the faculty rather than Rothko. Mell Rothko takes a part-time freelance job to help support the family. The artist is offered a temporary position at the University of New Mexico, which he declines. In April the Rothkos move from their 6th Avenue building, which has been condemned, to a walk-up at 102 West 54th Street.

Katharine Kuh proposes that Rothko inaugurate a series of solo exhibitions at the Art Institute. In July they begin to exchange letters about his work, intending to publish excerpts in a pamphlet to accompany the show. The brochure is never produced, as Rothko decides he does not wish a text to guide the experience of the viewer. *Recent Paintings by Mark Rothko,* held in Chicago 18 October–31 December, is his first one-man show at a major American art museum. The works, which include *No. 10* and *No. 1* (cats. 55, 64) are chosen by Rothko in conjunction with Kuh, and he advises her on their installation in a letter of 25 September:

Since my pictures are large, colorful and unframed, and since museum walls are usually immense and formidable, there is the danger that the pictures relate themselves as decorative areas to the walls. This would be a distortion of their meaning, since the pictures are intimate and intense, and are the opposite of what is decorative; and have been painted in a scale of normal living rather than an institutional scale. I have on occasion successfully dealt with this problem by tending to crowd the show rather than making it spare. By saturating the room with the feeling of the work, the walls are defeated and the poignancy of each single work…become[s] more visible.

I also hang the largest pictures so that they must be first encountered at close quarters, so that the first experience is to be within the picture. This may well give the key to the observer of the ideal relationship between himself and the rest of the pictures. I also hang the pictures low rather than high, and particularly in the case of the largest ones, often as close to the floor as is feasable, for that is the way they are painted. And last, it may be worth while trying to hang something beyond the partial wall because some of the pictures do very well in a confined space. (Courtesy The Art Institute of Chicago)

The show travels to the Rhode Island School of Design, 19 January–13 February 1955.

In December 1954 Rothko refuses to participate in the Whitney's *New Decade: 35 American Painters and Sculptors.* He paints *Homage to Matisse* at the close of this year—a tribute to an artist whose work had profoundly influenced his own, and who died November 3.

1955

Rothko's first one-man exhibition at the Sidney Janis Gallery—*Mark Rothko*—is held 11 April–14 May, with the artist hanging all of the work, which includes *Rust and Blue*; *Royal Red and Blue*; *The Ochre*; and *Yellow and Blue* (cats. 61, 64, 68, 69). Newman and Still both write to Janis condemning Rothko and his work. During the summer Rothko teaches for eight weeks as guest lecturer at the University of Colorado at Boulder and exhibits several paintings on campus. *Fortune* magazine declares Rothko's work a "speculative or growth" investment in its December issue. Rothko reads Kierkegaard's *Fear and Trembling,* a text that will play an important role in the Pratt Institute lecture he delivers three years later.

1956

A libel suit—over a piece published in the *College Art Journal* that satirized Newman and Rothko—is brought against Ad Reinhardt by Newman and tried on 15–16 February in the New York supreme court. The case is dismissed. During the summer Rothko is bedridden for about two months. Dr. Albert Grokoest correctly diagnoses his ailment as gout (earlier assessed as rheumatoid arthritis) and later becomes his primary physician.

Rothko moves his studio to West 61st Street, where he continues to work until the spring of 1958, when the building is demolished. His *Orange and Yellow* and *Light over Gray* (both 1956) are included in *Recent Paintings by Seven Americans* at Sidney Janis Gallery from 24 September–20 October.

1957

When Rothko serves as visiting artist at the Newcomb Art School of Tulane University in New Orleans, February–March, he and Mell stay in the home of artist Ida Kohlmeyer's mother in Metairie, a wealthy suburb. Rothko uses the garage as a studio, producing what he feels to be breakthrough works, *No. 14 (White and Greens in Blue)* and *No. 16 (Red, White and Brown)*. A small show of his work is installed at Tulane's art gallery. Writing to Clay Spohn, Rothko says he has been able to support himself entirely through his painting since the previous year yet asserts that he has "little faith that it can continue" (Spohn Papers, Archives of American Art).

This year marks Rothko's move toward a darker palette, which the artist acknowledges several years later: "I can only say that the dark pictures began in 1957 and have persisted almost compulsively to this day." He exhibits *The Black and the White* (1956) in the Janis group show *8 Americans*, 1–20 April. The Rothkos spend time over the summer in Provincetown, Massachusetts, as they have periodically since 1945.

The Contemporary Arts Museum, Houston, presents *Mark Rothko* from 5 September to 6 October, including *No. 7* and *No. 15* (cats. 50, 71); Elaine de Kooning writes the catalogue. The December issue of *Artnews* publishes Rothko's letter to the editor in which he dismisses de Kooning's association of him with action painting in her article "Two Americans in Action" (*Artnews Annual*, November), calling it "antithetical to the very look and spirit of my work."

1958

New Paintings by Mark Rothko, the artist's second and last one-man show at Sidney Janis, is held 27 January–22 February and includes *Earth-Green and White* (1957) and *Two Whites, Two Reds* (cat. 72). Rothko and Motherwell as well as Willem de Kooning, Philip Guston, and Franz Kline sign an agreement on 18 May allowing Bernard Reis to represent them in their contracts and dealings with Janis.

Negotiations take place in the spring for Rothko to undertake a commission to paint murals for the Four Seasons restaurant in the Seagram Building being designed by Philip Johnson. Janis confirms the agreement on 6 June, and by 25 June the House of Seagram has issued a purchase order for "Mural by Rothko for the Restaurant," which is sent to the cottage that Rothko has recently purchased at 250 Bradford Street in Provincetown. He returns to New York and begins work on the murals in July, painting in his new studio at 222 Bowery, a former YMCA gymnasium, and creates several groups of paintings for the project.

Along with David Smith, Mark Tobey, and Seymour Lipton, Rothko is chosen to represent the United States at the XXIX Venice Biennale, held 14 June–19 October, and he shows ten paintings, including *Black over Reds* (cat. 74). Without Rothko's knowledge, Janis submits *No. 14 (White and Greens in Blue)* (1957) to the Solomon R. Guggenheim Museum's International Award competition; when the work wins the U.S. national section award and its $1,000 prize, Rothko refuses both the award and the check.

Rothko delivers a lecture on his work at the Pratt Institute, New York, on 27 October. Notes taken during the talk are excerpted below:

The recipe of a work of art — its ingredients — how to make it — the formula.

1. There must be a clear preoccupation with death — intimations of mortality....Tragic art, romantic art, etc. deals with the knowledge of death.
2. Sensuality. Our basis of being concrete about the world. It is a lustful relationship to things that exist.
3. Tension. Either conflict or curbed desire.
4. Irony. This is a modern ingredient — the self effacement and examination by which a man for an instant can go on to something else.
5. Wit and Play...for the human element.
6. The ephemeral and chance... for the human element.
7. Hope. 10% to make the tragic concept more endurable.

I measure these ingredients very carefully when I paint a picture. It is always the form that follows these elements and the picture results from the proportions of these elements....

I belong to a generation that was preoccupied with the human figure and I studied it. It was with utmost reluctance that I found that it did not meet my needs. Whoever used it mutilated it. No one could paint the figure as it was and feel that he could produce something that could express the world. I refuse to mutilate and had to find another way of expression. I used mythology for a while substituting various creatures who were able to make intense gestures without embarrassment. I began to use morphological forms in order to paint gestures that I could not make people do. But this was unsatisfactory.

My current pictures are involved with the *scale* of human feeling, the human drama, as much of it as I can express.

1959

Art historian Werner Haftmann visits Rothko in the spring to propose that he participate in the second *Documenta* exhibition in Kassel. Rothko refuses because of the exhibition's location in Germany.

Rothko sails to Naples, Italy, with Mell and Kate on 15 June aboard the *USS Independence*. In the process of obtaining passports for this trip on 16 May, the artist legally changes his name to Mark Rothko. During the family's tour of Italy they travel to Pompeii (where Rothko feels "a deep affinity" between the wall paintings in the Villa of Mysteries and his own work). They also stop in Paestum, Rome, Tarquinia (to see the Etruscan murals), Venice (to visit Peggy Guggenheim), and Florence, where Michelangelo's Laurentian Library and Fra Angelico's murals in the convent of San Marco make a strong impact on him. From Italy the Rothkos travel to Paris on 15 July, then to Brussels, Antwerp, and Amsterdam. They then visit England, where Rothko may have considered purchasing a chapel in Lelant St. Ives to convert to a private museum. They sail for the United States on 20 August aboard the *Queen Elizabeth II*.

After returning from Europe, Rothko has dinner with Mell at the Four Seasons restaurant and is horrified by what he perceives to be an ostentatious setting. He immediately decides to abandon the mural project, returning the money he has received. Rothko's work is included in *The New American Painting* exhibition organized by the Museum of Modern Art, shown in New York from 28 May to 8 September following an extensive European tour that began in Basel in April 1958.

1955 / ROTHKO'S INSTALLATION
AT SIDNEY JANIS GALLERY, SHOWING
RUST AND BLUE, 1953 (RIGHT), AND
ROYAL RED AND BLUE, 1954 (LEFT).
SEE ALSO CATS. 61 AND 64.

ROTHKO TRIPTYCH AT THE HOLYOKE
CENTER, HARVARD UNIVERSITY,
BEGUN IN 1962 AND INSTALLED BY
ROTHKO IN 1964.

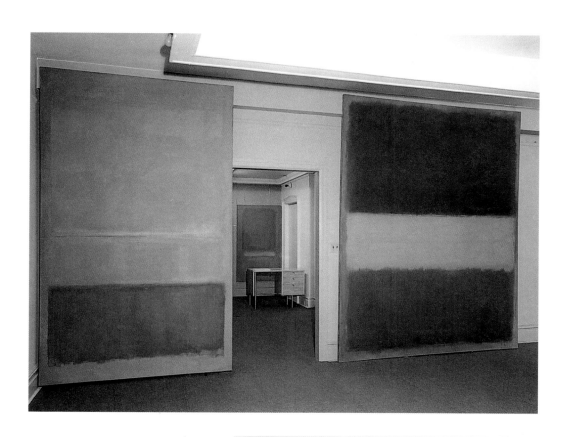

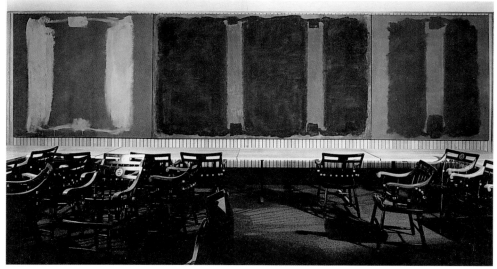

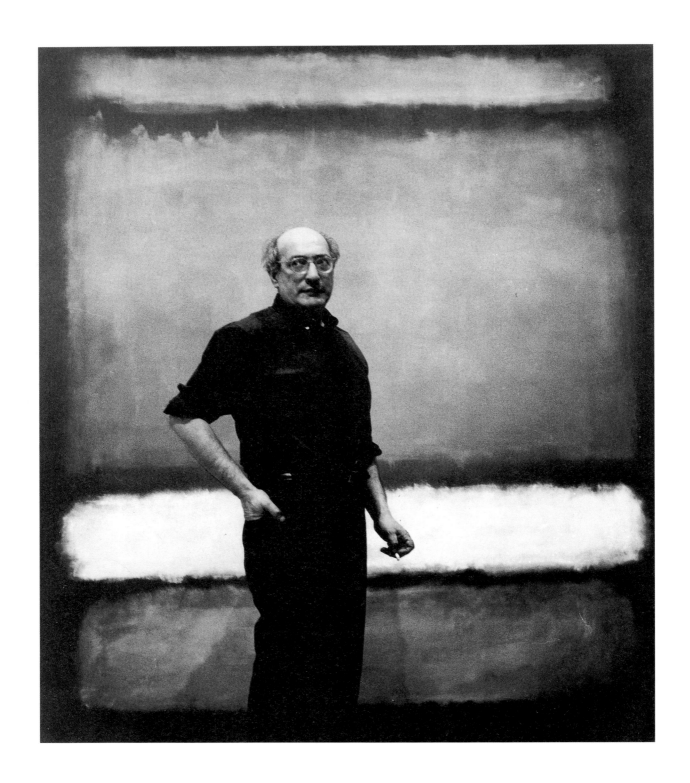

1960

The Rothkos purchase a brownstone at 118 East 95th Street. A small exhibition, *Paintings by Mark Rothko,* is held 4–31 May at the Phillips Collection in Washington, DC, from which two works are acquired for the museum. In November the Phillips Collection becomes the first public institution to install a "Rothko room," initially consisting of three paintings. John and Dominique de Menil, who will later commission a series of murals for a chapel in Houston, Texas, meet Rothko for the first time during a visit to his studio.

1961

In January the Rothkos attend John F. Kennedy's inauguration in Washington, DC, and while in town, Rothko visits the Phillips Collection's installation of his work. He responds very positively to the room but asks that it be slightly reconfigured and that the chairs be replaced by a wooden bench.

On 18 January, after extensive involvement by the artist with the selection, hanging, and lighting, *Mark Rothko* opens at the Museum of Modern Art. The retrospective contains forty-eight of his works, and the artist visits it virtually every day before it closes on 12 March, painting very little new work. His sister Sonia and two brothers, Maurice and Albert Roth, travel to New York to see the exhibition. Following the New York venue, the show travels to London, Amsterdam, Brussels, Basel, and Rome, closing in Paris on 13 January 1963. Rothko provides explicit written suggestions for the installation at the Whitechapel Art Gallery in London and travels by sea to view the show in early October.

Clyfford Still moves to rural Maryland, severing ties with members of the New York art community, whom he believes to be corrupt, focusing particularly on Rothko in this regard. The Guggenheim Museum's *American Abstract Expressionists and Imagists,* held 13 October–31 December, includes Rothko's *Reds No. 22* (1957). The artist accepts a commission for a series of murals for a proposed new building for the Society of Fellows at Harvard University.

1962

In early spring Rothko begins working in a studio at 1485 First Avenue. His brother Albert is diagnosed with colon cancer, and Rothko brings him from Washington, DC, to New York to be treated at Memorial Hospital, selling several paintings to pay the medical bills. Rothko also becomes ill in the late spring, suffering from shingles, bronchitis, and gout as well as exhaustion and depression. In May he and Mell attend a state dinner for the arts held at the White House.

Rothko meets with the president of Harvard, Nathan Pusey, on 24 October regarding his mural project, by now intended for a dining room. Harvard's board of trustees votes to accept Rothko's murals on 5 November. Rothko, Gottlieb, Guston, and Motherwell resign from the Janis Gallery in protest over the 31 October–1 December exhibition *The New Realism,* which includes pop artists such as Roy Lichtenstein, Claes Oldenburg, George Segal, and Andy Warhol.

1963

The five mural panels for Harvard University are shown at the Guggenheim Museum, 9 April–2 June, before being installed in Cambridge. Rothko signs an exclusive agreement with Frank Lloyd of the Marlborough Fine Arts Gallery, having been introduced to him by Bernard Reis (who soon begins serving as an accountant for the gallery). After an outright sale of fifteen canvases to Marlborough, he gives the gallery a contract for European as well as American sales for one year. Christopher Hall Rothko, the Rothkos' second child, is born on 31 August.

1964

Rothko travels to Cambridge in January to supervise the installation of his murals at Harvard. His first one-man exhibition at Marlborough in London, *Mark Rothko,* is held from February to March. On 17 April Dominique de Menil again visits Rothko, commissioning him to create a series of paintings for a planned chapel for the University of St. Thomas in Houston. His work is included in the Tate Gallery's *Painting and Sculpture of a Decade, 1954–1964,* from 22 April to 28 June.

The Rothkos rent a cottage in Amagansett, Long Island, during the summer. Returning to New York in the fall, Rothko moves to a new studio space at 157 East 69th Street, a nineteenth-century brick carriage house with a central skylight cupola. He employs William Scharf to assist him with the chapel project, and they rig the studio space with a system of pulleys and a parachute-like device with which to adjust the light entering from above. Temporary walls of the same measurements as the planned chapel are also installed.

1965

Delivering a eulogy on 7 January for Milton Avery, who had died four days earlier, Rothko acknowledges Avery's influence on his own development. On 15 January he receives a letter from Dominique de Menil that expresses her pleasure at the new commission and encloses the first payment for the chapel project; Rothko has been working on the paintings for four or five months. Philip Johnson is the preliminary architect, but Rothko objects to his role, and he is replaced by Howard Barnstone and Eugene Aubry. The artist spends the year working exclusively on the chapel paintings, which he feels will constitute his most important artistic statement. He hires Ray Kelly and Roy Edwards to assist him with the murals later in the year.

Rothko wins the Medal Award at Brandeis University Creative Arts Awards on 28 March. He shows *The Ochre* (cat. 68) at the White House Festival of the Arts, 14–20 June. The Los Angeles County Museum of Art holds *The New York School: The First Generation, Paintings of the 1940s and 1950s,* 16 July–1 August, with several works by Rothko. Sir Norman Reid, director of the Tate Gallery, London, visits Rothko in October to propose that the Tate acquire a number of his paintings to be shown in a room dedicated to his work.

1966

From June to August the Rothko family again travels in Europe, spending time in Lisbon and Majorca en route to Rome, where they stay with Carla Panicalli, the director of Rome's Marlborough Gallery. In Rome they visit the Forum, the Diocletian baths, and Hadrian's Villa as well as numerous churches, touring with Bernard and Becky Reis. The Rothkos also spend time with art historian Peter Selz—curator of Rothko's 1961 retrospective at the Museum of Modern Art—and painter Carlo Battaglia. They travel to Spoleto with Gian Carlo Menotti, to Assisi to see Giotto's frescoes in the basilica of St. Francis, then to France, the Netherlands, Belgium, and London, where Rothko visits the space proposed to house his work at the Tate.

The Cleveland Museum of Art includes three of Rothko's works in *Fifty Years of Modern Art: 1916–1966,* 14 June–31 July. The Museum of Modern Art's International Council exhibits three of his works in its *Two Decades of American Painting;* the show travels to Tokyo, Kyoto, New Delhi, Melbourne, and Sydney between 15 October 1966 and 20 August 1967.

1967

The art department of the University of St. Thomas holds the exhibition *Six Painters* (featuring Mondrian, Guston, Kline, de Kooning, Pollock, and Rothko) 23 February to 2 April; Rothko is represented by works from the 1940s through the 1960s. In April he completes the fourteen paintings and four alternates that will be sent to Houston for the Menil's chapel. After Dominique de Menil and one of the chapel architects view the works in June—and Rothko makes minor revisions—the eighteen designated paintings are placed in storage until the chapel can be completed.

Rothko and his family take the train across the country when he accepts a one-month summer position at the University of California at Berkeley. At the close of the session the Rothkos visit his family in Portland.

1968

Slow Swirl at the Edge of the Sea (cat. 19) is included in the Museum of Modern Art's *Dada, Surrealism, and Their Heritage,* 27 March–9 June.

Rothko suffers an aortic aneurysm on 20 April, caused by hypertension, and is admitted to New York Hospital. Because of multiple other health problems, including signs of cirrhosis of the liver, he is unable to undergo surgery but stays in the hospital for three weeks. After being discharged on 8 May, he is confined to bed for another three weeks, and when he resumes painting, his doctors recommend that he paint nothing more than forty inches in height.

On 28 May Rothko is inducted into the National Institute of Arts and Letters. In July the Rothkos rent a cottage at 621 Commercial Street in Provincetown near the Motherwells,

as well as a studio space several blocks away. It is a difficult summer, with tension growing between Mell and Rothko. The artist paints a number of small works on paper with acrylic and expresses a desire to create the kind of works he had done in the 1940s. Rothko invites a group of younger artists whom he has met through Stanley Kunitz to discuss art with him on a weekly basis. He grows frustrated with their responses to his work, however, as well as what he considers to be an adversarial attitude, and he soon abandons the practice. Over the course of the summer he sees Kunitz, Jacob Kainen, and Jack Tworkov regularly.

After his return to New York the artist draws up a new will on 13 September with the assistance of Bernard Reis, dividing his estate between his family and the Mark Rothko Foundation. In late November he begins an inventory of his work with the help of studio assistants Dan Rice and Jonathan Ahearn, joined in February 1969 by Oliver Steindecker, who is hired after doing an internship with Rothko through Hunter College. The nearly eight hundred works still in Rothko's possession are inscribed on their versos with dimensions, dates, and inventory numbers. Morton Levine then photographs the works for documentation purposes.

1969

Leaving Mell on 1 January, Rothko moves into the 69th Street studio, where he leads a rather spartan existence. In February he sells twenty-six more canvases and sixty-one works on paper to Marlborough and signs an agreement making them his exclusive agent for the next eight years. By March he has begun a relationship with Rita Reinhardt, the widow of Ad Reinhardt (d. 1967), but he continues to have lengthy phone conversations with Mell on a daily basis.

During the spring, having been unable to paint large canvases since his illness of the previous year, Rothko embarks on a series of large, somber works in blacks, grays, and browns. He travels to New Haven alone to receive an honorary doctorate from Yale University on 9 June.

The Mark Rothko Foundation is incorporated on 12 June, with Rothko, Morton Feldman, Robert Goldwater, Morton Levine, Bernard Reis, Theodoros Stamos, and Clinton Wilder acting as directors. Although the foundation is described as "exclusively for charitable, scientific, and/or educational purposes," there is no further language describing its intended purposes, which underlies a complicated legal struggle after Rothko's death.

The artist continues to have health problems and is diagnosed with bilateral emphysema on 30 September. At the suggestion of Professor E. C. Goossen, who has known Rothko for some time, the artist teaches several classes at Hunter College, which is located near his studio. The Metropolitan holds *New York Painting and Sculpture 1940–1970,* 18 October 1969– 1 February 1970, including a number of the artist's works from throughout his career.

Rothko holds a party in his studio that December to elicit opinions on his new dark paintings from members of the New York art community. He donates nine Seagram murals to the Tate Gallery, having initially proposed a larger gift during earlier negotiations.

1970

Rothko schedules an appointment with Donald McKinney, a vice president of Marlborough, on 25 February to select works for a new gallery contract, but in the early morning of that day he commits suicide. He is buried on 28 February in North Shore, Long Island, overlooking Shelter Island Sound. One year later, on 27 February 1971, the Rothko Chapel is dedicated as an interdenominational chapel.

NOTE

I have relied on a number of sources in preparing this chronology. James E. B. Breslin's *Mark Rothko: A Biography* (Chicago and London, 1993) has been invaluable, as have David Anfam's publications and his work toward the forthcoming catalogue raisonné. Other important sources include the Mark Rothko and His Times Oral History Project and other materials at the Archives of American Art, Smithsonian Institution; the Solomon R. Guggenheim Museum's 1978 exhibition catalogue *Mark Rothko: 1903–1970* and Dore Ashton's *About Rothko* (New York, 1983). JS

PHOTOGRAPH ON PAGE 332: MARK ROTHKO IN HIS WEST 53RD STREET STUDIO, C. 1953, TAKEN BY HENRY ELKAN.

C. 1964 / ROTHKO IN HIS 69TH
STREET STUDIO WITH CHAPEL
MURALS. PHOTOGRAPH BY HANS
NAMUTH.

THE ROTHKO CHAPEL INTERIOR
WITH ORIGINAL SKYLIGHT GRID.
PHOTOGRAPH 1971.

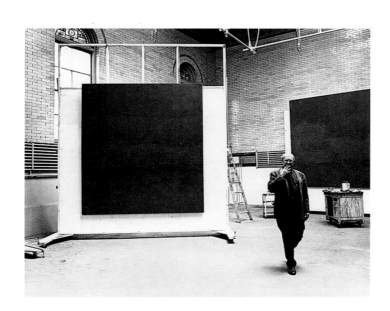

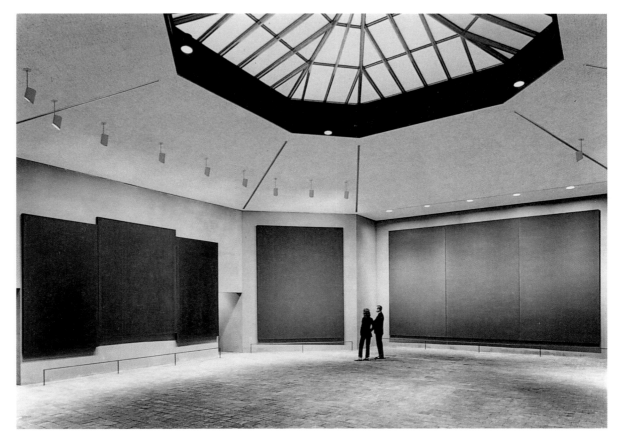

351

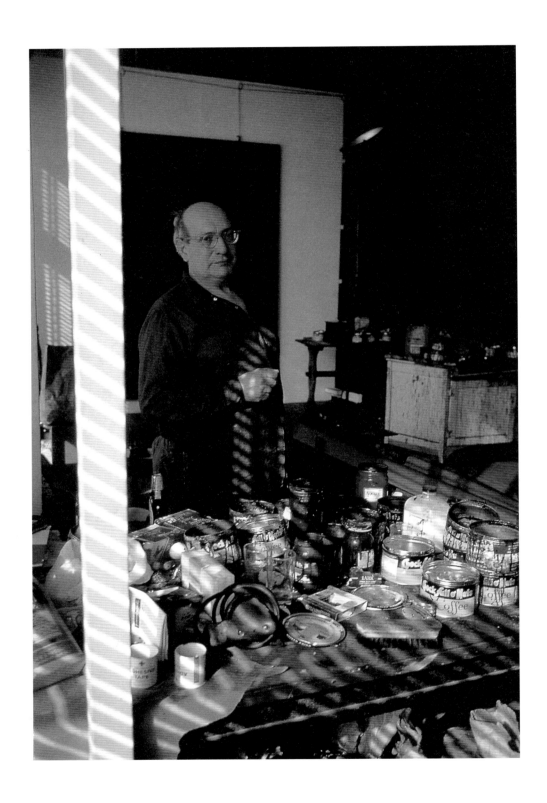

INTERVIEWS

Ellsworth Kelly

When did you first see Rothko's work and what were your thoughts?

In August 1954 I came back from Paris. I'd been there six years, and I knew nothing about what was happening in New York. Except about the time I left, in 1948, there was an article in *Life* magazine on Pollock. Otherwise, I never saw any American art magazines until just before returning to New York, when I saw what Ad Reinhardt was doing. In Paris there was considerable interest in, say, Soulages, or some of the Tachists. I didn't even know Sam Francis was in Paris.

I think it was sometime after 1959, when Dorothy Miller included me in the *16 Americans* show at the Museum of Modern Art. There was a small party upstairs at the time of Rothko's 1961 show, and he was there. Dorothy Miller introduced us. It's very interesting, because there was a Paris painting of mine called *Gaza,* in four joined panels, which I had finished when I came back. It was red on the top, with two yellows, and I'd seen a painting of red and yellow in Rothko's show downstairs. I said to Rothko that I had done a painting similar to his but that it was done with joined panels. He looked at me and he said something like, "Don't you think I need a rest?" And he walked away. No connection at all, and that's the only time I met him.

ELLSWORTH KELLY, *ORANGE GREEN,* 1966, ACRYLIC ON CANVAS, 244 X 165.4 (88 ⅛ X 65 ⅛), ROBERT AND JANE MEYERHOFF, PHOENIX, MARYLAND.

How did you see yourself in relation to Rothko, as well as Newman, in those early years?

Early Newmans and Rothkos were very soft-edged paintings, so in order for me to have my own stability about my beliefs, rather than give in to abstract expressionism—which a lot of the young painters were influenced by and carrying on—I felt that I had to resist it. Anyway, I had a different emphasis on edges, which I had done in my panel paintings.

Were you aware of Rothko's kind of metaphysical or transcendental interests?

That didn't interest me.

So you looked at his work just from a formal basis?

Yes. What I liked about Rothko was that there was no real sort of idea in the paintings. They were a presence, just pure abstraction. When I think about Rothko, it's color first, the exuberance, the luminosity, and the radiance of color that is so striking. I'm not much interested in the dark paintings.

How do you understand Rothko's use of color?

He doesn't use a whole range of colors in a painting. He's very sure of wanting to make a strong statement of color. And then when he goes to black and white, in the late paintings, he uses a black or a dark gray and a white under it, in modulated ways.

What other qualities in Rothko's work are particularly striking to you?

I'd say proportion and measure. He said his work was about measure. I understand this and agree. The French are very involved in measure. I think of French architecture, the Romanesque and the Gothic. The Romanesque— which is bold, block on block, or a curve of an arch against the thickness of the block, or the columns—taught me a lot about the measure. My eye tells me, this is going to work; this isn't going to work.

Rothko's sense of proportion shows in a painting, say of a large yellow with white over it, a thin portion of black at the top that has white over it mixed with gray, and then a very small black and red on the bottom, with a little bit of color left around the edge.

Paint application is also crucial. I admire Rothko's brushwork. When you look at a Cézanne, his work is made up of little blocks of color—like stepping stones almost—and they all blend together. Rothko employed large brushes.

If you're a painter, and you studied painting, you appreciate the way his work is painted. Kline and de Kooning are more ruthless in their technique;

they almost don't need you. They're really brash and virtuosos. With Rothko, you feel the way he caresses the canvas. His painting seems to absorb color and to glow.

I recall your once saying that you marveled at Rothko's paint handling, that it was difficult to know how he even applied the paint.

Yes. I think that's his secret. I understand he painted very thinly and with scumbling, but his work is not so much about that. It's about his decision-making. It would have been nice to have been able to watch him progress. Sometimes, when you stand in front of a painting in an exhibition, in the position where the artist was when he was painting it, I try to imagine how it was done.

How does Rothko's work hold up?

The way Rothko paints is devastating, and as with all good painting, it gets better with time. The work seems to glow. It looks very healthy and has a strong presence. When I go to some shows now of younger artists—big group shows—there is so little I enjoy looking at.

It makes you feel even closer to Rothko.

Yes.

Did you ever feel you were, in a sense, competing with Rothko?

No, but I'm not competitive. I started doing the panel pictures in 1949. I didn't know about the work of the abstract expressionists, nor was I influenced by it later. A critic once wrote in some book that he thought in the future perhaps my work will gravitate to being grouped with Newman and Rothko.

Rothko exhibits a control of the beauty of the void, the sea, the sky, and space. I like the sunlight and shadow. I like the difference between black and white, light and dark together.

BRICE MARDEN, *MIRANDA*, 1972,
OIL AND WAX ON CANVAS,
182.9 X 182.9 (72 X 72), FRANCES
AND JOHN BOWES.

Brice Marden

What were your thoughts about the 1996 exhibition of Rothko's late work at the Menil Collection in Houston?

What really surprised me about the show—and I thought I knew Rothko well—was that there was such a serious body of work around the Menil chapel commission, as well as the group of paintings with that kind of hard shape that led up to the chapel series. It is almost as if they're unknown paintings, yet each is unique in terms of that era. I knew a couple of the paintings, but to see them all together like that was absolutely wonderful.

The gallery in Houston presented some problems.

The room seemed a little small for the tall canvases, but I thought that it worked in that they were shown hanging in pairs. You could distinctly see which one went with the other one, and how Rothko was thinking. Because of the tightness and height of the room, it was an incredible experience, like being in the redwoods. The artist's ambition was very moving. Suddenly you could see a painter who was willing to make these things, who knew that they would perhaps disappear, or had the faith that they wouldn't, but who wasn't so insistent about getting them into a public space.

I used to think about him a lot. My idea of a vacation was to go to Houston, check into the Warwick Hotel, and go over to the Rothko Chapel a number of times during the day to see the works in different lights and different situations. At certain times of the day you can see a striation and a vertical stroking on the chapel paintings. I was really taken by that, because you had a plane and at the same time there was another kind of energy because of the striations.

Toward the end of the period when I was doing my own monochromatic panels, I was very carefully painting vertical strokes, which you can't really see unless you get down on the floor or take the work out in a little different lighting situation. That technique came out of Rothko's paintings.

I had the impression that at one point he directed his assistants in the making of the paintings. I wondered about that, since I thought I was seeing his hand in the works. But it wasn't his hand. Still, the paintings seem very alive to me.

I also enjoyed the ones in which he has the raised center, or when he was broadening the large shape, or when he elaborated the edges with a kind of vibrancy.

I thought, at a certain time, that the colors started changing in the paintings. He used a lot of extremes—technically—including Magna, which is a water soluble, oil-based paint. I have had talks with Franz Meyer in Basel about the beautiful painting at the Kunstmuseum there. He said it is completely different than when he bought it for the museum. It's a painting that I know, because when I first rented a house in Hydra, there was a reproduction of it there. (A bunch of kids from the University of Illinois had rented the house just before, and they left it there.) So I've always kept this one object, as kind of a house icon. Anyway, Franz Meyer says that this reproduction is probably more like the way the painting was than the way it is now.

To the extent that I have observed it, he's almost out of fashion. But now he seems to be coming back. I would think that some of this has to do with his ideas about what painting was capable of, which had gone out of fashion.

With Frank Stella and minimalism, aesthetics became so hard. When Rothko says he wants people to cry, and have real emotional experiences in front of the painting (that almost touchy-feely thing about painting), people turned against that.

I felt the same way he did, but it's almost indefensible. You're so subject to intelligent attack, because the ideas are too romantic. However, I've always felt that my own personal beliefs were supported by Rothko's ideas, so I've felt very close to his painting.

One of the things I like is how painterly his work is, and how he was almost painting in a new way. His approach in the late work hasn't been followed up on very much, but I think those works are particularly important.

What do you mean, "…they were painted in a new way?"

It was kind of "Now you see it, now you don't." Things that he would have going on in those dark areas disappear, though they're there and are having an effect. You can't perceive the color at first, then when you do, it's incredibly beautiful. Also, the surfaces become very hard and reflective.

In Chicago, at the Art Institute, there is a purple, white, and red squarish painting. It's almost like an impressionist work, because of the kind of touch involved. He was one of the last painterly painters, really into the act of painting. In a way he's very historically isolated because of this quality.

What do you mean?

He sits isolated in terms of his own colleagues. With Rothko there is a belief that touch and paint are about emotion, whereas for the others paint is simply about paint. You can really empathize with Rothko's works, and that becomes an important part of looking at each one. With the late ones, you look at those edges, and each one is distinct. His touch affects the whole feel of the painting: it's an empathetic, emotional response that I have. In de Kooning's work the touch facilitates the making of the image; in Rothko the touch was much more integrated, and less of a separated or isolated fact. I miss this in contemporary painting.

When was the first time you saw Rothko's paintings?

I used to go to shows at the Janis Gallery in the late fifties, early sixties.

Did you ever meet him?

Occasionally he would come into the Bykert gallery, because he was friendly with Ralph Humphrey. You'd be sitting there, and this big bear of a guy would come through the door. He was really foreboding, not the kind who you'd walk up and start chatting with. You'd get your head bitten off. Now, I'm really sorry that I didn't.

Did you, at that point, see yourself in relation to Rothko?

Yes, he was the abstract expressionist whom I related to the most. In terms of trying things with color, he was a big influence. I really liked it when the work started to become harder and harder; there was a combination of atmosphere and hard edge.

I've always felt more related to the abstract expressionists than any other group. I think that's what I came out of; they were my teachers. I started with Franz Kline, because I was coming from Spanish paintings, Manet, and things like that. You always admired de Kooning, who seemed to be the teacher of the methods of the abstract expressionists. But then it was Rothko to whom I would respond, especially in his later paintings. There was something in how you could look at that work and not have to worry about a lot of other stuff, about figuration and how that was being dealt with, or not. These paintings were just there.

So did you think in terms—not to overdramatize this—of whether your aspirations measured up to a Rothko?

The whole idea of beauty was not embarrassing to me, as it was for a lot of people. It's one of the things that was encouraging about Rothko, that he didn't seem to be embarrassed about it, either.

He gave permission?

Yes, and that's an important thing, to get permission from the predecessors or the peers. When I first came to New York, I had had an art education at Boston University and then at Yale. But when you get to New York, the early experience was, "Oh, my God, maybe I am an artist because I'm thinking like these people." Not that I didn't know artists at Yale, but you're out there. In the real world, it's very supportive when you discover artists involved with the ideas that you were a little nervous about.

I was isolated on the Lower East Side, ending up with paintings that confused me. You haven't learned how to justify it yet, but then all these other people help you justify it. So it was very helpful with Rothko. There was all this other stuff going on, and Rothko's out there, just going right along. When you don't give up your beliefs and you've got this person [Rothko] who is involved in the same things, these beliefs become believable. He was making it very, very believable.

Although for some artists you sort of have to break through the group in front of you and do some diametrically opposed thing, I couldn't do that. I just felt I was still much more in tune with abstract expressionists than with the minimalists. I just got stuck in with the minimalists, because there were a lot of things that were very similar.

What about Rothko's scale?

I liked his mobility, that he wasn't attached to a situation. He could do all these beautiful small paintings on paper, as well as these grand, huge ones. I see him in the tradition of grand painting, artists who dealt with large ideas and communicate a lot.

When you say grand painters, who are you thinking of?

What's in my mind is Delacroix and Courbet.

How do you imagine Rothko's process?

As far as I can see, he would lay on a ground color, because you could see the ground goes all the way around the edge. Then he would just add another color. It's this abstract expressionist process: it was spontaneity. I don't think he plotted the paintings, because you can see how they grew intuitively. He felt out the plane.

How do you view Rothko's legacy?

I don't see much activity related to him now, but I think Rothko's so strong that will change. Maybe because the layman loves his rich color, the intensely involved art world shuns it. But I think there are important issues that each artist must deal with, in terms of spirituality or mysticism. Rothko wasn't afraid of that at all, maybe because it came out of his religious tradition. I think it will come back, and when it does, Rothko's going to be right up there. Now, people don't allow themselves that; they think it's so much of a luxury to think that way.

For you, what is the experience of a Rothko room, like the chapel?

It's like going to the Villa of Mysteries at Pompeii, with the environment and the kind of intensity of the images. I think Rothko was making an environment where your whole spirit becomes isolated. You just have to deal with it. He helped you deal with yourself. It's a part of that kind of grand way of thinking.

Gerhard Richter

When did you first see Rothko's work?

It was sometime in the early or mid-1960s. The paintings were a shock. They were so serious, not wild like Warhol. Rothko's attitude with regard to painting and the job of the painter was particularly impressive to me.

What did you perceive his attitude to be?

I think it was the Art Institute of Chicago in the mid-1950s that has made a classic view of Rothko's images popular, as it says that one tends to enter *into* his canvases—not merely to look *at* them.

When was your next confrontation with the work?

That occurred sometime in the late 1960s, when I visited the Tate Gallery, London, to see the large series there. I came with great expectation, but the experience was a bit strange, like visiting a church. It was more an experience about mystery than about painting, I thought. Although I wasn't disappointed, I didn't identify with Rothko's work either.

GERHARD RICHTER, *ABSTRACT PAINTING 780-1*, 1992, OIL ON CANVAS, 260 X 200 (102 ⅜ X 78 ¾), NATIONAL GALLERY OF ART, WASHINGTON, GIFT OF THE COLLECTORS COMMITTEE.

Were there many of Rothko's paintings to see in Europe?

No, and I have never seen a retrospective, unfortunately.

During the 1970s, as you yourself came to work more consistently in an abstract fashion, how did you feel about Rothko?

At that time I really felt quite mixed about his work. It was both too holy and too decorative. Although the paintings apparently had a transcendental aspiration, they were used for decorative purposes, and looked overly beautiful in collectors' apartments.

Did you feel you understood Rothko's intentions?

The work had a presence that suggested a transcendental approach. While I certainly prefer that to cynicism, at the time I felt it was almost too easy to look serious and holy, just by painting dark works. There was a kind of science-fiction coming from Rothko's darkness that was Wagnerian or had a narrative side, which bothered me.

This dichotomy between the holy and the decorative seems to haunt abstract painting and painters. How did you solve this dilemma, theoretically and practically, and how did your approach to that issue differ from Rothko's?

Rothko's enormous, calm paintings, with their floating rectangles, where any trace of chance is removed, have something extraordinarily meditative that seems magical and mysterious. This deepness has got something religious. I myself distrust this message. This means I try to avoid every similarity with Rothko's art.

So I take it you have never related your work to Rothko's, that his attitude toward art was somehow traditional or old-fashioned?

I only identified with this seriousness, which was absolutely to be admired. At that time, in the 1970s, Barnett Newman, with his nonhierarchical structures, his nonrelational color field painting, seemed more interesting because his work was less pretty.

No, no, not at all. We need beauty in all its variations.

Certainly. I too want that quality in general for my work, and to touch the world. But my interest only parallels Rothko; I am not influenced. His metaphysical aspirations are found in all great art. Besides, the mystery and incomprehensibility of Rothko's paintings is based on the specificity of the structures, the transcendental effects, and the viewer's contemplation. The aesthetic experience in my abstract paintings is not metaphysical in the sense of being religious. Only the structure of my works is so complicated and difficult so that they are incomprehensible also. If you want, you may call it metaphysical.

Yes, but research or explaining such a development is very difficult.

Oh, no. For me romanticism is the likes of Philip Otto Runge, that is, an artist who presents a tortured view of himself. Maybe in the widest sense of the word Rothko might be a romantic, as Robert Rosenblum suggested in his book *Modern Painting and the Northern Romantic Tradition: From Friedrich to Rothko.*

I know that he had a tremendous sensitivity to music. As far as I know, he was a great fan of Mozart. I prefer Bach. Sometimes I listen to music while I paint. Since the nineteenth century, however, music has been a great influence on pictorial creativity, no matter how. Rothko's or my relation to music is not exceptional regarding abstract painting.

Well, I am less antagonistic to "the holy," to the spiritual experience, these days. It is part of us, and we need that quality.

Is there anything about you that has caused your recent evaluation of Rothko?

I suppose that I am less aggressive and militant now.

Perhaps the 1970s was a time for that?

Yes, and I am older, too.

How do you view Rothko's legacy?

He was a man who created a special art for us, and no one else will do such paintings again. I believe Rothko will be important for centuries to come.

Robert Ryman

You first encountered Rothko at the Museum of Modern Art in New York, where you worked as a guard from 1953 to 1961.

It was the first time I'd seen a Rothko. I'd been looking at all kinds of painting—Cézanne, Picasso, Matisse. Seeing a Rothko for the first time was a different experience, and I didn't know in the beginning what to make of it. The painting looks easy. It looks as if it just happened, that it was just such a natural thing. It projected a different experience. Looking back on it, most of the other painters—even de Kooning and the abstract painters, except for Pollock—had some kind of recognizable image. This painting of Rothko's was not like that. Here was something that was so naked, in a sense. The deep edges of the painting went back toward the wall, and the paint went around the side. You could see staples, it was so open. I hadn't experienced that before. The only other painter was Pollock. It was a totally new experience. I somehow didn't think of Barnett Newman, for instance, the way I thought of Rothko or Pollock.

I remember that, one day, the Modern put a box frame on a painting, which was not next to the edge, but a few inches away. It was a shock to everyone, including Rothko, and he immediately tried to get this frame off of it. It points out this different aesthetic that he had, where you couldn't really add anything to the painting such as a frame—even a box frame that didn't touch

ROBERT RYMAN, *UNTITLED*, 1959, OIL ON CANVAS, 110.6 X 110.6 (43 ½ X 43 ½), COLLECTION OF THE ARTIST.

the edges—because it completely changed the feeling of it. Even now, I think maybe that's not clearly understood. I've seen Rothkos with Plexiglas in front, and even frames. Of course, he would never have allowed that. Any time his paintings are exhibited in public, they should be exhibited the way he painted them, and not with any additions. And that holds true for painters like Ellsworth Kelly, Yves Klein, and myself. It's a matter of whether you want to dilute the aesthetic experience, or do you want it to be free, to experience it correctly.

That's critical, especially in relation to your work: the idea that the painting is not just an image, but an object. In that sense the edges become extremely important.

Yes. Also it has to do with the wall plane. The aesthetic goes outward toward the wall, rather than the way we're used to seeing pictures, particularly narrative images within a space that we know, that we've seen before. When you look into a Rothko, you see a plane of color. I think that this kind of aesthetic, where it moves outward, is dependent on presentation. Wherever it is, it will have an effect on things around it, and things around it will affect it, of course. If it's put next to another object, or even against an articulated wall— a brick wall—that affects the way it feels, because of that outward experience. Whereas you wouldn't have that with a framed picture, because you are always looking in it, you're not involved with the wall. The frame isolates our experience from the wall. But that's part of the realism of the painting: it is affected by real light, and the real presence of where it is.

When we look at a picture with a frame, we're generally not conscious of the frame. The frame is there to focus us into the world of the painting, which is an inward world. And light is painted into the painting, the illusion of light. We could say that with Rothko in a certain sense. But I don't think he was thinking of an illusion of light or any kind of illusion at all. His paintings dealt with real light. I think he preferred them in a very soft light. The best way to view painting of this nature is in different lights—if you have daylight, and you can see it on rainy days, on bright days, because then the painting comes alive, it changes all the time. Or in a reflected light from across a room at night. Having no illusion, the painting reacts with real light. Of course, my paintings react that way too. I mentioned it before as realism. The painting deals with real surfaces and real light, real structure. It's not involved with illusion or narrative or any kind of image of anything we might know. It becomes a presence of its own. It becomes an image that we've never seen before. I think of it as a different aesthetic. Rothko proved that there could be this different aesthetic.

The idea that there was a metaphysical side to abstraction and to Rothko's kind of abstraction is, you think, an overinterpretation, or simply the wrong way to look at the picture?

Yes. That's just in the mind of the viewer. It's not Rothko's intention. It strictly had to do with composition, color, plane, and presence, working with the wall plane. I don't believe it represents anything. It has no symbolic meaning. People can read all kinds of things into it.

In a work from 1958 you included an inscription, the words "paradoxical absolute." Doesn't that imply symbolic or metaphysical connotations?

Well, no. It was just a little painting I was doing. I was reading some philosophy at the time—it had nothing to do with this painting. That was the title, and I just put it on the front of the painting, instead of the back. It was just two words that I thought were interesting.

Did Rothko's presence or example somehow sanction your decision to start out as an abstract painter?

When I first saw Rothko, it changed my thinking about painting. The edges were so important, and the wall became so important, and as I said, the nakedness. Not so much the color, or even the style of painting, but just that: the way it projected off of the wall and the way it worked with the wall plane. Actually my painting was very different, my approach was different. But that didn't matter. It was just the presence of his paintings, and the way they worked with the light.

It's interesting that while you were attracted to Rothko, the scale of your work was never really comparable.

No, that wasn't a factor at all. I didn't think much of that.

What about Rothko as an artist who worked with permutations in a deliberately restricted format or compositional type?

It was just taken for granted. I didn't think about that approach so much. Early on, I hadn't really seen that many Rothkos. It was only later that I saw quite a number of them.

When was that?

Mostly after his death, when I visited the warehouse where a lot of his paintings were stored. And, of course, the Rothko exhibitions. The first one I saw was at the Modern many years ago.

In 1961. Were you still working at the Modern at that time?

I don't think so. But I remember the exhibition was kind of small by today's standards. That was the first time I'd seen a lot more than one or two.

Was there something historically about Rothko that made him relevant to you at that time?

Rothko and that generation were very dedicated. Their life was painting. That's the way it should be, and that's the way I felt. It was correct. I liked that—just doing it. Kline was another one. He was a brilliant painter. He really understood what he was doing—what art was, what painting was.

Rothko found that with the rise of pop art he was something of an outsider.

I guess so, I never thought of him in that respect. It was a difficult time. I think with Rothko, maybe he was left outside, but still he was respected as a painter.

Did you sense that one thing was coming to an end, and another was starting?

The approach I was taking was not very popular in the sixties. Painting was not very popular, except for pop painting—that's what everybody wanted to see. But I didn't feel that what I was doing was not right, not correct.

Of course, sculpture was very big. Painting was pronounced dead, which it is every so often. And then the Oldenburg "Happenings," a lot of installation art, and a certain amount of political and social art later. But there was always painting in the background.

I'm sure Rothko had an impact on many younger artists at the time. It's hard to say exactly what triggers certain responses. The most important thing is that someone find their sensibility. If you can really be genuine about the way you are and the way you approach things, then it's okay, whatever you do, whatever painting you make. And certainly Rothko found his sensibility. That doesn't happen to everybody.

George Segal

What were your first experiences with Rothko's art?

As a young artist I was extremely attracted to the work of the abstract expressionists, and I had studied with Baziotes and Tony Smith. In fact, Smith would come into class with a Rothko painting under his arm to show us what the new work looked like.

I also remember seeing Rothko's retrospective at the Museum of Modern Art. I was told he had hung it himself. The paintings were two or three inches apart and the lighting was low. In my eyes people looked ravishing with those bands of glowing color behind them. So when I joined the Sidney Janis Gallery in 1965, I had already had my experience trying to learn about abstract expressionism. I'd switched to NYU, saw the work, and thought it was marvelous, but found myself temperamentally unable to follow the rules. While I obviously loved it, I couldn't bring myself to shut out evidence of the real world and things I could touch.

Did the 1961 installation at MOMA have an impact on your own work, perhaps with respect to the idea of an environment?

Yes. When you walked into the room, all of the paintings made a totality that impressed me. At that time the artist Allan Kaprow and I were talking about

GEORGE SEGAL, *CINEMA*, 1963, ILLU-MINATED PLEXIGLAS AND METAL, 299.7 X 243.8 X 99.1 (118 X 96 X 39), ALBRIGHT-KNOX ART GALLERY, BUFFALO, NEW YORK, GIFT OF SEYMOUR H. KNOX, 1964.

all these ideas. The basic attitude we had picked up from abstract expressionist painters was that the size of the work swelled and filled your entire vision, that it announced the importance of aesthetic experience. If you put many paintings together, they made a giant image in a small room. Taking a small room (which was all anyone could afford in those days) and filling it with your artwork expressed a spiritual state.

When did you meet Rothko?

Rothko and I met when we were both members of the Janis Gallery. Here I was, relentlessly figurative, and I was working with every material of modern industrial times I could lay my hands on. I was struggling, floundering for a language in absolute contradiction to Rothko's convictions. I'm amazed that we were friendly. We had conversations. He would say to me, "You remind me of the way I looked when I was your age." And he'd say, "What music do you listen to?" I was kind of flippant, and I said, "the Beatles and Beethoven." And he waggled his finger at me and he said, "A serious young artist like you should be listening to Beethoven all the time." Damned if he didn't turn out to be right. I have my radio here, and it's been years since I've listened to the Beatles, but I listen to classical music all the time now.

Did you have conversations with Rothko about art ?

Yes. Janis was showing a new young artist, who had just come into the gallery, named Ellsworth Kelly. I heard a voice behind me while I was staring at the Kelly paintings. It said, "Makes me feel like a damned expressionist." It was Rothko.

Rothko had long since left his surrealist roots and had arrived at his characteristic way of working in bands of color. But what was remarkable about those bands of color was their subtlety, sensitivity, and modulation. They were expressionist! His work reminded me of Gauguin's and Serusier's idea that was current in those years: pure color. Pure color in amounts large enough to express invisible states of mind. Rothko, Newman, and Still were working with those ideas; Rothko, with an interior state of mind that was still ephemeral, and invisible.

I remember the liquid excitement talking to Motherwell when he had gotten a commission for making a painting for a synagogue in Millburn, New Jersey. His excitement at being able to tackle a spiritual subject. Conversations with both Rothko and Motherwell about charging this abstract work with meaning was what I had been doing with my gallery mates and I could not believe Clement Greenberg's statements that art was only about art.

Did you ever hear Rothko discuss Greenberg's ideas?

No. Instead he referred to his Jewish roots. What he said to me was, "Studying Jewish history will give you the opportunity to deal with spiritual states." It's the only positive indication I can remember where he was announcing his interest in expressing spiritual states.

Do you recall any other responses Rothko had to figuration in art?

[Laughing] Rothko's wife, Mell, came to me one time, pleading that I intercede for her with Mark. She wanted to take a course in life drawing from the figure, I think at the Art Students League. And he absolutely refused her that permission.

It was a crime?

Yes, yes. It broke the validity of all his convictions.

Well, that was the period when there was essentially a war between abstraction and representation.

Quite so. I had all this admiration for many people in that [abstract] movement. I wanted to be accepted by the avant-garde. The art world in that moment was the last refuge for idealists, you know—literally. That group did not go to Hollywood to become rich. Instead, the art world wanted, in effect, to take off to Vermont to write the great American novel. That attitude is long since gone.

What transpired at the Janis Gallery in the 1960s?

At that point there really was a generational split. When Oldenburg, Wesselmann, Marisol, and I came into the Janis Gallery, everybody, every abstract expressionist painter, except de Kooning quit. They quit the gallery in protest, convinced that Janis had lost faith with their entire generation.

Did it feel terrible that they would quit the gallery because of your inclusion and that of others? Did you feel as if you were to blame for something terrible?

We all knew the circumstances. Most of those artists had not had a one-person show at any gallery until they were over fifty. Rothko pleaded with Sidney Janis for a $600 advance. And I think that de Kooning had gotten a $600 advance. But de Kooning was selling—selling more paintings at higher prices.

And Janis turned Rothko down. It was the example of these artists expecting their dealers to become their patrons which I objected to. Rothko was devastated, and you know he desperately needed the money. That made me decide I'd be my own patron. I'd always have a job and I would not take an advance from the gallery.

Do you think that precedent had as much to do with Rothko leaving the gallery as the pop artists?

I suspect so.

When you met Rothko, he had just changed his palette.

Yes. I had just seen his retrospective with his color bands. When he went into the dark paintings, it seemed very obvious that he had slipped into some state of deep depression, questioning his own value. He had lost a lot of self-esteem and was uncertain about what he was doing. The paintings were jarring in how vividly they could evoke that depression.

When the dark paintings were first shown, was people's reaction that he had made a change in his formal vocabulary, or was the work read as an emotional shift?

There was, at the Janis Gallery, the example of the work of Giacometti, not only the slender sculptures and the Places, but the drawings and especially the paintings. These were black and gray and spoke of an incredible sadness. I think people connected Rothko's late paintings with the Giacomettis. I knew that Rothko's late paintings were tragic and that they possessed a dark vision, but I didn't know how serious they were.

How would you distinguish Rothko from Newman?

Barney's paintings were more schematic. They were intellectually arrived at. He allowed himself very little play of emotional response or process response. Rothko was allowing his aesthetic sensibility to operate all the time. If he liked a stain then he would leave it. If he liked a transparency he'd leave it. If there was some subtlety he'd leave it.

He trusted his intuition, you might say?

Yes, very much. He was able to allow himself to do that, you know, to commit himself to a faith in his own unconscious, I suspect.

Every effort has been made to contact the copyright holders for the photographs in this book. Any omissions will be corrected in subsequent editions.

Works by Mark Rothko in the National Gallery of Art collection and cats. 51 and 54 have been photographed by Richard Carafelli, Robert Grove, Lee Ewing, Jose Naranjo, and Lyle Peterzell.

Other photographs and transparencies are reproduced with the following permission or credit: cats. 1, 6, 7, 8, 9, 15, 17, 18, 20, 24, 27, 30, 33, 34, 35, 37, 42, 50, 71, 76, 81, 102, 105, 107, 116, by Christopher Burke, Quesada/Burke, New York; cats. 22, 43, 46, ©The Museum of Modern Art, New York; cats. 23, 75, 97, by Lynton Gardiner, ©The Metropolitan Museum of Art, New York; cats. 25, 52, 77, courtesy C & M Arts; cats. 26, 86, by Benjamin Blackwell; cat. 47, by Malcolm Varon; cat. 49, © Tate Gallery, London; cat. 53, by G.R. Farley, © Munson-Williams-Proctor Institute; cats. 58, 104, 108, 109, 111, 112, 115, courtesy PaceWildenstein, New York; cat. 61, by Valerie Walker; cat. 62,

©The Art Institute of Chicago; cat. 63, by Michael Bodycomb; cat. 65, courtesy Acquavella Galleries, Inc.; cat. 66, by Bruce C. Jones; cat. 67, by Geraldine T. Mancini; cat. 73, courtesy Squidds & Nunns; cat. 80, by Lee Stalsworth; cat. 84, by Photo Inc.; cat. 85, courtesy Sotheby's; cat. 88, by Carlo Catenazzi; cats. 93, 98, by Edward Owen; cat. 110, by Ellen Page Wilson, courtesy PaceWildenstein, New York; cat. 114, by David Heald, © Solomon R. Guggenheim Museum, New York.

GAGE: figs. 2, 7, ©The Museum of Modern Art, New York/Artists Rights Society (ARS), New York; fig. 4, Alinari/Art Resource; fig. 5, ©The Pierpont Morgan Library, New York.

NOVAK AND O'DOHERTY: fig. 1, ©Hans Namuth Estate, courtesy Center for Creative Photography, The University of Arizona (provided by the National Portrait Gallery, Smithsonian Institution, Washington, DC); figs. 2, 4, ©Tate Gallery, London; fig. 3, by Hickey-Robertson, Houston, courtesy The Rothko Chapel.

MANCUSI-UNGARO: figs. 1, 3, by George Hixson, Houston; fig. 2, © Hans Namuth Estate, courtesy Center for Creative Photography, The University of Arizona; fig. 4, by Walter Klein, Düsseldorf, ©VG Bild-Kunst, Bonn; fig. 5, by Hickey-Robertson, Houston.

WEISS: fig. 1, ©Time Inc./Bert Stern; fig. 2, Christopher Burke, Quesada/Burke, New York; fig. 7, ©The Museum of Modern Art, New York/Estate of Yves Tanguy/Artists Rights Society (ARS), New York; fig. 8, © Estate of Walker Evans; fig. 9, ©Dirk Bakker/The Detroit Institute of Arts; fig. 10, ©Peter A. Juley & Son Collection, National Museum of American Art, Smithsonian Institution, Washington, DC; fig. 12, courtesy Sotheby's; fig. 13, ©Artists Rights Society (ARS), New York/ADAGP Paris.

CHRONOLOGY: p. 332, courtesy the Archives of American Art, Smithsonian Institution, Rudi Blesh Papers; p. 335, courtesy Kenneth Rabin; and courtesy the Solomon R. Guggenheim Foundation, New York; p. 336,

courtesy the Solomon R. Guggenheim Foundation, New York; p. 339, courtesy the Estate of Aaron Siskind; and courtesy the Solomon R. Guggenheim Foundation, New York; p. 340, ©Time Inc.; p. 347, courtesy Sidney Janis Gallery, New York; and courtesy The Harvard University Art Museums, ©President and Fellows of Harvard College; p. 351, ©Hans Namuth Estate, courtesy Center for Creative Photography, The University of Arizona; and photograph by Hickey-Robertson, Houston, courtesy The Rothko Chapel.

INTERVIEWS: p. 358, by Zindman/Fremont; p. 363, by Richard Carafelli; p. 367, courtesy the artist; p. 371, courtesy Albright-Knox Art Gallery, ©George Segal/licensed by VAGA, New York.

Other photographs of the artist include: p. 244, ©Hans Namuth Estate, courtesy Center for Creative Photography, The University of Arizona (provided by the Archives of American Art, Hans Namuth Photographs and Papers); p. 352, ©Alexander Liberman.